Alex Stewart

Alex Stewart
Portrait of a Pioneer

by John Rice Irwin

Schiffer Publishing Ltd

4880 Lower Valley Road, Atglen, PA 19310 USA

Other books from Schiffer Publishing
by JOHN RICE IRWIN

A PEOPLE AND THEIR QUILTS, 1983, 214 pages, extra large format, hardback with hundreds of color photographs, mostly by Pulitzer Prize winning photographer Robin Hood, of the people who made, used, and cherished quilts. The author interviewed hundreds of old time mountain quilters, as well as many newcomers, in presenting this warm, empathic book on the country's favorite folk art.

BASKETS AND BASKET MAKERS IN SOUTHERN APPA-LACHIA, 1982, 192 pages, 300 photographs. Extremely well received, and described by many as perhaps the country's most authentic and colorful book on baskets and the interesting people who made them

GUNS AND GUNMAKING TOOLS OF SOUTHERN APPA-LACHIA, 1980, (new & enlarged edition, 1983), 118 pages, softback, colored cover, contains hundreds of photographs of mountain people, the guns, gunmaking tools, powder horns, hunting pouches, etc.

MUSICAL INSTRUMENTS OF THE SOUTHERN APPAL-ACHIAN MOUNTAINS, 1979, (new & expanded edition, 1983), 104 pages, softback, colored cover, hundreds of photographs

Copyright © 1985 by John Rice Irwin.
Library of Congress Control Number: 85-62592

ISBN: 978-0-88740-053-7
Printed in China

Published by Schiffer Publishing Ltd.
4880 Lower Valley Road
Atglen, PA 19310
Phone: (610) 593-1777; Fax: (610) 593-2002
E-mail: Info@schifferbooks.com

For the largest selection of fine reference books on this and related subjects, please visit our
web site at **www.schifferbooks.com**
We are always looking for people to write books on new and related subjects. If you have an idea for a book please contact us at the above address.

This book may be purchased from the publisher.
Include $5.00 for shipping.
Please try your bookstore first.
You may write for a free catalog.

In Europe, Schiffer books are distributed by
Bushwood Books
6 Marksbury Ave.
Kew Gardens
Surrey TW9 4JF England
Phone: 44 (0) 20 8392-8585; Fax: 44 (0) 20 8392-9876
E-mail: info@bushwoodbooks.co.uk
Website: www.bushwoodbooks.co.uk

Preface
(A Word of Explanation)

The story of Alex Stewart is told largely by himself, in his own colorful, succinct, and concise manner. Although his words, as well as his phrases, appear to be simple, the meaning is often substantive and thought provoking.

The fact that Alex is quoted extensively did not minimize the task of editing, deleting, organizing, and sorting through several years of taped conversations. The greatest care was taken to see to it that the spirit, the warmth, the wit and the truthfulness of Alex Stewart was left purely intact. At the same time it was deemed necessary to give attention to order, sequence and flow.

The reader will note an inconsistency on the part of Alex in the pronunciation of certain words. For example he sometimes says "seed" for seen; and sometimes he doesn't. The use of "hit" for "it" depends on the word's place in the sentence. While he would never say, "Where did 'hit' go?", he would say, "Oh, 'hit' was the biggest panther that ever I seed." When he used "hit" in place of "it" it augmented the flow of the phrase, and it seemed appropriate to the extent that one often is not aware of its use.

His frequent use of the word "country" will doubtless not be understood by some. When Alex said that Lou Trent was one of the most wealthy men, "in this whole country," he wasn't referring to the United States, but rather to the local community. This type usage is common throughout much of Southern Appalachia.

In a very few cases Alex's peculiar pronunciation of certain words was not used for fear the reader would become confused. For example he always pronounced "fire" as "far", and "fought" as "fit". But in virtually all cases he was quoted verbatim, even when I had to listen to the tape several times in order to ascertain his precise wording. After all, he was a master with cogent and descriptive phrases, and with storytelling in general. I couldn't have improved on his style, clarity and effectiveness even if I had tried.

J.R.I.
NORRIS, TENNESSEE

This book is dedicated to the following:

Our illustrious pioneer ancestors whose empirical wisdom, noble sacrifices, and lasting contributions go little noted and seldom appreciated

Tennessee's Governor Lamar Alexander for his wisdom and foresight in establishing a statewide celebration of those things good, noble and cherished in our culture and heritage—this event is called Homecoming '86, and it is receiving deserved national acclaim

My two young grandchildren, Lindsey Meyer, and John Rice Irwin Meyer—may they learn to understand and appreciate the attributes, ideals, and characteristics of Alex Stewart and his countrymen; and may they learn to apply these noble traits toward the attainment of whatever goals they choose to pursue

Table of Contents

Acknowledgments

I should like to express my appreciation to the Alex Stewart family, without whose patience and tacit support this undertaking would have been much more difficult. Alex's late wife Margie, his daughter Edith, his sons Mutt, Sam, and Lloyd, and his grandchildren Rick and Renée especially come to mind in this connection.

Alex had a number of staunch friends and admirers who have enthusiastically and consistently offered help and encouragement for the completion of his life story; and to them I am grateful. Among these are Bill and Billie Henry, Kyle and Dora Bowlin, Alex Haley, my wife Elizabeth, and my daughter Elaine.

A special award should be presented to Andrea Fritts, and to Janice Stokes for the many months they spent in helping to decipher the reams of taped recordings which I made of Alex over a period of several years. Andrea has typed many hundreds of pages of my "illegible" longhand, and she has retyped the manuscript numerous times. Thanks also to Shirley Gadd for her proof reading, and for compiling the index.

Pat Hudson Stapleton, a fellow writer, has offered professional suggestions on organization and continuity, and she has read the work more than once for spelling, grammar and such. Ellen (Sue) Taylor, the superb typesetter and patient lady at Schiffer's Publishing Company has been most helpful in the final stages of the book. There are others, too, who contributed appreciably to this finished product, and to them also I'm humbly grateful.

Introduction

Alex Stewart is a national treasure, the likes of which this nation is not apt to see again. His early life was spent in a truly pioneer setting where such "necessities" as window panes, matches, clocks, and store-bought shoes were unknown to him. He was to observe, study, analyze, and finally participate in this primeval culture. And he was to record it in the most exact and minute detail.

If ever there was an opportunity to know firsthand the thoughts, customs, habits, and whole lives of the pioneer, here in Alex Stewart, this opportunity is manifested. The independent mountain spirit, the happy and self-fulfilling accomplishments, the deprivation, the sorrow, the mountain feuds, the moonshiner, the humorous and quaint characteristics of the Appalachian hill folk—Alex knew them all.

In today's society, the mastery of one craft, trade, or profession is considered an accomplishment. Pulitzer Prize winner Harrison E. Salisbury once stated that he made a list of the various skills possessed by his great uncle Hiram Salisbury who lived in the last century. The list, he said, covered three legal sized pages. Then he noted that there was not a single one of his uncle's skills which he (Salisbury) possessed, and he suspected that this was true with most Americans. Another Pulitzer Prize winner, *Root's* author Alex Haley, one of Alex Stewart's friends, made a similar observation. He said: "When an old person dies, it's like a small library burning to the ground."

Like Salisbury's uncle, Alex mastered literally dozens of trades, crafts and occupational skills; and like Alex Haley's exemplary old person, Alex Stewart was a literal storehouse of human interest anecdotes, empirical philosophies, mountain lore, and folk humor. To know the life story of the remarkable Alex Stewart and his neighbors on Newman's Ridge and Panther Creek is to better know and understand the human aspect of American history—a knowledge and understanding which one cannot acquire from a textbook.

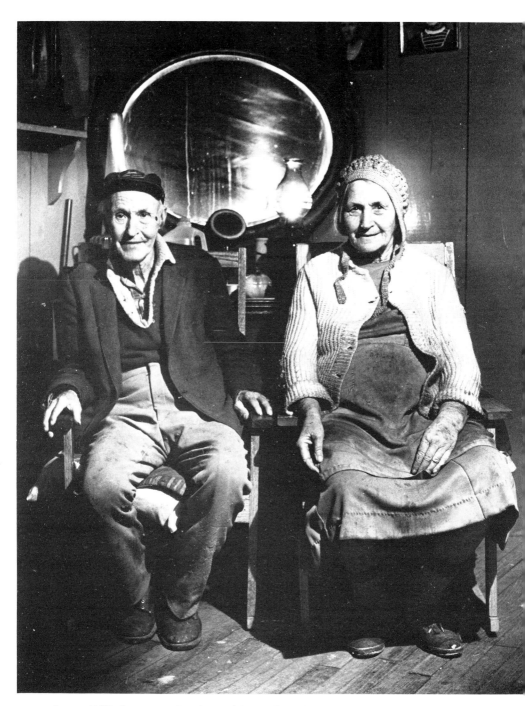

It was Ellis Stewart who first told me about his cousin Alex. He is shown here, with his wife Ruthie, in their log house on Newman's Ridge. (Photo by Robin Hood)

The Discovery Of Alex Stewart

"At First I Didn't Know What You Was Up To."

There he sat, 92 years old and only 94 pounds, the sole person on the stage of one of Washington's largest convention halls. The microphones were properly placed, the majestic room was filled to capacity and it was deathly quiet—but Alex Stewart wasn't saying anything. He was, very properly, waiting for someone to tell him when to begin. For a full two minutes he sat there before the multitude, gazing up at the high ceiling and then from one side of the spacious room to the other as if he were studying its architectural features. All eyes were upon him, but he appeared to be completely oblivious to the crowd. He was but a tiny speck on the grand stage, which he later described as being bigger than one of his corn fields. He had been introduced by folk musician Pete Seeger as the first recipient of one of the sixteen 1983 National Heritage Fellowship Awards, but he had not understood that he was to commence speaking.

He looked so small, so unimpressive and so out of place with his bib overalls and his plow shoes and his squirrel-hide watchchain. He continued to sit and wait, and there was silence everywhere. I could sense the audience responding with charity and pity, and I thought, how terrible. Here is a truly great man— the epitome of America's frontier spirit. He needs no pity.

Ultimately, an embarrassed official came on stage, whispered something in his ear, handed him the microphone, and Alex proceeded to talk. He spoke briefly about the many types of work he had "followed," and about the many years of toil, from his childhood to the present, and then he said, "I think I've about done my part, and now I'm aiming to turn it over to someone else and go home and rest for a while." The audience sprang to their feet, applauding the little mountain man exuberantly, and more than one person in the audience wept.

Alex had made the long journey from his home in Hancock County, Tennessee to attend the gathering. Hancock County was once described by the U.S. Government as the third poorest county in the entire nation, and Alex was born and raised on Newman's Ridge, the poorest and most isolated section of that

impoverished county. Now here he was in the marble halls of Washington, being recognized as a national treasure.

I recalled the years we had spent together and how the windows to this remarkable man's life were opened a little wider every time we talked. I remembered the first tiny bit of recognition he got, and how, belatedly, the regional, and finally the national media began to notice him.

My first encounter with Alex Stewart's region dates to 1950 when I enrolled in Lincoln Memorial University in Harrogate, Tennessee, a small college in full view of Cumberland Gap. Abraham Lincoln had suggested the college be built to educate the mountain people, the majority of whom had remained loyal to the Union throughout the Civil War.

I had heard of the Melungeons, a mysterious tribe of people who lived on Newman's Ridge in Hancock County some 30 miles from where the college was located, and my curiosity had been aroused. According to historical records, these people were living there when the first whites came into the area, and no one knew from whence they came. I became acquainted with a fellow student, and he invited me to spend the night at his parent's home near Newman's Ridge so I could learn more about the Melungeons.

As we sat with his family on the front porch of their home in the late afternoon, the sun shone horizontally against Newman's Ridge a few hundred yards to our east. The soft rays detailed every sassafras, every sourwood, and every gnarled oak on the mountain-side. It emphasized the silhouettes of the tiny, log cabins that sat on the very apex of the ridge. The mountain was so steep and the cabins so near the precipitous edge that it seemed they were in danger of falling from their sky perches and tumbling off into Blackwater Valley.

"How do those people get off the Ridge," I asked, "and how do other people get up there?"

This question was met with much laughter. "Well," someone said, "not many people want to go up there and them people don't come down very often; but there's some trails and paths that wind around and finally reach the top. You can get part of the way in a truck by going a few miles down the valley, crossing over the ridge at the head of Snake Hollow to Sneedville, then going up to Panther Creek."

After two years in the U.S. Infantry, and after more years of college, I returned to Newman's Ridge (as well as to other isolated areas throughout Southern Appalachia) for the purpose of gathering mountain artifacts which would become the nucleus of the Museum of Appalachia in Norris, Tennessee. Among the many interesting people I came to know on Newman's Ridge was

a most kindly old couple whose names were Ellis and Ruthie Stewart. They lived in a log cabin near the top of the Ridge, but they themselves were not Melungeons. I bought a number of quaint and unusual mountain relics from them, and one day I asked Ellis about buying a wooden pioneer vessel called a piggin.

"Well now son, I just can't let you have that. It was made by Boyd Stewart, and he was my grandpap. He was a cooper and made wooden buckets, churns, tubs, piggins and such as that. Now, I'll tell you what you do, though. You go down here on Panther Creek and you find Alex Stewart, and you get him to make you a piggin. He learnt the cooper trade from our grandpap Boyd Stewart. We're cousins, Alex and me, and Alex is give up to be the best hand around to make such as that. He can shore make you one."

I found Alex Stewart at his sawmill near his home on Panther Creek. In thinking back to that first meeting a quarter century ago, it could hardly be characterized as dramatic. I remember a little man with overalls too big for him, a well worn hat, and a pipe full of homemade tobacco that smelled even stronger than it looked. I recall the quick and jovial manner in which he responded to all my questions, but my unrestrained admiration and esteem for him came later—slowly at first, but growing as a thousand remarkable facets of his life unfolded.

As our friendship grew closer over the years, I thought of that first meeting and I wondered what had gone through Alex's mind on that occasion. "Well, at first I didn't know what you was up to," he said, "but I soon learned what you was interested in. And now I'm awful proud we got acquainted."

What I most remember about that meeting was his response to my question about making a piggin. I remember his amused laugh. "Why son, I've been out of that business for 40 years. These here store-bought buckets, plastic containers, and such put me out of commission. Anyhow I don't have no timber. It takes good cedar timber to make vessels, and they's not much left. If I had some timber I'd shore make you anything you wanted."

It wasn't long until I found some large, straight-grained cedars which I cut and took to Alex. He examined them carefully, making some cautiously optimistic comments relative to their quality, but pointing out that, "A body don't know how timber will work till he splits it open and examines it." Then he threw in a little philosophy, the likes of which I was to hear so often as we spent more time together.

"Timber is just like people. They's all kinds of people in this world, and they's all kinds of timber. They are more alike than anything I've thought about in my life, timber and people. You can go out here in the woods and find you the purtiest looking

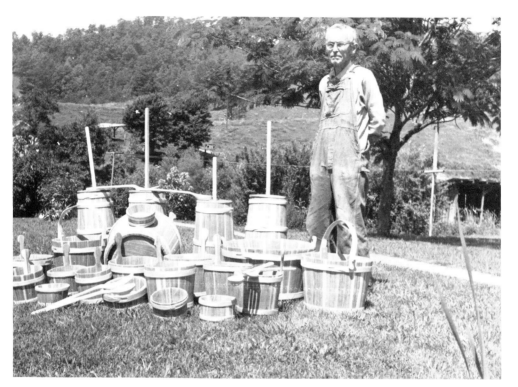

Soon after I met Alex in 1962, we took him a cedar log, to see if he really could make a churn, or a tub. When we returned a few weeks later, we found that he had transformed this one log into nearly two dozen tubs, churns, buckets, piggins, and staved bowls. This was the first such work he had done in nearly forty years, and it was the beginning of his rediscovery of the old ways. Most of these items are in the Museum of Appalachia collection. (Photo by James Webber)

tree. You cut it down and when you get inside you may find rotten places, and doty places and it's no account. Then you can get an old knotty, scrubby looking tree and it'll make the best lumber ever you seen. And that's just the way of people too. I've thought a lot about that. It's a purty good lesson if you just look into it."

After his parable, Alex went on to say that he'd see what he could do with the timber I'd brought. People tend to exaggerate their capabilities and talents, and even if they are capable of performing at the level which they claim, they often just never get around to doing it. I fully expected that the pile of cedar logs would still be lying there, undisturbed, when I returned three weeks later. I was mistaken. There wasn't a log in sight.

It was noon, dinner time, and Alex was just finishing a sumptuous meal. Both he and Margie, his wife, insisted I eat. This was the first of many great meals I was to enjoy there.

Nothing was said about the cedar and after we had finished eating we retired to the front porch. Looking back, I now know

that Alex was as anxious as a child that I ask him about the cedar. But he talked about the weather, the hateful sweat bees, and the crops that needed rain. His self-imposed protocol forbade him from bringing up the subject of the cedar, and I'm convinced he would have let me leave without mentioning it. I finally did ask about the timber, in as casual a manner as I could, for I didn't want to embarrass him in the event he hadn't made anything.

"Well," he said, obviously delighted that the question had finally been raised, "I've done a little something or other." He called for Mutt, his middle-aged son who lived with him. "Here Mutt, help me set these vessels out." Alex led us back into the house and into a room filled, or so it seemed, with the finest staved churns, buckets, tubs, and piggins that I had ever seen. Every stave in every item had been split, planed, and precisely beveled. Every white-oak band had been fashioned so that it fitted perfectly the curvature of its container. A years work, I thought, and yet this fragile little man had done all this in three weeks.

This was only the first of hundreds of feats that were to impress and amaze me, and, as Alex's fame grew, to amaze people throughout the country as well. We carried all these pieces into the front yard, and took the photograph of Alex and his work, shown on page 14.

I don't want to portray Alex as merely a remarkable craftsman, for he was much more than that. *National Geographic* featured him on the cover of their book, *Craftsmen of the World*, and he was indeed deserving of that honor, but this and similar publicity has emphasized this one aspect of him, while neglecting the other facets of his life. Characterizing Alex Stewart as a craftsman is a little like characterizing Thomas Jefferson as a farmer. Both men were adept in so many areas that it is misleading to imply that their expertise lay in only one field.

The more I talked with Alex, the more I realized I was talking with a man straight from pioneer America. Indeed, the conditions from which he sprang were as stark, dramatic, and unbelievable as the conditions 200 years earlier in more accessible parts of this country. Alex had remarkable recall and a fantastic ability to remember the most minute details. He could talk for untold hours and rattle off dozens of people's names, some of whom, I'm sure, he hadn't thought of in years.

Although he was one of 16 children who were reared in a primitive one-room log house, he never thought of himself as poor. Over the years I found that when I started querying him about the conditions he had endured, he often related stories about the plight and deprivation of other people, seldom dwelling on his own condition.

Once, I recall, Alex and I were sitting beside his fire talking, and the subject turned to his childhood on Newman's Ridge. It

was very cold outside, and the wind blew traces of snow around his Panther Creek home. Newman's Ridge was already white and I imagined the temperature was much colder up there. I thought about how difficult it must have been for Alex's large family, living there in pioneer conditions nearly a century before. But when I asked him about those difficult times, he recalled instead the deprivation of his former playmates.

"I don't see how they made it. I've set here and studied a heap about that. Grandpap Stewart and an old man by the name of Mason Goodman had a little blacksmith shop at old man Goodman's house, and Grandpap was up there working one day. He (Goodman) had two children and times got so hard that they's just starving to death.

"Them two kids got down under the house looking for corn that might have dropped through the cracks, and they found a grain on one of the sills and them two kids fought over that grain of corn—over who should eat it."

We sat there for a minute thinking of those little children scuffling over that single kernel of corn, and I knew he had thought often of that incident. After a moment he proceeded to give another example.

"They was another family that lived right out the ridge from us named Maxie, and they had seven girls and three boys. Now we lived hard enough, but we was never as hard up as they was.

"One time it come a big snow, over a foot deep, and it froze and laid on the ground for weeks, and this family had run out of anything to eat, and it was so cold they couldn't catch no game. They was awful good people and they wouldn't ask you for a handout for nothing. But one of them little Maxie boys come over to our place one day through the snow, as barefooted as a crow. Pap had killed three rabbits the day before and had dressed them and had them hanging up in a tree—up out of reach of the dogs. When we wanted one to eat, we'd just go out and cut it down. Well, Pap give that boy one of them rabbits, and he started to cry he was so happy, and he said, 'Oh, Lordy, we'll live good now.' And he started off toward his home a running, taking that rabbit for his family to eat."

Alex paused to stuff his pipe with homegrown tobacco from a large twist he kept beside his chair, and as he tamped the pipe full, I could tell he was thinking about those harsh conditions of long ago. He lit his pipe, and when he stopped his rapid puffing, he took it from his mouth and repeated what young Maxie had said. "Oh, Lordy, we'll live good now," and he chuckled at the absurdity of the statement.

I continued to take cedar and other timber to Alex, and soon he was again making almost every item he'd made during his earlier

years. Every time I'd visit him he would surprise me with some new object he'd made. He not only made the various staved vessels that a cooper, or barrel maker, would make, but he branched off into dough trays, scrub brooms, fish traps, crossbows, rolling pins, and many other items.

Word started to spread about the fine work done by this old mountain craftsman, and everyone, it seemed, wanted something made by him. He'd work two or three days on an object and then give it to someone (usually a woman) who "made" over it. A hundred times I've heard him say, "Do you know Miss (Smith or Jones) over here at Morristown? She come over here the other day and saw that big churn I made and she just took on about it. Oh, she thought that was the purtiest thing ever she seed. She asked would I sell it, and she just kept on and I said, 'No it ain't for sale, but if you promise to keep it, I'll make you a present of it.' Oh, that like to have tickled her to death!"

On extremely cold days, or on days when his health kept him indoors, he would make small items: puzzles, wooden shoes, walking canes, jack straws and literally dozens of toys, dolls, and animals. Sometimes he'd have a handful of these and when company came he'd start giving them away. "I don't know at the little tricks I've give away in the last few weeks," he'd say.

Many people paid him something, and I'm sure some paid him a fair price, but I was concerned about those who carried off his treasures without any type of remuneration, especially those who could afford to pay him handsomely. I tried to establish a price by paying him a certain amount for certain items, and eventually he did start putting prices on his handiwork; but I don't think he ever felt comfortable charging people for the things he made. In the early days on Newman's Ridge it was customary to give gifts to one's neighbors, and they would reciprocate, but I think Alex's practice of giving things away resulted mostly from his innate desire to accomodate others. The following anecdote succinctly illustrates the depth of this unselfish characteristic, and the fact that he possessed these tendencies as a child.

"When I was about seven or eight years old, I was playing in a field down below the house when I saw something real black sticking out of the ground. I dug it out and cleaned it off. It was about 6 inches long and 3 inches wide and had 7 holes in it. I took it and showed it to Grandpap and he said 'Hebbins, that's a Indian peace pipe. You take care of that. That's worth something.'

"Well it wasn't long before an old preacher come along. I showed him several arrow spikes I had. He wanted them and I just give them to him. Then I showed him the stone pipe and he said he always wanted one of them. Asked me what I'd take for it. Well, I didn't have sense enough to know. If he'd said a penny, I'd said, 'all right.' It was in the fall of the year and he had picked up some

chestnuts as he walked along the road. He said, 'I'll give you a quart of chestnuts for that pipe.' I said, 'all right', and he took that pipe for them few chestnuts.

"Grandpap found out about it and he didn't like it a bit. He said, 'that old son-of-a-bitch better never come back around here.' I've thought about that a lot—cheating a boy like that. If that preacher didn't get forgiveness for that, he's headed for hell just as shore as a fat hog's headed for the meat house."

My interest began to turn from Alex Stewart the craftsman to Alex Stewart the man. Years before I thought about writing a book on him, I began taping our conversations. After a decision was made to do this book, the taping sessions became more frequent. In the beginning we met only in the evening, for he was always busy working in his shop during the day. In later years, as he neared 90, he spent more time indoors, especially during the winter, and I would sometimes talk with him throughout the day. Although he talked incessantly, he seemed never to tire. His only diversion was to occasionally light his pipe.

I use the word "inspire" sparingly, but I never left him without being truly inspired. Each time, especially in the later years, I feared I might never see him again. This concern motivated me to work a little harder and a little longer each day, for I was most anxious to have the book finished while he was still alert and healthy enough to enjoy it.

I always thought he paid the least attention to notoriety of any person I knew; so I assumed he would have the same passive attitude about the book. As a matter of fact, I was well into the writing of it before I told him. He just chuckled a little, and said, "Well, son, you must be running low on things to write about."

After that, the book was not mentioned for months, although I continued to record all our conversations. Then one day as I was leaving, I sensed he wanted to ask me something, but was hesitant to do so. I was already at the door and we had exchanged our last goodbyes when he said, as if the question had just occurred to him, "Say, John Rice, how're you coming along on the book?"

I remember the uncomfortable, almost pitiful, look on his face. It was doubtless a question he had long wanted to ask, and I'm sure he was really asking if I still planned to write it. After all, it had been almost three years since I'd first told him my intention. Just when substantial progress was being made, I had taken time out, at the urging of my publisher, to write another book, *A People and Their Quilts*. This project took much longer than I'd anticipated. When I told him that steady progress was being made and that I hoped to have it out shortly, he seemed pleased.

"Well, I shore hope so, I'm anxious to see it."

That was the first time I realized he had any interest in this project, and I considered it one of the greatest compliments he ever paid me.

Boyhood

"Poor Little Boney Children."

Alex Lewis Stewart, the second of 16 children, was born in 1891, near the top of Newman's Ridge in a tiny one-room log cabin which his father Joe Stewart had built a few years earlier. So remote was this locale during Alex's growing-up years that roads were nonexistent, and the Stewart homeplace could not even be reached by wagon. There were numerous families living near them on the ridge, trying desperately to survive from the woods and from steep corn patches and garden spots.

Today these families and their descendants are all gone from Newman's Ridge, and gone too are the huts and cabins where they lived. A half-standing chimney of unhewn stone, a few gnarled apple trees, and the trace of an occasional rail fence are all there is to indicate that people ever lived there. The little hillside fields, once so laboriously cleared of trees, are becoming forested once again. The Stewarts and their compatriots came into the forest primeval, confronting and conquering the untamed wilderness; then they moved on, but not until Alex spent a romantic and memorable boyhood there.

Alex talked a great deal about his grandfather Stewart, but very little about his parents. He almost never mentioned any of his brothers and sisters. When one considers that he spent most of his formative years with the old members of the clan, it is understandable that his affinity was for them and that he was eager to talk of them. He doubtless was not only a very precocious little fellow, but one who was a helpful errand boy. He in turn was fascinated with every aspect of the grown-up culture and he developed an unquenchable thirst to participate in it, and to learn and understand all aspects of it.

It was only when I gently pressed him that he would talk of his father's family. It wasn't that it was distasteful to him, or unpleasant, but rather that he so thoroughly delighted in the memories of his grandparents that he preferred reminiscing of them.

Tell me about your family, Alex.

"Well, Pap's name was Joe, and he had ten children by his first

wife, my mother, and he had six by his second wife. I was next to the oldest. I had one sister older than me.

"Pap encouraged me to work, and the first work I remember doing was trying to plow an old bull that he had broke. Pap bragged on me, said 'Why, son, you can plow purty near as good as I can.' I plowed that old bull and nearly made a crop with him myself.

"I's about eight or nine years old. I was barely big enough to hold the plow up, but I done some purty good plowing. I'd take my pockets full of nubbins to the field, and when I'd get tired and have to take a rest, I'd feed the bull some of them nubbins, and he'd stand still.

"I's out there in the field a plowing one day and they's a feller come along and wanted to buy that bull. He wanted him to log

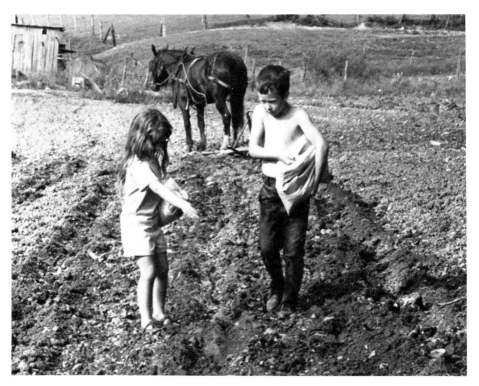

In a very few areas of Southern Appalachia, children are still exposed to the old ways of planting and tilling the soil, in much the same fashion as when Alex was a boy. Here, in a community not far from Newman's Ridge, the little girl plants beans while her brother drops corn in the same row. (Photo by Ken Murray)

with. He went and talked with Pap about buying him and Pap said, 'Why, I wouldn't take that bull away from that boy a 'tall.' We didn't have no horse nor mule stock. All we had was that bull and an old cow. We kept the cow till she's 18 year old and sold her for $20.00. She's a great big old red and white-faced cow.

"Mama took the flu and pneumonia and it killed her. Pap was 68 years old then and in a year or so he married another woman and they had six more children. Then he took sick and died and left them little bitty fellers. Only two of them was up to where they could do a little work. The mother, she went blank and them younguns just had to wander here and there to get something to eat. You talk about seeing it rough, they did. If people in the community hadn't taken pity sake on them, I guess they would have left here (died). One of them stayed with me for a while, two of them stayed down here with Brock Fleenor, and they all managed to survive. One joined the Navy when he got old enough and never did come back here no more. He stayed there till he retired and he come back on this side (of the ocean) and they give him a job where the ships would anchor, a watching after them. He had a tumor on the brain and he died and he wanted them to bury him at sea; so they buried him in the ocean. All the rest of them boys lives around here and are doing real well. They was industrious alright. Talk about seeing hard luck, they went through it till they got up where they could get out and take care of theirselves."

How old was your father, and what was the cause of his death?

"He was 74 years old. He died on his birthday, no, he was buried on his birthday. Pore old feller, he'd seed a (hard) time. He took typhoid fever and he lay from the time chestnuts got ripe in the fall till the next spring at corn planting time. You couldn't see how he lived. He was covered up with boils. Back then the doctors couldn't do nothing with typhoid fever. They'd starve you to death. Now it's not much more to cure than pneumonia."

They wouldn't let him eat anything?

"No, wouldn't let him eat hardly nothing at all. They just starved him. He never was very strong anyhow."

Did your father take as much time to teach you things as your grandfather did?

"No sir, he didn't. The biggest thing he ever used me for was to help him collect timber and to help him split it. He never took no pains to show me how to do things. He made chairs about all the time, churns, barrels, dough bowls, and spinning wheels. After I's grown and got started at the trade, he soon learned that I could beat him, and that liked to have tickled him to death."

You and your father, it seems, always got along pretty good. Did he ever whip you when you were a child?

"One time was all. We was coming home from meeting one night and I couldn't keep up with the rest of the family. I had a big rising on my leg and it was about to kill me. I couldn't walk. Pap thought I was just putting on, and he grabbed a switch and cut the blood out of both my legs. I laid in the bed for two weeks over that, and the scars, I guess, are there yet. After he found out what my trouble was he hated it awful bad and he never did whip me any more."

Did you spend very much time with your father, when you were small?

"He used to take me squirrel hunting with him when I was just a little tow-head. He'd have me to go down below him in the woods to beat the leaves with a brush. That would scare the squirrels and they'd sorta go toward where he was hid and he'd kill them. I kept begging him to let me shoot the old hog rifle, but he's afraid I'd miss. He didn't think I was old enough. Finally he agreed to let me try it once, and I killed a squirrel the first shot. From then on he would let me go hunting by myself. He never did have to hunt squirrels after that. I'd keep a count of how many I'd kill without missing. I killed 13 squirrels and one pheasant and never missed a shot. I made my own bullets.

"Pap would put up a little hay with a mowing blade, and make a hay stack or two, but most of the gardening and so forth he left to Mama. He never was much of a hand to farm."

Your mother took care of that department?

"Oh yes. She took care of the house and gardens till I got big enough to help her a little. I've seen her many a day with her bonnet tied with a string, out in the hot sun just a digging and working. I can see her just as plain. She never stopped. You don't see women wearing bonnets and working like that no more."

I imagine she kept you and the other children pretty busy, didn't she, helping her do things?

"I'll say. I'd rather took a whupping than to see Mother getting ready to make a quilt. She'd lay a great lot of cotton around in front of the fireplace to dry out so me and the other children could take out the seeds. Every night we had to seed enough cotton to fill our shoes before we went to bed. I've set there many a night and seeded cotton till my fingers was sore. I'd get my shoes full, and I'd call Mother over to inspect. She'd take her hand and stuff that cotton plumb down in the toe, and I'd have to start over again."

You mentioned once having to help your mother pick the geese?

"Oh, I've helped do that many a time—helped my mother and my grandmother too. Grandma Stewart had 12 geese, and we'd pick them three times a year. We'd pick them along about the first of April, then up in May, and again in September."

Would you get all their feathers?

"All but the wing feathers and the down. The down was white and puffy and laid right next to their skin. That's what made your next run of feathers. If you killed a goose to eat, then you'd get the down, but otherwise you'd leave it to grow more feathers. Them geese, after they was picked, was the funniest looking things you ever saw. They looked right scary for a while."

So it was your job to hold them?

"I had to hold their heads so they wouldn't peck. If you didn't hold them, they'd grab a hunk of flesh out of you every time you got a handful of feathers."

How did you know when a goose was ready to be picked?

"If you pick them too soon, you'll bring the blood every time you pick a feather; so you pick them when they get loose, just before they start to shed."

You picked ducks also?

"We used to raise a lot of ducks and I always liked to help pick them. Every time you'd pick a feather, they'd go 'quack, quack, quack.' It would tickle me to hear them holler."

How did you catch them?

"If you ever got ducks in a row, they would drive just like cattle. You could drive them in a stable or a pen and fasten them up. Then you could catch them one at a time, whenever you got ready for them. You could pick one in 20 or 25 minutes. Duck feathers are not as good as goose feathers. They're coarser."

What other kinds of feathers were used?

"Chicken feathers from the breast and from under the wing is about as good a feather as they is. The rest of their feathers has got a stiff quill that will stick through the cloth in a pillow or feather bed. The same way with turkey feathers.

"You could put a featherbed under you and one on top of you, and I don't care how cold it got, it slept warm. We'd fill all our pillows with them, and the bolsters. Do you know what a bolster is? A great long pillow that goes all the way across the bed."

Taking corn to the mill was a job most country boys did at one time or another, it seems. Was that one of your chores?

"I've took many a turn of corn to the mill. Grandpap's second wife was a Collins and her folks lived about two miles and a half below the Melungeons, and they was the only people in that whole settlement that had a corn mill. It had a big wheel on it and it was powered by water.

"Now Pap always planted his corn in March and he had corn before anybody. Mama would put it in the oven and dry it out so it could be ground. I's just a little feller, eight or nine years old, and they would put half a bushel of corn on my shoulders and send me down to that mill. It took about all day to wait my turn. They was

a bunch of fellers hanging around there and when they found out my corn was good and dry they would start eating it like it was parched corn. They would might near eat all my corn up before I could get it ground."

You told me once that your grandfather Livesey made your first pair of shoes when you were about seven years old. How did you, and other children, manage to get through the winters without shoes?

"Oh, lots of children never knowed what a shoe was the whole winter through. Many a time I would go out in the snow barefooted to dig taters that we had holed up in the garden, or maybe to get some wood. Why, son, I've waded the snow half knee deep without any shoes. I've raked the snow off the ground so I could stand there a while, trying to warm my feet a little. They'd get so cold they'd crack open and bleed, and hurt me so bad of a night that I couldn't hardly sleep. When Grandpap Livesey made me that first pair of shoes I was the proudest little feller ever you saw. When they started to tear up or wear out, Pap would fix them. I've held a pine torch many a time for him to mend my shoes."

And some children never had shoes until they were much older.

"I would say! Some never had a pair of shoes on their feet till they's might near grown. I'd say two-thirds of the women who lived up there never had shoes, even for the wintertime. They'd tie rags around their feet when they went out. Course when it was real cold they didn't stir out too much. Them rags, once they got wet and froze, didn't help out much.

"Finally they got to coming on with shoes here in the store. They called them brogans. We got to wearing them, and you'd go out and get them wet and set them around the fire of a night. The fire would die down and when you got up the next morning they'd be froze stiff. You could peck on them and they'd sound like a gourd."

Did some of the poorer families have a hard time getting enough clothes?

"Oh yeah, they just wasn't no clothes at all for most of the little fellers. They was a family named Campbell that lived on the upper end of our place. They'd get out and try to catch rabbits and things to eat. They had a little boy, and they didn't have any clothes for him, so they couldn't take him outside. They built a box to set him in, close to the fire so he would stay warm while they was out hunting. One day it turned cold and when they come back the fire had gone out and that baby had froze to death. That was awful. I just set here and study about things like that.

"A lot of folks went naked winter and summer. Why, I can remember my first pair of britches. I wore my sister's old dress till

I was a great big boy. I's four or five years old. You never thought nothing about seeing four or five kids going around stark naked. You never paid no more attention to that then if they'd had on silk.

I suppose your mother made her own soap?

"Law, I've seed Momma make hundreds of gallons of soap. She was the best soap maker in that country, and she had a certain time she'd make it, according to the moon. We burnt hickory and blackjack wood all the time in the fireplace, and got the ashes to make lye for making the soap. That's the only ashes that's fit for anything and you have to burn green wood.

"She had two big ash hoppers full, and she'd put me to watering them hoppers to run lye. You had to pour just so much water at a time. Pour it slow and let it sink down. If you poured it too fast it would run the ashes out in your lye."

Did they use anything except hog parts for making soap?

"That's all. You could use any part of the hog, the skins, fat, scraps as well as the guts. Kill the hogs and split the guts and wash them, then hang them up and let them dry and that made good soap. Beef don't make good soap like hog lard. It just won't do it. They's nothing beats hog lard for making soap. Mother'd use a feather to tell when her soap was strong enough. If the soap ate that feather down to the stem, then it was strong enough. But if it didn't then she'd put in more lye.

"She'd put sassafras in her soap. I'd dig her some sassafras root, and she'd wash them good and clean and cut them up, boil them a while in that lye, and then flip them out. That took all the bad scent away and made your clothes smell good."

Did your mother iron her clothes?

"Yeah. She was one of the few people around that knowed what an iron was. She had two great big old irons. Grandpap Stewart made them for her. While she was using one of them, the other was by the fire getting hot. She could just keep ironing right along.

"If they was a bit of rust come on the face of them irons, all you had to do was wet it and take a little salt, rub it, and set it in front of the fire. Then you didn't have no rust. It'd be pretty and bright."

The living conditions were pretty hard, apparently. You told me once that bed bugs were a problem—that they were a bother.

"Bed bugs? Oh, I'd say a bother! A bed bug's the same as a chinch. He's a little flat feller, and stinks, Jesus Christ! Let him bite you and you mash him, why you can't hardly go to sleep for smelling him. I've seen them flat and as big as my fingernail.

"Just as long as the light burns they won't bother you s'bad; but you blow out your light, and I'll say in five minutes they'll eat you

up. Strike a light and you'll see them agoing. They got a bill to them like a mosquito. They just bite right through your clothes.

"Chinches, they claim, hibernate on bats. You can kill or catch a bat, and you'll find its got chinches all over it. They claim that when bats get in your house that's how you get your start of chinches. Used to, bats would get in your house at night because the door was always left open in the summer. They'd hang from the joists and rafters and winter right there if you didn't watch.

"I ain't seen a bat in two or three years, but they used to fly thick at sundown. Them bats would see the light in your house and in they'd come. I'd get my coat or a hand towel and get them out."

Alex's remark about bats flying into the houses at night is most noteworthy. First, it indicated they had no glass windows or window screens, although the process of making glass was known to man thousands of years before the birth of Christ. It is significant that the first factory in America, established in Jamestown in 1608, was a glass factory, and panes of glass were among the first articles transported to the frontier settlement which became Nashville. This was in the late 1700's, over a hundred years before Alex's childhood, an indication of the primitive conditions that persisted on Newman's Ridge.

"I's raised in a house up on the ridge that didn't have a piece of glass in it. They wasn't a window nowhere, just a little hole and a shutter over it. We'd leave it open unless it was raining or awful cold. I's grown before I ever seed a screen. In the summer, the only way you could sleep was to leave the shutter and the door open."

In addition to bedbugs, I suppose head lice were also a problem?

"I'll say a problem! Just about everybody had lice at one time or another back then. They was them great old big lice—big as a match head. I don't see how some folks lived, going s'lousy and dirty. They could have got rid of them if they just would."

How do you get rid of lice?

"Oh, they's several remedies for lice. Crealin will get rid of them. You can take yellow sarsaparilla root, boil it down and take the water and wash yourself. It'll kill lice, nits (louse eggs) and all."

Well, Alex, I know that you consider your childhood a happy one, and I don't want to talk only about the bad times, but since we're on the subject of the difficulties of the children, tell me about the problems caused by worms.

"Aw, half of them little children didn't look like they could live—small and boney and eat up with worms. They didn't know how to get rid of them. The doctor come up to our home one time and we was all just eat up with worms. I's standing there by the fireplace and my belly was just killing me. I'd take spells and

might near die with it. Dr. Mitchell said to my mother, 'Don't you know what to do for that?'

"She said, 'No, I've give them several kinds of stuff, but seems like it ain't doing them no good.' He said, 'Don't you know wormweed? The yard's full of it. It's that weed that stinks so. You get out there and gather a handful and put it in a half pint of molasses and cook that till it gets hard enough to make candy, then let them eat that.'

"Well, she fixed that in a pan full of molasses and I ate, I guess, all you could hold in your hand. It tasted good to me. The next morning I went out of doors and they's 52 worms come from me at one time—just clean worms. Some of them were over a foot long."

It's a wonder it hadn't killed you.

"Oh, they'd killed lots of children. I've been to children's buryings where they wasn't nothing in the world wrong with them but worms. Oh, God that was trouble! Poor little ole boney children."

The round worm and the pin worm are probably the most common human parasites, and were likely the type to which Alex alluded. Infestation comes from the eggs of the species, and a person acquires these eggs by eating unwashed food, or from poor sanitary conditions in general.

The absence of toilet facilities and the inability to control the housefly population were enough to cause constant problem with these parasitic worms. When Alex told me of these terrible conditions, I was appalled. I grew up in the mountains of Southern Appalachia and thought I was familiar with all forms of deprivation, but the sordid conditions he described presented a new dimension to the often romanticized frontier family. It's not a pleasant part of the picture, but it cannot be ignored, and it should cause all of us to be more appreciative of our modern-day conveniences.

"The first toilet ever I seen was built right down here on old Lou Trent's place, and I didn't know what it was. I was walking to school and passed along there. I asked one of his grand-daughters what they was building and she said it was a playhouse. She was ashamed to tell me it was a house where they went to do their business."

So there were no outdoor toilets in your community during your boyhood days?

"Oh, no. In the summertime folks would generally use the woods around the house, and if the younguns went out at night, they'd just step out the door and sit down anywhere. Now in the wintertime they'd just sit across a pole and do their business, right

at the back of the house. They'd drive two forked stakes in the ground, and put another pole in those two forks; just like you was making a place to hang your wash kettle. It would be about two feet off the ground, and there's where they'd go.

"Why, it wasn't a bit more to walk up on somebody doing their business than it was to walk up and meet them in the road. They never thought about getting out of sight. That's the biggest thing the dogs had to eat. They didn't have enough food for the children, let alone the dogs. If they didn't have a dog, that manure would pile up there two feet deep and when spring came it was awful at the smell."

During winter nights when it was raining, or when it was very cold, what did people do about toilet facilites?

"I've seen them take a board, they didn't have iron shovels, and pile ashes on the hearth, and there's where the kids would do their business. They'd dirty right there on the hearth. Let it lay there all night and the next morning take it and throw it out.

"I can remember mighty well the first time I ever heard of a bucket that you could set under your bed—chamber, they called it. Mommy got her one. Grandpa Stewart made it outta wood. It was a big, round thing that she put ashes in, you know, and she'd take it out and empty it of a morning. It was sorta like a dough bowl, and for sick folks, they'd slip that ole bowl under them. Let them lay there and wet and nasty in it. Wasn't fit, didn't look like, for a hog to lay in but that was the best they could do."

Did they ever dig a hole in the ground for use as a toilet?

"No, they never thought about digging out a hole, like for a toilet or nothing like that. One of our neighbors had a great big family—about 16 children. Right out from his house, about as far as from here to the woodshed (a distance of 30 feet) is where they'd go, just ever when the pain struck. It was awful to step out there. What a time they had. And the flies, Lord God, them piles would just be solid black with flies.

"They would bother you to death, and if you didn't get rid of them, they'd just take over. I've seen black swarms of flies in people's houses. If you ever saw a piece of food, why it'd just be covered with flies.

"Mother used to make fly traps out of straw. She'd take a needle and thread and sew wheat straws together, and the trap, when it was finished, would be in the shape of an egg, sorta pointed on both ends. It would be about the size of a gallon bucket. The flies could go in from one end, but they couldn't get out. They's trapped in there."

How did she get rid of them once she had caught them in the trap?

"She'd hold them over a steaming kettle and that'd kill them. Then she'd open the trap and get shed of them.

"They was a weed that growed around here that we'd kill flies with. You'd put it in a bucket and mix some molasses with it. Then you'd bake a big pone of cornbread and take just the crust off and cut it to fit on top of that bucket. You'd cut a hole in that cornbread crust, and the fly would light on the cornbread and smell the molasses through that hole. When he went down in that hole, the scent of that plant killed him dead. She'd catch a bucket full of flies that way. It'd get might nigh every fly on the place."

Do you remember the name of the plant?

"For the life of me I can't think of the name of that plant. (This was the only time I found Alex unable to recall something.) It used to grow right down from the barn, plenty of it. It's a hateful weed when it gets started growing—just takes over everything and you'll want to get shed of it. I kept on fighting it till I got rid of it."

In discussing the extremely poor living conditions of his childhood, Alex was sailing rapidly through one story after another when he mentioned something about a cabin not having a board (shingle) roof on it.

"Now, wait Alex," I said, "What do you mean about the cabin not having any boards?"

"It was covered with bark—long dried pieces of peeled bark."

This was an amazing revelation. I had never heard nor read of bark being used as a roofing material by any of the early settlers in America, other than the Pilgrims, who presumably employed it as a temporary measure. But with Alex, dramatic surprises such as this were apt to occur at any time.

Were you ever in any of these bark covered cabins?

"Certainly. One house was right up here in the gap, and they wasn't a board on it. It was covered in bark. They'd put that bark on there and put rib poles on the top of it, to hold it down. They would drive wooden pins through the rib poles and through the bark, and that would hold it in place. To make sure they held, they'd tie the ends of these rib poles down with strips of bark, or sometimes with old handspun rope."

Would the bark side be turned down on the house?

"No the sap side would be turned down and the bark side turned up. It wouldn't leak a bit."

Did the bark strips run up and down with the roof of the house?

"Yeah, they'd run up and down the house. They used chestnut bark and young-like poplar. After poplar gets so old, you can't peel it long enough. You can if you've got a spud, but you can't do it with just an axe. Poplar can be about a foot and a half (in diameter) but any bigger than that and they don't peel good. Old poplar, it gets heavy. I've seen pieces of bark peeled off that I couldn't carry to save my life. It'll get two inches thick or thicker.

They commenced peeling the bark when the tree started budding out good."

These roofs wouldn't last very long would they?

"They'll last right on. You see, it didn't have enough sap in it to hurt it. That's why they'd peel them s'early (in the year) before the sap got too high in it. It'd last several years. I've seen them make their lofts out of dried bark too. After it got good and dry, it would be as strong as a two by four. You could take a piece of that bark and make a good foot-log to cross a branch or creek."

I suppose that most of the cabins were just one-room affairs.

"Oh, yeah. And they's plenty of them that didn't have a floor in them, except the ground. Just had a dirt floor and it would be rounded down like the bottom of a bowl. The middle would get wore down before the sides. And they wouldn't have a stick of furniture in them. They'd take a split-out rail with a big rock under each end and use that to sit on, and drive some big wood pegs in the wall to hang things on. They just had leaves and straw piled in the corner to sleep on.

"I've seen them that didn't have a sign of a table to eat off of. They'd maybe take a piece of dried bark and stick it in the cracks of the logs, from one corner to another and use that as a sort of table."

I seldom talked with Alex without learning something I considered exciting and historically significant. Late one night, after several hours of conversation, I was preparing to leave and noticed that the fire was getting low. I commented that we'd better add some more coal or some wood or it would soon go out. "Yeah," he said, "if we let it go out, then we'll have to catch some more." The expression didn't sound right, and I had to think for a moment to understand Alex's meaning.

To "catch fire," as we understand it, means to be engulfed in flames. When a person or a building "catches fire," they are being burned, but when the frontiersmen struck a piece of flint-stone with his knife, it caused a spark of fire which he quite literally "caught" in a bunch of cotton. The spark ignited the cotton, which had a little gunpowder sprinkled on it. From this frontier term, our present day expression "catching fire" is doubtless derived.

"Back then folks had to keep fire all summer if they wasn't fixed to catch it. I've seen Pap, many a time, take down his old powder horn and just get a pinch of powder. Then he'd take a little bunch of cotton, we always raised a little cotton, and he'd take his finger and wiggle out a little hole in that cotton. Then he'd put the powder in and take his pocketknife and strike it on a little piece of flint-rock. When he caught that first spark, he'd blow that cotton till it blazed up; then he'd have some shavings to

put on it and purty soon he'd have plenty of fire. I've done that many times myself.

That was before there were matches on Newman's Ridge?

"They wasn't no matches. I remember the first matches that come in our country. They'd stank worse than cuarn (carrion). Strike one and the smoke would catch you in the face and strangle you. George Bell got the first matches that ever I seed. He followed smoking all the time. He'd never use them unless he got down where they was a gathering of people; then he'd pull out one of them matches and light his pipe. Everybody thought that was something."

If a family didn't have matches, and if they weren't fixed to catch fire, then they'd have to keep their fire the year 'round?

"Yeah, they'd take and burn hickory and it would make good coals. Then they'd cover them ashes with bark of a night, and the next morning there'd still be plenty of fire. But if you didn't watch out, you'd let your fire go out and then you either had to start one or go somewhere and borrow some.

"We used to live close to George Bell. Well, before he got matches, they'd have to keep fire all the time. If they let the fire go out they'd come to our house and borrow fire. (Alex chuckles.) They've come many a time at daylight to borrow fire to get breakfast with. They had an old metal bucket, and his two girls, Nodie and Sary, would come after coals. Mama would get them a shovel full and put it in that vessel, and they'd take off running for home." Alex laughed heartily at the memory of those two girls running through the woods with a bucket of coals.

Candlelight has been man's chief source of light for over two thousand years, and when we think of the most primitive form of lighting, candles come to mind. They were usually made of tallow and beeswax, and one would think that this ancient form of lighting would have been, as Alex would say, the "go" on Newman's Ridge in his time. Here again, Alex had a surprise in store.

"You hardly ever seen a candle. Just a very few people, what you might say the well-to-do, had candles. Most people had to keep what little grease they had to season their food with. They wouldn't ever waste a bit of beef taller. Used it to cook with the same way they use pork meat now. And they'd use it to grease their shoes with.

"The main light way back then was a pine torch. Take the heart of a rich pine and split you out a great bunch of long splinters, and tie them together. Sometimes we'd use beef taller and beeswax melted together to make a good candle, but it was just about as bad to smoke as pine. Everything in the house would get as smoked up and black as the chimney jamb. Sometimes we'd

31

just put some grease in a little bowl or saucer and twist up a rag, and lay it in there, and it would burn right on. You could use taller, hog lard, polecat grease, or any kind of grease. We didn't have no lamp when I's small. I remember as well as yesterday when Pap went over to Jonesville and bought a little kerosene lamp. It was just a little tin lamp with a handle on it, and it had a little straight spout. It held about a pint. Didn't have no globe at all."

Quite by accident I discovered a most interesting and dramatic happening in the life of young Alex Stewart. I learned that he had, at one time, lost his eyesight. A few days before Christmas in 1980, I took my young nephew Rob and my step-grandson Eric Erickson to see Alex. We had spent the cold day in the mountains of upper East Tennessee and in Scott County, Virginia, and it was after dark before we reached Alex's cozy house. We spent an enjoyable two hours there, and Alex gave each of the boys one of his wooden carvings. He had spent many hours on each one and he had people waiting in line to buy them. But his instinct was to give his visitors something, and the carvings were all he had.

During the course of our conversation I noticed a piece of root lying on the cluttered little table next to where he sat, and I inquired about its purpose. "Well, now that's the root of slippery elm and it's good for all kinds of things." He gave each of us a big chew, and the boys were not at all impressed by its taste. While Alex was preoccupied with his pipe, the boys ridded themselves of the medicine, making all sorts of faces because of its strange and bitter taste.

Alex began to tell them of the many uses of the herb, as if it was something that would benefit them for the remainder of their lives. Realizing they were not too impressed, and in an endeavor to emphasize it's medicinal qualities he said, "It brought back my eyesight one time."

Were you really blind?

"As blind as a bat. The measles settled in my eyes and left me blind. I's seven or eight years old, I guess. Me and my sister was going to school in the late fall and we caught the measles. I took them and they liked to have never broke out on me.

"They's a feller by the name of old Bob Moore who come along by the house one evening and was carrying whiskey in a gourd. Didn't have no jug or jar—just had it in a big gourd.

"Well, folks said if whiskey wouldn't break the measles out, nothing else would, so Pap got ole man Moore to give me some of that whiskey. I drunk it and that broke them out.

"I got up right soon after that, thought I's well, and struck out to work. It was cold and they was snow on the ground and I took a

back-set and went as blind as if I'd never had an eye in my head. Pap went and got the doctor for me—old Doctor Mitchell. He come and give me some medicine, and in a few days, he come back to see me. He made about five trips up to see me, and the last trip he said, 'You're just a blind boy. That's all they is to it. I've done everything I know to do for you, and your eyes is just gone.'

"Well, that very day old man Goins come in. That was Pap's cousin. He was just an old beat—went from house to house for his living. I's setting with my head down, and he asked what was the matter. Mother told him I was blind. 'Been that way,' she said, 'for a week. He can't see a thing.' My eyes looked like balls of fire.

"Old man Goins said, 'Go out and get some slippery elm and put it in his eyes and if they's anything in the world that will cure him, that will.' Well, Pap didn't like him much, and he didn't put any dependence in what he said, but Mother said, 'Now, Joe, it won't hurt nothin' to try. The simplest things is sometimes the best.'

"Pap didn't believe in it but he went out and got a little root, and that night Mother made two poultices and bandaged one to each eye and next morning I could tell my eyes was better. She put poultices on me for three days and my sight came back. If it hadn't been for that, I'm satisfied I'd never seed no more."

Since it was the Christmas season, it seemed a good time to ask Alex about how he, as a boy, observed Christmas with his family. I told him I'd return on the following Saturday to discuss this and other subjects. The Museum received numerous inquires from the news media every year about how Christmas was celebrated in Appalachia during earlier times. They all expected, it seemed, to be told of a Norman Rockwell scene where the famiy members gathered at Grandma's highly decorated house for a sumptuous meal and extensive gift giving. But a more realistic depiction of the Christmas season in many rural areas of Southern Appalachia was far less romantic.

In 1964, I spent the day before Christmas in an isolated section of Hancock County, going from one old homestead to another in search of relics for the Museum. Just before dark I saw a decorated tree in a modern home and it occurred to me that this was the first Christmas tree I'd seen during the entire day. In the fertile valleys almost everyone had a Christmas tree and accompanying decorations. But not here in the mountains.

The lack of Christmas celebration was not peculiar to the remote sections of Southern Appalachia. The old ways, I think, just lingered much longer here. Harrison E. Salisbury, long-time correspondent for the *New York Times*, wrote an article for the *Reader's Digest* in December, 1983 about his great-grandfather's brother, Hiram Salisbury, who lived from 1779 until the start of

the Civil War in 1861. Salisbury noted that his uncle, in his daily diary, didn't even mention Christmas, in his entry for December 25, 1817.

Jean Ritchie, the balladeer from the mountain community of Viper, Kentucky, tells about the first Christmas tree her mother Abigail Hall Ritchie had. She had read about such things and went out in the forest (about 1910) looking for an evergreen. She could find nothing suitable and had to settle for a dormant sourwood. She decorated it with red ribbons, apples, and popcorn. The elder Ritchie, the mother of 14, said the children liked the tree so well she put one up every year thereafter.

I knew I could get first-hand information from Alex about the early Christmases. Saturday, my day to visit him, was cold. The west wind was blowing and the temperature was dropping toward zero. One of Alex's sons, Lloyd, met me down at the sawmill where I parked.

"Pap's been looking for you all day long," he said. He finally give you out a little while ago. He said, 'I guess the weather got a little too rough for John Rice.' He'll shore be proud to see you."

As usual he was in his tiny room in the back of the house, and when I entered, unannounced, he seemed unusually happy to have company. "I just about give you out," he said. "Figured you'd froze up."

Although his legs had almost completely given way, Alex looked better and seemed to be suffering less than when I'd last seen him. He had the chair in which he was sitting leaned against the bed and was trying to finish a cedar walking cane with his pocket knife. He had a good fire going in his grate and plenty of coal and pine kindling beside the fireplace. He gave me a bottle of blackberry brandy which he'd been "holding for a long time." He said he felt like talking so I turned on the tape recorder and away he went for almost two hours.

"The first Christmas tree ever I knowed of was put up by the Presbyterians who had come in here and built a churchhouse down on Blackwater. I's about ten years old, and nobody had never seen such before. The people just went crazy about it. Miss Axel (one of the Presbyterian missionaries) got me to make her a lot of toys to put on the tree; little pistols and things like that. And, oh, the stuff she put on the tree for me, for doing that: a knife, a French harp.... that like'd to have tickled me to death."

The children weren't accustomed to getting presents?

"The first present I ever remember Pap getting us for Christmas was a little candy and an orange. I'll never forget that. I wasn't over four or five years old. I saved that candy and just took a little bite off it every once in a while. I don't know how long it lasted

me. And they didn't have no decorations along back then. That come in later on."

On a very few occasions I had heard references made to "Old Christmas" but no one, not even those older than Alex, seemed to know anything about it. I asked him if he'd heard of Old Christmas and he responded as follows.

"Oh, yeah, they call it Piffiny (Epiphany) now. Today, lot's of people don't believe in Old Christmas, by the way they talk. If you don't believe what I'm fixing to tell you, why you try it and you'll find out whether it's right or not.

"On Old Christmas night at twelve o'clock, you go to where there's any cattle, and you go and sit down and listen at them pray. I tried that twice. The first time, it liked to have scared me to death. They got to going on so, that I broke and run back to the house. But I got to studying about it and then I tried it again. Me and my oldest sister went together, on one Old Christmas night. We went to the barn and set down and waited till about twelve o'clock, and just slipped up right easy, didn't make no racket. We had two milk cows, and directly they commenced. Just moo-o-o-o-o, moo-o-o-o-o, and groaning and going on, and we got scared and run to the house. Grandpap Stewart told me they'd do that, but I didn't believe it. And after I'd tried it twice, I saw they was something to it.

"And I don't care how cold it is, nor how deep the ground is froze, elder bushes will sprout out of the ground on Old Christmas night. They'll sprout out that night and never get no bigger till the sap rises in the spring of the year. If you don't believe me, you find you a place where there's a bunch of elders a growing and you look around underneath the bushes the night before Old Christmas, and you won't see any sprouts. Then you go back the next morning and you'll see them sprouts a peeping through the ground everywhere, don't matter how hard the ground is froze. I've checked that out, I don't know at the times. And don't ever loan anything to anybody, if you can help it, on Old Christmas; because you're not apt to get it back."

Well, Alex I don't suppose the children of today know how little their ancestors had—and I guess they don't know how well-off they really are?

"Oh, it's a sight at how much better the little children are clothed and fed today. Yeah, they're in paradise today compared to what they was back then."

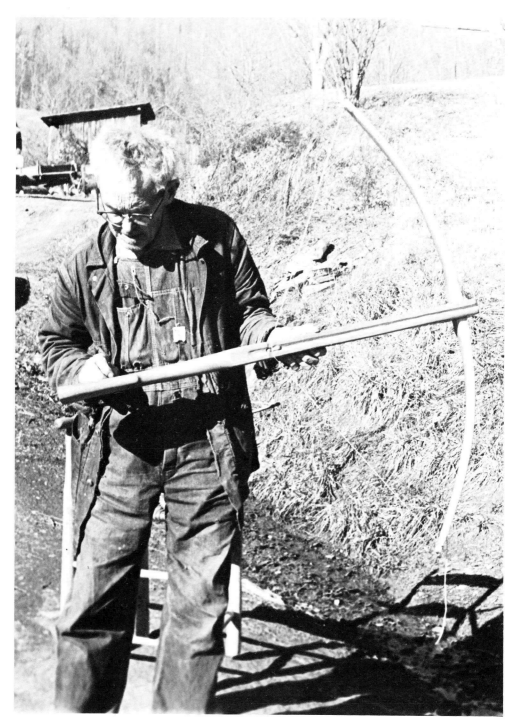

Alex signs the stock of the crossbow he made for the author based on his memory of the one which belonged to his grandfather. This crossbow is now on display at the Museum of Appalachia. (Photo by the author)

The Pioneer Ancestors

"If They's Ever A Good Feller That Ever Lived, Grandpap Stewart Was One."

Alex knew and liked all his grandparents, and he had a close relationship with his own parents, but it was his grandfather Stewart that had the greatest impact on him. No matter what subject we discussed, Alex would eventually get around to quoting "Grandpap Stewart." I asked him once why he spent so much time with his grandfather.

"Back when I was a very small boy Pap would go off in the woods to hunt timber, or to work in the fields. I was too young to go and as soon as he'd leave, I'd go to see Grandpap. I'd watch him work, and help him a little, and I learned a lot. If he liked you, he'd take the greatest pains in the world to explain anything to you. If he didn't care anything about you, all you could get from him was a 'yeah', or a 'uh, huh.'

"Oh, I've spent lots of nights there. I'd set and hold a pine torch for him and Grandma to work by many a night. Every once in a while a big drop of hot tar would drop from that torch onto my hand. Oh God, it would hurt. Grandma would say 'don't touch it, don't touch it. If you'll let it alone it won't blister.' She said that if you took it off it would blister right away, but if you left it on, the rosin would draw the fire back out. I learned that she was telling the truth."

How much education did your grandfather have?

"He had a purty good education but I don't know how much schooling he had. He could read and count alright, enough to take care of hisself. Oh, what a handwrite he had! He could write the purtiest handwrite ever I seed. He wrote with a red pen all the time, and wherever he got it I never did know. Back then you never seen no red pens.

"I was there one time when an old Methodist preacher come along selling Bibles, and he said, 'Mr. Stewart, would you let me borrow a little of your time?' The preacher was a one-eyed man. He'd stuck a butcher knife in one of his eyes and put it out. He got him a chair, pulled it up and set down, and he had him an old big satchel of some kind and he retched down in there and got out a Bible.

"He told Grandpap how great it was and how much better it was than old timey Bibles. Grandpap had an old-timey Bible. It was that thick, I guess," (Alex measured off five or six inches on his hand.) "Never seed one like it before nor since and it had a solid leather back. Grandpap just got up and walked in the house and got it and said, 'Here's my Bible.'

"Well, the preacher said, 'Now this one'll explain lots of things that yours don't.' Grandpap said, 'My Bible explains all I want to know about it, and if that's all you want from me, you just as well get up and get gone.' I'll never forget that.

"Every Sunday morning he'd get up and get that Bible down. He'd sharpen his razor on it and sit down and shave. I never have seed a book like that of no kind. My Daddy got it and when he died, his (second) wife got it, and she went crazy and set the house on fire and burned it up. He had all the names and ages of his children in it. If I had that Bible, money wouldn't buy it."

Alex knew a little more about his ancestors than most of the people from this region. Typically, many "natives" of Appalachia know, at most, that their people came from North Carolina or Virginia. It is most unusual for someone to describe themselves as being of English, German, Welsh, or Scottish descent. This is understandable when one takes into account the constant movement of their ancestors. From the time they landed in one of the American ports, the generations moved westward, each time a little further into the wilderness. Oftentimes frontiersmen had not even known their grandparents, and it wasn't long before all contact with the past was lost. Add to this the fact that most all their thoughts and efforts were devoted to matters of survival, and one understands why most mountain families knew little about their background.

"Well, the Stewarts was Arish (Irish) and they came from Arland.[1] The first ones to come to America was Jim Stewart and his brother Sam. Jim was my greatgrandfather. They weren't allowed to come into this country and they had to hide on the ship in order to get here. I've heered my grandpap tell about them hiding in a big box of ducks on the ship. They hid in that box till they got plumb across the ocean.

"Jim was a Captain in the old Revolutionary War. He settled over here 'round Jonesville, Virginia. One of Jim's three sons settled close to his daddy, and one, Dan, settled at Pennington Gap. The third one was Boyd, my grandpap. He come over here

1. The name Stewart, variously spelled, is apparently of Scottish derivation. It is likely that the family had moved from Scotland to Northern Ireland in the 1600's and thus came to be known as Scotch-Irish. When Alex was told that his people came from Ireland he naturally assumed they were Irish.

on Newman's Ridge and saw that boundary of timber and he bought it for the timber, and not for the land. It belonged to the government back then, and I believe he got it for $1.00 an acre. It was the best timbered piece of land that ever I looked at. Why it had sugar (maple) trees in there that was three or four feet through them—just plenty of them, but they tapped them so much it finally killed them."

So your Grandfather Stewart was a pioneer in this area?

"He was one of the first men ever to settle on that ridge."

According to our best calculation, Boyd Stewart was born about 1810, and he probably settled on Newman's Ridge in the 1830's as a young man. Although most of the wide, fertile valleys and the river bottoms were settled a quarter century earlier, Newman's Ridge was doubtless an untamed wilderness at that time.

Where was the nearest trading center or the nearest country store?

"The nearest store was in Jonesville, Virginia, and that was 20 miles away. He'd go off the top of the ridge and walk plumb to Jonesville and back in one day. He had to cross them mountains: Walden's Ridge, Copper Ridge...it's a long way over there. They wasn't no roads back then; just little trails where people could walk. You couldn't get a wagon back up there at all."

Forty miles is a long walk across the mountains. Why didn't he ride his horse?

"I don't know; he was a funny old feller. He told me one time that he left home one morning bright and early to go to Jonesville to get him some coffee. He made chairs and he took four of them to sell. Packed them on his back to Jonesville and got him some coffee. He got 50¢ apiece for the chairs.

"Grandpap was lucky if he could get the money to buy coffee. They's a lot of folks that never had no coffee at all. I've drunk what they called coffee made out of wheat. Put wheat on the stove and parch it right brown and hit makes purty good tasting coffee."

It is interesting to note the importance of coffee in the life of Boyd Stewart and in the lives of most of his neighbors. When he got money for his chairs, it wasn't sugar, salt, cloth, food, or medicine that he bought, but coffee. All these other items and commodities he could produce himself, but not coffee, at least not genuine coffee.

Purchasing a luxury like coffee in a land where food and other essentials were often in short supply seems illogical, but Europe had fallen in love with the beverage in the 1600's, and the habit had followed the immigrants to America. Here it flourished despite the strict religious teaching of Southern Appalachian

churches that discouraged its use. Uncle Campbell Sharp, for example, was bragging one day on what a fine Christian woman his wife was; how loyal she had been to him and what a hard worker she was. Then he paused, as if he wasn't sure he should reveal more. "She does have one very bad habit," he said dramatically. "She has tó have her cup of coffee in the mornings."

I suppose there were no churches or schools anywhere near Newman's Ridge during those early days?

"Oh, no. Grandpap and Grandma would go over to Jonesville to camp-meeting at certain times of the year. They'd stay there several days with one of his brothers. I can remember the first church that was ever built in this part of the country. They built a log churchhouse down here at the foot of the mountain on the side of the road, about three or four miles from where we lived. Didn't have no school, so it was used as a schoolhouse too. I went to school down there many a morning, barefooted and the ground froze and white with frost. Had to run, might near it, to keep from freezing to death."

Your Grandfather spent his life on Newman's Ridge?

"Yeah, he built a log house and raised his family there. He had ten children, but two got poisoned to death on strychnine."

How did that happen?

"John Overton, an old feller who lived up there, was crippled—had the white swelling and his leg was drawed up thisaway. Couldn't get it to the ground. Well, he'd hobble through the ridge up there and he got to drinking the beer off a still that was run by the Newmans. Some of the boys got to stopping by Newman's still also, getting them a drink once in a while.

"This old man Newman found out about them drinking his beer, and he went and got some strychnine and put it in a cup and set it on top of the hogshead—that's the barrel where he made his beer. Well, Pap's brother, Edgar, and Dan Creech come through there and stopped at the still. Edgar said, 'Let's wrestle to see who gets the first drink.' Well, Uncle Edgar throwed Creech, and he got the first drink, and by the time he got to the house he didn't know nothing. He didn't live no time till he's dead. Creech, he come so near dying that it took all the hide off his mouth. Then he had a sister, Pap did, that was sickly, and she took a dose of strychnine and killed herself."

What happened to the other eight children? Did they stay in the area?

"No, they all left but two. The oldest one, his name was Witt, he stayed up here on the ridge and my Pap stayed."

These two vessels are the only known surviving staved pieces made by Alex's grandfather, Boyd Stewart. The honey bucket, at left, was acquired by the author from the Martin sisters, who lived on Panther Creek a few miles down the road from Alex's home. The large tub, or "wash stand" was acquired (also by the author) from Noah Bell, who lived on the opposite side of Newman's Ridge, on Blackwater Creek. Both these items, are on display at the Museum of Appalachia in Norris. (Photo by Robin Hood)

Witt lived where Ellis Stewart lives now?

"That's right. Ellis was the son of Witt. Witt lived to be 87 years old. He had 11 children and Ellis is the only one of them that's still living. They was seven boys and two of them went to Oklahoma and died out there."

Your Grandfather was quite a craftsman, wasn't he?

"He could make anything that could be made out of wood. He made them ole spinning wheels, and he made looms to weave on, and he made them little flax wheels. He'd go to the (blacksmith) shop and make all of his iron—his tools, cranks, spindles, and everything. It takes a good workman to make them flax wheels.

"He made a flax wheel for a feller once and the man come to get it and he's the proudest (particular or fastidious) feller ever you saw. He was sorta wanting to court one of Grandpap's sisters and he was bragging on that wheel. He was wearing a new pair of handspun britches they called jeans. Wells, he's a standing there

in the yard, and hit was purty sloping under a big apple tree where he stood, talking to Grandpap. The chickens had been roosting in that tree and had messed all over the ground. Well, that feller, he stepped in that slick chicken manure on that hillside and his feet flew out from inunder him and he just got chicken manure all over him. He said, 'I wish them god-damned chickens had been shut up in their nests.' Grandpap laughed about that."

How much would he charge for a spinning wheel?

"He charged $5.00 for a big wheel—the wool wheel. I don't know what he charged for the flax wheel. He'd get things right before he quit. I've seen him set humped up working on something or other for a week. But time didn't mean anything to him. Why, I doubt that he ever kept track of how long it took him to make something like that.

"He could make the purtiest little wheels of anybody I ever saw. He made one for a feller, Bill Sadler I believe was his name, and he got me to go with him to deliver it.

"We started up that mountain and we went higher and higher and had to rest every once in a while, and Grandpap said, 'Hebbins' (heavens)—that was his word—'Hebbins, it's bad to be poor and have to work.' I'll never forget that."

Your Grandfather Stewart was in his prime during the Civil War. Was he involved in that conflict?

"No. He didn't believe in it and he wouldn't go. The rebels wanted him to join them but he never would. He hid out in the mountains in a big sinkhole for about six months. Grandma would slip out in the night and take food to him. Every once in a while they'd make a big raid for him, but they never caught him.

"Seven rebel soldiers come looking for him one time and of course he was gone. They was poking around and they got in the smokehouse and was carrying off a lot of his meat. Grandma saw them and grabbed a maul and beat them with it and they dropped the meat and left."

Did your Grandfather have a large house?

"His house was built long. He had a living room, a kitchen, a dining room, and a smokehouse all attached together right in a row. His porch stretched all the way across, and he had his turning lay (lathe) on the far end of it. Right above it he had him a hole bored in a log that he kept grease. Anything that he turned, he'd reach up there and get some grease on his finger and put on his timber, and that made it turn as good again. He'd use hog lard or taller (tallow) either one."

And you learned how to make things from your Grandfather?

"Yeah, he'd sit down and take the most pains to explain something to you of any man I ever saw. I'd get out in the fields

and woods and hunt pieces of horseshoes that had been lost off the horses, and I'd take them to him and that would just tickle him to death. He'd take them to his blacksmith shop and make things out of them. He showed me how to heat the iron, and temper it, and make different things.

"He always raised a little patch of wheat, enough to make him a little flour so he could have biscuits for breakfast. Ninety-five percent of the people never had biscuits. They just had cornbread, three meals a day. A lot of people didn't have no bread of any kind. But he had biscuits and whenever I'd go there he'd give me one and put some honey on it. I thought that was the best eating that ever was.

"He was counted (to be) one of the best fellers around here. People would go to him in the spring of the year to get their seed 'taters, corn, beans, and so on to plant. They'd do a little work for him, and he'd let them have some seed, or sometimes he'd give them a little corn to live on till they could raise something of their own."

We've all heard about the hunting shirts that Daniel Boone and Davy Crockett wore, but that era seems so remote it lacks the touch of reality. When Alex spoke about hunting shirts, that facet of frontier life took on new meaning.

"Back then everybody wore handmade clothes. They had their spinning wheels and their looms and they'd make their own clothes and that's all Grandpap ever wore. They didn't have no opening in the front of their shirts. They fastened in the back but they didn't have no buttons—just little pegs made out of pine. Sometimes they'd make buttons out of a cow's horn. You had to have somebody button them up for you.

"They didn't have no coats back then, just wore them hunting jackets. I remember the first coat I seen in my life. An old circuit rider had one. He'd make a trip through here every five or six months, going wherever he got the opportunity to preach. He come through here with a coat on, and he was the first man ever I seen with one. It was blue and it come down to his shoe tops. I thought that was the funniest thing. He looked like a woman!"

Not only did Alex seem to remember everything his grandfather told him, he also remembered the most minute details of every item Boyd Stewart made. For years I took Alex various wooden relics, antiques, and tools that needed mending. He was always curious about what I'd brought, and would come out and peer into the back of the station wagon. On one occasion I stopped to see his cousin Ellis and found an old rocking chair in the attic of the Stewart homeplace. Although it had been made by his grandfather, Ellis sold it to me because the bottom was gone, and he'd "never get around to having another one put in."

When Alex learned I had a chair made by his grandfather Boyd Stewart, he volunteered to put a hickory bark bottom in that would, "outlast either of us." He applied the bottom over 20 years ago and it shows little sign of wear. (Photo by Robin Hood)

Later in the day, when I drove up to the old barn where Alex worked, I saw his faithful dog sleeping in a pile of cedar shavings near the entrance, and I knew Alex was inside. When he recognized me he smiled broadly, greeting me as he did virtually every time I visited him, "Well, I'm shore proud to see you. I's just a studying about you a while ago."

He took a twist of his homegrown tobacco from the bib pocket of his overall, and with his pocket knife, shaved off a palm full. As he did so we walked toward the station wagon. He peeped through the glass, using one gnarled hand to shade his eyes from the glare. Then with an air of excitement he said, "John Rice, where'd you get that rocking chair? That's one of Grandpap Stewart's chairs!"

The southern mountains are filled with chairs of similar design, and I was amazed that he could distinguish this one from all the others. I said, in what I hoped was a convincing manner, "Why, Alex, I bought that old chair down in Georgia. It couldn't have been made by your grandfather." But his confidence wasn't shaken in the least. His response was quick, almost snappy.

"I don't care if you bought it in China, I know my Grandpap's chair when I see it." Indeed he did. When I confirmed he was right he laughed heartily. "You didn't have to tell me, I knowed it was one of Grandpap's chairs the minute I laid eyes on it.

"I've bottomed enough chairs, if they's lined up in a row, they'd stretch from here plumb down to Knoxville. I've told everybody that I've bottomed my last one. I ain't able to roam the mountains and ridges getting the bark and packing it home on my back any more. I don't know at the folks that's wanted me to bottom their chairs, and I've turned them all down, but I'll tell you what I'm gonna do. You put that chair out here and I'll put you a hickory bottom in it that'll be here long after you and me both are gone."

Well, I did just that, and when I returned a few days later the old rocker had a sturdy and attractive bottom woven from strips of inner hickory bark. I'm sure that Alex took special care in bottoming this chair, and that he felt a communion with his grandfather as he worked with it, knowing it had been fashioned by the elder craftsman. The bottom has seen almost 20 years of daily use, and shows no sign of wear. It should last at least another 50 years, and Alex's prediction will have been right.

Do you remember your Grandmother Stewart?

"I remember her some. She was a worker and she done all the gardening. I used to help her when I was a small boy. She'd raise ever kind of food that you could think of and she raised all kinds of gourds.

"She used gourds in place of bowls and jars. She had them hanging on the walls full of coffee, sugar, meal... She had one for every kind of food and she used them for water buckets, eggs, and dippers, and for storing anything she wanted to keep."

I had no idea that Alex knew any of his great-grandparents, and it was only by accident that I learned of his great-grandfather, Carter Livesey. I had asked Alex if he'd heard of a small, primitive corn grinding mill called a quern. He remembered this Biblical type grinder, and he proceeded to tell me about it, and to tell me of his great-grandfather who owned it.

"My great-granddaddy was the first man who ever had a mill in here that you could grind corn on. He made it by hand. The rocks laid up there on the ridge for years and years. It's growed up now and you can't tell they's ever been a house there. Somebody must have got them or they're covered up till I can't find them. They was about as big around as a dishpan, and you had to crank them like a grind rock. He just ground four or five grains of corn at a time. He'd grind his meal on that."

Could he grind flour also?

"Yeah, he could grind wheat, and sometimes he'd grind his coffee. I heard Grandpap talk about that many a time. I never did see him grinding none, but I've shore seed the rocks many a time. They had little furrows in them just like on these big mill rocks you see today.

"Back then great-grandpap was counted to be the bravest man around. Everybody was scared to death of him. They wasn't a better feller ever lived, in a way, but he was mean in a way too. He didn't care a bit to shoot you or cut you if you made him mad.

"Old Jeb Owens out here on top of the ridge, was the bully of this country. People would parch corn to take with them to eat for their dinner when they'd go to town, and my great-grandpap Livesey was standing there, and he'd get a grain of corn out of his pocket ever once in a while and eat it. Jeb come up and commenced laughing and making light of great-grandpap. He got mad at Jeb and just cut him all to pieces. Jeb was a mean, over-bearing feller and it liked to have tickled everybody to death. Great-grandpap said, 'I'll cut your God-damned backbone in two,' and he cut him nine times. Old Jeb, he finally got over it, and he never was so hateful anymore.

"That was my great-granddaddy Livesey. I was small but I still can remember. He died right out here on Fox Branch, and he's buried just above the road there. I see his grave every time I pass that way."

We haven't talked much about your Grandfather Livesey.

"Grandpap Livesey? His name was Richard, but they called him Dick. Well, he was an awful good little man. I guess I'm a

little bit taller than he was, but he might have been a little broader through the shoulders.

"He lived out here toward Sneedville about three or four miles at a place they call the Sinks. I told you about him making me the first pair of shoes that ever I wore. I remember it like it was yesterday. I stayed with him three weeks and worked for him to get him to make me a pair of shoes. I'd pack in stove wood, and get water and one thing or another, and help Grandma, and he made me a pair of shoes. I wore them shoes for two years, pert near it, and they got so little for me I couldn't get my feet in them."

That's the first pair you ever had, and you had to work for him?

"I gathered up their walnuts for them. Law, at the walnuts they had down there. They was way up on the side of the hill, and I'd take a sack up there and fill it up, tie it good, and just turn it loose and it'd roll right down to the foot of the hill.

"Grandma said, "Why, Lord we've got to have something else to live on besides walnuts, son! That's a plenty!' She said, 'I's just a wanting most of them for the chickens!' She said if you cracked them, and throwed them out to the chickens, they'd lay better'n they would eating corn.

What did your Grandfather Livesey do for a living?

"He farmed some and was in the logging business a right smart. I remember one time he cut timber all fall, and when wintertime come he made all them logs into two big rafts and took them down the river all the way to Chattanooga. They was about 250 big logs in each raft. I went with him and we was gone several days. Liked to have froze to death, all of us. When we got back and he paid his hands off, all he had left was $5.00."

That's about a penny a log! That's all the pay he got for the value of the timber, cutting it, snaking it to the river, and transporting it all the way to Chattanooga?

"That's right. That's all he got. He just hit a streak of bad luck, but he took that $5.00 to Sneedville and put it in the bank. I don't guess they's a workin'er feller that ever walked (lived) than Grandpap Livesey.

"He raised six boys and two girls by his first marriage and he worked till the day he was killed. He was 89 years old and he was cutting timber and one big tree lodged in another. He was trying to unlodge it and a big limb broke off and struck him right there. (Alex placed his hand on the back of his neck.) It broke his neck.

"He was a working up there on the mountain by hisself. His wife had just took him a drink of water and she was going back to the house. She heered that racket when the tree fell and looked back and couldn't see him. She went up there and there he was. Dead.

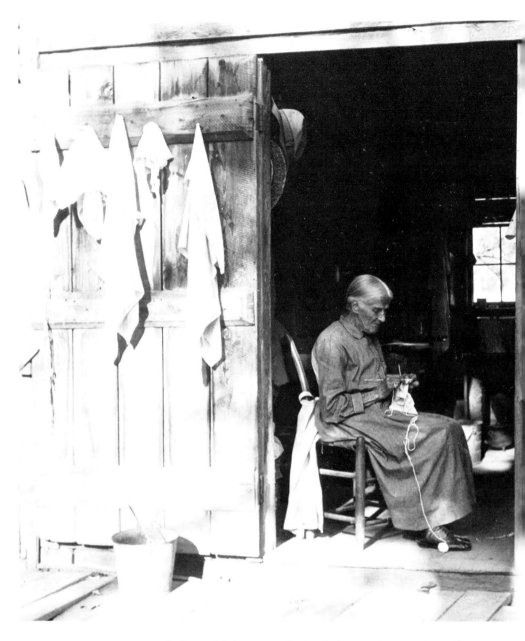

"He was an awful good feller—awful religious. I bet I've heard him pray a hundred prayers, and it never failed but what he'd ask the Lord that when it come his time to leave here, not to let him linger. I've thought about that many a time. He never realized, I don't guess, what killed him. That limb broke his neck square in two."

And he was still working at 89?
"Yes sir! He'd married again. See, his first wife had died and he married a young woman and had three children by her. She was

Sarah Wilson of neighboring Hawkins County is reminiscent of Alex's account of his grandmother Livesey. He said of her: "You never caught her idle. If you wanted to talk to her she'd get her chair and her knitting and she'd knit just as hard as she could—while she talked." (Photo by Lewis Hine)

just about 18 years old when they married—a great big, fine, healthy woman. Them three children are living yet."

Do you remember your Grandmother Livesey?

"Oh, yeah. Everybody said that she was the workin'est woman they ever saw. She raised a big lot of chickens. They was big white dommer-necker chickens, and the barn set I guess 25 or 30 steps from the house where they roosted. Every time she come in from the barn, or the garden or wherever, she'd pick up them little tiny feathers as she's walking around and she'd chock them down in a big, long cloth poke she had hanging on the porch. She'd save

them to fill pillows, cushions, and featherbeds.

"Now, you know it takes a person that's purty saving to do that. I've seen that poke a hanging there many times; a great long poke, longer than me, made out of homemade cloth that she'd spun and weaved.

"Oh, what a working woman that was. She never would stop. You could go there and you would never catch her idle. If you wanted to talk with her, she'd get her chair and her knitting or something and set down and knit as hard as she could. She'd be setting there seeding cotton or carding wool or doing something.

"She was a regular weaver. That's one thing that helped Grandpap a lot, was her weaving. She had an old maid sister that stayed there named Toad, and the two of them had a big, old-timey loom, and when they weren't weaving for us, they was weaving for other people, and making a little money. They learnt me how to weave."

And your Grandmother Livesey died when you were young?

"I guess I was about 12 or 13 years old. She was a big, fleshy woman and she died working. She was stooped over washing clothes and she just pitched over in the wash tub and died."

I believe you told me your Grandfather Stewart left Newman's Ridge for a while?

"Yeah, several years after my granny died. She had made him a great big poke out of flax and tow, and it had a draw sting on it. He'd saved all his life, and he had that sack plumb full of silver money.

"After about eight or ten years, he married again. She was a big woman, weighed over 200 pounds, and had Indian blood and everything else in her. Well, Grandpap had a nephew who lived up in Indianny (Indiana) and he come in here and took up with Grandpap's wife. They talked Grandpap into selling out and going to Indianny. He took that sack of silver along, and all the money he got out of the sale of his belongings. That's where he made his mistake. In a few months they had run through all Grandpap's money and they run him off and he came back here and moved in with Pap."

It was pretty sad, wasn't it, after he'd worked so hard all his life?

"Oh, Lord, that was bad! Didn't have nothing, poor old feller. He tried to work after he come back, but he couldn't. I believe he's 88 or 89 years old. He come back and died on Daddy. I stood right there by him and seen the last breath leave him. Poor old feller. I'll never forget it. That's the first person ever I seed die."

Alex sat there a couple of minutes filling and lighting his pipe, but clearly his mind was still on his grandfather. Then he said, "I believe if they's ever a good feller that ever lived, Grandpap Stewart was one."

School Days

"The Schoolhouse Had A Dirt Floor And Not A Stick Of Furniture About It."

"I worked for Starling Lawson for six days pulling fodder at 10¢ a day. I got my 60¢ and walked to town, about six miles, barefooted and bareheaded, to buy my school books. I was about eight or nine years old and that was the first time I was in Sneedville, and them was the first school books that ever I had.

"I got me a first reader, a spelling book, and a language book. Got them from an ole feller by the name of Alex Manis. I got started from that and every once in a while Pap would get me a book, and finally he got me a geography.

"The first teacher ever I went to was Mary Maxie. We had to walk two miles to an old cabin, and sit on rails for a bench. I shore done that. Not a desk or a bench in the building. It was just an old log building where nobody lived anymore. Didn't have no floor except the ground. It was dug out in the center where they'd kept it swept and wore down.

"I think they was about eight of us in the school when I went there to Mary. She would turn us out for dinner and she didn't have no bell to ring to get us back. She'd have to holler: 'Books, Books.' Bud, she'd have a time getting us all back in the house. We didn't have no tablet, no pencil, no slate. Didn't even think about paper. I was the second boy in school that had a spelling book. There was several of us boys that studied out of that book, and the teacher, she borrowed it and teached from it."

The teacher didn't have any books?

"No, they wasn't any school books around here. That ole feller Manis, he'd get a few once in a while. I started to school before they got to using slates. You'd just write on a blackboard nailed on the wall; then a little later we got to using slates. They's two sizes. The little children would use small ones, and the older ones would use the bigger ones. You had to have a slate pencil to write with, and we would find pieces of slate out here on these banks that we used to write with.

"They was a little boy who didn't have any books to learn out of, and he'd set next to me so he could study my books. By that time we had us a little slate apiece that we'd figure and write on.

I've seen big old lice fall off his head many a time on that slate. They was so big that you could hear them pop when they hit that slate. I don't see how he stood it."

How long were the school terms and how many terms did you go?

"They generally started about the time we laid by the corn crop, about July, and the term would last to October when it commenced to get cold. There was no heat in the school. I started when I was eight or nine years old and went four or five terms.

"They elected Pap one of the school Commissioners, and the Commissioners had to see to it that the teacher got paid. I believe it was two dollars and a half a month that the teacher drawed."

Well, you spent only a few short sessions in school, but you're one of the best all-around educated men that I know.

"Oh, I can read anything I want to. I could learn more at home than I could at school. I took my books home and I learned more there than I did at school. Pap had a purty good education and he helped me."

In recalling his early school days, Alex told a touching story about a perceptive, compassionate teacher he had during his third year in school. Even at that age, Alex would have been highly offended if he'd been treated as a charity case, and the teacher was apparently aware of this and therefore he contrived a subtle method of giving Alex part of his lunch without impinging upon his pride.

"I've went to school and took bread and molasses for my dinner many a time. Back then they'd be lots of school children come to school and not bring a bite of dinner. I went to school right down here at Panther Creek, I believe it was the third school that I ever went to, and a man by the name of Haskew Fletcher was the teacher. He lived over here on the river and boarded with Lou Trent. Lou Trent was a good liver, so the teacher would take biscuits for his dinner all the time. I had so little to eat that I'd try and sneak out to get away from the crowd to eat my dinner. I'd go around the side of the cabin and the teacher started coming around there to eat too. He'd have biscuits and butter and applebutter and something like that every day. All I'd have was just dry cornbread and molasses, and I was ashamed for him to see me eat. I'd have my molasses in a tea cup and I'd carry it and my cornbread in a little wood bucket that Grandpap had made for me.

"He looked over one day, and I's sitting there with a big piece of cornbread and he said, 'Would you care to swap some bread with me?'

"I said, 'Swap some with you?!'

"He said, 'I like cornbread better than I do biscuits. I'd like to swap with you.'

"Well, he knowed that would tickle me to get to swap with him. I had a half pone of cornbread, and I retched (reached) it over to him, and he retched me back two biscuits. And he said, 'I can spare you some applebutter to go on them biscuits if you want it.' And he retched over and got one of them biscuits and put me some applebutter on it and I thought I had a fine dinner that day. From then on, every time I'd go to school, he'd come around and swap biscuits for cornbread."

You've told me you enjoyed school, and that you especially enjoyed the games you played with the other children.

"Oh, we'd have a time. They finally built a schoolhouse down here at the foot of the hill and then we went there. Jim Alder was my teacher. Oh, he was a teacher! He'd learn you something if you'd listen to him. He'd let us play games at recess. Back then we didn't have no games like they do now. We had two games that we played mostly. Bullpen was one.

"All the clothes we wore, Mommy made, and she'd knit us yarn socks. When I'd wear a pair of socks out, why I'd cut the legs out, ravel them out and get that yarn. Then I'd roll the yarn up and make a ball to play Bullpen. I've cut the legs off my socks many a time to make me a ball to play with at school."

How do you play bullpen?

"It's a little like baseball. You'd have four corners, and you put one man at every corner, and four or five in the center; the Bullpen they called it. Them men on the corners they'd run from one corner to another, just run back and forth, and one of them would have the ball but you wouldn't know which one it was. They'd go round and round, and finally when they had the chance, they'd throw the ball at one of the men in the middle—in the Bullpen. If the man in the Bullpen didn't catch that ball, but let it hit him, then he's out. He's dead. But if he caught the ball, then the man who throwed it had to go in the Bullpen, and the one who caught it would come out on one of the corners, and would get to throw at the others. Oh, we played that till I plumb give out. I thought that was the best thing that ever was in the world.

"There was a marble game they called Roller Hole. You'd find some smooth, hard ground and dig you out a good sized hole, and dig three smaller holes around it. And you'd get back off a ways and try to shoot a marble around them smaller holes and into the big one. That was called the Kingdom. We'd shoot to see who could get in the Kingdom first, and whoever did won the game. Then we played just regular marble games.

"We had a game that we called Hickory Hiding, or Switch Hiding. You'd get a great big long switch, and some of us would

hide it. There'd be eight or ten out hunting and we'd be off a watching them. If they got way off from it, we'd say 'cold, cold,' and if they got close, we'd say 'hot.' They kept on till they found it and the one that found it, buddy, he'd whup the rest back to the line with that switch. It'd tickle the old man (teacher) to watch us play that."

What else would you do for entertainment?

"We'd use crossbows to hunt with, and regular bows, and we'd use slingshots. I've killed many a bird with a slingshot. We'd make what they called flippers. Take a small forked stick and tie a piece of leather to each end of the fork and you could shoot a gravel a long way. And pop guns. (Alex laughs.) Law, that used to be *my* gun. I'd take tow and make my bullets, and I could raise a blister on you. I made one for my uncle once. He was about the same age as me, and he shot me on the jaw with that pop gun and a great big blister come up. His mother whupped him, gee, God you talk about a whupping, she gave it to him that day."

Did anyone ever take you snipe hunting?

"Old Jim Miser used to pull pranks all the time and he wanted to take me snipe hunting when I was just a boy. He had me about ready to go and Pap told me they wasn't no such a thing as a snipe. Jim took some boys down on the creek one night and scattered them out in different places. He give each one a bag and told them to make shore they kept it spread out good. Told them to keep it wide open. Him and some other fellers left them boys a setting there and told them all to set right still and not say nothing or make any noise, and they'd go run the snipes in the sacks. Well, Jim and the rest of them went home and left them boys setting down there for ever-so-long. (Alex chuckled.) Set there half the night waiting for Jim to run them snipes off the ridge and into their sacks."

We made flippers when I was a child, but we used strips of rubber, usually from an old worn-out automobile innertube. I don't see how leather would stretch enough.

"Well, you can take what they call harness leather, you know. You take and wet it, but don't get it water soaked. It'll stretch almost like rubber."

I was interested in the marble games Alex mentioned, especially from the standpoint of the source of the marbles. Thurman Tinch, a tall, lanky mountain man from rugged Overton County, Tennessee, had the only marble "mill" I ever saw. (It is now on display at the Museum of Appalachia.) It consisted of a rock about two feet in diameter and ten inches in thickness. Near the center of this roughly rounded stone, there was a hole five inches deep and about the right size to accommodate a golf ball.

Thurman would place this stone under a small waterfall, positioning it in such a way that a good portion of water poured directly into the hole. He would then place a small pebble in the hole, and the falling water would cause the pebble to bounce around from one side of the cavity to the other. Each time the small stone hit the surface of the larger stone, it became a little more rounded. After about three months the small, irregular pebble became almost perfectly rounded, and Thurman had himself a stone marble.

I thought maybe I'd stump Alex on this one, but I was mistaken. He did indeed have knowledge of a marble mill, as his response to my question indicates.

Did you ever hear of making marbles out of rock?

"Yes sir! Grandpap Stewart showed me how that was done and I tried it once or twice. Yeah, they'd take gravel and put it in a hole in a big rock, and then let water run on it, and that would make a marble."

How would you make the hole in the big rock in the first place?

"Get a little steel drill and hammer it and hammer it, and finally you'll have a hole in it.

"An old man by the name of Miser had a stream of water that come by his place, and he had him one of them marble mills. I stopped and watched it many a time, but back then I was always so afraid to bother anything and I never would go down there. Pap learnt me to tend to my business and let the other feller's stuff alone. I've watched it though, that rock would just play around in there."

You can make marbles out of mud can't you?

"Oh, yeah, if you've got the right kind of mud you can, but they won't last as long as stone marbles. I've made lots of them. That's where I got my marbles. I would just take my knife and bore me out a pattern in a piece of wood. Keep working it. You put your mud in the mold and let it dry just a little. If you leave it in the mold too long, it'll stick. Let them dry a day or two, then just wet them in a little bit of water, put them in a fire, not too hot, and they'll last a long time. Now if you wanted a glaze on them, you would make your water a little salty. That makes the purtiest glaze you ever saw. But Mommy would get after me if she caught me using her salt to make marbles. Salt was hard to come by. Don't put too much fire on them to start; they'll get hot too fast and they'll bust."

Do you have to use a certain kind of mud?

"You have to use blue clay. That's Indian clay. It's the kind of mud you make brick out of.

"I'd bring them marbles, 'P.J.'s' we called them, to school all the time. I got so good that the other boys wouldn't let me play

with them. I played so much that I got a corn on my thumb, and I got perfect with them."

By the time Alex started attending school in the new building, which was also a log structure, the attendance had grown considerably. Alex pointed out that there were 19 children near his age. The teacher, Jim Alder, with whom Alex was soon to have serious trouble, was also a preacher.

"He started a revival meeting one winter after school was out, and all 19 of us was baptized. I've thought about that a lot lately. There's just one of us left out of that 19, and that's me. I would have swapped chances (for a long life) with any of them back then, because they was so much heavier than me. I just thought I never would get big enough for nothing.

"We was baptized straight down from the house over there in the creek. There was ice froze in the creek that day, I guess a foot to a foot and a half thick. It was about as cold as I've ever seen. They never paid no attention to the cold, and if it made any of us sick, I never knowed about it."

You mentioned to me once that you quit school and ran away from home. Tell me about that.

"Well, the schoolhouse set on a sort of point at the edge of the woods and there was a hollow on both sides. Course we didn't have no toilets, and the girls had one side they used, and the boys had the other. Some of the boys got to slipping up through the woods peeping at the girls, and the girls catched them at it, and went and reported it to the teacher.

"Well, the boys knowed they's in for it, and they commenced to try to make up some excuses to tell the teacher and they couldn't agree on what to say and they got in a fight and got me in it, and we fit for an hour. I knocked a DeBoard boy down twice, and of course he's mad at me. They's three boys on me at once, the DeBoard boy, a Gibson boy and a Mullins boy. One was pulling my hair, one was hitting me in the back and one was kicking me. I jerked loose and whupped all three of them. Knocked them down.

"Well, the teacher, Jim Alder, he called all of us up before the front of the schoolhouse, and tried us. Questioned us all and wanted to know who was into peeping at the girls. Someone, one of the boys I'd been fighting with, said I'd been into it. 'Now, look here,' I said, 'I was doing no such thing.' One of them DeBoard boys spoke up, the one I'd knocked down, he said, 'Yes he was, yes he was!' (Alex mimicked him in a derisive, high pitched voice.)

"I said, 'That's a black lie!' and we started fighting again. It was 30 minutes before the teacher could break us up.

"He said, 'You've all got to take a whupping.' When he give you a whupping, buddy, you knowed you'd had one. He was

Alex recalls: "Jim Alder was the teacher, and he was also a preacher. He baptized all 19 of us (in the winter) down here from the house, and if it made any of us sick I never knowed about it." (Photo by Ken Murray taken about 1970)

left-handed, and when he brought that switch around he'd bring the blood. They was 13 of them boys and he brought them up one at a time and whupped them all. Buddy, you could see the lint fly from their clothes every lick he hit them. He was the toughest schoolteacher I seed in my life. He finally called me up.

"'Now,' I said, 'Jim, I wasn't into that.'

"He said, 'You're going to have to take a whupping anyway. You was into the fighting.'

"I said, 'No sir, I ain't taking nary a whupping. I ain't done nothing to take a whupping for. I fit to take my part, and that's what I'm supposed to do.'"

Alex, even at this young age, was expressing a rather universal philosophy of the Southern Appalachian region, one embraced by most of early, rural America. One was not supposed to start a fight, but if offended, one was "supposed" to fight for his rights. Children of the mountains have been told for generations, "Don't ever run over anybody or pick a fight, but if someone jumps on

you, you take your part." That's what Alex had done and based on what he'd been taught, he'd done the right thing. He continued with his story.

"He come back with that great, long switch raised up like he was going to whup me, and I just grabbed up my books and walked out the door. I got out in the yard and I said, 'Now you ain't going to whup me nary a time for I shore don't deserve it.' I went on home and never did come back anymore.

"Pap talked to me about it, and I said, 'He wanted to whup me when I didn't deserve it.'

"Well, Pap said, 'You better go on back, you don't know what a little learning is worth to you.'

"I said, 'If I never get none except what I get from him, why I'll never have none.'

"He got to studying about it and said, 'If you have your mind made up like that, they ain't no sense in fooling with you.'

"Well after five or six days they got after Pap to make me come. Back then they had a law that you had to send a boy to school so many days and Pap said, 'Well, I can't help it, I tried to get him to come and he won't do it, and if it's like he said, I don't blame him.'

"I seed they were going to keep on and maybe get Pap in trouble, and that's when I took out and went to Virginia. I run away from home. I got a job working on the roads and my folks didn't know where I was. After a month they heard where I was at, and I come home one Saturday after work just for the weekend. After that I never did stay at home any more. I would just come in to visit or for the weekend.

"If I had thought I deserved a whupping, I'd have took it. That teacher, Jim Alder, had no right to whup me, and he was the cause of me quitting school. He was a magistrate (Justice of the Peace) for as long as he lived, and every time he run I voted against him. I'd be voting against him yet if he's a living."

Courtship And Marriage

"I Give The Preacher 50¢, And If He'd Charged Anymore, I'd Been In The Hole."

During most of our conversations, Alex spoke of his wife Margie only in passing. Seldom, if ever, did a story revolve around her, or even around the two of them. This is not to say their marriage of 62 years, which ended with her death in 1973, wasn't a happy one. They were a devoted couple, but the men of Appalachia simply didn't talk about their wives much—especially not to other men. Still, when I specifically asked about his years with Margie, Alex talked freely and at length.

"I got married November 10, 1911, and paid the preacher 50¢ and had 50¢ left. If he'd charged any more, I'd been in the hole. We spent the night at my uncle's, and the next morning we eat breakfast and started walking to Pap's. We had to pass a store where a feller by the name of John Mullins was selling goods. I's out of t'baccer (tobacco) and I told Margie, 'you stand right here and I'll get me some 'baccer and we'll go right on.'

"I walked in there and run my hand in my pocket to get my half-dollar and it wasn't there. I just kept scratching around, and directly the merchant said, 'What for you?'

"I said, 'Well, I don't reckon anything. I's just looking around.' I walked out and me and Margie come on home. I never did name (tell) that to her. When I got home I searched every pocket I had. Come to find out, they'd stole my money where I'd stayed all night, down at my uncle's. That used to be the go—to steal your money on your wedding night. We moved in with Pap and we didn't have a red cent to our name."

Alex tell me about your courting days and about how you met Margie.

"I had me seven girls that I was seeing at about the same time. People have asked me how I got by with that and I said it's all in knowing how. I'd see one on Saturday maybe, take her to meeting. I'd take another one to meeting on Sunday morning and then see another one in the evening (afternoon). The next weekend I'd sorta switch around.

"If courting would get you anywhere, no telling where I'd be today. (Alex laughed.) I've spent many a nickle on them, buying

them ribbons, handkerchiefs, shoes, side combs and little pretties. Oh, how they loved them side combs. See, they could fix their hair with that. I bought a side comb for Lizzie Ball once and she took a pure fit. She thought she's a millionaire."

Did you say you bought shoes for some of them?

"Yeah, times was s'hard back then that they all had to go barefooted in the summer and some never had any shoes at all. I used to take this girl to Sunday School every Sunday. I went by to get her one day and it was cold. The ground was froze hard and it was snowing. I asked her if she was ready to go and she said, 'I can't walk down there in this snow barefooted.' I went the next day and bought her a pair of shoes and that liked to have pleased her to death.

"When ribbons started coming on in the stores, I'd buy them for all the girls. I'd get one for their hair and one to put around their waist, and they'd go to meeting with them ribbons just a flapping. Oh, they thought they's up in the papers."

Did the young girls wear bonnets?

"Yeah, old homemade bonnets with a great long bill in front. You never heard of a woman's hat."

Seems like it would be hard to kiss a girl who was wearing one of those bonnets.

"It'd be pretty hard. You'd have to hold it up." (Alex laughed again.)

Did you ever get into trouble, by having that many women? Did they find out that you had other girls?

"They didn't know for certain. Two of them found out and they fit over me. One of them was on her way to see me and the other found it out and stopped her down here in the road and they got into it. They liked to have pulled one another's hair all out.

"I was up at my cousin George Stewart's one day and I'd started to see one of my girls. I looked up the road and seen two other girls coming that I'd been going with—a Ringley girl and a Parks girl. I couldn't figure out what they was doing together and what they was up to. When they saw me they commenced snickering and talking but they was so far away I couldn't understand what they was saying.

"They'd found out, somehow or another, where I's headed. They come on up and asked me where I's a going. I told them I was just running about, and about that time one grabbed hold of one of my arms and the other got hold of the other arm and they commenced pulling my britches off. We wrestled there for 30 minutes and buddy I had a time. They liked to have got them plumb off once. It was a good thing I had on underwear that day, or I'd been as naked as a bird's ass.

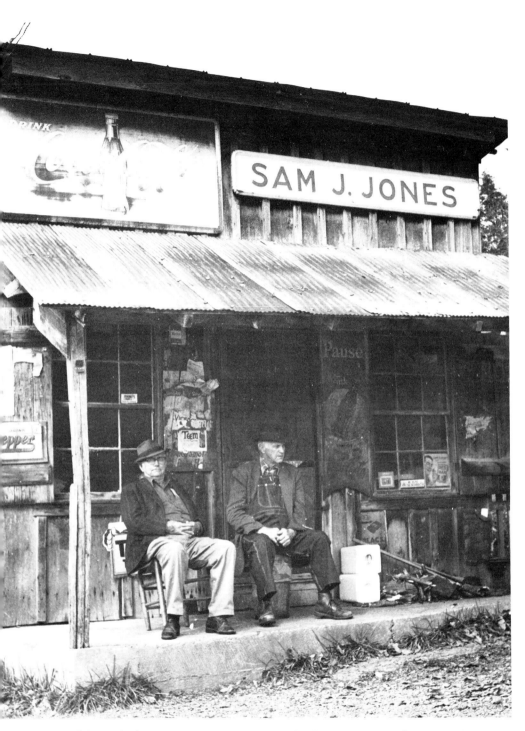

This typical Hancock County store, which Sam Jones (shown at right) operated until recently, was similar to the one where Alex discovered that his last 50¢ had been stolen. (Photo by Frank Hoffman—in 1977)

"Now a woman has got a lot of strength about her when she takes a notion to do something. They didn't mean for me to go down there and see that other girl. They was going to take my britches off and run away with them. They never did get them plumb off, but I was so wore out when I finally did get them back on, I just turned and went on home."

Do you remember the names of those seven girls, Alex?

"Oh, yeah. I remember their names as well as I do my own."

Why don't you name them off for me and tell me a little something about each one?

"Well, there was Mary Castle. She had the purtiest, longest yellow hair of any girl ever I seed. She was as pretty as a doll. Her home was over here on the far side of the river. Her mother and daddy both died and them children just had to be taken in by the neighbors. She come up here and stayed with old man Sizemore and that's where I got acquainted with her. We went together for a long time.

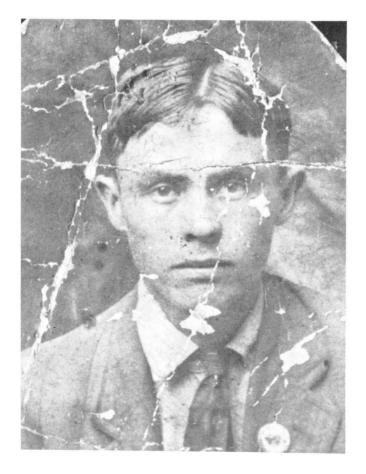

Alex at age 18.

62

"I worked up here in Kelleyview, Virginia one time for nine months and three weeks. There was two girls up there that I'd see. Oh, I had a time.

"One was Becky Rhoden. She lived about a quarter of a mile from where I was boarding, across the river. She was fair skinned and blond, and a purty good sized girl.

"There was a fellow from over here on Chestnut Ridge who come up there to work, and he found out that I had them two girls. He said, 'you're treating them wrong,' and he begged me to let him go and talk to Becky. I told him to go ahead, and him and her got to going together. I think they finally got married.

"The other girl up there was named Sudie Williams. She was as pretty a girl as I ever seen in my life. Had pretty yellow hair. On Sunday I'd go to a little church that was about two miles below us. There's where I met her. I was the cook at the boarding house at the time and she'd come in and help me wash the dishes and dry them. We took up with one another, and law at the good times we had.

"When I left there to come home it liked to have killed her. She said 'you'll never see me no more, I guess.' I told her I'd try and come back. After I got home I wrote her a few letters, but I never did get back. I haven't seen her since I left and that's been over 70 years ago. I've thought about her a lot. Wondered what ever happened to her.

"Stella Johnson was another. Me and her was about the same age and we went to school together. Oh, what a girl she was. She was a good girl all right, but she was a captain. We started going together, and after a while there was a boy from Virginia who come down one time to visit her brother Charlie. His name was Nate Edders (probably Edwards). She said to me one time, 'I declare, that's a good looking boy.'

"'Well', I said, 'if he looks any better than I do, why don't you take him?'

"She said, 'Oh, no. I don't want him, I want you.'

"Well, it wasn't long before me and her quit and she started to see this other feller, and they finally married. She's been dead, now, for several years.

"There was a Johnson family that lived up there on the Ridge and they had 14 children. One was named Ida, and I'd go to see her a right smart. There was another girl named Polly Podwell that lived out here on the Ridge that I'd see. She was one that fit over me. And Kellie Burdine. She was a good girl, but me and her just couldn't get along. She was pretty and smart alright, but she was a high-talking girl and that didn't suit me.

"Lizzie Ball. Me and her courted seven years. She was raised right close to us and I knowed her since she was a child. She

thought sure we'd marry. We's engaged one time, but we never made it."

What was the problem?

"She got to slipping around and seeing her cousin. I saw them more than once going up to the barn together and I decided that if she was that kind of a girl she wouldn't suit me.

"I went up to her house one night. I pecked on the back door and she got up to see who it was. I told her to put on her clothes, that I wanted to talk to her. We went out from the house a piece and set down. I told her that we had been raised together, went to school together, and had been friends all our lives, but that 'my time and yours is over with.' She commenced crying and bawling. She said, 'you're the only man I ever wanted. What have I done to make you change your mind?'

"I said, 'Now I don't think you want me to tell you' But she kept on and I told her what I'd heard, and what I'd seen. I said, 'Now if we went ahead and got married, he'd be your man the same as I would, and that would never work.' I said, 'It's a dirty shame that you let him treat you that way.' I knowed that she could be easily persuaded, but I never mistreated her in my life.

"She said, 'I'll just tell you the truth. Pap went off to the penitentiary and left us young'uns here to live as we pleased. He never give us no counsel. I hate that I done it.'

"'Well,' I said, 'they's a feller that has begged me several times to quit seeing you so he could marry you.' I said, 'You go ahead and marry him. He's good enough for your man and you're good enough for his woman.' She said, 'I won't have him. You know I won't have him on account of you.'

"I told her that we could still be friends and that I would stop by and see her every once in a while, just as a neighbor. She said, 'if you leave me now, I don't ever want to see you any more.'

"Well it wasn't long 'til I heard she was with child. She got a woman doctor (a doctor for women) to make her up some medicine to make her miscarry. After she miscarried she got in bad shape. She was just wasting away to death. I went down there to see her and she was just as white as that piece of cloth. I just stayed a while and come on home. She got better and started going with the feller that I had told her about and before long they married. They left here and went to Indiana and done well out there."

Alex, I asked you to tell me about the seven girls you knew, and you've given me the names of eight.

"Oh, pshaw. I had more than I thought. (Alex laughed.) Now, I treated everyone of them girls good and we was everyone friends as long as they lived.

"They're all dead, I think. The last one died about a year ago. I don't know about the one in Virginia for sure, but I guess she's dead too."

Tell me about how you and Margie met.

"Oh, I had knowed her all her life. See, her mother died and left her daddy with them little children. He married my aunt the second time and that give me a good excuse to go down there. I'd go down to see my aunt pretty often and of course I'd see Margie every time I went.

"Well, we got along good and we made it up to get married. Her daddy was an awful high-tempered feller, and I figured he'd cut a shine when he found out about it. I wanted to be there when he cut it.

"I went down one day and called him out of the house. I said, 'I'm going to take your girl, and I don't want you to think I'm going to steal her. I don't want you to think I'm that sorry and low down. I think I can take care of her, and if I didn't think so, I wouldn't be taking her off.'

"The old man commenced crying. He said, 'You've shore got a good girl. She's been a mother to my children.' He said, 'It's nature for people to get married.' Said for me to take her on, but to always be good to her. That like to have killed him. He thought so much of her.

"Now he was shore right about her. She could cook, sew, and do anything she wanted. They wasn't a lazy bone in her body. I never could stand laziness.

"I told Margie that we'd get married Sunday at two o'clock if she was ready, willing, and able. She said, 'I'm as ready as I'll ever be.' I got there at one o'clock and when I got in sight of the house I saw her standing on the porch watching for me."

How were you traveling? Were you in a buggy?

"Oh, no, I was on foot. That's the only transportation I had. We pulled out and went up to my uncle's where I had made arrangements to have the preacher waiting. He married us, and we spent the night there."

When you went to your father's house the next day you were not only penniless, but you didn't have any possessions of any sort, did you?

"No, we didn't have anything except the clothes on our backs. Well, Margie did have a few things in a little bag."

So, how did you manage, starting out with nothing?

"I struck out the next morning and went down on Blackwater, about three miles, and rented me a house off a feller. I was to raise a crop for him, give him a third of what I made, and get the house free. I worked for him five days, and he paid me $2.50 for that five

day's work. I come on home and began looking for a stove. They didn't have a fireplace in the house.

"Well, Fate Johnson had bought his wife a new stove and they'd set their old one out at the side of the house and covered it up. I's passing by there and Miz Johnson said, 'I heered you got married.'

"I says, 'I reckon I did, and I hear you got a new stove.'

"She said, 'Yeah, Fate got me one.'

"I asked what she wanted for her old stove and she said she'd take $2.00 for it.

"'Well,' I says, 'I just bought your stove.'

"I got up the next morning, hooked up the horse and took the sled down to get it. 'Now,' she said, 'I've got a gallon iron kettle here, and hit's too little for the caps (the eyes on her new stove)—it just drops right on through. Have you got airy kettle?'

"I says, 'No, I ain't got nothing.'

"'Well,' she says, 'I'll sell you this one. I'll take a quarter fer it.'

"So, I loaded it up and brought it and the stove on home.

"Next morning I got up purty early and went down to clean out the house I'd rented, and the man wanted me to work for him that day. Well, I worked for him and that give me another 50¢ to start out with. I said to Mommy 'If I had me a bed I'd move out.'

"Well, she said, 'That one you sleep in, I reckon you can have it, and I'll give you two pillows and three quilts. That ought to do till your wife can make some more quilts.'

"She give me about a peck of meal, some meat, a tea kettle, and a little skillet called a hoecake skillet. She said I could bake my bread in that, and she give me another skillet so I could fry my meat.

"Well, we moved down there and didn't have no table to eat off of nor nothing. We ate off a box for a few days, and then I decided to build a table. I was getting tired of eating off that old box.

"A feller by the name of Jim Miser had a sawmill. I went down there and he didn't have nothing but some yellow pine that was a foot wide. I bought two planks and took them up to Pap's and got me some timber and made legs. The planks was ten foot long and I cut one in two and made two planks for the top. I had one plank left and I made the frame from it.

"When it was done I turned it bottom-side-upwards, laid it right across my back, and packed it home. I'd carry it two or three hundred yards, then lay it down and rest. Finally I got home with it. I set it up and Margie said, 'Oh, that looks more like it.' I'd took pains with it and put a good, smooth top on it. It was a good one.

"We just had one bed, and Margie got to talking, saying we ought to get another bed somehow. A house with just one bed makes it rough when somebody comes around to see you. I went

up to Dad's and cut down a walnut tree and made me one. Made the railings, headboard, footboard, and everything. I got me some domestic and made me a straw tick. Then I stuffed it real big with fresh straw. That liked to've tickled Margie to death. It looked s'good in the house."

What happened to the table and bed you made?

"Oh, I kept them right on and raised most of my family with them. After we had several children I had to make another table— a bigger one. I've got it setting in there now. I give the old table to a man who got his house and everything burned up."

What about the chairs?

"Well, I made my chairs; six of these straight chairs and a rocking chair. That's one of them that you're setting in. They're nearly 75 years old and they're about as good as ever.

"When we first went to housekeeping we didn't have no coffeepot to make coffee. Had to make coffee in a teakettle. You'd have to parch it and then grind it or beat it. I'd get me a new piece of domestic and put the coffee beans in that and take me a hammer and beat it. To make coffee in a teakettle you had to let it set a long time (after brewing) to let the grounds settle out. If you didn't, the grounds would come right out with the coffee, but you could break an egg in it and let it set a minute, and that egg would take all the grains to the bottom."

I take it that you were sharecropping at the time?

"Yeah, I made a contract with old man Anderson to clear the timber off the north side of the ridge and put it in corn. I was to get two-thirds of what I made. It was old-timey timber and had never been cleared before. I chopped it with an ax. I started cutting at the bottom and worked my way up. When I'd cut a big tree it would generally roll off, it was so steep. Some of the real big timber I would deaden. Just cut a ring all the way around it and it would die.

"There was about three acres on that hillside and I worked for several weeks clearing it. Oh, what a mess it was! Then I had to dig the corn in with a mattock, and keep all them sprouts cut off all summer. When it come time to gather it, I had to pull it off and pitch it down the hill to where I could get to it with a sled."

I never heard of a field too steep for a sled.

"Hit was just might nigh straight up. A mule couldn't stand up on it. Old man Anderson, he set right there on his porch and watched me make that crop. When I commenced to gather the corn he was still there a watching me.

"After I got it all gathered and throwed down to the foot of the ridge, I got his sled and mule and started hauling it in. I'd take him one load and me two.

"I cleared that whole mountainside of timber and planted it in corn. It was so steep I couldn't plow it with a mule—had to plant it with a mattock. Now its all growed up in timber again." (Photo by the author)

"His grandson was helping me haul in the corn one day, and we had took one load to the old man, one load to me. Well, we started toward my crib with a load and he come out and said, 'That load belongs to me.'

"I said, 'No, I don't think it does.'

"He said, 'Oh, yes,' Said, 'I've been a setting there a watching you.'

"I said, 'Yeah, I knowed you was a setting there, but that's shore my load of corn,' The boy who was a helping, his own grandson, said, 'Grandpap, that's shore his load.'

"The old man kept on, but I took the corn to my crib and unloaded it. Well, he got mad and said, 'You can just hunt you a place to move!' And I said, 'All right.'

"I hauled my corn up the valley about half a mile and rented from a feller by the name of Al Moore. I'd been living at Moore's a while when old man Anderson come by, one day, and said 'How do you like your new home?'

"I said, 'It's all right, I reckon.'

"He said, 'Well, when you get tired, come on back.'

"I said, 'I'm not apt to be back.' And he kicked his ole horse in the ribs and struck out and left me."

That was the end of your association with Mr. Anderson?

"That was the end of me and him. I made a good corn crop there, and of course he got his land cleared up, but it's all growed up now till you can get saw timber off it. I's back over there eight or ten years ago and they was trees there, I guess, 11 or 12 inches through."

I visited the site of Alex's cornfield, and could hardly believe that it was once cultivated. I could readily understand why a mule couldn't be used on it. When one views such inhospitable terrain, he doubtless wonders why it was ever cleared, plowed and tended. The reason, of course, is that everyone in that area and during that era depended on the land for a livelihood. There simply was not enough suitable land to go around.

First, settlers from Pennsylvania, Virginia, and North Carolina had poured into the region during the early part of the 19th century, mainly because of the lure of cheap land. Secondly, there was a rapid increase in the population caused by the large number of children born to most families. Although there was a constant out-migration from East Tennessee, it did not offset these two factors.

Interestingly, the prosperous valley dwellers were more apt to move on, than were the poorer mountain folk. Many of the latter were literally too poor to make the arduous westward trip. They had no transportation nor funds to finance such a journey. They had to stay put, clearing the most precipitous mountainsides in an endeavor to raise enough corn to feed their families.

When you moved into your second home, on Al Moore's place, what kind of an arrangement did you have?

"He leased me a piece of ground up there and give me seven dollars a acre for cleaning it up, and he give me the first crop. Well, I cleaned it up, and I guess they was 40 or 50 big chestnut oaks on it that was three or four feet thick. I didn't aim to cut them down—just deaden them. And that Spring they come a demand for tanbark.

"Well, one day here come Al, and he said, 'I've got you a deal. I can get you $12.00 a cord for that oak bark hauled down here below the house where they can load it on a wagon.' He said, 'If you're willing, I'll help you cut and peel it, furnish the team (of mules) and we'll go halvers on it.'

"When spring come we cut all them big oaks and had the whole ground covered with them. We peeled all them trees and, oh law, at the tanbark we had. We got the logs out for saw timber, and we burned the tops. I got $190.00 for my part of the bark, and got the

land cleared too. Al was so tickled with getting the land cleared that he give me the crop for another year."

What kind of house did you have on the Moore place?

"Oh, just a little old two-room boxed house, right beside the creek. Hit was one of the coldest winters I ever saw. I had to cut my firewood on the north side of the ridge, and I used one of Al's old mules to snake it in to the house. For three weeks that creek was froze hard enough to hold us up. People's chickens froze to death on the roost, and some of the cattle froze too."

How long did you stay on the Moore place?

"Stayed there three years and would've stayed right on, I guess, if he hadn't accused me of being responsible for his girl marrying off. Clay Livesey was my first cousin and we was raised up together. He'd come over once in awhile to see me. Him and old man Moore's girl started courting and finally married, and he (Moore) blamed me. Said, 'All the help I had has done gone and left us.' He got awful puffy, and we had a few words.

"I done had my wheat sowed, had my garden out, and my onions up, but I told them we's a leaving.

"I went and got a feller with a wagon and team to move me and I went out to the crib to move my corn. Miz Moore come out there and just begged me not to move.

"I said, 'I ain't staying here and his nose all turned up at me.'

"She finally left and talked to Al and in a few minutes here he come, trying to get me to stay, but that didn't do no good. Then he went and talked to Margie, trying to get her to talk me into staying. But I went on about my moving.

"Long after I moved to another place he come by wanting me to come over and daub his house. He lived in the biggest old log house ever I saw. It had been there so long that the chinking and daubing was falling out of the cracks and he knowed I could put it back right. He sat there and talked awhile and finally he said, 'When do you think you can come down and fix my house?'

"I said, 'Mr. Moore, just to make the horse quick curried, I'll tell you: if it's my dependence to daub your house, you'll sit and listen to the air whistle through them cracks many a day.'

"Well, he grabbed his hat purty soon and left, but he come back that fall wanting me to move back on his place, and I never would. He told some folks that I was worth more to him than anybody he ever had in his life, and that he shore missed it by getting rid of me."

Where did you move when you left the Moore's?

"I moved up to the Widder Mullins' place. She owned three or four hundred acres, close to a mile up and down that mountain. It was mostly mountain land, but they was some farm land on it. Her man, Jerry Mullins, died and left her with five small children

and she was having a hard time making it. I started raising corn, and wheat, and molasses, and we went halvers. I give her half of the crops and I took half.

"I sowed seven acres of wheat late in the fall, winter wheat, and it was so late everybody said I wouldn't make anything. Hit come up and done awful well, but she had a bunch of calves to winter and she would turn them out on that wheat every once in a while. I told her one day, 'I'm afeered you're hurting yourself letting them calves run on that wheat like that.'

"And she said, 'Lord have mercy, why?'

"I said, 'everywhere they bit that wheat off, they won't be nothing but cheat. They won't be no wheat.'

"'Cheat,' she said, 'what is that?'

"'Well,' I said, 'it's just sorry run-out stuff. It ain't no account—ain't even fit for chicken feed.'

"Well, she was just a woman and she couldn't tend to them like she ought to, so she kept letting them out in that wheat. When it come threshing time the next summer, I guess they was 20 or 25 bushels of pure cheat. 'Lord, have mercy,' she said, 'what in the world will I do with that?'

"I give it all to her. I said, 'There it is, I ain't got no use fer it.'

"'Well,' she said, 'you don't get too old to learn.'

"I stayed there three years and got along fine. I'd been there a heap longer but her girl got married and didn't have no place to live, and one day the Widder asked if I would care to let her girl move there.

"I said, 'No, it's yours.' She said, 'I shore do hate to see you go but it partly belongs to my girl and she don't have no place to go.'

"It was a log house, but it was a good one. We liked living there."

Where did you go from there?

"I come back up on the ridge where I started from. My oldest sister had a house up there and had moved off and left it. We moved there and stayed one year. Then we moved down in the valley (on Panther Creek) on a place where Margie's uncle lived. He moved to South Carolina and I rented from him and we stayed two years there.

"I got to studying about how I'd worked, and about how I'd paid out enough in rent to have bought me a pretty good place. I decided I'd buy me a place even if I never could pay for it."

Alex had lived in five make-shift houses in the seven years he'd been married, and he had given up half of his crops for rent. One can understand his dissatisfaction with this system and his determination to buy himself a piece of land. He returned to Newman's Ridge, to a place adjoining his father's property, and

bought a piece of mountain land where he lived for the next 44 years.

Sixty-five years after Alex bought this piece of land, the writer bought the little one-room log cabin which had served as Alex's home when he first moved to the property. It was the cabin where Alex raised his family of nine children, and I was anxious to rebuild it at the Museum of Appalachia. The roof was mostly gone, one wall had already fallen down, and the logs were rapidly deteriorating.

The cabin site could only be reached in a vehicle equipped with four-wheel drive. Alex's grandson Rick helped, as did Alex's twin sons Lloyd and Mutt, while another son, Sam, took his tractor to haul the logs out. When we finally got the logs hauled down to the main road on Panther Creek, it seemed a pitifully small pile. It was not much more than a pickup truck load of old poplar logs, and it hardly seemed possible that they had constituted the Stewart home for so many years.

I sent the load of logs to the Museum and went back to talk with Alex. For years he had wanted me to purchase the little house from his son-in-law and rebuild it; so he was eager to talk about the cabin and how he acquired it.

"John Miser owned the land—about 40 acres on the ridge. He got married and built that house. It was right close to Pap's place and I helped him build it. He stayed there five or six years, and had four or five children, then he took a notion to sell.

"Well, by this time I had three milk cows, and one of them was a Jersey. I never have saw as pretty a Jersey as she was. Every time John seed that cow, he wanted to buy her. I had some good apple trees and he come by one day to get some apples and he named buying that cow again.

"I said, 'John, they ain't but one way I'll trade that cow to you.' And he said, 'How?'

"I said, 'You sell me that piece of land. You've got plenty and plenty of land here without it and you're climbing up and down this ridge and you're getting to where you oughtn't (because of his age.)

"He said, 'I's studying the other day about trying to make a trade with you.' I asked him what he'd take for it, and he said $400.

"I said, 'Shucks, I ain't gonna give no such price as that, they's too much work up there to pay that much money for it.'

"I offered him $300 and he said, 'I'll be doggone if I won't trade with you, if you let me have that cow.' That's how come me to own that place, cause of him liking that Jersey cow."

So you paid $300 and a cow for the 40 acres and the buildings?

"Yeah. It had two old log houses and the barn. It was a shunt of a barn then, but I built them two barns that's up there now.

"I raised my family up there, and I finally built another log house on the place and moved into it. Later I moved down here to Panther Creek. My daughter Mary and her man Cecil have lived up there on the old place ever since we moved out."

Did you have $300 to pay for the land?

"Not at the time I didn't. He give me two years to pay for it, and I hadn't had the land but eight or nine months till he took sick and died. That left his wife with about 60 more acres. I got to studying about it and said, 'I'll just try my best to buy the rest of it.' She come by one day and I said, 'Now, Liz, you finish selling me the rest of this place. You don't need it. You're paying tax on it for nary a thing in the world, and it ain't worth a dime to you. You got four times more land than you got any use for.'

"'Well,' she said, 'I hadn't thought nothing about it.' So I told her then what I'd give for it. I says, 'I'll give you $300. That's more'n it's worth, to clean up and fence and everything else.'

"'Well,' she said, 'I'll just let you have it.'"

I take it that most of the land in thoe two tracts was in timber?

"Yeah, most of it was in timber. The fall after I bought it I let John Riley Kinsler and his son-in-law cut eight or ten acres of good timber on the halves. They went in there and logged it and after they got it logged out, I cleaned it up, and I had six acres of new ground. I tended it two year in corn and sowed it in grass and made me a pasture, and after I got that done, why I got along pretty good up there.

"We had that whole place cleaned up and it was a good looking place. I stayed there 44 years, and then I bought this place here and let Mary and Cecil have the place on the ridge.

"Now, I'll swear you wouldn't think that its the same place. He's let it grow up and run down. Cecil's a good feller, but he wasn't cut out to be no farmer."

Alex, you've talked about how it was when you first got married, the various places you lived, and about buying your own land, but you haven't talked much about how you and Margie got along.

"I was 20 years old when we got married and she was 16. We were married 62 years, four months and 14 days when she died. I never thought but what she would outlive me—that she would put me away. But she's been gone for years now, and I'm still here.

"I don't guess they was ever two people that got along better than we did. Course we quarreled and jawed at different times, but I never struck that woman a time in my life. If we couldn't agree on something, one of us would just walk off.

"The worst thing I remember was when I whupped Mary, our oldest girl. Margie didn't like it and she got all over me for that. I was in the kitchen getting me a drink out of a little gourd dipper when she started fussing at me because I whupped that child. That was the prettiest little dipper ever I seed and Margie thought the world of it. When she commenced fussing, I just threw that gourd down and busted it all to pieces. Oh, buddy that made her mad. She grabbed me by the arm and bit me. It just burned and hurt and I pulled up my shirtsleeve to see what she had done to it. It was just as red as a turkey's snout where she'd bit me. Oh, she commenced pitying me then, and I just pulled my shirtsleeve down and said, 'You get away from me and let me alone.' Now, that's the only time that we had any racket a'tall that I ever remember.

"They wasn't a workin'er woman in the county, and if she ever had an enemy, I never heard tell of it. She'd go to meeting every time she had a chance. I couldn't have got a better woman."

Did she ever complain about you making liquor?
"Oh, yeah, she was on my hide all the time about that. That's one thing that made me think so much of her. She tried to get me to do the right thing all the time. I couldn't afford to quarrel with her, but I said, 'Now, I can't keep my younguns here and send them to school and clothe them, feed them and everything else unless I've got something to do it with.' I said, 'We've got to live someway and I don't aim to steal for them until I have to.'

"I said, 'I'm gonna make some liquor to give my young'uns schooling, even if they put me in jail.' That's how come I got into making liquor, but I never would let the boys have none. I never was indicted and never did pay out a nickel in my life. I followed it for over 40 years."

Did your boys ever help you make whiskey?
"No, they never helped me make a drop of liquor. I wouldn't let them. Never seed but one of them under the influence of liquor in my life. Some boys come along down here one time and they got one of my boys to go with them up the road here. They give him some whiskey and then some beer to drink and that got him drunk.

"When Margie smelled liquor on him she just walked out and got a switch about three feet long. I'll swear she like to have wore that boy out! Gee, God did she give him a whupping. From that day to this if he ever drunk another drop of liquor I don't know it.

"Now that's the only time I ever recollect her whupping one of the children. I whupped Mary, like I told you. I didn't have sense enough to raise a child hardly, but Margie soon learnt me about that. A good talk is better for a youngun than all the whupping's

74

you can give it. Learn it to mind you and don't promise it something and fail to follow through."

You never had any trouble with them minding you?

"No, they all minded me. They'll mind me today just about as good as they did back then. Yeah, even Sam will. I don't care what I tell him to do, he'll go do it."

How old is he?

"He'll soon be 66 years old. He could be a drawing (social security) now if he would, but he won't do it."

And all of your children live nearby?

"Yeah. We had 11 children and the nine that are living are close by. Mary, the oldest, lives up there on the ridge where's she's raised, Sadie lives over here in Morristown, and of course Sam lives here on the farm. Foy lives about three miles down the valley in what they call Sink Valley, and Frank spent over 20 years working in a chair factory in Morristown. Vol lives close by and helps Sam run the sawmill. Mutt and Lloyd live here with me, and Edith lives up here on Fox Branch.

"Yeah, Edith, she's the baby one. She works up here in Virginia at the sewing factory. She's been up there going on 20 years. She'll soon be ready for parole (retirement). She'll soon be discharged from it. She comes by after work and helps out: washes, cleans the house and helps Mutt and Lloyd cook sometimes. Oh, she's a worker, Edith is.

"Yeah, they've all stayed close and I've got 26 grandchildren, 42 great-grandchildren, and 4 great, great-grandchildren, and most of them are around here too. I'm just lucky to have them all so close."

Alex had mentioned his two deceased children only a time or two, and he never dwelt on the subject, nor did he give any details. I sensed it was a topic he found hard to talk about. But I felt I ought to pursue it nevertheless. I did so during one of our talks in December, 1984, a few weeks before his 94th birthday.

I soon learned that the passage of those many years had not swept away the hurt he felt from the loss of these children. His voice broke and it was the first time I saw him unable to talk. He searched for a match to relight his pipe and I pretended not to notice his distress. In a little while he continued.

"The little baby, he was two months old. He took sick one evening and he laid there and groaned right on up until he died. I've wondered a sight about that. That little thing couldn't have committed no kind of sin, and him a suffering like that. But the Bible says we all have to suffer. The just has got to suffer the same as the sinner."

What was the little girl's name?

"Alvata was her name. She was 12 years old when she took the measles and then pneumonia. The doctor came every day and the last time he come he said they was no use of him coming back. She died, I guess, before he got out of sight.

"She was a fun little kid, and oh, how well she done in school. I never saw anybody who could learn like she did. The teachers said they had the least trouble with her of any student they ever had. But she had to leave here."

Alex continued to have difficulty talking about his little girl. He tried to talk matter-of-factly, to disassociate himself emotionally from the story he was relating, but he couldn't do so. Tears came to the old man's eyes. He was determined to finish his comments,-however, and after tamping more tobacco in his pipe he did continue.

"Fate Johnson made her coffin. He was a good hand to make coffins. And Steve Gibson preached her funeral. She's buried down the valley here about three quarters of a mile, along with the little boy. That's where I buried Margie. I put up a marker for each of the children, and I've got a double one for me and Margie. There's where I'll be—beside Margie, and my children."

Working For A Living

"I've Rolled In The Bed Many A Night Studying How I Was Going To Feed My Family The Next Day."

From the time he was a child, Alex roamed the hills and hollows of Newman's Ridge exploring all their secrets. It was the home of his ancestors, and he understood and loved the isolated coves and hollows, the forested glens, the steep pastures, and the stump-dotted fields. His greatest aspiration was to own a piece of land on the ridge. In his early years, the possibility of realizing that dream must have seemed very remote. But this longing, coupled with the dismal prospect of spending the remainder of his life as a tenant farmer, pushed him into taking the big jump.

Now he had a hundred acres of land and a $600 debt. By today's standards the amount is inconsequential, but at the time it was staggering. If he had worked for hire six days a week at the going rate of 50¢ per day, applying every cent he earned toward the debt, it would have taken more than four years to pay for the land, not to mention the interest which would have accrued during that time. Undaunted, Alex had agreed to make full payment for the land in only two years.

Much of the acreage was too steep and rocky to be useful, and virtually all of it had to be cleared before any farming could be done. The land was so isolated it could only be reached by a trail running through the woods and up the mountain that led to the Stewart's tiny one-room cabin, home to a family that eventually numbered 13.

He was faced with a difficult decision. If he spent all his time working for others, his land would lie fallow and be worthless to him. If, on the other hand, he worked only on clearing and planting his land, he would receive no money and no crop for months, making it impossible for him to feed his family during the interim. Typically, he chose to do both. He worked at clearing and improving his land during the summer months when he could spare the time; and when the opportunity presented itself he worked for others to earn enough to sustain his family. He worked variously as a coal miner, railroad man, logger, stave-maker, log rafter, sawmiller, water mill operator, pearler, well-digger, and steel driver. In addition, he mastered dozens of crafts.

This log cabin, on the right, was the first home Alex and Margie owned and it was here that 10 of their 11 children were born. A framed room was later added to the rear of the structure. The barn is on the left. (Photo by the author)

There were no marauding Indians on Newman's Ridge at the time Alex and Margie moved there, but in other ways, the conditions were very close to those of the frontier. An undomesticated piece of land, a cabin, a sled full of household chattels, a handful of tools, and an immeasurable amount of grit were the possessions that Alex and Margie shared with their pioneering forefathers. Years later, I asked him to tell about those times of toil and struggle.

With a family of eleven, it seems you would have been awfully crowded with only one small room.

"Well, we wasn't crowded so much. We had three beds in it, and all but four of my children was boys and they'd sleep together, three or more in a bed. We had a little loft and some of them slept up there. All my kids was born in that house but one.

"I had a fireplace for heat, and we done our cooking on that little stove that I was telling you about. We carried our water from a spring down at the foot of the hill. Had to carry it right straight up that hill.

"I shore done many a hard day's work there. It'd take plenty of

corn to do us, and I'd put up two or three stacks of hay there with a mowing blade. Didn't have no mowing machine, wasn't able to buy it, so I'd cut it with a mowing blade and stack it. I'd sell some corn every spring. We never did have to buy nothing to eat. That's the best land to grow 'taters and beans that I ever saw in my life. And we had one of the best apple orchards around. Had about 35 to 40 trees, and they wasn't a one that didn't have good apples. Now it's a getting where the bugs won't let nothing grow."

It seems that you kept busy doing something all the time, even when it was too wet to work the land. What were some things you did to make money, or to get food for your family?

"Oh, son, I worked at about everything you can think of. I was always busy. I never in my life had any trouble finding something to do. Why, I've made a whole lot of money digging roots and herbs and 'sang (ginseng). I've raised 'sang. Down below the house there was several outcropping of big limestone rock and everywhere you saw one of them, why you found a big, nice, black walnut tree. I planted 'sang under them trees and that made the purtiest 'sang patch you ever saw."

One of the earliest money crops in Southern Appalachia was the root of the ginseng plant. In going through the old tools of mountain homesteads one often finds long narrow ginseng hoes, used by the old timers to dig this valuable herb. Its primary market has traditionally been in China where it was thought to be a cure for many diseases. The roots often grow in the shape of a human body, and the more they resemble this form, the more valuable they are. The word "ginseng" is reportedly of Chinese derivation, and means "likeness of man." Some ginseng roots have, quite literally, been worth their weight in gold.

In addition to its medicinal qualities, the ginseng root is considered by many to be an effective aphrodisiac. Although the Chinese have long cultivated the plant, the wild variety found in the Southern Appalachian region was, and is, worth considerably more than that which is grown domestically.

The plant is small, has three leaves at the top, and grows in deep woods. Direct sunlight will kill it. Although I had been familiar with ginseng and ginseng digging in a cursory way, I read up on the subject after talking to Alex, and discovered one authority's statement that the best ginseng grew under and around black walnut trees. As usual, Alex knew what he was doing.

Hunting "sang" usually occurs in September when the leaves start to turn. When they are bright red, berries appear. I was never sure whether or not "sang digging" extended all the way back to pioneer times. I thought I might get a clue from Alex.

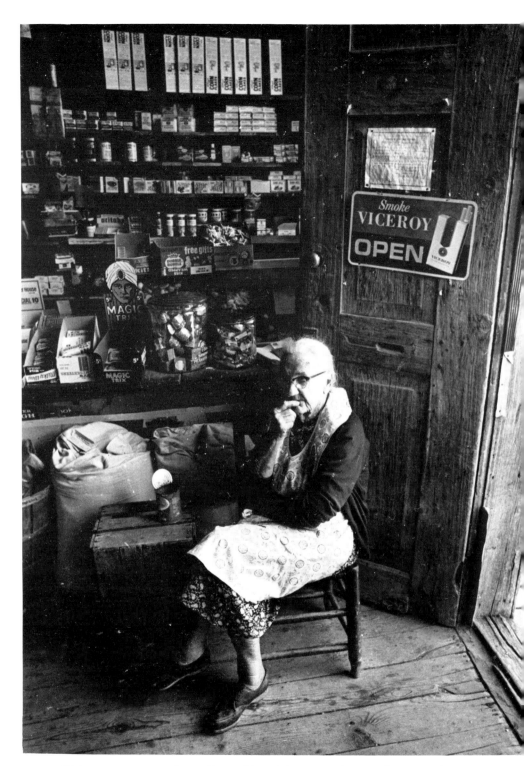

This country store where Alex sold such items as ginseng, bees wax, honey, and pearls, was the closest one to his home, and was operated by the Martin sisters. The patron shown here is unidentified. (Photo by Ken Murray)

Did your Grandfather Stewart know about Ginseng, and did he dig and sell it?

"Oh yeah, he dug it but he wasn't so hot for it like I was. Mostly he'd look for it when he was out in the woods looking for timber to make his chairs and things. He'd come back with a pocket full of 'sang nearly every time. Yeah, he shore knowed what 'sang was.

"It brought a purty good price back when I was hunting it, from 25 to 35 cents an ounce. That's about $5.00 a pound, and now it's bringing from $150 to $175 a pound. Of course them roots have to be well dried, and it gets awful light. It takes a heap of 'sang roots to make a pound.

"I've spent the whole day many a time hunting for 'sang. I'd go for miles and miles on the north side of this ridge, and some days I wouldn't make more than ten or 15¢. They was so many people out looking for it that it got scarce, but if you could find a patch of it you could do pretty good."

Alex, all the old ginseng diggers I've talked with dug the root to sell. I understand the Indians used it and I'm wondering if it was ever used by the white people of this area?

"Oh, yeah, they'd eat it—some people would. They claimed it was a good blood medicine. I've heard it said that 'sang wasn't fit for no kind of disease. But I say it is. Hit would surprise you if you could just see the 'sang I've eat. Just put it in my pocket and eat it. It's a good stomach medicine. You can be burning up in your stomach and not feeling good, and eat you a little of that, and doggone, in a few minutes it's all over with. It'll purify your blood if you'll eat enough of it."

Alex had often talked about pearl hunting in the Clinch River which flows a couple of miles from the foot of Newman's Ridge, and I was most anxious to hear the details of his involvement in this most interesting industry. From the late 1800's until the 1930's, Tennessee was among the nation's leading producers of fresh water pearls and an appreciable number of these came from the Clinch. Researchers have discovered that this stream produced more different types of bivalve mussels, or mollusks, than any stream in the world. One study discovered 45 species in a single small area, and one authority, A.R. Cahn, states that the finest fresh water pearls known to man came from the Clinch River. In the 1930's some of these pearls were bringing as much as $6,000 each, on the wholesale market.

The pearl, officially designated by Tennessee as the state gem, is formed when a grain of sand, or some other irritant, enters the shell, prompting the mussel to surround the foreign matter with a shield or protective covering. The resulting pearls range in color from pink, bronze, and blue, to lustrous white.

Only a small percentage of mussels contain pearls, but the shell itself contains a lustrous inside lining, mother-of-pearl, which came to be valued for the making of buttons. Here again the shells from Clinch River were considered superior, and according to local newspaper accounts, they were used to make buttons for dignitaries throughout the world, including several Kings and Queens. Even if one found no pearls during a day's hunt, the shells could still be marketed.

Several years ago you told me about hunting mussels and pearls down here in the river. Were they plentiful in this area?

"Oh, yeah, tons of them. I's the first man ever invented a box to find them, least ways that I've got any history of. I just made one myself. I's raised partly on the river, and I's pretty well-acquainted with it. I'd get down there and roll my britches up and I'd get in water so deep you couldn't see them. I said, 'Doggone, I'll make me something so I can see them.' I made a box about 18 inches square with a piece of glass in the bottom and with glass sides. You could put it down in the water, just so the water don't come up over the top of it, and you could see four or five feet in all directions—well enough that you could pick up a pin if they's airy one down there.

"It wasn't long before a lot of people was making them mussel boxes. I ought to have got paid for that. Well, in a way I did get paid, by finding so many more pearls."

Where did you sell the pearls, and how much did you get for them?

"They bought them at Sneedville, Kyles Ford, and any of the little towns. They'd ship them out. It wasn't any trouble to get rid of them.

"The most I ever got for one was $18.00. I sold most of them for three or four dollars. There was a feller down here at Sneedville that got a thousand dollars for one. That's the most I ever heard of one bringing around here.

"Me and another feller was pearl hunting one day, and we got our boat full of mussel shells. He had his in one end, and I had mine in tuther. (The use of the word "tuther" for "the other" was not uncommon among the old folk in most remote areas of Appalachia, but Alex seldom used it. It seemed that when he got excited during the narration of one of his stories he was more apt to use the older form.) It was getting late and we had five or six hundred pounds of mussels and we unloaded them on the bank and started to bile them down. We'd put a lard can full and heat it till it struck a bile, and then we could open them up and see if we had a pearl.

"We had two lard cans and I'd bile mine, and he'd bile his. We done that all day, and it was getting late and this other feller said

he was tired and was going home. He just had a handfull of mussels left and he give them to me, and when I biled them open, I found a great big pearl. That was the only one found all day. (Alex chuckled.)

"Why, the bottom of this river was just covered with them big mussels. You could stand in one place and pull them out. People would come here from all around to get them mussel shells. They'd come in here and camp. It was something to see, in the summertime, people all along the river hunting mussels. Some of them would bring big vats, sort of like molasses pans, to bile them in.

"After they went through the shells, looking for pearls, they'd pile them up and they'd come in here and haul them off in trucks. They'd pay a hundred dollars a ton for the shells for buttons, knife handles, pistol grips, and chicken feed. They'd grind up the outside part and it shore would make the chickens lay. It would might near make an old rooster lay."

Did you use any of the shells yourself?
"Yeah, I've made buttons, pistol grips, and so forth out of them. They's a woman down here in Knoxville that I made some pearl crosses for, and law she was tickled to death with them."

How do you make a pearl button?
"To make buttons, you'd take a hammer and a little chisel and keep chipping that shell till you got it as small and round as you wanted. It would be rough and jagged. Then you'd take a file and smooth it up. I'd hold it under water when I's filing it, because if you don't it will just gum up and you can't do anything with it. See, that water floats that fiber away. It gets it out of your way so you can see what you're doing. But your water will get milky in a little while, and you'll have to change it every so often. I made me a little bit (drill) to bore the button holes with."

A certain type of mussel is a very fine food, served in many restaurants. Were these mussels edible?
"No, but if you got them before they tainted, they's good hog feed. They'd fatten a hog quicker than corn. They're sort of a cousin to the oyster."

The Clinch River has long been known for the thousands of log rafts that once were floated down its winding course to the sawmills located in Clinton and Chattanooga. Clinton, with a population of only a few hundred, had six active sawmills in the late 1800's to early 1900's. The largest, Fisher-Burnett, employed 50 men, and early reports indicate there were times when as many as a hundred rafts were tied on the banks of the Clinch at the Clinton mills.

Some of the country's best timber grew in the rich, moist hollows and coves on land drained by the Clinch. Roads were always poor, and bridges were not sturdy enough to stand the weight of a load of these great logs. Even if the roads and bridges had been adequate, land transportation was impractical. It would have taken two or three weeks to deliver a big log by an ox-drawn wagon from Hancock County to Chattanooga, a distance of about 130 miles, and the price received would have been negligible. Hence, river transportation was the only economical and practical means of transporting the large logs to the mills.

The logs were bound together with long poles called binders, and a wooden peg was driven through a hole bored into each log. A single raft usually consisted of 200 giant logs and often two of these rafts were joined together to form a double raft.

Two oarsmen were required on the front of a double raft and two in the rear. They worked in careful concert to prevent the raft from running on sandbars or shallow rocks, and to keep the raging current from smashing the rafts against the banks.

The key man in this operation was the steersman who had to know the river intimately. The rafts could only be floated when the "tide was up," when the river was in a semi-flood stage, and this usually occurred in the winter or early spring.

When the river was in this condition, the rocks and shoals that usually protruded were covered with water. The steersman had to know where these shallows were, and long hours of toil could be lost in a few seconds if the steersman erred. The job required skill, stamina, decisiveness and a quick mind. A good steersman was a much respected person among the loggers and rafters.

One such person was a young man from the Cumberland foothills near Livingston, Tennessee. Born in 1871 in a rented log cabin, this young lad had all the qualities necessary to make an expert oarsman, but his days of rafting logs on the Cumberland River were short lived. After delivering a raft of logs to Nashville in the 1880's he saw his first newspaper and decided to educate himself. He got his law degree, served in the Tennessee legislature, practiced law, was appointed to a judgeship, and eventually became a United States Congressman, serving for a quarter of a century.

In 1930 he was elected to the United States Senate and in 1933, President Franklin D. Roosevelt appointed him Secretary of State. He was presented the Nobel Peace Prize in 1945 and is called the Father of the United Nations. His name was Cordell Hull.

Few jobs in the Appalachian mountains were more demanding and more dangerous than log rafting. My grandfather, Marcellus Moss Rice, made a few trips down to Chattanooga in the late

1880's. Many times I've listened with awe to his stories of the days and nights on the freezing river—of those who died of exposure and pneumonia.

Log rafting was one subject I had not discussed with Alex, though he mentioned it when talking about his grandfather Livesey. I had no doubt that he could speak eloquently on this mountain activity.

Alex did you ever run log rafts down the river?

"Yes, sir. I've run log rafts and crossties, too. I've helped put log rafts together down here at the mouth of Panther Creek when it was so cold that the water, when it splashed on you, would freeze in less than five minutes. You had to put them two binders across them logs and drive wood pegs to hold them together. Every time you struck that peg, water would splash up through the cracks in them logs, and purty soon you was wet. Why, many a time I've seed my overalls froze so stiff they would have stood by themselves."

Were the logs mostly oak?

"They was mostly oak, but oak was so heavy that they wouldn't float by theirselves, so you'd have to put in a few poplar. The poplar was a good deal lighter.

"It was awful hard work, but it paid a dollar a day. Now, I thought that was big money. Fifty cents, even 25¢, was what I'd been used to. They generally sold the logs in Clinton but sometimes they took them on to Chattanooga. When you got to Clinton they didn't need as many hands from there on down and they'd let some come on back."

How long did it take to go to Clinton?

"Just depended on the tide. If you got the right kind of tide, you'd make it in about three days. Of course, you've got to run day and night."

Did you get any sleep during this time?

"Oh, you didn't get to sleep none—maybe a few winks the second night. You had to be on the job. If the tide got too high and wild, you tied up for a while of a night. You'd sleep a little setting up. But I've knowed of them going six days and six nights and never tying up. It depended on your water. If it got too low you had to tie up, and if it got too high you had to tie up."

Even if you had the time, there wasn't much of a place to sleep, was there?

"Oh, they's just a little old bunk, with a little straw throwed in there. They had a little stove you could cook on. That's all you had.

"When you got to town they had a little boat, they called it a nigger-head, come out and pull in your raft and measure it up. If they's crowded sometimes it'd take a day or two to get your logs

measured. Every one of them logs had a peg that stuck up through the binder about that far. (He measures two or three inches.) And they had a trick (tool) to go along cutting the tops off them pegs, just like you'd cut a cornstalk with your pocketknife. They had two fellers pulling them in and another feller standing there measuring."

When you got to Clinton, they gave you $3.00 and turned you loose. How did you get home from there?

"We'd catch a train over to Knoxville and then walk on home from there. It was about 60 miles home from Knoxville."

How long did it take you to walk that 60 miles?

"Just one day. You had to stir early and they wasn't no rest along the road. You had to keep packing down on it. Of course, it would be late at night when we'd get in. It wasn't no easy way to make money. They wasn't no easy way back then. If they was I never found it."

Alex, I believe you told me once that you spent some time working on the railroad.

"Yeah, I worked on the railroad. The coal company bought a whole lot of mountain land back from Norton (Virginia) and they had to build their own railroad line back in there to get their coal out. We built the roadbed. Used a pick and shovel, that's all we had, and sledgehammers to bust the rock. I worked there in the fall after the crops was laid by and on up till way after Christmas. I started working there before I married, and would go back up there nearly every fall."

How far was it to where you worked, and how did you get there?

"It was 75 miles to where I worked above Norton. Back then they wasn't no cars of course, and I'd walk it. After work one Friday I decided to come home. I lit out a walking and I got over here about two miles from Jonesville, Virginia, and hit got dark and went to kinda drizzling rain. I couldn't see the road hardly. Didn't have no light. I just walked off the road eight or ten steps, made up a fire and laid down by it. I's tired. I happened to look up and saw this great burning thing a flying through the air, and later I heered that it was Halley's Comet. Hit skeered the chickens and they started a crowing for daylight. (Halley's Comet is documented to have appeared several times in the spring and summer of 1910, the first sighting being May 10. At that time Alex was 19 years old.)

"Well, I just got up and started on towards home, and pretty soon it started getting dayling, and I had to wade Powell's River. They wasn't no boat nor nothing there. I just rolled my britches legs as high up as I could and come on across. And that river was cold! When I got out, I thought my legs would bust."

"When I got home Mommy was getting dir ner (the noon meal) over with. She told me to come on and eat, and I told her that I was too tired and sleepy to eat. I was plumb wore out after working 12 hours, then walking nearly 75 miles. I slept two or three hours and then I felt all right.

"Another time I got a job building a railroad over 'round Big Stone Gap. It was 52 miles over there and I left here one morning long before daylight a walking, and before dark I pulled in there. I laid on a sandpile that night and the next morning I went up and asked the foreman for a job. He worked a bunch of convicts in a rock pile, and he said, 'Well, you're too small to hold out for work like that, handling them big rocks.' So, he give me a job carrying water for the convicts and for the other workers. He give me $1.00 a day. They was a great big spring down at the foot of the hill, and I carried water from there.

"They had a steam powered drill to drill holes in the rock so they could shoot them. We'd always drove the steel with just a hammer, you know, but they had this steam-powered drill, the first ever I seed. They's a feller named John Cox, an awful friendly feller, who run the steam machine. Well, them steel bits would get dull and need sharpening every time they drilled two holes, and Cox asked the boss could I take them big bits down to the blacksmith and have them sharpened. The boss said alright, and I packed them down there and was back before they knowed it.

"The very next day they had this big ten-foot drill and the boss said, 'We'll get two of them convicts to load that ten-foot drill on the wagon and let you take and have it sharpened.' I said, 'Why, I can pack that on my back.' He said, 'You can play hell!' That's just what he said, 'By God, if you think you can carry it, take it and go on.'

"I took me an old gunny sack and put it on my shoulder and packed that big drill to the blacksmith shop, had it sharpened and brought it back, and the boss said, 'I'll be damned, you're more of a man that I thought you was, I'm going to raise your wages.'

"'Well,' I said, 'I shore do thank you.' Then I said, 'Why don't you put a shop here so we can sharpen all our tools and bits, and we won't have to carry everything backwards and forwards so much?'

"He said, 'Hell, we ain't got no blacksmith. Who could do the work?'

"I says, 'If you get me the tools, I can do the work.'

"He had a shop over in East Stone Gap and he sent over there and got the tools. The first thing he did was to give me a two-foot jumper. That's the drill you start off with.

"Well, I fired up the forge, heated my metal and hammered out that drill just as purty as ever you seed, and I tempered it just

right. He took and put it on the drill, and that bit just went right on down through that rock. He pulled it out and looked at it and you couldn't tell that it had ever been drilled with. I give it the right temper and it hadn't got dull at all. He said, 'I'll be damned! I see where you're a gonna stay, and I'm aiming to raise your pay again.'

"He raised me to $2.50 a day and I just stayed there and run the blacksmith shop. I had a pie from then on. The other blacksmith had to sharpen his bit after every two holes was drilled. But they always drilled three holes with mine before they needed sharpening. That's the first time ever I worked in steel. Course I'd worked back home with iron."

I asked Alex about the hardest work he ever did.

"Driving steel, he answered quickly.

During the latter part of the last century railroad building in America reached its peak and it continued well into the first part of this century. The locomotives could operate economically only on relatively low grades, and in the Southern Appalachian region this meant many great cuts, fills, and tunnels through the rugged terrain. Most of all such work involved solid rock.

The method used in removing solid rock was to drill holes in the stone and then place powder inside for purposes of blasting. The earliest means of drilling these holes was the driving of a steel rod, or bit, into the solid rock. One man assumed a kneeling position, holding the bit and turning it slightly every time it was struck. The striker, or driver, wielded a heavy hammer, frequently weighing ten pounds. The shaker's life was at stake every time the driver hurled the heavy hammer through the air to strike a blow. A miss, or a "glancing lick" on the bit could be fatal to the shaker. Also, the top of the bit, because of repeated blows from the hammer, would become frayed and peel off. If these steel "burrs" were not cleaned off they could fly off with the speed of a bullet and seriously injure, even kill, the shaker.

When the steam powered, steel driving machine was introduced in the mid to late 1800's, there was opposition to it among the workers. Some feared it would replace too many workers, and others doubted the machine's capabilities.

This conflict was dramatized for the entire nation when a contest ensued between the new steam drill, and a black steeldriver named John Henry. It took place in Big Ben tunnel in West Virginia, where the Chesapeake and Ohio railroad was constructing one of their lines. John Henry, according to tradition, took a 20 pound hammer in each hand and entered the race with the steam rig. At the end of 35 minutes, the engine had drilled one hole nine feet deep. John Henry had drilled two seven foot holes in the solid rock, easily beating the controversial contraption; but

he had so strained himself that he burst a blood vessel and died. From this was born one of America's best known folk songs, "John Henry, the Steel Driving Man."

This famous contest took place about 1873, but 35 years later, much of the steel driving in the rugged mountains of East Tennessee and Southwest Virginia was still being done by hand. It is interesting that Alex would quickly identify this romantic, yet extremely hazardous occupation, as being the hardest work he ever did. I asked him to tell about his steel driving experiences.

"Uncle Luke Livesey took the contract (to clear and grade) for the railroad they was building around Appalachia (Virginia) and he begged me off up there. He come through one morning with a string of wagons and I caught them and rode up to where he's a working. He wanted me to help cook. Hit was just his wife and a girl they raised, cooking for that gang of men. I helped cook for a right smart while. Finally he put me to shaking steel.

"I was working with two fellers from over here on the river. I was the shaker, and I'd set there for ten hours a day all humped up in the dirt and dust, a shaking that steel. One day that big sledge hammer glanced off and hit me right here on the side of the knee, and OH! that liked to have killed me! Made me so sick for an hour or two that I couldn't hardly live.

"I looked up and I said, 'If this is the only job that I've got, then I ain't got nary a one.'

"Ed Johnson was driving the steel—the one that hit me. He said, 'Here you take the hammer and you drive till you hit me.'

"I said, 'I don't want to do that Ed, I never did drive no steel.'

"'Well,' he said, 'By God you ain't too old to learn.' So I took the hammer and I went to driving and I drove nine straight weeks. And then they was two darkies that come up from North Carolina, Ralph and Sam. And Uncle Luke, he didn't like them and didn't hire none.

"Well, they come and ask him for a job and he told them that he generally didn't work no Colored folks. But he never could keep steel drivers and he asked them could they drive steel. And one of them said, 'I's a steel driving fool.'

"Well, Uncle Luke, he's as wicked as the Booger Man, and he said, 'By God, I'll try you, and if you can't, you can go down the road a running.'

"So, Ralph and Sam went to driving and I went back to shaking. One day Ralph says to me, 'I's gonna let you drive steel awhile.' Said, 'I got a hurting in my shoulder, and can't do no good at it today.'

"So, I got the hammer. It was a cold morning and I commenced driving and I hit that drill a hard lick and hit broke in two right

above his hand just as smooth as if you'd took a saw and cut it off. Uncle Luke was standing as close as from here to that door— standing a watching us.

"Oh, he commenced cussing and giving us the devil. I never said a word. I just laid my hammer down and went up there to where my coat was a laying on a big rock, and I took and put it on. He said, right snappy, 'What are you a gonna do?'

"I said, 'Well, I'm through.'

"He said, 'Ay God, no you ain't.' Said, 'Come here and go to driving that steel.'

"I said, 'No, I'll never work another lick for you what time I live, Uncle.' And I quit him right there and never did strike another tap for him."

Wasn't it pretty hard to work up there in Virginia as a day laborer, not seeing your family for long periods of time?

"That's why I didn't work there any more than I had to. But they wasn't no work here during the winter, and that was about the only chance."

In pioneer times the counties required all the able-bodied men to contribute a certain number of days work on the roads. Do you remember that practice?

"I shore do remember that. If you was 21 years old you had to pay $3.00 a year road tax or work on the roads six days. Before I got to be 21, I worked Pap's time. We used a pick and shovel and a great big old sledgehammer. We'd bust them rocks up and put them in them big deep ruts, and in the chug holes so you could sorta get over the roads with a wagon and team.

"After I got to be 21, I had to work for me and Pap both. They made me an overseer and all I had to do was supervise the other men and keep a check on who showed up. If someone brought a team of mules or horses to haul the dirt and rock, then that counted for two days work.

"Back then nobody had any money, and so just about everybody worked off their taxes. Later on they put a tax on your land, and that's when they done away with you having to work on the roads. The tax on a farm would just be three or four dollars a year. And now I pay two hundred and ninety-some dollars a year in property taxes on this farm."

Alex, you were about the right age to have been drafted in World War I, but you didn't have to go. What happened?

"I was in Dickinson County, Virginia helping build an incline, about a mile straight up a mountain. The boss come up one day and said, 'Is there a feller here by the name of Alex Stewart?'

"He reached me a letter and I just stuck it in my pocket. He said, 'You better take a look at that letter, it's from Uncle Sam.'

"Well I broke it open and it ordered me to report to Sneedville the next day by one o'clock to be examined for the Army. I's a shoveling and I just put my shovel down and went on down to get paid off.

"They didn't have any paper money and they had to pay me off in nickels, dimes, and quarters. Just as they got the money counted out, the train whistle blowed. I didn't have time to get no permit nor ticket, nor nothing. I just run to catch the train, and my pockets was so weighted down with all that silver that I could barely run.

"I rode to St. Paul, then I hooked a freight train to Norton, and then I caught one down to Ben Hur, and got in there at three o'clock in the night, and it didn't cost me a penny. I walked on home, and Margie was up getting breakfast. I drunk a cup of coffee and pulled out to Sneedville, and it was three o'clock when I got there.

"Dr. Dougherty was give up to be one of the greatest surgeons anywhere around, and him and another doctor examined me. Well, I'd been working and on the go for two days and a night and no sleep and nothing to eat in 24 hours, and I was as gaunt as you could get, pert near it.

"When they weighed me I weighed 102 pounds. Dr. Dougherty said to the other doctor, 'That's the best little man ever I saw, but he's too light.' They let me go, and they called me about a year later, but Armistice was signed before I reported and I didn't get to go. I wished a thousand times that I would have gone."

Franklin Roosevel't W.P.A. (Works Progress Administration) came into Hancock County in the summer of 1935. The pay was $2.50 a day as compared to 75¢ a day for most other work, and jobs of any kind weren't easy to come by in those Depression years.

Alex had inquired about a job with the W.P.A., because, as he said, he was trying to feed nine children and "times was hard." He had talked with the person in charge who promised him a job, and that official sent his brother over to talk with Alex.

"His brother come to see me and bragged on how handy I was and what a good job I could do. I told him I'd shore try because I needed the money.

"He said, 'Well, they's a job for you but my brother wants to talk to you. He wants you to promise to vote with him, and he wants you to trade with him at his store.'

"I says, 'You tell your brother to take his job and go to Hell with it!' (Alex raised his voice considerably when he came to the "go to hell" part. I think that was the first time I'd heard him use the word.) I says, 'I don't sell out.' Well for years they wouldn't speak to me, and little did I care."

Many people your age left Tennessee for better farm lands in the West. Did you ever consider leaving this country?

"I left here two different times looking for land, but I always came back. One fall when the corn and fodder had made itself and was getting ripe, I decided to go out to Indiana. They was a feller from here that had gone out there and he wanted me to come buy a farm close to him. I went out there and looked around but I come on home."

You didn't buy any land in Indiana?

"No. The land out there was alright, just as level as this floor, but the people weren't nigh as friendly as they are here. After I got back home they asked me how I liked the people out there. 'Why,' I told them, 'the dogs in Tennessee are a lot friendlier than the people are in Indiana.'"

You said you made two trips to the West. Where did you go the second time?

"I went to Oklahoma. The land out there didn't look like it would grow anything much. It was purty level and smooth but it was white. Old white, puffy looking land. You couldn't raise no corn out there on account of the sand storms. If it come a sand storm about the time the corn got up waist high, it would cut it every bit down.

"You'd have to burn cow chips through the winter to keep from freezing to death. I had an uncle that lived there and he had a garage piled full of cow shit. Yeah, that wind out there would dry it out just right away. A dry cow pile would burn for two or three hours when you set it afire. They lived hard out there for a long, long time. I wouldn't have moved out there if they'd give me a farm."

Even though you liked farming, it seems that you had to work a great many other jobs because the pay was so much better.

"Yeah, I worked a little over five years in the coal mines over here in Virginia. They've tried to get me to sign up for this Black Lung (benefits). Said I could draw a pension. I said, 'No. As long as I can live without it, I ain't going to.

"I done just about every kind of work there is to do about the mines. I've laid a heap of track, and I've help build them big concrete pillers for the railroad tracks going up to the mines. And I've shot and loaded a heap of coal.

"I've worked in seams only 18 inches high, and I'd get 5¢ a bushel for drilling, shooting and loading the coal. Did it by the contract, and I've worked in there 36 hours many a time before I'd sleep. I shore have. I'd work all day, all night and all day the next day. I'd stop long enough to eat, and back I'd go. You could work as long as you wanted to back then.

"Then I worked as a brakeman—as a sprager. Them cars would

start rolling too fast when they come down a steep grade and I'd stand at a certain point in the tunnel and jab a piece of iron in the spokes of the car wheel to lock it and slow it down."

Did you ever do any timbering in the mines?

"Yeah, I've set timber many a day. Had to keep that top propped up to keep it (the slate) from falling in on you."

I suppose the mines were pretty dangerous, especially at the time you worked in them?

"I never did get hurt bad. I've hurt my knees and legs where slate would fall on me, but never did get my head or body hurt. I'd always be careful overhead. You could take your crowbar and peck it and tell what it would do. The sound would tell you whether it was solid or loose. And if it didn't sound right, you'd better get it (the loose rock and slate) down. If you take that down you're in pretty good shape, but lots of people just didn't do it and it got them killed.

"They's one feller that I never was so sorry for in my life. He lived right over here next to me, and he was one of the best fellers I ever got acquainted with. He went back in the mines, and got killed the first day.

"Then there was a hunk come in up there at Stonega and went to work. He'd never been in the mines before. Back then you had to buy your own tools—a shovel, pick, crowbar, and lights. He bought him an outfit and went in there to work, and worked about a week. He was going in at night and had his pick on his shoulder. The pick hit that electric wire and it killed him. Yes sir, I was there and I helped take him out."

What did you call him? A hunk?

"Yeah, a hunk."

What's a hunk?

"That's just one of these foreigners. I don't know where they was from but you couldn't a bit more understand them than you could a goose. He was just a regular hunk."

Did they have any mules or ponies in the mines?

"Oh yeah, they had mules in there, lots of them. They was mules that never seed daylight from the time they put them in there until they died or got killed. They'd feed them and water them and everything in there. They stayed there all their lives."

That was sort of cruel wasn't it?

"Yeah, it shore was. The fellers that I worked with at Stonega, they'd come out with a dead mule just every few days. Them mules would raise their heads a little too high and their ears would touch that electric wire. That would get them nearly every time.

"In a way the mule was better off than the miner. If a mule got crippled up or killed, the company had to buy another one. But if

a miner got killed or hurt, all they had to do was hire another one, so they tried to take care of their mules.

Did you ever help make coke?

"I've helped burn a lot of coke up here in Virginia. They had great long rows of coke ovens, and we'd fill them with coal and burn them for 24 hours to make coke. Coke will put out so much more heat than coal will, and it don't smoke. You can take coke and melt steel with it.

Oh, it was a hot job and none of the white men could stand it much. Sweat drops would come on you as big as a nickel."

Alex, you've mentioned the many different things you've done to make a living, but you haven't mentioned sawmilling. The sawmill that you and Sam have now—I know it was here the first time I met you.

"Oh, I've worked in a sawmill, on and off might near all my life. I worked at a sawmill for my uncle before I married. I worked as an off-bearer. That's where you carry them big green slabs away as fast as they fall off. Buddy, that's a job. It'll kill you. They paid me 50¢ a day for a long time, and they finally got up to a dollar a day, and I thought I's rich.

"Years later me and Henry Sergner went up to Ohio. He had a boy up there, and we bought us a sawmill. Paid $650.00 for it and went down here to Red Hill and bought a engine off of George Hatfield to run it with.

"Me and Henry run that mill two or three years, and then me and Sam bought Henry out, and we run it for over 40 years. Sam got a truck and he'd go haul the logs until the truck wore out and then he just let people bring their own logs. Law, at the lumber we've sawed on that mill."

Alex, we're always talking about the different things you've done, and how hard you've worked, but we've never talked much about your health through the years. Have you had much sickness?

"I was bothered a heap with my stomach. Had them little ell worms after I married, and they eat the lining out of my stomach. Oh, that like to have killed me. The doctor said they *would* kill me if I didn't get rid of them. I suffered with that, but I never quit work. Never stopped.

"The doctor said you could build your stomach lining back by eating raw eggs. He said every time you get a chance, you eat a raw egg. I found that they was good, and I made a crop one summer eating nary a thing in the world but raw eggs. I'd punch a hole in the little end, and just turn it up and drink it down. Why, I got to where I could swallow them just as fast as I could break them. I made barrel staves that summer and hauled them over to Ben

Alex's son Sam, left, and grandson Rick continue to saw logs for themselves and for their neighbors. (Photo by Ed Meyer)

Hur, Virginia, and raw eggs is what I lived on. I bet I didn't eat two pounds of bread the whole time. I'd suck five and six eggs, two and three times a day.

"Eggs was high, and I didn't always have enough to do me, and I couldn't afford to buy them. I's going across the mountain one day taking a load of staves. I'd run short on eggs that day, didn't have none to take with me. I had an awful heavy load of staves and the road was bad and muddy. I's just letting my team take their time, and I stopped to rest them. Right above the road there set a hen on a nest. I said, 'If you've got any eggs, I'll get them.' I set there and looked at her awhile and I got down and she flew off and I got eight eggs out of that nest. I eat five of them right there, and took the rest of them home and eat them the next morning."

Abraham Lincoln who, lived over here in Kentucky at one time, was known as the railsplitter. I think you've split a few rails yourself?

"I've made thousands and thousands of rails. When I first

95

started making them I'd get $1.00 a hundred for splitting rails and laying them up into a fence."

I saw some rails the other day that priced at $7.00 each. That's seven hundred times what you got. That's hard to believe, isn't it?

"Yeah, and I had to lay my rails up, build a fence out of them before I got my penny a piece for them. You had to put two props at every corner to keep it from falling over.

How many rails could you split in a day?

"If I had good, straight-grained chestnut, I could split two or three hundred. That's just splitting and not laying them up. Young white oak, where it grows in rich soil splits pretty good, but nothing beats good chestnut. Of course the chestnut is all gone now. Killed by the blight."

Alex, we've talked a good deal about the many types of work you did and how hard it was to make a living for your large family. Was there ever a time when you were concerned about whether you could make it or not?

"Son, I've rolled in the bed many a night studying how I was going to feed my family the next day."

The Arts And Crafts Of Alex Stewart

"They Was A Time When Nobody Had Handier Hands Than Me."

It is incredible that one man could learn and successfully engage in as many skilled activities, arts and crafts as has Alex Stewart. If he wasn't a master of all, he at least learned them well enough to gain the approval and respect of his peers. We've talked about the various trades and occupations Alex "followed" to make a living: farming, mining, steel driving, railroad building, log rafting, sawmilling, to mention a few. In this chapter we'll look at activities which, though often helpful in sustaining the family, were taken up mostly for the pleasure and satisfaction of engaging in new and challenging pursuits. Alex tended to occupy himself by doing the things he enjoyed rather than working at tasks which might pay well or be considered prestigious. He told me a little story once which illustrates this characteristic.

"Old Dr. Mitchell come to our house once when I was just a boy and saw a walking cane that I'd made standing in the corner. It was all fancied up and had animals and things carved all around on it. He said, 'Brynger'—he always called me Brynger—'Did you make that cane?'

"I told him that I did and he said, 'Now that's a mighty fine job, but if you can do that, why you can do something that will make you a lot more money.' Well, I've studied about that a lot, and I've decided that he was just about right."

Despite the fact that he made little or no money from his crafts, Alex continued to engage in them throughout his life. The sheer number and variety of his endeavors are simply staggering. He himself put it quite well: "Somebody, Charlie McDoald, I think it was, asked me the other day if I knew how many things I'd worked at. I said, 'I never built no ships nor no freight train, but anything else I can think of, I've worked a little at it.' I undertook to count up all the kinds of work I'd followed and I got to a 150 some odd, and I just quit. I said, 'Shucks, this ain't paying me nothing.' I bet they ain't another feller living that's made more different kinds of things than I have. I've made everything that I took a notion to make."

Alex is extremely knowledgeable and skillful in dozens of areas relating to early crafts and mountain activities, but he gained national attention as an old-time mountain cooper.

Alex, tell me how you got your start as a cooper.

"Well, after I got married and got me a cow, I realized I didn't have no churn to churn my butter in, and I went up to Pap's to get him to make me one. He had him an order to make six chairs, but he said, 'Quick as I get this order filled, I'll make you one.'

"Well, I set there a few minutes and helped him bottom a chair, and I got to to thinking and I said, 'Dad, I'll be a working, if you don't care (mind), making up the staves (for the churn).'

"When I got the staves rived out I just went ahead and jointed them, made my bands and started putting it together. By the time he had his chairs done I had the churn done. I brought it around and showed it to him. He looked up at me and said, 'Well son, you've got me beat. I'm shore proud of you.'

"And that was the first vessel that I ever made. Of course I'd watched Pap, and Grandpap too, and I'd been purty anxious to try it, but Pap never did want to risk me too far with it. He's afraid I'd waste the timber. But I didn't, and I made a good one. It took me three days to make it.

"I laid it on my shoulder one evening—I lived about three miles and a half down in the Valley—and I started home with it. I's about half way home when an old man come riding up. His name was Rufe Anderson. He says, 'Whatta you got there?' I said, 'A churn.' Course he knowed what I had, but he just asked anyway.

"He said, 'Hand it up here. I wanna look at it.'

"I retched it up to him and he looked it over, took the lid off and rolled it around, and he says, 'That shore is a good one. What will you take for it?'

"I said, 'Mr. Anderson, I don't want to sell it. I've got me a cow now and I ain't got no churn.'

"He said, 'My churn's give out and we can't churn, and I've been trying to find me one. What do you get for one?'

"I said, 'Well, Pap always get $2.00 a piece for them.'

"He said, 'I'm aiming to give you $3.00 for this one.'

"Back then $1.00 looked bigger to me than $50.00 does today, and I decided to let him have it. The next day I went back to Pap's and told him what I'd done. He said, 'Well, I don't blame you,' said, 'if you can make one you can make two.' I put in and made me another one, and that's how I got started in the cooper trade."

Alex has been called the country's best known old-time cooper. Eliot Wigginton's popular book *Foxfire 3* devoted 29 pages and some 60 photographs to Alex Stewart the cooper. It was mainly

because of his renown as a cooper that Alex was featured on the cover of *The Craftsman in America,* a hardcover book published by the National Geographic Society. Most of his notoriety is based on his work as a cooper, or barrel maker, and an entire chapter could be devoted to the various aspects of this subject. (For example, the type wood used to make a keg depended on whether it was to contain water, milk, liquor, honey, and so on.) But, because his work as a cooper is so well known, it will not be discussed at length here. Mention should be made, however, of some of the types of staved containers which Alex has made. They include: churns, buckets, tubs of all sizes, barrels, kegs, piggins, butter bowls, and firkins. Some of the non-staved pieces include: dough trays, wooden spoons and forks, rolling pins, bowls and countless other items which were not then available at the corner store.

I've talked to you before about basket making.

"Lord, I've made many a basket, mostly out of white oak. It makes the best baskets, and they'll last the longest. I've made them out of willer (willow), broomcorn, and honeysuckle."

Tell me about making a white oak basket.

"The most important thing about making a basket is selecting your timber. You want a white oak sapling about six or eight inches through (in diameter). Now it has to be perfectly straight, no limbs, no knots, and the bark has to be straight, and sorta soft. You can take your hand and feel the bark, and if it feels rough and tough, why you don't want it. You want to get timber that's growed on the north side of the mountain and where the soil is rich. North grown timber is a third better than timber grown on the south side of the mountain, and your basket will last a third longer.

"If you take a split made from timber that's growed on the south side of the mountain, you can blow through it like blowing through a piece of cloth. It's so open-grained. If you make a basket out of it you ain't got much. It won't last.

"The soil has more to do with timber than just about anything else. You take timber that's growed on real poor land and hit's no good. If you want good timber, go to where the soil's good.

"Always cut it on the old of the moon. It's a heap better to cut it when the sap is down, but you can cut it any time of the year just as long as it's on the old of the moon. To make a nice basket you want to get your splits thin—as thin, might near it, as paper. If you work it when it's green, you can take and tie it in a knot it's so soft and strong. The width of your splits depends on the size of your basket. If you're making a small basket you need to have narrow splits; but if you're making a big basket you can use wider splits.

"The biggest basket ever I made held five bushel. They was an old man, Ross Lawson, who lived over here on the River Ridge. He come up to my place when I lived on the ridge and asked if I could make a five bushel basket. Said he wanted it to carry shucks to his cows."

Baskets made from broomcorn were very unusual, weren't they?

"Yeah, I never did know of anybody else, except Grandpap, making them. You have to get that hull from the stalk when it's green—just before it gets ready to shed its bloom. If you let it get too ripe it'll get brittle and hit'll break when you start to work it."

Alex, I know you've bottomed thousands of chairs, including several dozen for me. Some folks spend a day or two putting a bottom in a chair. How long did it take you to put a good white oak or hickory bottom in a chair?

"There was a little log church up here on Blackwater and the only seats they had was chairs. They was 24 of them that didn't have bottoms in them. Old man Alder, he was sort of the boss over it, he asked Pap would he bottom them chairs. Pap agreed.

"Well, we worked a day or two getting all the splits ready, and Pap says to me one morning, 'Let's go over there and put the bottoms in them chairs for that old man.' All them chairs was setting out back of the church house. We had mostly white oak splits, but we had some (hickory) bark too. I went down to a feller's house and borrowed a dishpan to put water in so we could soak the bark and splits.

"We bottomed them 24 chairs in one day, and we went up to the old man's house late in the day and he said, 'Well, how'd you get along?'

"Pap sad, 'Very well, I guess. We got them all done.'

"He said, 'Well, I'll be dogged.' And he got up and went down there and looked for hisself. He just couldn't believe that we'd bottomed all them chairs in one day. He said, 'I swear, that's an extra good job.' And he give Pap a little money and half a side of meat. Now that's how long it took us to bottom chairs.

"They was an old colored man who lived over there and he followed bottoming chairs. I's over there one day and he was bottoming chairs for Jim Stewart. (Alex's great uncle) I got tired a watching him. I finally said, 'Willie, if you don't care I think I'll try bottoming one of them chairs for you.'

"He sorta talked through his nose. Says 'Go right ahead, go right ahead.' So I got one down and had a botton in it long before he finished his. He wasn't half done when I finished.

"He said, 'Upon my honor, that beats anything ever I seed. I wish I could do that.'

"I said, 'Well, you can if you work your hands fast enough. You've got to keep your hands a going.'"

Did you ever use poplar bark for bottoming chairs? .

"Yeah, I've bottomed with poplar bark. It's purty good, but it won't last like hickory. They ain't nothing that beats hickory. If hickory is peeled at the right time I'll guarantee it'll last 50 years."

Poplar won't last that long?

"Oh, no, it won't last half as long. It gets dry and breaks."

What else did you use?

"Well, you can use lynn bark, and pawpaw bark and red elm. Red elm makes a pretty good chair bottom. Now, shucks (from corn) makes a good chair bottom, but it's so tedious to work with. I never fooled with it much."

When is the best time to get hickory bark?

"You want to get it just when the sap starts to rise enough that you can peel it. If you let all the sap rise before you peel it, then your bark will be rotten. Too much sap. Then you can wait till later in the year when nearly all the sap's gone, and that's another good time to peel it. Sometimes you can peel it on the new moon in April, but generally you have to wait till the new moon in May. After the new moon in June you can't peel it at all. Now there's seven different kinds of hickory around here, and not all of them has bark that will work for bottoming chairs."

Tell me about your chair making?

"Well, we're both setting in chairs I made over 70 years ago, and as far as I can tell they're as good as the day I made them. They've been used every day, and they got some pretty rough treatment along the way, with all the children."

I bought several hundred metal chairs a couple of years ago, and many of them are falling apart already. How were you able to build chairs so much stronger and durable than factory made ones without glue or nails?

"First, you want to get the right kind of timber. Cut it at the right time and place, and then season it right. Not too fast or it'll crack. I'd use green post, and I would season the rungs as much as I could and when you put them rungs into the post, then the green post will cure out and clamp them rungs just like they growed there.

"Now hackberry makes the finest chairs ever was. When it's green you can take and bend the post and the slats and they'll stay bent. Hit's a light wood, yet it's strong. Generally people used maple for the post and oak for the rungs and slats. That's what I made most of mine from.

"Old man Miller, he tried to buy some of my chairs the other day and I told him, 'No, I made them when I started housekeeping

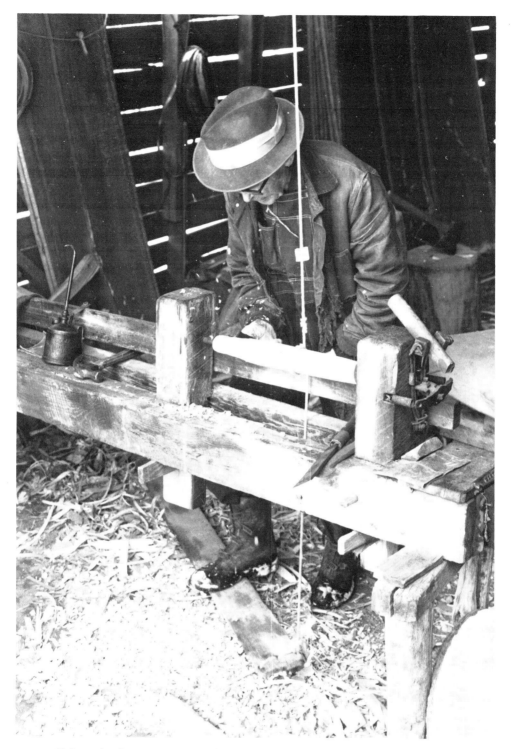

Although the foot operated, pole "powered" turn lathe was largely replaced by the great wheel lathe hundreds of years ago in Europe, and in most sections of this country, Alex never gave up the primitive device. He is shown here making a chair post.

and they've lasted me up till now and I know they're going to last me as long as I need them, and then some."

How long did it take you to make a chair, and how much did you get for it?

"If I had all my timber, I could make a chair frame in one day, and if I had my bark, or splits, I could bottom it that night. I'd get 50¢ apiece for them, delivered."

If you took into consideration your time gathering the timber, as well as your labor, you were making very little.

"On the average I'd make 25¢ or maybe 30¢ a day, but that was pretty good money back then."

How many chairs, would you say you've made?

"I guess I've made between 500 and 1,000. I never kept count."

A while ago you said you had never made a freight train nor a ship. How about boats. Did you ever make a boat?

"Boats? Oh, I've made many a boat. I learned boatmaking from my uncle. He lived on the river and followed fishing and he made his own boats.

"I made several for myself, and one day Milt Wilson come by and wanted me to make him a boat. Well, I got my timber and put right in on it and in about a week I had it finished. Charged him $10.00. He liked it so well he told other people about it, and before long I's in the boat business. I made 13 boats that one summer."

How did you make them tight enough so they wouldn't leak?

"I used poplar. Take a tree that's about 18 inches through, and that will make planks 14 inches wide. You can't have many knots. A knot will crack and then you've got a leak.

"Now, in making boats, you don't want your timber too well-seasoned. If it's too dry, then when you put in in the water it will swell too much and it will buck out. You want your timber about half-seasoned. I made my boats from 16 to 20 feet long. After I got one made you could take and put it in the river, and the first two or three days it would leak a little. You could take and dip that water out and hit would never leak another drop, as long as you kept it in water. Oh, at one time a heap of the fishing boats up and down this river was ones I'd built. I never had no kick about a boat I'd made."

One hot day when Alex and I were sitting on his front porch, the conversation lulled momentarily. I had no particular question to ask but noticed a horse down near his barn. A simple question or two was all that was needed to spark a dissertation on breaking horses.

Is that your horse down there?

"Horse?"

It's a mare, I think, down there in the pasture. Is that yours?

"No, that belongs to Rick (Alex's grandson). We've got a mule down there. Got a dandy mule. Plow our t'baccer with it."

Did you ever break any horses and mules?

"Oh, broke many a one."

Are they much trouble to break?

"Well, it's a whole lot of trouble if you don't understand horse nature. Every horse ain't natured alike.

"I went to a sale over here on Blackwater and bought a mule. Give $50.00 for him, harness, check-lines and all. There was a terrible big crowd, and nobody didn't bid on him much, and they knocked him off on me. I *thought* they was something wrong with that mule or he wouldn't went for no such price as that, and as I got about ready to leave, there was two fellers come up to me and one of them says, 'Now, I'm gonna tell you something. You watch that mule. He'll kill you.' Said, 'It took seven of us to shoe him, and he wants to go to the barn with you every time you get out and work him. When it goes to getting hot he'll go to the barn with you in spite of everything you can do.'

"I thinks to myself, 'That's awful encouraging,' but I said, 'I'm glad you told me the way he was.'

"I come on home and the next day I put the gears (harness) on him and took him back in the ridge there to cut firewood. I cut me down two or three great big black jacks, about 30 feet long. I hooked him to one and got started. He run a little piece, and here he come right back on me and almost backed over me. He commenced kicking, and when he quit, I just tied my lines to a bush to where he couldn't get away. Then I cut me a pole about six or eight foot long about as big as my arm. I come back and called on him again, and here he come again, right back over me kicking and rearing.

"I took and let him have it with that pole around the side of the head with both hands. It knocked him down, and he laid there with his eyes a rolling. I thought surely I'd killed him. He laid there a few minutes and I called on him and he got up. He stood there and trembled just like a leaf. I called to him and he struck right out and hauled that load to the house. I went back and hauled two or three more before I let him out. He never showed another trick. Everybody wanted to know what I'd done to him. They said, 'That mule couldn't be broke.'

"They was a feller come here one day a looking at him and asked me would I sell him. I said, 'I'll take $150.00.'

"He said, 'I've just bought him.' He took that mule home and worked him a day or two and come to me and said he couldn't do a thing with him. I give him his money and took the mule back. He couldn't do nary a thing with that mule."

Did you ever break any oxen?

"Yeah, I've broke many of them. I've broke them from the time they was six months old on up till they got to be great big ones. They're not too bad to break. I'd druther break a steer any time than to break a horse. I've plowed corn, snaked timber and done all kinds of work with steers. If you put them on level ground, nothing can out-pull a good steer, but they don't do so well pulling up hill. They have to pull using their weight, and they can't do that very well when they're going up a grade.

"You want to start breaking cattle when they're yearlings, and load them according to how fast they grow. Don't load them too heavy. When you're breaking a young team of steers like that, you have to make a new yoke every once in a while, as they grow."

I had a pair of oxen and we didn't work them very much. They finally got to where they'd just start off and you couldn't stop them. How do you control them without a bridle or anything?

"Well, you've just got to learn them that. You put what they call a 'G' string on them. If they start, you can shore learn them to stop. If one wants to run with you too much, just put a rope on him—first around his forelegs and then around his withers towards his back. When he starts to run, just pull that rope a little and you'll jab his nose in the dirt every time. He'll soon quit that."

I suppose you doctored livestock too, and castrated them?

"Why Lord yeah, I've cut many a brute. I learned it from my Dad. He was a good stock doctor. Old man Mathis lived right down the road here and he had five or six bull calves. They was awful purty ones, weighed 400 or 500 pounds a piece. They was getting up big enough for service, and he said, 'I've been wanting them changed (castrated) for a long time. I just don't know nobody around here that does that.'

"I said, 'Well, if you want me to, I'll change them for you.'

"He drove them up in the barn and he said, 'Are you gonna throw them down?'

"I said, 'No, you tie him to where he can't get away and I'll show you what I'll do to him.' He tied his head up to the wall good, and I just went over there, grabbed him by the sac and pulled it right down to where he couldn't kick me and I stood there and trimmed him, standing up.

"Jess said, 'Well, I'll be doggoned, I always seed them throwed.' 'Well,' I said, 'that's foolishness. Throwing them is liable to hurt them.'"

Did you put anything on them?

"No, never put a thing on them. Just trim them and let them go. All that blood will drop and dreen (drain) out before it closes up, and they do better, not to put nothing on them. If you trap

that blood up in there, that's what causes them to swell up. Now if you don't trim them right, or if you trim them at the wrong time of the moon and if they have trouble, later on, then you need to doctor them. You can take and peel buckeye bark and boil it down and bathe them in it. Another thing that's good is dishwater. Bathe them in that, and it will cure them if anything will. You needn't worry about them kicking you and them sore like that. They're not going to kick nary a thing."

I guess you've castrated a lot of hogs, huh?

"Yeah, I've took many a ball off of hogs. Now they's a time to do that. If you've got a male hog and want him changed, don't never cut him if he's been to a sow in the last two or three days, and cut him when the signs (of the moon) leaves the hips going down to the feet, and you'll never have a bit of trouble in the world with him. Don't never trim them while the signs are in the heart and the head. If you do, he's liable to bleed to death or swell up.

"When I lived on Miss Mullins place she had six fine boars, and she had a feller to trim them at the wrong time of the moon. I told her when he left, I said, 'Now Miss Mullins, I don't want to dishearten you none, but you're shore going to have trouble with them hogs.'

"She said, 'Why? What do you mean?'

"I said, 'He's trimmed them at the wrong time of the moon. The signs are in the heart and the head, and they'll be a month getting well, if they get well at all. Shore enough, three of them hogs died, and the others had a tough time."

Some people used to eat the testicles—Mountain oysters they called them.

"Oh, they're good, didn't you ever eat them? That's one of the best things you ever eat. They have a tough skin on the outside, and you have to take that lining off, put them in salt water for a day or so and then fix them. And if you don't tell me them's good... Oh, I eat every one of them I get a hold of—Mountain oysters."

Historians, in writing about pioneer products, almost always mention beeswax as an important commodity. Did you ever make any?

"Oh, yeah, I'd say I've made beeswax. You take the comb out of honey and pine rossum (rosin) and put it in water and boil it. Then let it cool down a little and all that wax will come to the top. You can just lift it off and make any shape out of it you want to. That pine rossum makes it a heap better."

Do you have to get all the honey out of the comb in order to make beeswax?

"No, the honey don't hurt anything. When honey gets hot it

evaporates, and it's gone. It don't help none. You can't sweeten nothing hot with honey; it'll just evaporate and be gone."

What was beeswax used for?

"Oh, it was good for all kinds of things. You put you a good coat of beeswax on your shoes and you can wade water all day and your feet will never get wet. Your shoes will last twice as long if you wax them with beeswax once in a while. About once a week Grandpap would take and melt a batch of beeswax and give his boots a good saturation. He never had no wet feet. You can use it on your harness or any kind of leather. In making shoes, you coated your string in beeswax so they wouldn't rot and let your shoes come apart."

I remember that my grandmother, and even my mother, kept some beeswax to coat the bottom of their irons when they ironed clothes.

"Oh, yeah, they always used it for that, and it was the very thing for grafting. When you grafted an apple tree, peach tree, or whatever, you'd coat it with beeswax. I grafted many a tree like that. Learned that from Grandpap and Pap too. Sam's a good hand at grafting too. He's got a tree over at his house that he's grafted and it bears five different kinds of fruit.

"If you ever had a pot, bucket or pan that leaked airy a bit, you could shore stop it with beeswax. Just melt it down and put it in the hole and it would harden just like cement. That would be the end of your leak."

Was there a market for beeswax?

"Yeah, you could sell it at the stores. I've sold many a pound for 10¢, and it takes an awful big hunk of beeswax to weigh a pound. It's light. The price went up, and it finally got up to $1.00 a pound then it sorta went out of style and I guess they finally quit buying it at all."

You mentioned the importance of beeswax in making shoes. I don't think I ever asked you whether or not you made shoes.

"I've made two pair in my life, out and out. The first pair I made for myself, and the second pair I made for a boy named Rick Miser. He was just a little old ragged thing, barefoot and his feet so sore, rusty and scaly he couldn't hardly go. He's a great big boy and he'd never had a pair of shoes on his feet. His pap got ahold of some leather somewhere and asked me could I make his boy a pair of shoes.

"I went and borrowed the lasts and some tools from Grandpap Livesey and made that boy a pair of shoes. Oh, he was the proudest boy that ever you saw."

Could you buy shoes at the stores?

"In the early days you never heard of store-bought shoes in this

country. If you didn't have somebody to make your shoes, you just had to do without. They was a lot of women that never had no shoes. They'd wrap rags around their feet or sometimes they'd use deer skins. They called them moccasins. They'd skin a rabbit sometimes and line them.

"The first store-bought shoes that come in were called brogans, and the first women's shoes was called nigger-straights. They was just straight, narrow-toed shoes, and if you got them airy bit wet and let them dry, they would get as hard as a rock. You had to warm them up before you could get them on."

I assume the leather for shoe making, and for other purposes, had to be tanned locally. Did you ever tan hides and skins?

"Yeah, I used to tan squirrel hides, groundhog hides, coon hides. Law at the hides I've tanned. I used to burn hickory and white oak mostly to make my ashes for tanning. I'd bury my hide in the ground, cover it over with them ashes and wet it down till it was right soupy. I'd let it set 24 hours and then take it up and the hair would come right off. Then I'd go to a good stream of water and wash it good, then put it in a tub of water for another 24 hours to make sure all the lye (from the ashes) was out.

"Now after you get all the lye washed out of your hide, you'd hang it up and let it dry for a day or so. Let it get about half dry—not too dry."

I used to help Uncle Campbell Sharp tan hides, and the biggest job, I thought, was what he called working the hide.

"Oh, yeah it's got to be worked. That's the most important thing. I'd saw them back and forth across the back of a chair. Keep working, twisting, and sawing it, and when you worked it till it was completely dry it would be just as soft as a rag. If you let it dry out before you worked it, it would be as stiff as a board and you never would be able to do anything with it."

I suppose there were many uses for these hides, once they were tanned?

"Oh, yes. You could make a pair of shoestrings out of a good groundhog hide and they would wear out any pair of shoes that ever you saw. Coon hide makes good shoestrings. A lot of people used squirrel hide, but they wouldn't last as long.

"I used to mend shoes for my family, and people got to bringing their shoes to me, ripped open and coming apart, and I'd take groundhog strings and sew them up for them. Back then people would keep patching their shoes just as long as they'd hold together.

"I've used groundhog hides to make banjo heads, but cat hides is the best. We'd make whangs (leather thongs) to sew harness with. Oh, tanned hides come in handy for a lot of things. You'd find a use for them, might near every day."

108

Did you ever tan hides without removing the hair?

"Yeah, but you don't want to use lye or ashes if you want to leave the hair on. You take your hide and wet it good and sprinkle it with alum, roll it up and let it set for 24 hours. Then unroll it, wash it good, and get all that alum out. Then you work it till it's good and dry. You can tan a deer hide like that and it makes a good rug.

"They used to be a lot of groundhogs over here on Blackwater when I lived there and an old lady, Mary Bell, lived right close. One day she said, 'You catch one of them big groundhogs and tan his hide and I'll make you a pair of gloves.'

"Well, it wasn't but a few days till I catched a big one, tanned his hide and took him to Mary. She made me a pair of gloves out of that and doggone I liked to have never wore them out. I wouldn't take nothing for a good pair of groundhog gloves if I had them now."

Alex, you remember the old Trent place down here on the river. They say that it was the home of the ancestors of Senator Mark Hatfield of Oregon. Well, I found an old bark grinding mill there and was told that it was used to grind bark for making tannic acid for tanning heavy hides.

"That was old Bill Trent, Margie's great uncle, that run that tanyard. Yeah, I can remember that old mill and tanyard when it was in operation. He'd take and grind his tanbark, chestnut oak generally, with a mule or an ox. He'd put that ground-up bark in a pond that he made in a little stream. Then he'd put his hides in. They called that the ooze.

"You had to leave your hide in that ooze for 90 days. He'd put lime in it too, but not too much. Then he'd take the hide out and scrape the flesh side with a big long scraper that looked a lot like a drawing knife. You can't buy leather today as good as that was. He was particular and didn't want kids hanging around there too much, but I'd go down there sometimes and just sanco around and look it over. That pond would be full of cow hides."

Your talk of tanning hides and skins reminded me that I was going to ask you about the various ways you hunted and trapped game.

"I started out hunting with a crossbow, and sometime with a bow and arrey (arrow). I got to where I was pretty good at killing rabbits, groundhogs, and things like that with a crossbow. And I made deadfalls."

Tell me about the deadfalls. I understand it's one of the oldest forms of killing wild animals.

"Well you can take a big, thin, flat rock four or five feet wide, and about as long, and stand one end up off the ground about two feet, and prop it up with a stick. Then you get a bone of some

kind, a green bone, and char it right good so hit'll stink. That puts off a terrible odor and a fox can smell it for a mile, I guess. You take and put that bone under the rock on your trigger, and when the varmit undertakes to pull that bone off, he trips the trigger and that rock will come right down on top of him. That would shore hold him.

"A deadfall is about the only way the Melungeons had of catching game. If they couldn't find the right kind of a rock, they'd make a deadfall out of heavy poles. I used to help Grandpap Stewart make pole deadfalls. I've laid off to make me one but I can't get out to do nothing.

"Now a deadfall is dangerous about catching dogs and I never liked to use them too much. I trapped mostly with steel traps, box traps, and snares and when I got me a rifle I used it a heap. But I've used about every way you can think of to catch varmits, and I've hunted and trapped for every kind of animal that was around here."

We were sitting on the front porch one day and I noticed a molehill in the yard. Since the conversation had lulled, I asked Alex about moles. This question, like many, brought a radiance to his face and a chuckle which told me that the subject reminded him of some long ago incident.

"Now if moles are bothering you and you want to get shed of them, you can take a cow's horn and put it in their route, and you can catch every last one of them. They go inside the big end of the horn and they'll just keep working forward trying to get through that horn. They'll be there till they die or until you go take them out. They don't think about backing up.

"I learned that from my granddaddy. He knowed which way they traveled most of the time and that's the way he'd face the horn. We'd go back every once in a while and empty that horn until we'd catch every last mole around there."

Were mole skins worth anything?

"I got $1.50 for a mole skin at one time, and that's the most ever I heard of a mole skin bringing. I was walking across the ridge there and I saw where a mole was rooting in the dirt. He was making a hill as big as my arm and I got a stick and slipped up on him and got him out. He was a great big old blue thing. He was three times as big as a regular mole. I set right down and skinned him and took him to my uncle. He sorta dealt in fur, and he give me a dollar and a half for that skin."

Did you ever trap quail?

"They's several ways to catch a quail. You can make you a box out of little round poles, about two foot square, and just find you

a smooth place on the ground and turn your box upside down. Go out from your box two or three feet and dig you a trench about three or four inches deep right on up under that box. Sprinkle you some cane seed in that trench and under the box. Them quail will start eating them seed and they'll keep going in that trench right on under that box and when they realize they're trapped they'll all start flying up and fluttering around, and they never think to look down and go out the way they come in. I went down to check my bird trap one time and I had nine partridges in it. Every time one would stick his head out a crack, I grabbed him and pinched it off. I took them to the house and made dumplins and gravy out of them and I thought that was the best eating ever I eat."

In the mid 1700's Denis Diderot, the noted French philosopher and encyclopedist, made drawings of netted fish traps, illustrating how they were made. I had never encountered this type net anywhere until I started finding them along the Clinch River in Hancock County, near where Alex lived. Years after I found the first one, I got around to querying Alex about the making and the use of these nets.

Alex, you told me that you've made netted fish traps?
"Oh, yeah," he chuckles, "I've made many a one. You take a hickory sapling and split it and make your hoops. The first one, at the throat, is about two feet across and the next one is a little smaller on down to where the last one is not near as big. You take little blocks of wood and do your knitting around that. You cover the hoops with your net and make two V-shaped traps inside. One time I went to check my net and I had catched 53 catfish in one net and every one weighed at least two pounds. They was channel cats. I took them down to Gene Livesey's and he said, 'That's the most fish ever I seed that come out of one net.'

"Another time I caught three big yellow cats. Two of them weighed 52 pounds (each) and the other weighed 48 pounds. They ain't many people around here who has caught more fish than I have. I followed it a long time, and if I couldn't catch them one way, I'd catch them another."

What other methods did you use in catching fish?
"Well, I've used trotlines a heap. And of course, we seined, gigged, and speared them. Then in later years I used reels. I dynamited them a few times but I saw what it was a doing— killing all them little fish, and I soon quit that. I don't believe in that."

Tell me about gigging fish.
"I run into Albert Lewis one day and he was telling me that the fish had started shoaling down there in the river where he lived.

We decided to go gigging. I went out in the woods the next day and got me some good rich pine knots, split them up in splinters and made two big torches.

"That night we went down to the river and I give him one of them pine torches and he took one side of the river and I took the other. Them torches give off plenty of light and I could gig one might near every time I throwed my gig. When we quit I had four more than he did and he said, 'I swear you're the first feller that ever beat me gigging.'

"Me and a feller by the name of Miller was fishing right down here in the river and I caught one that weighed about five pounds. When I come out with it I noticed it looked a little bit odd. We got to looking at it and found it didn't have an eye in its head. Hit was just as smooth all round it's head and had no sign of any eye.

"Now, if I didn't have proof of that I wouldn't tell it. It had no symptom of an eye in its head. That learnt me that fish has to smell as well as see, otherwise this one couldn't have found his food, nor got around."

Alex had mentioned the crossbow in a passing way.

The first early crossbow I ever saw was in the possession of Guy Bowers, my long-time collector friend from Greeneville, Tennessee. When I was finally able to acquire it after years of negotiations, I set out to learn something about the use of the crossbow in this country. Dr. Robert Riedl, a respected anthropologist at the University of Tennessee, was greatly impressed with my acquisition. Although he was a native of Austria, he knew more about Appalachia than almost anyone I've known. I recall him saying that of the tens of thousands of items in the Museum, he felt this early crossbow was the single most significant piece.

I had found no mention of the crossbow being used in early America, but my friend, Gene Purcell, one of the more astute observers of our early culture, points out that there have been objects discovered which suggest to some that crossbows were used in the Revolutionary War period. Others disagree. Robert Johnson, owner-operator of the museum, Whistle in the Woods, in Rossville, Georgia, thinks the crossbow was used in early New England and later in the Pacific Northwest, but had never heard of it being used in Appalachia. Even DeSoto's men, coming into this region in the 1540's, 200 years before the first settlers arrived, had largely converted to the use of firearms.

But there it was, a genuine early crossbow, doubtless of the 18th century, found in Greene County, Tennessee. I began to inquire in that area and a couple of the old men recalled seeing the remnants of "old-timey" crossbows when they were young. I was

anxious to find out what Alex knew about this ancient weapon. I asked him if it had, at one time, been commonly used on Newman's Ridge.

"Why Lordy, yes. I recollect the crossbow. My Grandpap Stewart had one when I's a boy. And the folks back before my time hunted with them. They's so poor they couldn't get hold of a rifle gun, and they couldn't have got powder and lead for it if they had one. If a feller back then had a gun, he's a big man."

Tell me about making a crossbow.

"Well, they generally used poplar for the stock. It's light and yet it's strong. But black haw is the best for the bow if you can find it. Cedar will do if you get the right mixture of red and white. And hickory makes a good arrey (arrow). It is straight-grained and won't hardly break."

Since I had found no pioneer artifact which Alex could not make from scratch, I asked him if he thought he could make a crossbow. His response was quick and confident. "Why shore, if I can get the timber."

When I next saw him, a few weeks later, I told him of my effort to find a haw tree, and he responded enthusiastically.

"I'll swear, I've had that on my mind all week, to go back yonder and hunt me a haw and make you that bow. If I can't find a haw, I'll just get me a piece of cedar.

"A haw tree is the solidest wood you ever saw. You can't see no grain in it, and its got plenty of spring. That's the reason the Indians used it for their bows."

Well, we never were able to find a suitable haw, so Alex proceeded to use cedar for the bow. When he finished it, I was simply amazed. It was not only a well-proportioned work of art, it was a dependable and deadly weapon. And it was made from memory of the last one he'd seen, perhaps 70 years earlier. If I was ever tempted to question Alex's claims relative to his attributes of making any of the pioneer arts, his expertise in making the crossbow alone would have allayed my doubts.

It is cocked by pulling the bow back and catching the bow-string on a notch cut near the handhold of the stock. The arrow lies in a groove cut into the top of the stock so that when the string is released by the trigger, the bow springs to its original position, driving the arrow out of the groove at near bullet speed.

The crossbow was developed in the medieval period and mechanized as early as the 1400's by the addition of a two-handled windlass to draw the bow into the shooting position. The crossbow Alex made was more simplistic, representative of an

earlier time, and it was devoid of any metal. It, like many items made in the pioneer setting of this region, was less advanced than the European counterparts made several hundred years earlier.

So, the crossbow was used on Newman's Ridge in your Grandfather's time instead of a gun?

"There wasn't no guns hardly. When I's a growing up, my daddy and George Bell had the only rifle guns in our whole community.

"Before that, when Pap was growing up, he hunted with a crossbow. Him and a Creech boy was out hunting one day with crossbows and they got sorta separated and Pap accidently shot him in the side. He pulled the arrey out and brought him down to Grandpap's. Grandma bound him up and put turpentine, tallow and coal oil on him. He got all right, but if it hadn't been for his clothes, that spike would have went two-thirds of the way through him."

So the crossbow wasn't just a play thing?

"No sir, that's all they had to hunt with."

What did you use for the string when you first made the bows?

"Flax string or tow. Course you can use nylon now. You could use cotton but it wouldn't last long."

What about rawhide?

"Rawhide won't work. It's too bad to stretch if it gets wet a little bit."

And the crossbow was a deadly weapon?

"Oh, yes, you could kill anything with it. I used to hunt mainly rabbits and squirrels with them. I heard Grandpap talk about killing deer with a crossbow. I recollect once that I went down to the blacksmith shop and made me a fine steel spike for my arrey.

"After I got it finished, I's a hunting up here in the holler and looked over on the far side of a ditch and there set a rabbit. I drawed back and set that arrey right across his back, right under his hide and he took off up through the cedars. I went a piece looking for it and couldn't find it. About six or eight months after that, I's up there again and there laid my arrey and the bones of the rabbit. Hit was rotted, the arrey was, but I got my good spike back."

The art and knowledge of performing many of the frontier crafts and activities are, in many cases, on the verge of being totally forgotten. Indeed, even the knowledge that some of these old time ways ever existed is being forgotten. Making tar from pine knots is an example.

The subject came up quite by accident. My longtime friend W.G. "General" Lenoir, who founded the Lenoir Museum in Norris, Tennessee, and who is the same age as Alex, called me late

one night to pose a question which had been on his always inquisitive mind. "Where did the saying, 'I'll beat the tar out of you,' come from?" Although this is a most common expression throughout this area, I didn't know the origin of the phrase. We agreed I should ask Alex, and I posed this question the next time I saw him.

"Oh yeah, I've heard that all my life—'Beat the tar out of them'—always sounded to me like they meant they was gonna beat the life out of them, but wherever it come from I don't know."

But Alex didn't stop there. The subject, like most all subjects one raised with him, sparked a discourse. He told me that he had run many a batch of tar.

How do you go about making tar?

"You go in the woods where some big pine trees have rotted away, and you get them rich pine knots that's left. You split them into real fine pieces and lay them on top of a flat, sloping rock; then you cover that with mud. You pat that mud down good and build you a good fire on top of that, and in a little while that tar will start running out from under that mud. You'd have a bucket there to catch it.

"Now you have to be careful not to let it catch fire, because it'll burn like powder. Most of the tar ever you saw was black, but that's because the smoke got to it. It comes out purty and yellow if you can keep the smoke away from it."

I have a tar rock in the Museum with grooves cut into it so the tar could more easily escape and be channeled to a central point and to be caught in a kettle. All my information heretofore described a different method of making tar. It consisted of placing the pine on the stone as Alex described, placing a large iron kettle upside down over the pine knots, daubing the cracks with mud, and then building a fire.

I suspect the process Alex described was a much earlier one, going back hundreds, even thousands of years. One could make tar in the manner he described even if he didn't have a kettle. I have several wooden tar buckets in the Museum, still coated with the thick, black substance. They were used mainly to carry tar for lubricating the axles of the old 'tar pole' wagons. (The words tar and pitch are often used interchangeably, and pitch was one of the earliest and most important exports in colonial America.)

I encouraged Alex to further enlighten me on the fascinating subject of making and using pine tar.

"I can remember when we used to run tar and sell it for $1.00 a gallon. They used it to grease the old time wagon wheels. It won't let your wood wear. (In the early wagons, a wooden axle turned inside a wooden hub.) It seals off that wood and it just won't wear out. Uncle Joe Livesey followed logging all the time and he had two big wagons and I've sold him gallons of tar for them wagons.

"When steam engines and sawmills started coming in, they'd take tar and put it on the belts, so they wouldn't run off the pulleys. We used it also in dehorning cattle. Cut the horns off a cow and put a patch of tar over it, and that keeps the flies off. I've seen them go around with their heads black with tar and it would melt and run down their jaw and make them look like monkeys. That tar was full of turpentine and it was good medicine."

I've heard that they put tar on hogs when they had lice.

"Oh, yeah. Hit'd take lice off of them, and their hair too if you put too much on. Hit was good for that and it was good to give a dog when it had distemper. Grease him under his throat, and it would break the distemper right away.

"A lot of people raised sheep back then and in the spring of the year they'd take tar and run it up their noses and blacken their faces with it to keep them from taking what they called the (head) rot. Pap had sheep and I've held them many a time while he tarred them."

Was it in liquid form, the tar?

"No, it was like thick molasses. You could make it as hard as you wanted to. You could make it so hard that you could take a knife and hack it and it'd fly like glass. Or you could make it thin. You boil it after you run it, you know; boil it down like you was making molasses, and just make it as thick as you want it. The longer you boiled it, the thicker it got."

Could you use the heart of pine, or just the knots?

"The knots is the best. The main body isn't hardly as rich. Once in a while you get a rich one. I've seen them s'rich plum through they just looked greasy. But you won't find one out of 50 that a way."

Alex, I've asked you about every pioneer activity I could think of, hundreds of them, and you've never failed to provide first-hand information. Let me try a new one. Do you know how to make lime?

"I've built two lime kilns in my lifetime and burned a heap of lime. You've got to know what you're doing to make lime."

Tell me, from beginning to end, how you made lime.

"You need to find a right steep bank and dig back into it and make you a big room. Then you line the walls of that with big rock to keep it from falling in, and you cover them walls with

116

mud. Cover the rock plumb up so you can't see a rock nowhere. Then lay you a big flat rock across the top and cover that with dirt. You leave a little hole in the back about a foot square so the smoke can come out.

"You need good hard wood to burn lime, hickory or oak. You've also got to get the right kind of rock to make lime. You want a certain kind of limestone. Not too hard. They's a kind of limestone that's mixed up with flint and it won't burn into lime. We call it bastard rock.

"You take the right kind of limestone and bust it up into five or ten pound rocks and put them in your kiln and get your fire right hot. It takes two men to fire a kiln and it'll take 24 hours to make a run. You have to have the fire awfully, terribly, hot and you can smell the rock when it starts burning. Them rocks will go into ashes, just like wood ashes in your fireplace, except they're whiter.

"When you was up on the ridge tuther day, to get my old log house, you passed an old lime kiln where they burned a man up. His name was Creech. Some fellers got into a disagreement with him and they killed him and burned him in the kiln. Uncle Bert Goins, that was Grandpap's uncle, said that place was hainted (haunted) and him and Grandpap wouldn't come by there of a night because the haints had got after them. They'd go ten miles out of their way before they'd go by that old lime kiln."

What uses did you have for lime, other than tanning leather?

"Oh, the biggest thing we used it for was on the crops. Hit's a heap better than fertilizer, and it'll last for at least six or seven years. They's nothing that will make a pasture grow like burnt lime. You get a heap better results than from this here crushed lime. When you're putting it on your row crops, don't put it to close. It's high-powered stuff and it'll kill your corn and stuff if you put it too close. But talk about growing; buddy you put a little of that burnt lime on your garden and just set back and watch it come from there."

Any other uses for lime?

"We used it to make cement, and we used it around toilets in later years. People kept a little bag of lime in their privies, and every once in a while they'd throw a handful down in the pit. That would keep the odor down, and it'd keep the flies away. You can put a pound or two of lime in your vat when you're heating water to scald hogs, and that will help make the hair come.

"I've used lime to whitewash fruit trees. Take your lime and mix it with water and paint your apple trees and peach trees up about two or three feet high. That keeps the rabbits, goats, and everything else from eating the outside bark and killing the tree.

It kept the ants and other insects away too, but it don't hurt the tree."

Someone, Bill Henry I think, told me that you used to dig wells by hand. Tell me how you were able to do this without any equipment.

"The first well ever I dug was for Al Moore. I was telling you about living on his place. The regular pay was 50¢ a day, and he offered me $1.00 a day to dig a well and that sounded awful good. I was about 20 feet down and a big rock was in the way and I just went around it and went on down—left it sticking out. I worked for two or three weeks and got down about 50 feet deep and hadn't struck water. One morning I started down in the well and that big rock had come loose and fell all the way to the bottom. I was just lucky it hadn't come loose when I was down there."

That would have been the end of Alex Stewart, wouldn't it?

"If I'd been in there, they would never have knowed what happened to me. They'd never have found me. But I went down and busted up that rock and got it out and kept going."

How many feet could you dig in a day?

"If I was in regular dirt I got along pretty good, several feet a day. But when I hit solid rock I wouldn't make more than a foot a day. I had to drive a steel bit in the rock, and no room to work down there. I'd take powder and fix in the holes I dug, then I'd come out and shoot the rock. Then I'd have to go down and get all them rock out."

Did you have someone to take out the dirt and rock?

"We had a rope and box. Al stayed at the top and took out the mud and rock, and he'd pull me out the same way. Had a crank and a windlass and he'd just turn that crank till he pulled me out. I had a little box to set in, and a coal oil lantern to see with. When I had the box full of rock or mud, I'd give a jerk on the rope and that would ring a little bell on the outside. If I wanted to come out I'd climb in the box and jerk the rope the same way and he'd pull me out.

"After I got below 50 feet it took two men to wind me out. One would go about halfway, and then the other would take over. When I got down to 83 feet the air got so bad I couldn't breath and the walls was so dangerous I said, 'I'm not gonna go no further.' Al got a feller with one of them drilling machines to come and he didn't go but a few feet till he struck water.

"Usually you didn't have to go so deep. I dug a well over here on Blackwater for a Robinette feller and struck water at 32 feet. Then I dug one for Bert Livesey and hit water at 22 feet. It was as dry as this floor and I pulled out a piece of slate, and the water just jumped might near in my face."

After you got water you had to line the well with stone, didn't you?

"Yeah, you had to wall it from the solid rock on up. If you didn't the dirt would come in and soon you wouldn't have no well anymore.

"I dug my wells four feet across (in diameter). When I walled the well up I just left a small opening. Just big enough to get your bucket in. I never used no mortar, just good smooth rock, and when it was finished you didn't have to worry about it falling in. It was there to stay."

Lining the walls of a well is about the same as building a chimney, I suppose. Did you ever build chimneys?

"I've built them from start to finish. Gone out and quarried the stone and hauled them in with a steer or a horse. I helped Pap build one for Jesse Maxie once, and from then on I could build them by myself. Daly Johnson built him a house up here and got me to build the chimney. After I got all my material together, I built it in two days."

What did you use for mortar?

"Just used clay mud. There's a certain kind of yellow clay that's best. I'd put a few ashes in it and that would help to keep it from cracking."

Did you ever build any brick chimneys?

"Yeah. Jim Miser used to make brick close to where I lived. He had him a mill to grind and mix the dirt, and he pulled it with a horse. He'd mold them, then put them in a furnace and burn them for 24 hours. I've used brick he made to build chimneys, and in later years I used other brick.

"The main thing in building a chimney is to get the throat in the fireplace shaped right so it will draw. If you don't shape it right, it'll smoke you right out of the house."

On a Sunday afternoon early one summer a group of Alex's friends gathered to celebrate his 87th birthday. We had planned a party near his actual birth date in January, but weather conditions had caused us to postpone it two or three times. After we'd had the noon meal under the shade trees in his yard, several of us played some old-time tunes on our stringed instruments, much to Alex's delight. He disappeared into the house and soon reappeared with a mouth bow.

He joined us and was soon following along as if we'd always played together. Several people expressed a great deal of interest in this unusual instrument, and Alex promised half the crowd of nearly 100 people that he'd make them a mouth bow. When I next visited him he had a dozen of the finished instruments standing in a corner of his room.

Alex, in my many years of traveling through the Appalachian Mountains talking with thousands of old timers, I've only known two other men who could play the mouth bow. I've tried to learn about its history but have had little success. What can you tell me about it?

"Grandpap Stewart learnt me to make them when I was just small. He was getting out some cedar timber to make some churns one day, and he rived off a big splinter but it was too thin to make a stave. I was setting right on the end of the bench from him, and he picked it up and said, 'Hebbins, I'll make you a purty out of that.' And he made a bow. He went in the house and got a flax and tow string to put on it, and took English resin and rubbed the string and showed me how to play it. I soon caught on. The sound comes from your mouth, and in order to play a tune you've got to work your mouth right. I could shore play back yonder, but I've lost my teeth and I can't play half so good.

"Grandpap said he learned that from the Indians. Said they would set around of a night and play music on their hunting bows. They'd put one end in their mouth and pluck the string and they'd get a tune on them. Sort of like playing the Jew's harp."

Alex these mouth bows look so simple, so easy to make, but I know there's much more involved than meets the eye. I worked all day getting one whittled down to what I thought was the right thickness, the right width, and the right taper towards the ends. The first time I bent it to put the string on, it snapped in two. (Alex laughed hartily.)

"That's the way Bill Henry did. He was up here and he worked and worked on a mouth bow and finally got it done and asked me what did I think of it. I said, 'Well, if it don't break it's all right.' The first time he pulled it back it whopped in two. I knowed it would. He had the grain turned the wrong way. (Alex chuckled again.)

"The first thing to remember is to rive your timber with the grain. If you rive it bastard fashion, it don't sound so good and hit'll break every time. You want the bark side out when you bend it. If you don't bend it with the bark side out, it'll shore break before you get your string on it."

One of Alex's mouth bows was acquired by Carlock Stooksbury who is the writer's cousin and a member of the Museum of Appalachia band. When television personality Archie Campbell heard Carlock play this quaint instrument, he arranged to have him appear twice on the nationally televised program "Hee Haw." Carlock has also appeared on the Nashville Network, and more recently with the band on a program filmed by the British

At his 89th birthday celebration in 1979, Alex plays the mouth bow while being accompanied by the author on the mandolin.

Broadcasting Company. As a result, tens of millions of people have heard the melodious sound of Alex's mouth bows, and several people have expressed an interest in learning to play this instrument which had largely been forgotten by even those few who were at one time familiar with it.

Have you made other instruments?
"I've made several different kinds. The first banjo I made, I

used an old dinner bucket for the rim. I's setting on Pap's porch one day playing that banjo and a feller by the name of Matt Singleton rode up on his horse. They was a young colt following him. He tied the mare and come up on the porch and took hold of that banjo, and buddy he was a banjo picker. He played a few tunes and asked me what I'd take for it.

"I said, 'I don't reckon I want to sell it.'

"He said, 'I'll trade you that colt for the banjo and $5.00' I told him I didn't have no money, and he set there and played another song or two, and then he said, 'I'll take $2.50 and the banjo for the colt, and you can pay me when you get the money.' I said, 'All right, we've made a trade.'

"I raised that horse, and broke him and kept him till he was 10 or 12 years old. I would have kept him longer but he got the fistelow (fistula). That's a bad horse disease and it's hard to cure."

Did you make more banjos?

"Oh, yeah. I don't know how many I made. I'd generally get about $5.00 for one if it was any account. The best one I ever made was when I used a cat hide for the head. Grandpap Stewart told me cat hides was the best for making banjo heads, and Mother had a great big old cat. One day I catched her gone and I killed that cat, skinned him and tanned his hide. That was the best banjo I ever made and I got $8.00 for it. Mama missed her cat, and she finally found out what I'd done. She liked to have made a cat out of me. I give her half of what I'd got to keep her from quarreling so. I's about 12 or 13 years old at the time."

How did you know how to space the frets?

"I just kept trying till I found out where they were supposed to go. Then I'd take a saw, cut a little gash across the neck, and take little pieces of tin to make the frets by putting them in those gashes."

I heard you play the Jew's harp the other day and you really sounded good.

"I used to couldn't be beat on the Jew's harp, I don't care who it was. I wasn't ashamed nor afraid to play before anybody."

I never heard of anyone making their own Jew's harp. First, the making of a Jew's harp required very special blacksmithing skills, and secondly, the instruments have been available at very cheap prices in country stores since colonial times. I asked Alex if he made his own Jew's harp, expecting a negative answer.

"Yeah, I've made them. You give me the right kind of wire and I can make one yet. It's got to be steel, but there's different kinds of steel. I want the hard kind to make a good one. I've put two or three tongues in Jew's harps for the Lovell feller down there. What's his first name? I can't think of it; it's a funny name." (Reginald)

122

How many different kinds of instruments do you play?

"Oh, I got to where I could play the banjo pretty good, and like I said I never seen nobody that could beat me playing the Jew's harp when I had my teeth. Of course I played the mouth bow and done purty well on the French harp. I learned to start a few tunes on the fiddle, but I never had one of my own. Pap had one and he was a purty good hand to fiddle."

Alex, some people think the dulcimer was common throughout this region, but 90% of the old people have never heard of it until recently. I know you're familiar with them, and that you've made some. Tell me about the dulcimer.

"I went to see an old charm doctor once to have her to take some warts off my hand, and she was setting there playing one of them dulcimers and that was the first one I ever heard. It wasn't long before I made one myself. Made it out of walnut, and I give it to an old woman from over in Virginia who come and helped Mama wash once in a while. She could pick one, I'm telling you."

I never realized you'd made so many kinds of musical instruments. Is there anything else in the music line that you've made?

"I made me a drum one time, out of sheep's hide. I tanned a big sheep's hide, took all the wool off and worked it till it was good and soft. I made the rim from rived-out white oak, and I made my brackets out of heavy wire, about the size of an eight-penny nail. Made me two sticks to beat it with, you know. I took pains with them, and they looked better than the drum did."

Where did you ever get the idea of making a drum? Had you seen one before?

"I saw one, one time. There was an old feller by the name of McGhee, and he had one. He'd travel around and put on a show, and he'd charge 10¢ for you to listen to him. He come up here on the ridge one night to an old log house where nobody lived and had his show there. I went to hear him, and oh, he beat that drum."

When you mentioned making Jew's harps a while ago, it reminded me of your blacksmithing. You said that you learned that from your grandfather?

"He learned me the different kinds of steel and iron and how to work and temper them. It wasn't long before I was making about anything I needed. I'd gather up pieces of scrap metal anywhere I could find them and make hinges, fish gigs, horse shoes, plow points, and such as that. I'd upset (sharpen) axes, and take augers that was wore out and draw them out to make new ones out of them."

How were you able to get your iron and steel hot enough to work? You didn't have coal or charcoal then did you?

"We made our own charcoal. I've made many a batch of charcoal myself."

123

Historically, the making of charcoal was a rather tedious process. The wood to be burned was stacked vertically and covered with dirt and mud forming a type of kiln that permitted very little air to enter. This allowed the wood to char, but deprived it of the oxygen needed to sustain an open flame. I would have been surprised if the people on Newman's Ridge had employed such a sophisticated method of making charcoal, and sure enough, Alex knew another, simpler method.

"Dead chestnut made the best charcoal. I cut the tree in blocks about three feet long and then split them into pieces about the size of your arm. I stacked them up crossways and set it afire and let it burn till it got red coals on it. When them coals started cracking open I'd water it down. Put the fire out and what you've got is charcoal. You could use that in your forge and it would shore put out the heat. It wouldn't get quite as hot as coal, but it worked all right."

You mentioned making plow points. Did you also make plows?

"Oh, shucks. I couldn't tell you how many plows I've made if my life depended on it. I've got a plow up here now that I made and used for 64 years. I took care of it, kept it in the dry when I wasn't using it, and it's still a good plow. About everybody on this creek has borrowed that bull tongue plow at one time or another to lay off their corn ground with."

Where did you learn plow making?

"Well, Pap followed making them but he never made one to suit me. I never could get his plows to plow right. He'd put the foot in the beam solid, and it would either be too straight or too crooked.

"I went out in the woods and cut me a good white oak and split out the red part of it and made my plow. I put the foot through the beam, but instead of making it fit solid, I left a quarter inch play on each side of the foot, and I fixed it so it could be adjusted. Everybody that plowed with that plow, just about, wanted me to make them one. I commenced making plows and I don't know how many I did make.

"My son-in-law, Marsh Roberts, come down here one summer and we made 14 plows. We got $12.00 a piece for them and I give him half the money for helping.

"I guaranteed my plows. I'd tell them if it didn't plow to suit them to bring it back and I'd give them their money, but I never did have to take one back."

You made every part of it?

"I made everything about it. I never went to the store and bought anything. For my handles I'd go to the woods and get two small hickories. I'd boil them in water and bend them to get the

right crook, and when they cooled, that crook would stay. They're worth a heap more than store-bought handles."

Did you ever make a plow for a person to pull?

"Yes, sir. The first man-plow ever I made was for a feller over here on Mulberry, named Thompson. He didn't have a mule or ox to work, and he had to pull that plow hisself. His wife would guide it, least that's what he said. He may have had her pulling it for all I know. A lot of women did that. Back in old times, when the colored folks was in bondage, they would pull the plows. A man-plow is smaller and lighter than a mule plow. I've made a few of them."

Alex, most of the men of the region never learned to do that which was considered to be women's work, such as spinning, weaving, sewing, quilting and cooking. If, out of necessity, they did learn any of these crafts, I'm sure they kept it hidden from anyone outside their immediate family. But you learned to do all these things. Was it customary for the men and boys to do this kind of work?

"No! I's the only feller that I knowed that took up such as that. Anything I ever saw anybody else do, I wanted to learn myself. I learned to knit from watching Mama. When I's a very small boy I'd set and hold a pine torch for her to knit till late at night. I watched how she done it and when she'd lay her needles down to do something else, I'd grab them up and go to knitting.

"I got to where I could knit a stocking or a sock as good as she could. I knowed how many stitches to put on each needle to get a sock. I believe it was 80 for a man's. It depends on the size you want your sock to be."

I understand you're a good spinner.

"I've spun many a yard of thread. Mama learnt me that too. I used to be able to spin just about as good as any woman, but I don't guess that I'd make much of a hand at it now. Did I ever tell you about being down in Gatlinburg when that woman was demonstrating how to spin cotton?"

She didn't think you could spin?

"No. She didn't think I had sense enough to know straight up. She was so independent talking that I knowed she thought they wasn't nothing to me. I asked her if she cared if I tried spinning on her wheel. She couldn't half spin—just had the wheel barely turning. She said, 'What do you know about spinning?' (Alex mimicked her in a high pitched, derisive voice.) I said, 'Well, lady if I was to damage your wheel I'd shore fix it, or pay you for it.' I started on off and she grabbed my by the shoulder, and said 'you can try it if you'll be careful with it.'

"Well, I took hold of that wheel and give it a great big whirl, and I knowed just how big a spin it would take to use up the

125

cotton she had there. I just walked back with that cotton in my hand and when the wheel stopped all the cotton was spun into thread. It was the finest thread you ever saw. Hers was big old puffy thread that you couldn't have got in a darning needle.

"She come running over to me and said, 'Where in the world did you learn to spin like that?' She said, 'Why, law, you can thread any kind of needle with that. Come here and show me how you do that.' And I said, 'No, I just wanted to show you that I knowed what a spinning wheel was.' And I just went on off."

You also learned to weave cloth?

"Oh, yes. My grandmother Livesey had an old maid sister that lived with her, named Toad. Aunt Toad. She'd set at that old loom and weave day in and day out. I'd watch her, and whenever she got up for something she'd let me weave. She called me 'Beanwacker,' and she'd say 'Beanwacker, you're gonna make a weaver.' She encouraged me and helped me, and that's where I learned to weave. I can see them filling their loom just as well as if they's setting right over there. It took them all day to fill a loom. That was tedious work."

I suppose you learned every step in making clothes, from the growing of cotton and flax to the finished product.

"Yeah, I've raised cotton and flax both. It takes more time to get flax ready for use. You plant it in rows in the spring, and of course you have to cultivate it all summer and keep the weeds out. When it gets ripe in late summer or early fall you pull it up, roots and all, and lay it on the ground to rot. You let it lay there until the outside part of the stalk rots off. Then you put it on a flax break and break it up good. Them little fibers inside won't break, but you've got to get all the hull off. You've got to comb it with a flax hackle and keep working it to where it will make good linen."

Many of the old coverlets and dresses were very colorful. What did you use for the dyes?

"We'd use roots, bark, leaves... Hickory bark and alum makes the purtiest yellow cloth you ever saw. Back then if a woman had a bonnet or an apron dyed with hickory bark and alum she was flying. It wouldn't fade. To make a red dye we'd take the bark of red oak, white oak and chestnut oak and mix it with alum. Walnut root will make brown and catnip will make green. There was a lot of other things we'd use to color the yarn: paw paw root, poke berries, yellow poplar root...

"I've gone out and dug roots for Mama many a day so she could dye her thread. We'd put it in a pot and boil it, then we'd put the yarn in. You could dye one hank one color and another hank another color and when you wove it you would have striped cloth. The women would make their undercoats (petticoats) out of that purty striped cloth and they'd pull up their dresses so you could see their undercoats."

Alex, all my life I've heard the expression, "As Blue As Indigo." Are you familiar with indigo, and was it used as a dye?

"We used to grow indigo. It looked something like a pea growing. It was a vinelike plant that had narrow, keen leaves. I don't remember using it as a dye, but we'd put a little in our fruit, and that would give it a good taste."

In enumerating the various arts, crafts, vocations, and avocations in which Alex engaged at one time or another, we should not overlook quilting. But because an extensive interview with Alex on that subject was included in my book, *A People and Their Quilts,* it will not be pursued here.

During the many visits I've paid Alex over the past 25 years, I've never known him to have his house locked, and I soon learned that one was not expected to knock before entering. For a long time I entered through the front door, but in later years he was almost always in the back of the house, and I started using the back door instead. This necessitated coming through an enclosed back porch. While passing through this enclosure one day I noticed an interesting, well-made broom, shaped into proper sweeping form from years of use. I assumed Alex had made it, and I carried it into his room to ask him about it.

Alex, Mutt tells me that you made this broom. Is this something you've been doing for a long time?

"Everybody back then raised broomcorn and made their own brooms. I learned to make brooms when I was a boy, helping Grandma Stewart.

"There was an old preacher over here on Blackwater by the name of Lambert. His wife raised a lot of broomcorn but she couldn't tie (make) brooms. She'd wrap a string around the stalks, but she couldn't make a broom that was any account. I was passing there one day and she said, 'They tell me you can tie a broom that's worth something.' Well, I said, 'You can sweep with them.' She said, 'Will you tie me one?'

"Well, hit took me about two hours to fix and tie it right, trim the stalks and everything. You've got to keep all the short sweeps to theirselves, and the long ones to theirselves to make a broom look right and sweep right. I graded them out according to size and tied four brooms. She said, 'Now how much do I owe you?'

"Well, I said, 'I get 10¢ a broom.' 'Why, Lord,' she said, 'You got to have more'n that,' and she give me $1.00 for the four.

"After that somebody would send word ever once in a while for me to come and tie some brooms for them. Here in late years they got to selling store bought brooms. But they're not near as good as the old fashion brooms, if you made them right."

Was broomcorn hard to raise?

"When you're growing broomcorn you've got to break the tops

over before it gets too ripe. If you wait till it gets red-looking, then the broom straw is too brittle and your broom won't last. Break it over when its green and tough and it'll last twice as long. Now, you take this broom, I've had it for several years and it's half wore out, but hit will still out-last a store-bought broom."

In addition to straw brooms, Alex also made brooms from sedge grass and from hickory saplings. The latter is called a scrub broom because it was commonly used to scrub the log, or puncheon, floors in the early log house. I'd heard about these pioneer scrub brooms, but the first one I ever saw was one Alex had made. The most practical, yet simple, feature about this type broom is that the sweeping "straws" are shaved from the sapling and remain attached to the handle. After I expressed an interest in this innovative item from the past, Alex made several, giving them, free of charge to anyone who expressed an interest in them. Eventually there was such a demand he began to charge $1.00 for them.

During our conversations, Alex frequently mentioned making trips to the mill to have his corn ground. Millstones have been used for grinding grain into flour and meal for thousands of years. The basic principal of stonegrinding has remained essentially the same through the years. One stone, the bedstone, is fixed in a horizontal position. The top stone, or runner, is suspended over it by means of a vertical shaft. When powered, the shaft turns the runner stone, and the grain is crushed between the two.

A most important element in this operation is a series of grooves cut into the face of each of the two stones. This allows the meal, or flour, to be more properly ground, but the stones eventually wear, leaving the grooves shallow and ineffective.

The deepening of these furrows is accomplished by carefully pecking them with a specially tempered steel hammer. The stones, often called buhrs, or buhrstones, are made from a siliceous rock and are extremely hard—some compare them to a diamond. Because of this hardness, the deepening of these grooves is extremely slow and laborious. The stroke must be hard enough to cut the stone, but if the stroke is too hard, it may crack or chip the entire stone, rendering it useless. It was a task requiring special skill, and only a very few people in any community could be trusted to do the job.

We've talked about the old water mills that ground corn and wheat. Were you ever involved in sharpening the mill stones?

"Yes, sir, I've sharpened millrocks. You've got to know what you're doing, and its hard work. I've set a half a day at a time and pecked them rocks. If you're not careful you'll get them grooves too wide or too deep and they won't grind right. They have to be just right, or they'll ruin your meal."

Almost every time Alex finished a story, he'd reach for his tobacco twist, shaving off slivers of the brown, twisted leaves to fill his pipe. All my life, I'd heard of a "plug" of tobacco, a term used to describe any pressed, store-bought chewing tobacco. I had no idea what the origin of the term was, but Alex soon enlightened me.

"You take a green hickory stick like you'd burn in the fireplace—and about six inches in diameter. Take a two inch auger and bore in the end of the log just as far down as the auger will go—about a foot and a half."

You bore straight into the heart?

"Right in the heart. You take your 'backer and stem the leaves, and take some brown sugar, dissolve it, and sprinkle it around on the leaves. Then you take a couple of leaves to wrap around the ones you've sprinkled the sugar on. You don't want no sugar on the wrapping leaves. They'd be so sticky that you couldn't twist them with your hands. You twist them up and tamp them down in that hole. It will fool you at the 'backer you can put in there. You can get two or three pounds in a hole like that.

"You drive a wood plug in that hole and take and put that log in the fire and leave it there till the bark is all burnt off. Then you take it out, and if its afire too bad, just take a little water and dampen it. Throw it out in the yard and let it lay there as long as you want to, then split the wood open and that plug of 'backer will be as round and solid as a stick of wood. And that's the best t'backer you ever had in your life."

Is that for chewing mostly?

"That's chewing t'backer, yeah. Oh, hit's a heap harder than this bought t'backer. It would be so hard you could knock a bull down with it. You couldn't bite it off. You'd have to take your knife to cut you a chaw.

"You see, green hickory has a maple flavor to it, and that brown sugar just about matches it. By putting it in the log and letting it get hot and then letting it dry out—it gives it a flavor. That's how they got started calling chewing t'backer plug t'backer, because of that wood plug they used to stop up the hole."

For three quarters of a century or so, tobacco has been the number one cash crop in much of our region. Did people raise it to sell back when you were a boy?

"No, they never thought about selling it on the market or anywhere like that. Oh, if you run out you might go to one of the neighbors and buy some, but they wasn't no market for it."

In discussing tobacco and its uses Alex got off on the subject of old women smoking pipes, and this led to a discussion on yet another Alex Stewart craft—pipe making.

"Yeah, my grandma and all them old women smoked pipes. Law, I've lit my granny's pipe many and many a time for her. Just dipped it in the fire—we didn't have no matches. I used to have some of their old pipes and I give them away. I wished I'd kept them now.

"You make a mold first, and then make some mud up just so stiff. You fill the mold plumb full of mud and tamp it in good and solid. There's some clay over here in that (creek) bottom that will make pipes, and bricks too. They used to be an old brick-kiln over there. You can cut little notches around down in your mold if you want to, and make your pipe look purty. When you get the mold full of mud, just take a little wooden pin and go right down in the center. That makes the bowl of your pipe. You can open up your mold and let it dry a while, so you won't dent it when you burn it. Then put it in the fire and cover it up with ashes; let it burn till it gets right. If you want a slick glaze, put you a little table salt on it.

"The women wore old homemade linsey dresses. Grandma had a great long pocket on one of her petticoats, and there's where she'd keep her pipe and her t'backer. Law, I've seed her many a time pull up her dress, it come down to her shoe tops, and reach in that old petticoat pocket and take out her pipe and 'backer."

Why didn't she have the pocket on the outside of her dress?

"Well, if she had it on the outside people would see it, and then too she'd be getting the pocket caught in things."

I understand that tobacco came from the Indians?

"Yeah, they got it off the Indians, and corn too. Grandpap said the Indians raised corn, cabbage and t'backer. He told me that when the Lord made cabbage, the devil come along and seed it and said, 'I can make that too!' Grandpap said he (the devil) went out and claimed he made cabbage, and when it come up it was tobacco." (Alex laughed.)

Alex, I'm about to run out of trades and crafts to ask you about. What about barbering—did you ever do that?

(He chuckles.)

"I've cut hair all day long, without stopping to eat a bite. People found out I could cut hair and they'd come from all around. Didn't have no clippers back then. I just used a pair of scissors and a comb."

How much did you charge for cutting hair?

"Oh, I never did charge them nothing. Some folks would give me a nickel, if they had it. A lot of folks didn't have a nickel."

I don't suppose there were any barber shops?

"We never heard of such a thing. The first barber shop ever I seed was down in Sneedville in an old log house. Back when I was growing up people didn't cut their hair like they do now. Men would let their hair grow down to their shoulders, and every once

in a while they'd reach around and whack a little off. The women wouldn't have their hair cut at all."

Alex, when I was a child I heard stories about crock haircuts. The old people, supposedly, would take a crock and place it upside down over the head, and cut all the hair that wasn't covered. I always assumed those stories were told as jokes. Is there any truth in such tales?

"Yeah I've heard of them doing that. Now my mother had a big wood ring, she called it, that she used to cut hair with. She'd set that on a boy's head, and she'd cut all the hair that stuck out. See, by using that, she could get it cut even all the way around.

"Sam Munsey, he was a preacher over here, went off somewhere and seed that men was having their hair cut off short, like they do now. Well, I'd been trimming the edges of his hair once in a while, and he put in for me to cut it the new way, and finally I did. It changed him so much people didn't know him. He didn't favor hisself. People laughed at him, and it was a sight to hear them talk. They said he was the funniest looking feller that they ever seed.

"But it wasn't long before other folks started having their hair cut like that, and that's when I had so much barbering to do. I was living over on Ally Mullins place at the time. She was a widow woman and had five grown girls living with her, and I was going by there one day and them girls stopped me. They wanted me to cut their hair. They'd been off somewhere and seen women with their hair cut. I wouldn't agree till Miz Mullins approved. They kept on after her and finally she said: 'If nothing else will do them, go on and cut it.'

"I set them down and law their hair come way down below their waists. I took and whacked it off and laid it in long straight piles on the floor, and I swear it looked right pitiful.

"Everybody just went on about how good them girls looked, and every woman, might near it, up and down that creek started coming to have me cut their hair."

Didn't this interfere with your other work?

"Well, they'd generally come on Sundays. We always had our meetings (church service) on Saturday."

The Hancock County area is the only place I knew of where the practic of Saturday church service was, and is, followed. Although I made numerous inquiries, I was never able to learn anything about the derivation of this custom.

As Alex became older and less able to work outdoors, he stayed inside and started making smaller items. Every time I visited him he had some new creations. For a few weeks he got into making

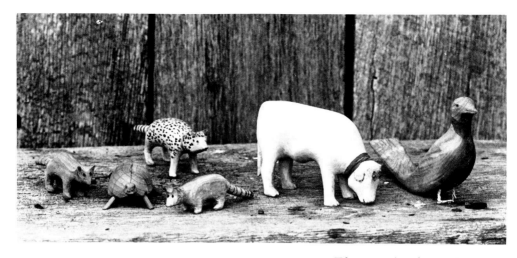

These animal carvings are among those Alex completed after he was well into his nineties. (From the Museum of Appalachia Collection—photo by Robin Hood)

Most of Alex's evenings were spent in such non-utilitarian pursuits as carving wooden chains or such unlikely endeavors as decoratively carving the handle of his fly swat. (From the Museum of Appalachia Collection—photo by Robin Hood)

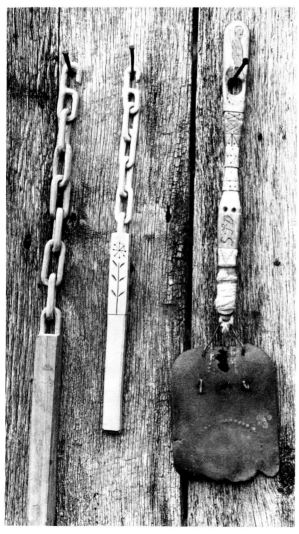

The bottom of this buckeye bowl bear's Alex's signature and his symbolic method of connotating that it was "hand made". (From the Museum of Appalachia Collection—photo by Robin Hood)

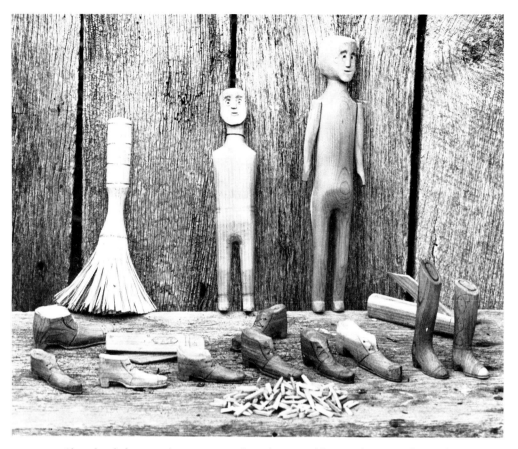

Alex doubtless made more wooden shoes and boots than anything else. At left is a miniature scrub broom, made from a single piece of wood. The primitive type wooden dolls and the pocket knives were also among his favorite subjects. The pile of wooden objects in the foreground are wooden pegs, used for attaching the soles of shoes. (From the Museum of Appalachia Collection—photo by Robin Hood)

puzzles. He made several types and I was curious as to where he'd learned how to make them.

"I recollect the first puzzle ever I seed. An old feller by the name of Mel Collins had it. I picked it up and looked at it and he showed me how it worked. I's just a little feller, but I went home and made me one like it from my memory. That's the way I learned to make all these puzzles."

Many of Alex's artistic accomplishments were directly connected to his memory of childhood experiences. When I visited him one day in November during his 92nd year, I discovered a different type wood carving that he had just finished. It depicted three hounds barking up a tree which held four raccoons. The dogs were straining to reach as high up the tree as they could, and the coons looked anxious. I was genuinely impressed and told

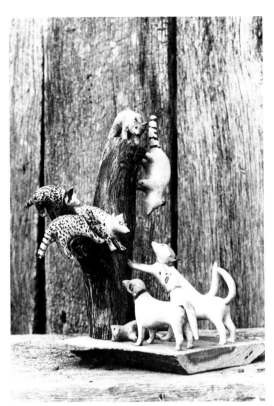

When Alex, in his 92nd year, finished this carving, for me he wrote: "Dear John Rice, the dogs have already killed one of the 'coons and if you don't hurry and get up here, them hounds will kill the rest of them." Note the "dead" raccoon at the base of the tree. (Photo by Robin Hood)

him I'd like to buy one. He'd already promised this one to someone, but said he would make me another.

In a few weeks I got a letter from him saying he'd finished a carving which had three coons in a tree, and a fourth lying on the ground among the dogs. The last part of the letter is a classic example of Alex's humor. It read: "John Rice, the dogs have already killed one of the coons, and if you don't hurry and get here them hounds will kill the rest of them."

People knowledgeable about American folk art are most impressed by this interesting creation, finding it hard to believe that this fine specimen wasn't the result of many years of practice. As indicated earlier, this work involving the 'Coons and the hounds suddenly appeared on the scene, and I was curious as to why Alex chose that particular subject. He didn't know, he said. The idea just came to him and he started whittling. But in a few minutes he told me about a 'coon hunt he'd experienced when he was a boy, making that long ago adventure come to life with his vivid description.

The expertly carved raccoons sat beside Alex as he talked, and the animals looked disturbed and full of motion. I told him how much I liked it, and he sat in silence for a moment. Then he said, as though talking to himself: "They was a time when I don't believe anybody had handier hands than me—but they're not here now."

Alex, The Doctor

"I've Cured People When The Regular Doctors Failed."

One day, not long after I first met him, Alex began discussing herbs and herbal remedies, and I was amazed at his vast knowledge of the subject. I hadn't realized, at the time, that for many years he was recognized in his community as an herb doctor.

"Pshaw, son, I took up doctoring and followed it for a long time. They's plenty of people around here that'll tell you I cured them when the regular doctors failed. They's a plant for every disease. If we just had sense enough to find the right ones, we'd never have to go to a doctor. Of course you need to know when to get your herbs. If you don't get them at the right time they ain't no account much. Now, the Indians wouldn't gather no kind of herb unless it was in full bloom. Said it had more strength then.

"Everything is put here for some purpose, and if people don't use it, it's their own fault. Now, you take the medicines that comes out today, I'd say two-thirds of them is just to get your money; they ain't no help to you.

"Back then, people didn't go off (to a doctor). They went to the woods and got their medicine and made it, and they wasn't near as much sickness and disease as they is today. They wasn't accused of heart trouble and things like that.

"Now, my medicine would get that syphilis and clap clean out of your system. Them shots they give you now just stops it, and it'll show up in your children. I's up there on the ridge a grubbing (digging out small stumps) one time. I's by myself. I heard something and looked around and there was the sheriff. He come on up and we talked awhile and I was expecting him to say any time that he was there to raid me, because I had a still not far away.

"But after awhile he said, 'Well, I'll just tell you my business. I come up here to see if I could get you to make some medicine.' He says, 'They's a feller that's got the bad disease, and he's sorta ashamed and asked me to come and see if you'd make him some medicine.'

"I says to myself, 'Now, I wonder who that other feller is?' And the sheriff kept a setting there talking and finally I says to myself, 'Oh, oh, I know who that feller is that's got the bad disease, and I'm a setting here talking to him right now!'

"Well,' I said, 'You come around tomorrow late. Hit'll take might nigh all day to gather in all the herbs and things, and steam them down.'

"I started in on it early the next morning, gathering my stuff, and worked on it pert near all day and just about the time I got it strained out, here he come. Now, I said, 'You tell that feller to drink a pint of this every day till it's gone. Eight days it'll last him.'

"Well, in three days here the sheriff come back, wanting another gallon for that "other" feller. I says, 'The devil you say! That was supposed to have lasted him a week.'

"'Well,' he said, 'I think his old lady's got it too, and they've both been a drinking it.' (Alex laughed.)

"'Well,' I said, 'Alright, but I think I know who that feller is.'

"He sorta grinned, and he says, 'Fer God's sake, don't never name it to nobody!'" (Alex laughed heartily.)

Where did you learn to be an herb doctor?

"Well, a lot of my people followed making medicine. My uncle was a herb doctor and he mostly learnt it to me. He cured diseases that none of the regular doctors could cure. He could cure syphilis when all others failed.

"They's a woman that lived over here on Clinch River, and her family was well off. Her daddy had a big farm and a lot of stock. They was big shots. She was the proudest woman ever I seed in my life. She wouldn't hardly speak to a poor person.

"Well, she got the bad ailment and she'd slip off to the doctors, but it just got worse and worse till her face got in a solid sore. Why, you couldn't see no skin a'tall. She was about to die, and she come to my Uncle Witt's. That was Ellis's daddy. She had heard about him being such a good doctor. Old Dr. Mitchell down here had done give up on her—said she had done gone too far. She'd gone to Dr. Miller over here in Rogersville too, but he couldn't help her.

"It was beneath her to come see my uncle because they was so prosperous and Uncle Witt was just living from hand to mouth, but she was in such bad shape she come anyway. You could tell that she thought he was beneath her.

"I was at Uncle Witt's setting on the porch and here she come, riding a horse. The porch was pretty high and we was setting there and she come right up to the side of it. Uncle Witt never spoke nor told her to get down nor nothing. She commenced

talking to him, and you could tell he didn't like her for she was s'mean and hateful.

"She said, 'I understand you make some good medicine, some good bitters.'

"He said, 'Well, I've made some.'

"'Well,' she said, 'I come to see if you'd made me some. I've got exemey (eczema) and the doctors can't cure it.' She pretended like it wasn't nothing but exemey.

"'By-ginneys,' he said, 'I don't guess they can.'

"Well, she kept on talking to him, and he was out of corn that year. Nobody had any corn to sell that year, and Uncle Witt didn't have no money even if they'd been corn for sale. He was just about at starvation.

"She said, 'Now, I ain't got nothing to pay you right now, but if you'll make me that medicine I can pay you in corn.'

"Well, he set there a few minutes, and he said later that it looked like his only chance to get bread to feed his family. He was up against it. He said, 'Well, by-ginneys, if you'll let me have some corn, I'll make you some medicine.'

"I went out to help him gather the herbs. We first got the roots of hemp. He called it 'east and west.' He cut them roots in little short pieces and they was as black as they could be. The same way with mayapple roots. He got the roots of black haw, paw-paw, sarsaparilla, elecampane, polk root, elder root, and bittersweet. It took nine herbs beside the barks. Then he got some wahoo bark and some red dogwood bark, and then some hemlock leaves, and he put a handful of that in it. Then he added some wild comfort and he said, 'It don't matter how much of that you use for it's not poison. If you want you can put in a little mountain tea and that'll flavor it and keep it from tasting so bad.'

"He knew how much of each one to put in. Just guessing at it could help once in a while, I guess, but it would be an accident. When he got it all together it was a great big kettle full of herbs. He put in three gallons of water and built a fire under it. He didn't boil it, just let it get hot enough that the steam come off, and he steamed it down to one gallon. It took about all day to do that.

"Well, he took that to her, and told her how to use it. He said, 'Now, you don't eat no fat meat, don't be on no horses, and let the men alone for six weeks or longer.'

"She said, 'Oh, I don't have nothing to do with men nohow!' (Alex chuckled.) Uncle Witt knowed that was a lie.

"Well, she took that gallon of medicine and that cured her. Her daddy was so pleased he let Uncle Witt have enough corn to feed his family all summer and wouldn't charge him nothing for it. After that she was the best friend to Uncle Witt you ever saw. She'd go to see him and stay all day—just visited with him."

Alex described several instances where he cured the "bad" disease, but one was especially poignant. It tells much about the pathetic, desperate conditions of that era, and that area, and the misery which venereal disease wrought before the days of penicillin and other miracle medicines.

"Now, they's a feller right close by, and he caught it and give it to his wife, and she was in a family way. He was so bad that he had to go on two canes. I was way up yonder on top of that ridge one day plowing corn. All of a sudden the mule stopped and I knowed she'd seen something. I looked down the ridge and here come that poor feller hobbling along on them canes. When he got up close, he said, 'I come to see if I could get you to make me some medicine.'

"He set down and commenced talking, and he told me he'd spent every cent he had trying to get cured, and that none of the doctors had done him any good. He said, 'I've gone and had shots, and by the next day I can't tell that I've ever took them.'

"Them doctors had doctored him till he'd run out of money and then they dropped him. 'Well,' I says, 'Don't get out of heart with it. I'll make you some medicine, and if you take it like you ought to, hit'll cure you, son.'

"He said, 'I've got a brass bedstead down at the house that I paid $25.00 for, and that's the only thing I've got in this world that's worth anything. I'll give you that bed for the medicine.'

"He just had two bedsteads, and he had a wife and three children. I said to myself, I don't want nothing for the medicine. But I didn't say anything to him. I went and made him some medicine, and took it to him and told him how to take it. I said, 'Now, if it's too stout on your bowels, just cut down a little on it till your bowels will move about once a day.'

"While his wife was taking it, the baby was born, and it had no eyes. It just lived a little while. After they both got well, he come up here and wanted me to go with him to get that brass bedstead. I said, 'You just let that bedstead set where it's at. If you want to come up here and help me work for the time I took off from plowing, that'll be pay enough.' He come up and helped me work for one day. I oughta charged him more, but I felt sorry for him. I felt more sorry for his wife, for he had no business going out and catching it in the first place."

In almost any society, no matter how primitive, there develops specialization in crafts, vocations, and professions. Even the Old Testament talks of the scribes, the herdsmen, and so forth. But specialization was most difficult in the isolated frontier regions of America, mainly because of the sparce and widely scattered

population. There were simply not enough people in most areas to warrant a full time blacksmith, cobbler, tanner, miller, etc. It became necessary for every family to make their own clothing, do their own blacksmithing, tan their own leather, make their furniture, and perform a hundred other tasks, including doctoring.

It's interesting to note that some specialization, starting hundreds of years ago in Europe, had made no advancement whatever on Newman's Ridge. The story Alex told me about Nal Mullins specializing in the treatment of scrofula is a good example.

"Old Nal Mullins was her name. She could lay her hand on you and say a sort of ceremony, and that would cure the scrofula. She was a good looking woman but she was rough too. She had an awful, terrible big nose.

"Now, Uncle George had a girl, her name was Mary, that had scrofula. She was all swelled up inunder the jaw. A heap of people used to have that. Hit was a great growth under your neck and it looked like it would have choked you to death. You don't hear tell of it any more. Uncle George come by one day to get me to go over there on Blackwater to see old Nal.

"We took the girl over there, she's about five years old, and George asked Nal could she do anything for that.

"She said to me and Uncle George, 'Now don't pay no attention to me. Look over there toward the ridge.' She put her hand on the girl and said a few words and directly she had her doctored.

"Uncle George took Mary back over there in three weeks and that scrofula was nearly gone, and when he took her the third time, it was plum gone. Now, you wouldn't believe what I'm a telling you unless you could see it. It just looked like that thing was going to choke her to death."

Did the charm doctors charge anything?

"No. No, I heard them say that they wasn't allowed to charge, or the charm wouldn't work. Now, if you wanted to give them something, that was all right."

Well, honesty compells me to admit I'd never heard of scrofula, and I wasn't at all sure that anybody except Alex and his neighbors on Newman's Ridge had heard of such a disease. But it didn't take much research to find that scrofula is a form of tuberculosis which usually affects the lymph glands in the neck, most commonly in children, causing extensive swelling just as Alex said. What was most intriguing was the fact that scrofula was once known in England as "the Kings evil" since it was commonly believed that it could be cured by the King if he merely

touched the victim. The practice apparently started with King Edward the Confessor, who reigned in the 11th Century. It is little less than incredible that Nal Mullins, in her one room, dirt-floored log house on Blackwater Creek, would employ the same method of curing scrofula as did this British King nine hundred years before. It's reasonable to assume that Nal never heard of King Edward the Confessor, or even of England. But while the practice of healing this disease by the touch or charm method had largely disappeared in the old country many years before, it had lived on in this section of the Southern Appalachian mountains.

While Alex seemed to believe in her ability to heal, he did manifest some doubts. The following comments are illustrative.

"She could cure the thrush too. I've took two or three of my children over there when they's babies and she'd blow in their mouths to cure them. But I got to studying about that. It looked to me like that would be dangerous. Say she got some bad disease and blowed her breath in your mouth two or three times. You're liable to get it. I quit taking them over there."

Back to *your* doctoring; what other kinds of illness did you treat?

"Oh, a heap of things. They was a boy who lived up the valley and he took pneumonia and was just about dead. He was laying there breathing as hard as he could. Couldn't hold his eyes open. Dr. Trent came and looked at him and never gave him a dose of medicine. He said, 'They's nothing I can do for him.' He just turned around and walked out.

"It just looked like it was impossible for that boy to live. When he did breathe, you could hear him from here down to the road yonder. He'd just get his breath every two or three minutes. Well, I said, 'It can't hurt him. I'm gonna bathe him in liquor.'

"I just pulled that cover down, poured that whiskey out and commenced right here at his chest rubbing it on him. I guess I used right at a pint on him. And it wasn't but a few minutes till he quit breathing thataway. By night, he was 50% better, and by the next day he was feeling pretty good.

"Coal oil, turpentine and onion is the best thing for pneumonia there is. You take and put some onions in your fireplace and cover them with hot coals for a little while. Let them get real soft and mushy and squeeze that juice out on a piece of flannel. Put that on the person's chest, and then wet it good with coal oil and turpentine. You can put a little mutton tallow on and that makes a kind of salve. Cover that over with another piece of flannel, and I'll say that in 30 minutes they'll go to breathing better."

Whether or not this and other remedies worked as well as Alex thought they did, is debatable. The fact that the patient had

confidence in them may have been as beneficial as the medicine itself. Wilma Dykeman, a close friend, a noted writer, and the official Tennessee historian, comments on this point.

"Much of the medical treatment in our mountains was practiced by those who knew as much about plants as they did about people. The herb doctors knew nature and human nature and brought the two together in ways that often effectively healed the illness of friends and neighbors.

"It has been said that 'in the main, the medicine of the mountains drew its power from the most ancient and basic magic of the physician's art, the magic of the mind. It worked because the patient thought it would work.'

"They used to be a heap of people when I's a boy who had what they called the scald head. Did you ever hear tell of the scald head? I learnt how to cure it, but by the time I got to doctoring you never heard tell of it."

The scald head? I don't think I've heard of it. What exactly is it?

"It's a mean disease. Your whole head gets all infected. There was an old lady that lived out there on the ridge that took the scald head, and she lost every hair on her head. She got a red handkerchief and wore it around her head all the time. Never took it off. I catched her with it off a time or two, and it might near killed her. She had a gang of children and they every one had the scald head. Some of them got cured and some never did.

"Old Bill Mason out here, he had the scald head, and he lost all of his hair. He was an awful fine feller. He got him a wig made up to wear and it was red. He got old and he still wore that old red wig and he was the funniest looking thing ever you seen.

"Then there was Paul Croft. He's a plum good man, and he lost all of his hair that way. He wore a hat all the time. He'd go to church and set way in the back and never pull his hat off. He's ashamed.

"Oh, I don't know at the people that had the scald head." Alex paused to fill and light his pipe, and was silent while he puffed. Finally he said, "I ain't heard of no scald head in, I don't guess, 50 years."

What was the cure for scald head?

"You could go up here on the ridge and cut a gash in a pine tree and go back in a few days and have you a quart of rossum (resin). You boil that down with beeswax and beef taller and a little camphor and turpentine, and make you a grease or salve. Hit'll cure any kind of sore, might near it. You make a plaster out of that and put on your head and tie it up. Then when you take it off, hit'll take all the hair off with it, roots and all, and that's the only way to get shed of it. Your hair never grows back; you'll be bald as

a pumpkin till the day you die. Your whole head will be slick as a peeled onion."

An old family physician's book described the scald head pretty much the same way Alex described it. This source indicated it was caused by fungi around the roots of the hair, and that it attacked people who had no regard for cleanliness. Most interestingly, the medical doctors of that day (mid 1800's) indicated the treatment must include a removal of the crusts formed on the scalp, and that the most effective means of doing this was by softening it with an oil and removing the hair. One doctor specifically recommended the use of a cerate, a mixture including resin, much the same as Alex described.

"Yeah, that salve will cure any kind of sore. Law, I've made a heap of it. I sent a big beef over to Rogersville the 10th of this month to have it butchered, and I meant to have them save me a couple pounds of taller to make me some salve."

Alex, let me ask you about a few more ailments and you can give me the remedies that you used.

"Go right ahead. If I know it, I'll tell you, and if I don't, I'll just pass over it."

Well, let's start out with rheumatism.

"You can take a bunch of big red worms and put them in a bottle or a can, and in a day or two they'll turn into what looks like pure water. They call it red worm oil. Them worms will just disappear, and they won't be nothing left but that red worm oil. You take that and rub it on your knees, or wherever you're bothered with rheumatism, and that'll give you relief. Polk root is awful good, and polk berries. They're poison so you don't want to take too much of it."

What did you use for the fever?

"A person with a fever needs to be sweated, and boneset tea is the best medicine for that. You gather it when it gets in full bloom. You gather the leaves. I've got some of it out there on the porch in a poke now, that I gathered over two years ago. You talk about sweating you, hit'll do it. Hit'll break a fever on you when nothing else won't. But it's bitter; it's as bitter as quinine ever dared to be. You take and drink you a saucer full of that before you go to bed and if you don't sweat it's because they ain't no sweat about you."

Here and in other instances Alex mentions drinking a saucer full of medicine, rather than a cup full. This reference was doubtless prompted by the then commonly followed custom of "saucering" one's coffee, instead of drinking it directly from the cup. Mutt, Alex's bachelor son who lives with him, still drinks his

coffee that way. The practical reason is that it cools more quickly in a saucer than it does in a cup.

Alex, I know that the condition of the blood was considered to be very important, and that many patent medicines and bitters were sold for the express purpose of improving the blood. Did you have herbs to improve the blood?

"As long as your blood's pure, you ain't bothered with no kind of disease. I don't care what it is. You'll hardly ever catch a disease till your blood gets mixed up and run down. That's where diseases start from.

"Oh, that's the biggest thing I doctored for, was your blood. I used to get out and dig nine or ten hours and make some of the best blood medicine ever you saw. I'd get red root, lobee, mayapple, black root, yellow dock, burdock, ginseng, goldenseal, sarsaparilla...

"Sarsaparilla is a good blood medicine. Hit grows in little vines. I've seen the roots grow as long as from here to that tree (about 20 feet). Just a little round root and hit's yellow and as bitter as gall. You can drink all of it you want, and it won't hurt you. The more you drink the better off you are. Hit'll shore purify your blood. And star root, now that's getting scarce here, star root is. It grows crooked just like a big grub worm. Hit'll grow as big around as your fingers. Little fibers grows all around it, and you get a few of them roots and cut them up. It's just as white as it can be. Make a gallon batch, and if you use it right, you'll feel like a new man—certainly. A lot of people don't know it but rhubarb is a good blood medicine too. Yes, sir, hit'll purify your blood right quick.

"Black root, some people call it culvers, is good for your blood and a lot of things. I'd go a long ways if I knowed where I could get some of that. Hit grows up about three feet high and has a little white tassle on it and a little keen leaf. You can take a little of that and make you a tea, and buddy, if your bowels ever give you any trouble, hit'll clean you right out! That's one of the best medicines I ever seed for bowel trouble, and it is a good liver medicine. It'll work you quicker than a dose of salts will. Pap used to have black root, but after I got up and left home the weeds took it. It's got to be took care of."

What did you use as a stomach medicine?

"They ain't no better stomach medicine than goldenseal. Years ago I set out four or five of them goldenseal plants up here on the ridge, and every time I'm up there now, I get a pocket full of that root."

Do you make a kind of tea from the root?

"Well, a heap of people does that—cut the root up fine and put them in water. But I don't take the time to do it that way. I just eat

the whole root and swaller it and that way I make shore I get it all. (He laughed.)

"You can have stomach burn and take you a goldenseal root and chew and swaller it and hit's all over with. It's good for gonorrhea too.

"Now you wouldn't think about the white oak bark being worth anything. That's the greatest stomach medicine ever was. Just take that inside bark, peel the old rough bark off. Law, what a stomach medicine and blood medicine that is. The white oak has got more medicine in it than anything that grows. Now, you want to get the sap from the north side of the tree. Just take you a knife and peel the north side, and that makes your best medicine."

What would you use for a cough?

"For a cough? You take the bark from a wild cherry tree, boil it down and make you a syrup. Take you a teaspoon full. Don't take too much, its high-powered stuff. Hit'll make you silly and drunk if you take too much.

"Mountain tea is good for a cough and to sweat you. That's about all that it's fit for, except for flavoring things. You know it has a great flavor."

In most cases the remedies Alex prescribed seem to be based on at least a semblance of logic. Occasionally, however, his "cure" was more akin to superstition. Such was the case with a method of treating whooping cough.

"You take the child that's got the whooping cough and face him toward the south up against a tree, and mark his height. Then you go out and find a sourwood sprout and cut it the same length as the person is high. Hang that sprout up over the door where the child lives, and when it dries out the whooping cough will be gone."

A similar example dealt with stopping nosebleed. There seems to have been more such remedies for nosebleed than for almost any other malady.

"You take a bullet that's been shot out of a gun, bore you a little hole in it, put you a string through it and tie it around your neck. You won't have no nosebleed a long as you wear that. If you don't believe me, mash your nose and try it out."

I think I'll take your word for it. But how did you stop the bleeding if you cut yourself?

"Get you some soot out of the fireplace and put it all around where you're cut, and that'll stop the bleeding. The skin will grow over that and trap that soot and you can see it for a long time, but it'll finally go away.

You've mentioned that whiskey was good for the measles. Were there other treatments for measles?

"The main thing, when you've got the measles, is to get them broke out. Measles killed a lot of people when they couldn't get them broke out. Whiskey is about the best for that. Hit's good for a lot of things. Of course it'll make you cut a shine if you drink too much of it.

"Back then people let their stock run out in the mountains. There was a big high cliff with an overhanging rock up here on the ridge where the sheep would go and lay when it was snowy, or during cold, freezing rains. They was all kinds of sheep manure there and we would go there and dip that up and boil it and make a tea that was awful good to break out the measles. Sheep shit tea, they called it."

Did you put anything else in it?

"No, that was all. Just boil them little sheep balls in water, strain it and drink it. Law, my mother poured, I guess, a pint down me one time. I'll never forget that. After you got the measles broke out, the main thing was to stay out of the cold air. If you ever took a back-set, why you was just a gone sucker, most of the time."

When I was growing up I remember that a lot of children had what they called sore eyes, or the pink eye. Did you ever hear of that?

"Oh, sore eyes. Lots of people had that. I've seen their eyes swell up, turn red, and it looked like their eyes was growed together. Old yellow matter would run out, and it was terrible.

"Now they ain't nothing that beats yellow root, that's the same as goldenseal, for doctoring sore eyes. You dig the roots and boil them till you get a good thick brew. Then just take you a cloth and bathe your eyes with that every two or three hours. It'll sure cure the sore eyes. I've not heard of that in years and years."

The state of West Virginia publishes a most interesting magazine called *Goldenseal* on the folk culture and customs of the people of that state. According to this periodical, the plant goldenseal was commonly used by the Indians for treating skin diseases and sore eyes. It was subsequently used by the pioneers for the same purpose, and was later incorporated in manufactured medicines. It is sometimes used for these purposes even to the present day. In 1909, the magazine pointed out, goldenseal roots were selling for $1.50 per pound, and in 1975 the price was $50.00 a pound.

You told me once what you prescribed for poor circulation.

"Yeah, spikenards, was good for that. It grows a great long, round root as big as your finger sometimes. You take a little of it,

145

slice it up and put it in a glass of water, and you can just see the grease coming up to the top of it. Don't drink too much, it's high-powered medicine. Now that used to grow right north of that ridge, just worlds and worlds of it. There's been truckloads of it dug and sold for medicine."

What about the colic? I've heard that this was a common problem and that people sometimes died of it.

"I learned to doctor the colic from my mother. I was out in the woods once squirrel hunting. Back then they was a type of white oak that growed an acron about like a chinquapin. I's just a boy and I got to eating them and I eat too many and they give me the colic. It like to have killed me. For two or three hours I couldn't get my breath and they was knots as big as your fist that drawed up in my stomach.

"I come home and Mama slacked some ashes in the fireplce. She had them right hot and made a poultice to put on my stomach. Them hot ashes caused me to get sick and start vomiting and I got all right in a few minutes. You can make an ash poultice to cure a headache too. Put it on just as hot as you can stand it."

Cold ashes wouldn't work?

"No, they wouldn't do any good. It took the steam from the hot ashes to stop the misery. Cold ashes won't drive misery."

Earache used to be a serious problem for children, it seems. Did you have a treatment for that?

"A lot of the little children was bothered with the earache. I've seen them where the ear drum would burst and run. There's two or three remedies for that. One of the best is angelica. It's a plant that grows around here and has round leaves and a berry at every leaf. You can smell it a ways off—it's good smelling stuff. You take and dry it good, powder (grind) it up, wet it and mix it with a little flour to make a pill out of it. Put it in your ear and it'll cure the earache. I used to carry it in my pocket all the time and I'd eat a little once in a while. It's a good heart medicine too."

What did you do for dropsy?

"Calamus is good for dropsy. It grows along marshy, swampy places and looks like a cat-tail. It has long blades on it. You dig the roots and let them dry. They'll get right hard but they'll soften up when you start chewing on them."

When I was a boy I used to dig calamus for my Aunt Sophia. She chewed tobacco, and sometimes she'd use calamus instead. I didn't know it had any medicinal qualities.

"Oh, shucks, I've carried it in my pockets and chewed it many a day. It won't hurt you. You needn't be afraid of eating too much. It's good for the dropsy. Elecampane is good for dropsy or asthma either one. Grandma raised her a little elecampane every year."

146

You mentioned once doctoring for "female" trouble. What types of herbs did you use for that?

"You take a woman that's all the time bothered with female trouble and they ain't no better medicine than comfrey. You've got some growing down there at your place. It's a great woman medicine. Tansy is a good woman medicine. It'll start a woman's sickness or it'll stop it either one. I've got some tansy growing out here now.

"Take the roots or the leaves either one and powder them up and make you a tea out of it. The root is black when you dig it, but when you break it open, it's as white as that piece of paper.

"Red root is good for a woman that's had a miscarriage. Hit grows up just like a huckleberry bush. Hit'll grow that high (he measures about three feet), and has a white, round flower on it, about like a clover flower, only it's bigger. The root of it is just as red as blood. It grows a woody root, it's not a fiber root, and it grows down deep in the ground. You dig that and make you about a quart of that tea, and drink it. I saved a woman's life one time with redroot. I may of told you about that once."

No, I don't think you did.

"She miscarried. Cordy was her name, Cordy Wilson. She was just wasting to death and they got Doctor Trent and Doctor Miller to come see her, but they couldn't do no good with her. They gave her up.

"I was tending a crop right above them and I'd go to see her on my way home every day. I never was inside the house—just stopped at the door to ask about her.

"I went by one day and I looked in the door and they was four or five people standing right by the side of her bed. I thought she was dead, lying there with her eyes shut. I looked at her a minute and she went back to breathing. Bob, that was her man, was standing there and I said, 'Look right yonder on that hill at that redroot a growing—looks like a huckleberry bush. You get the mattock just as quick as you can and go dig some of that and lets make a tea for her. If they's anything in the world that'll help her, that will.'

"He got the mattock and took out. We put some water on the fire, and by the time Bob got back with the redroot the water was getting pretty hot. We put that redroot on and boiled it about 15 or 20 minutes. I said, 'Now give her every bit of that you can get her to take.'

"They had to give it to her with a teaspoon. I stood there and watched it. They kept on till they got a saucer full, I guess, down her. In a half hour she began to open her eyes. The next day she was setting up. They all wanted to know what in the world I'd done that helped her thataway. I said, 'I never done nothing. Hit was the medicine that done it.'"

What's good for emphysema and breathing problems?

"Horehound is as good a lung medicine as they is. Hit grows a little round leaf that looks just like catnip. Take the leaves and make you a tea and it will shore help your smothering. But it's bitter, worse than quinine, might near it. But you can put a little sweetening in it and it makes good syrup, and candy. There's a lot of candy flavored with horehound, you know.

"Catnip is good for smothering more than anything else. Grandma always growed her plenty of catnip. Doctors got to claiming that catnip and horehound both was dangerous, but they weren't no such thing."

As we sat on the front porch in the late afternoon one day, Alex finished one of his stories, and there was silence. I was not anxious to suggest another topic; for he almost always thought of one without suggestive comments or questions. But he kept working with his pipe tobacco, and I finally commented on a wild, flowering plant down near the road.

I see a Queen Anne's lace down there. You know what I'm talking about?

(He held his head back and sniffed like a hound on a hot trail.) "Sometimes you can smell it from here. I do now. I smell it from here. That's good to beat up and put on a rising or boil. But that ain't old enough yet (to make medicine)."

What do you call it?

"Yar."

Yar? I've never heard it called that. We always called it Queen Anne's lace.

"They ain't no herb that grows but what people's got different names for it."

I'd never heard the plant called "Yar" before, nor was I aware that it possessed any medicinal qualities. I should apologize for checking on Alex, but I consulted the encyclopedia and found that "Yarrow" is listed and is described as a plant similiar to the one in question. It was also described a a tonic, an astringent and an ointment for dressing wounds. Alex, in calling it Yar, was closer to the proper name than I.

Alex, you mentioned using hemlock leaves, and some other plants that are considered to be poisonous. Socrates, you know, is supposed to have died from drinking a cup of hemlock juice.

"Hemlock is a good medicine if you mix it with other herbs and boil it down. A lot of tea just made out of one kind of herb will kill you. But fix it with other things and it will do you good in place of hurting you. Uncle Witt told me not to use the roots of hemlock, or the juice. He'd just use the leaves and they made a good medicine and they wasn't so poison.

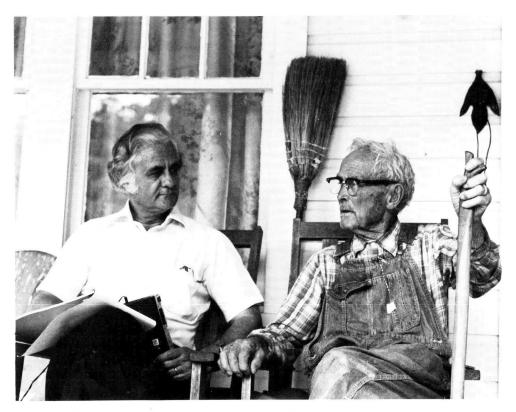

The author taping a conversation with Alex on the subject of herbs—on his front porch in 1983. It was during this interview that he said: "They's a plant for every disease. If we just had sense enough to find the right ones, we'd never have to go to the doctor". (Photo by Ed Meyer)

"Poke root, to take it straight, is poison. The Indians would take that poke root and boil it down and stick their arrows in it. When they shot something, if it drew airy a bit of blood, it would kill them. Grandpap said they did that and he knowed all about them. He was raised up with part of them. They would come around and trade with him some."

What were some other poison herbs?

"There was a little yellow flag that used to grow up here on the ridge that looked like an iris. It had a long flat leaf on it and growed a flat root right on top of the ground. There was a feller up here on the ridge once grading the road, and he dug up a bunch of that and decided to try eating it, and he died before night. Old Bill Carroll was his name."

Did you use it in medicine?

"You can cut it up right fine, salt it and mix it with meal and give it to a horse that's got fearsey and that'll cure him. That's a kidney disease and their belly will swell up. That's the only thing that I ever knowed yellow flag being fit for. To cure fearsey in horses."

What remedy did you have for poison ivy?

"If someone gets poison ivy inside, you can take and pour about a quart of liquor down them and that will cure them. If you get it on your hands or arms, burn a pile of green cedar limbs and hold your hands in the smoke. That will turn them as red as a turkey's snout, and that will take care of the poison. It will kill it as dead as a hammer. I've done that many a time.

"Some people is easier poisoned than others. My mother could pull that poison vine up with her hands and it didn't bother her. Pap could walk close to it when the dew was on and the sun was shining, and he'd get the awfulest case you ever saw. I'm the same way."

I suppose that one would have to characterize "Dr." Stewart as a general practitioner. Certainly he was no specialist, although he seems to have spent more time doctoring the "bad" disease than anything else. But his practice, I was surprised to learn, extended into dentistry as well. I asked him how, and why, he got started pulling teeth.

"Back then we didn't have a tooth dentist anywhere in this whole country, and if you had a tooth to hurt you bad enough, why he had to come out. Didn't have no dope (anesthetic) nor nothing; just had to reach in there and get it. I started pulling my own teeth with a pair of wire pliers."

So you were your first patient, as far as pulling teeth is concerned?

"Yeah. I ruint my teeth cracking hickory nuts. I used to crack hickory nuts and eat them all the time. But I learned that my teeth wasn't made for that."

I didn't know anything but a squirrel could do that.

"Shoot, I just wish you could see the hickory nuts that I've cracked with my teeth. I'd never think about getting down a hammer or rock or something to crack it. Just stick it in my mouth and bust it. But that ruint my teeth and when I was a young man they got to bothering me so much that I had to pull them. I've had false teeth for over 50 years.

"The first one I pulled was over at Carson Jones' place on the river. I was tending a crop there and we come in for dinner one day and I had the toothache so bad I thought I couldn't stand it. I thought I's gonna die and I couldn't eat a bite.

"I asked Carson for some pliers while we's all setting there under a shade tree in the yard, resting a while before we went back to chopping corn. I got ahold of that tooth with them pliers and just kept a pulling, and turning, and ringing, and finally I got that thing out.

"Thirty minutes after I'd pulled it, I went to getting easy. I eat dinner and went back to work. He (the tooth) was giving me just about all the pain he could, and when I went to pull him he didn't hurt much worse. Couldn't have hurt much worse.

"After that I started pulling my other teeth when they got to hurting so bad, and I got to pulling teeth for other people. Brock Fleenor lived right over there, just a little above where Sam lives, in a little boxed house. And he was just about to die with the toothache one day. He come over here and wanted to know did I know anything that would do him any good—help ease the pain. I said, 'Only a piece of cold iron. That'll help it.'

"He said, 'Cold iron? What do you mean?'

"I said, 'A pair of wire pliers. Pull it out of there.'

"He said, 'Aye God, did you ever pull one?'

"I said, 'Yeah, I've pulled some for myself.'

"'Well,' he said, 'go ahead and try it. I've got to have something done.'

"Well, I went in there and got them wire pliers and got ahold of him thataway and I said, 'Now you get ahold of the chair right there and hold to these rungs, and now don't you turn them loose. I'll fish that tooth out of there.'

"Well, I got ahold of it, and I commenced pulling and he commenced yelling 'Oh-h-h-h-h-h, Yo-o-o-o-o-o-o', and he got me by the arm. He's hollering and praying and everything else, and begging me to stop. I just give it a big ring and jerked it plum out. And buddy, you talking about bleeding now, the blood just flew. A few minutes later he said, 'Boy, I thought you'd killed me!' He just hollered. Law, you could hear him a half mile. (Alex laughs.)

"I had an eyetooth that got to hurting me s'bad that I couldn't hardly stand it, but I never could pull it. By that time they had a tooth dentist down here in Sneedville, and I went down there to get him to pull it. He saw all them other teeth missing and wanted to know who pulled them, and I told him I did. He wanted to know if I sterilized my pliers or anything and I told him no.

"He said, 'That's the most dangerous thing that ever was. It's a wonder it hadn't got infected and killed you.'

"Well, he tried to pull that eyetooth and couldn't. His puller kept slipping off. I seed right off he didn't understand what he was doing. I told him to take another holt (hold) and when he did I grabbed them pliers with him and wouldn't let go, and the two of us yanked it out."

Did you ever charge for pulling teeth?

"No. It would just tickle me to death to get a chance to get ahold of an old tooth and twist him out."

Why did you stop making medicine, doctoring, and pulling teeth?

"I just got to studying, after all these drug stores come in, that somebody was liable to die from somebody else's medicine, and their folks would come and blame me. And I just quit. I thought once about taking out a license but I never did."

One of the last long talks I had with Alex was in the summer of 1984. The public nurses had started visiting him frequently by this time, and they enjoyed one another immensely. Alex enjoyed people of all walks and stations of life but he particularly liked the company of women, preferably those who were young and attractive.

On this particular afternoon nurse Ella Freeman was sitting close beside him, and he was especially talkative and jovial. The more she laughed at his jokes the more he engaged in them. The following is an example.

Alex, did you ever doctor rickets? You know, it causes children to become bowlegged.

"No, I never doctored no bowlegged crickets."

Alex laughed heartily, as did Ella, Mutt and myself. But then he turned serious and gave us a summation of his feelings about herbs and their uses.

"The Bible says there's an herb to cure every disease there is, except one."

What's the one thing that no herb will cure?

"Death. No medicine will reach death. Everybody that's borned has their days numbered, according to the Bible, and every hair on your head is numbered. When it comes your time to go, all the herbs, medicine, doctors, and everything else can't change that. You can shorten your days by what you do, but you can't prolong them."

Moonshining

"I Had The Name Of Making The Best Liquor In The Country."

The story of Alex Stewart would be far from complete if it didn't include some account of the half century he spent making whiskey. Moonshining in the Southern Appalachians has been romanticized in so many books, songs, and motion pictures, that many find it difficult to differentiate between fiction, and the true role the production of illegal alcohol played in the lives of the people in this region. Alex's reminiscences should help set the record straight.

First, illicit whiskey making was part of the heritage the people brought with them into the mountains. Their ancestors had made liquor in Scotland, and especially in northern Ireland, from whence the Scotch-Irish people came. In the 1600's, they had been forced to hide their small stills in wild and inaccessible areas to avoid the despised British tax collectors. The distillation of spirits was considered to be a man's own business. He tilled the soil and grew his grain, so why should he pay a tax on the whiskey he made on his own land?

When the Scotch-Irish poured into America in the 1700's, they brought with them the knowledge of whiskey making, and their contempt for government taxation. They tended to settle on the frontier, especially in western Pennsylvania, in Virginia, and in the Carolinas. Horace Kephart, in his book *Our Southern Highlanders,* points out that Scotch-Irish troops made up the first regiment of the Continental Army, and were the first to serve under a Federal Banner. During the Revolutionary War they were given credit for saving the day at Saratoga. A group of very early settlers from upper East Tennessee crossed back over the mountain into the Carolinas and engaged the British in the now famous Battle of Kings Mountain. The American victory there was hailed as being one of the most important battles of the American Revolution and was called the turning point of the war in the South. Kephart said, "from the beginning to the end of the war, they (the Scotch-Irish) were Washington's favorite troops."

After the Revolutionary War, during Washington's administration, a whiskey tax was passed. This tax was viewed by many as

especially punitive toward the small western farmers, many of whom converted a portion of their grain to whiskey. Roads were almost non-existent, and, they argued, their crops could only be marketed by distilling them into the more transportable liquid. These people, many of whom had helped create the new nation by defeating the British, were now ready to take up arms against their infant government.

The protests were loud and angry, and the subsequent "Whiskey Rebellion" rocked the new nation to its foundation. It was mainly led by the Scotch-Irish of Western Pennsylvania, the same area from which many of the progenitors of Southern Appalachia came. It was in this rugged region, embracing parts of Kentucky, Virginia, Tennessee, and North Carolina, that the moonshiner practiced his ancient art long after it had died out in other parts of the country. When national prohibition was imposed in 1920, illegal distillation was revived throughout the country, but it wasn't necessary to revive the art in Southern Appalachia; it had only to be expanded.

The price of illegal alcohol increased dramatically. This was good news for the moonshiner since he could reap higher profits from his labor, but it also drew various criminal elements into the industry, ruining the reputation of the proud, old-time mountain moonshiner.

These newcomers, often lacking know-how or concern for the safety of their customers, sometimes produced poison whiskey. The perception of the moonshiner as greedy and uncaring can be attributed largely to this relatively recent influence. The traditional moonshiner was a poor, God-fearing family man, who took immense care and pride in his work. Such was Alex Stewart.

Alex, the people who knew you years ago say you made the best whiskey of anybody in this area. I know it's a long and tedious process, and that neither your father nor grandfather made it. Where did you learn?

"Well, you might say I learned myself. My mama was sick and old Dr. Mitchell come to see her several times. One day he said, 'Now, they ain't but one thing that'll help you. You get you some good liquor and drink that every day for a few days and that'll cure you.'

She said, 'Why, we don't have no liquor here and I don't know where to get any that's any account.'

"And Doc Mitchell said, 'Brynger (he always called me Brynger) can't you make liquor?' I was just a boy, and not quite grown, but I said, 'Well, I'll shore try it.' He told me exactly how it ought to be done, and that's the way I got started. I made it for Mother and she lived seven or eight years longer than if she hadn't had it, so the doctor claimed."

Although moonshining was generally accepted by the people who settled the region, not everyone approved. There were many teetotalers in the area, doubtless a result of strict religious teachings. Alex was aware of this attitude and spoke defensively about his moonshining. He stressed that he only sold to people who knew how to handle it, and that he never sold to boys. He emphasized its medicinal qualities and played down the extent of his operation, claiming he made very little.

"A lot of people have said that Alex Stewart made his living making liquor. Course it did help me and all that. But, I'd take an oath that I never paid a penny on a debt in my life with any of that liquor money. I used it on my family, a schooling them, getting them clothed, and feeding them. I went to drinking it and got in the habit and it took a lot to do me." (We'll talk later in this chapter about Alex's drinking and how and why he stopped.)

When did you get involved with handling it?

"The first time ever I handled any whiskey was not long after I's married. I run a gristmill over here on the side of the ridge for an old man named Joe Odom. He was crippled—had the swelling when he's a young man and it drawed one of his legs up a lot shorter than the other, and he couldn't hardly walk. I'd cut wood for him, run the mill, and just whatever needed to be done. I helped him put in the mill race and everything. We didn't have enough water to turn the wheel in the summer when it was dry. People would know when they's enough water and when the water was too low, they wouldn't bring their corn. He couldn't make a go of it grinding corn and he got to selling liquor, and I'd help him. He had a pretty slick way of selling his whiskey. He called his system the 'blind tiger.'"

What's a blind tiger?

"Well, he had a little room fixed up where all you could see was a drawer. You'd pull it out and put your money and your empty bottle in it. Then you'd tap it a couple of times and push the drawer back. We'd put in whatever amount of liquor they'd paid for, and we'd shove the drawer out, and they never seed who was doing the selling. We never spoke a word and they couldn't turn us in.

"I've seen people come there in droves and Joe would be just hopping backwards and forwards getting that liquor poured. It was a sight to see him go.

"He kept getting a little braver and finally the law closed him down—put an end to the blind tiger. He was as good-hearted an old man as you ever seed in your life. And sense—he had plenty of sense. Why, he could make one of the finest speeches you ever heard. He used to meet down here at election or a gathering, and they'd get onto him and he'd get up and make a speech and he was

a sight to hear. He run for Sheriff down here one time and was elected, I believe by 20 some votes."

How did he do as sheriff?

"Oh, he did very well. He wasn't afraid of the devil. They's one feller they had a tax against—Milt Johnson. Joe went to collect it, and Milt kinder stuttered and said, 'W-w-w-well, by God, you'll have to wait till I shear my hogs f-f-f-fore I p-p-p-pay you.'"[1]

Wait till he sheared his hogs?

"Said, 'Wait till I shear my hogs, fore I pay you.' That made Joe mad and he said 'By God, you're gonna pay me now'. Milt was a great big square-shouldered feller and he just picked Joe up and pitched him in a ditch and took out running. He run about 100 yards when Joe shot him right in the heel. Milt went and paid his money, and Joe laughed and said, 'I'm proud I just winged him. If I'd drawed a little higher, I guess I'd a killed him.'"

Were you ever bothered with the law enforcement people?

"Not very much. See, they all knowed I made good liquor and that I's clean and particular with it, and that I never sold it to boys, and they let me alone. They pretended to raid me a few times, but they never tried to find anything. Why, I've sold a heap of liquor to the sheriff and the federal men. Me and one of the sheriffs went into business together and made liquor for years. Made it in the sheriff's smokehouse."

Tell me about your partnership with the sheriff in the moonshine business.

Alex laughed. "This sheriff come up once to raid me, and he set down and talked a long time and directly he said, 'I'd like to have a good drank of liquor.'

"I said, 'I ain't got none.'

"He said, 'Now I ain't here to cause you any trouble. I got a drink of your liquor the other day and that's the reason I come here, to get another drink.'

"And I thinks to myself, 'Now he's a gonna pull something on me.' But I finally told him, 'Let me see if I can find you a drink.' I never turned a man down for a drink in my life, if I had it.

"So I went and got him a drink, and he sipped and sipped on it, and finally he said, 'Now that's real liquor! I'll tell you what I'll do. I'll furnish the sugar and I'll get rid of it (sell it) and you make the liquor, and we'll go halvers.'

"We agreed to go into business together, but we needed a safe place to put the still. 'Sheriff,' I said, 'the best place to put that still is right in your smokehouse. Nobody would ever expect to find a still in your smokehouse, and if they saw airy bit of smoke

1. Since, of course, it is impossible to shear hogs, that was Milt Johnson's defiant way of telling poor crippled Joe Odom that he would never pay his taxes.

they'd just think you were smoking your meat. It's handy there, close to water and everything.' He finally agreed.

"I guess me and him made a thousand gallons or more. We'd make 18 to 20 gallons every run, and I'd make a run every week. The sheriff was in debt. He was just up against it till we got into that. He was too much of a lady's man and spent everything he'd get on women and liked to have ruint hisself. We started making liquor together and I put him back on his feet."

You mentioned once that the federal revenuer paid you a visit one time.

"He had the name of being the worst man they ever was in our country. He was a government revenuer and he'd killed seven men. He killed three men at one time up in Kentucky. He wore a metal jacket all the time—a bullet wouldn't phase him unless it hit him in the head or down in the legs."

Did he ever get shot?

"Yeah, they shot him two or three times but it didn't amount to nothing.

"I was working one day splitting some wood and putting it up in the woodshed. He walked up on me and like to scared the life out of me. I thought to myself, 'I'm a goner this time!'

"I had, I guess, 15 or 20 gallons of corn liquor up in the smokehouse loft with some stuff throwed over it, and he come up and said, 'Bud, you got any liquor?'

"I said, 'No.' I's telling the truth, I didn't have none in my hands.

"He asked me a whole lot of questions, and finally he says, 'I've drunk some of your liquor and that's the reason why I'm here.'

"Come to find out, a doctor I's selling to had let him have a drink, and he made the doctor tell who made it.

"'Well,' I finally said, 'I've got a drink I might give you.' I had a quart can sitting in there in the cupboard and I went and got it.

"He took it outta my hands, tasted it, and said, 'That's the best liquor I've got since I've been a revenue man. How much you got?'

"I says, 'I ain't got much of it.'

"He said, 'I want a gallon. A man that makes liquor like that ought never be bothered.'

"I kept him in liquor right on up till he started attending Holiness meetings. He got saved and went to preaching and he never did come back for any more liquor. I figured after he got saved that he'd shore pour it to me. I said, 'I've played the devil now.' But he never did name it to me, and he didn't live but a little while after that."

Although the revenuers weren't out looking for you, it was still necessary for you to hide your operations, wasn't it?

"Oh, yeah. You had to keep everything out of sight. At first I moved my still around a right smart. I soon got tired of that and I dug me a big hole right near the barn about six foot square and four feet deep. I put planks over that and covered it with corncobs, shucks and such. You could walk or drive a team of horses over that and never know it was there.

"I used hard, dry wood to burn, and it didn't hardly make no smoke at all. Sourwood, dogwood and oak is best."

I think you told me once that you and Ellis made whiskey for a while.

Alex chuckles at the recollection of those days.

"We made liquor together for years. Ellis was a good hand to work but he never could make liquor. He'd ruin it ever time.

"He sent word for me to come up there one time and when I got there he wanted me to help him make a run, and that's how come us to get started together. We dug us a big pit, a room nearly half as big as this house, right there in his front yard. We covered it with chestnut logs and then put dirt on that. We had a little trap door and we hid that door with a shock of (corn) fodder. There's where we made our liquor. Ellis would pack (carry) the water and such as that, and do anything I needed doing.

"We had a peep hole, and one day we was a setting there getting ready to come off with a run and we saw the law a coming—the sheriff and two duputies. That liked to have scared Ellis to death. He jumped up and said, 'Alex, get out of here. Run for the ridge!' Said, 'You've got a family to feed and I ain't.' Said 'I'll stay here and take the blame.'

"Well, I wouldn't leave. Just set right still, and Ellis saw I wasn't going to run; so here he went. Headed out the ridge like a rabbit with the dogs after him. (Alex laughs heartily.) The law went up and set down on the porch and I slipped around and went in the back door, come thru the house and set down with them. They'd raided Herbie Collins over on Blackwater and poured out two barrels of his mash.

"After a while the sheriff asked if we had any good liquor, and I went in the kitchen to get them some. They all took them a drink, bought them a half-gallon, and went on.

"Well, about supper time here come Ellis in from the ridge. He was all scratched and skinned up and scared and trembling. He said, 'I thought we's caught for shore.'"

Apparently you had a lot of interesting customers.

"I even had a preacher that would buy a little liquor off me once in a while. He was as good a man as you could find anywhere. If anybody was living right, I believe that old man was. He didn't know a letter in the book, but he'd go preach every Sunday if they wasn't but one soul in the church house.

"Now he had a son-in-law who followed drinking. He bought a gallon off of me on credit. He'd been a soldier in World War I and he drawed a pension. He said, 'When my check comes, I'll pay you for it.' Well, he got into a meeting and got sorta stirred up and pretended to get saved, and he never did pay me. I never did think that man was saved."

What did you use to make whiskey and brandy?

"I've made liquor out of about anything you could think of: barley, raisins, grapes, paw-paws, dandelions, rye, corn, peaches, apples, plums, 'simmons, tomatoes and on and on. I threatened to make it from bananas but I could never get me enough.

"I made brandy out of lots of stuff people said wouldn't make brandy at all. Brandy is hard made. If you don't understand it, you'll just make a flash every time. I've made it out of apples, peaches, blackberries, and lots of things. I used to have a field up there on the ridge, about 12 acres, and it was just covered with blackberry briars. People would come from everywhere to pick them berries.

"I'd make brandy out of them and I'd hardly ever put any sugar in it. Always used molasses in making blackberry brandy. It suited it better. I've made many a gallon of blackberry brandy, and it was good. I wish I had a little snort of it right now."

Apple brandy was very popular, wasn't it?

"Oh, you couldn't hardly beat good apple brandy. I gathered up a great lot of sweet apples up here at George Stewart's place once. I squeezed out the juice and they made three big barrels full. I set them barrels in the corn field and put a big cornshock around each one so nobody would know where they's at. It took them till long about Christmas to work off and make good hard cider. Then I took it and run it through my still and made brandy.

"Everybody that took a drink of it said it was the best brandy they ever tasted. They was a lawyer down here in Sneedville and he started supplying me with sugar. He wanted to buy every drop of brandy I made. He'd give it to them big lawyers down in Knoxville when they'd come up here. He ruled things in this county, and he said I need never worry about getting prosecuted as long as he was around."

I understand that one of the oldest types of alcoholic drinks was a wine called mead, made from honey. Did you ever make that?

"We called it figlin instead of wine. You take good honeycomb and put it in a jar and pour some water over it and let it set till it works off. It makes the best drink you ever drunk. It'll make you feel funny but it won't make you drunk. It's about like beer."

You were going to tell me about getting raided.

"My first cousin Eli Jones lived over here across the ridge. You knowed him. Him and his wife made liquor and bootlegged

liquor, and the people got after them over there and he couldn't put his still nowhere that they wouldn't find it. He come up to my home and wanted to know if he could come and make some whiskey on my place.

"I said, 'If you can make it and get by with it, I don't care (mind) but I don't want it made close to the house.'

"I took him way back up to an old pasture field where there was a big rock pile with bushes and briars grown up around it. Right off from it about 50 to 75 feet was water, and I said, 'Right there's a good place for you to make liquor, Eli.'

"He got in there and put up two barrels, and made three or four runs and took a notion to quit. He hadn't been quit long when Charlie Mullins run for sheriff and was elected. Eli went down there and got in with Charlie, and Charlie put him in as deputy. It wasn't long till Eli brought the sheriff and another feller by the name of Collins up here to raid me. Eli wanted to be sheriff and thought leading a few raids like that would help him.

"He brought them up there, and me and Hugh Nichols was out rabbit hunting. I looked down the ridge and there set Charlie (the sheriff) on the fence. Just about that time, the dog jumped a rabbit. I told Hugh, 'You wait right here and I'll go kill that rabbit.'

"I walked out and there was Eli hunting for my still. I raised that shotgun, cut right down at him, and shot. Buddy, you talk about somebody getting gone! I put two shots through his hat. Hugh and the sheriff thought I's shooting at the rabbit. I stood there and watched Eli go just as hard as he could.

"I come out down where Charlie was, and we all come on down to the house and they said they needed to wait on Eli. They didn't know he'd done run plum off the ridge down to where they'd parked their car. While they's waiting the sheriff said, 'Well, we've looked everywhere and we know they ain't no still up here,' and he sorta laughed. After awhile they walked on down the ridge to where their car was parked and when they got down to the road there set Eli with them two holes in his hat. That liked to have tickled the sheriff and Collins to death. (Alex laughed heartily.) They said later that I'd done exactly right.

"That was the dirtiest thing I ever knowed of a man doing. After me letting him make liquor on my place, for him to turn around and try to get me sent up (to prison). He thought shore he'd catch me and make a big name for his self. He's down there looking for signs—had a stick pulling the briars back, looking for a trail that led from the water, and poking around everywhere— when I spotted him. That's when I let him have it. He just flew off that ridge (Alex laughs again.) If he'd been close enough, I'd shot

160

him till he'd never run airy step again. I shore showed him the way out.

"I sent him word that he better never show up on the ridge no more, and as far as I know, he didn't. He run for high sheriff years later and he asked me to vote for him. I said, 'Son, if you never get a vote till you get one from me, you'll never get nary a one.'

"Just a while before he died, he was in the hospital down here at Sneedville. I was down there, went to see somebody that was awful bad off, I forget who it was now. But Eli was in the bed right over from them there. And I spoke to him, and asked him how he was getting along. Oh, he sort of grinned and turned his head over and said, 'I ain't doing no good.' And I believe he died about a day or two after that."

All the moonshiners tell me their worst enemies were the other moonshiners, not the law enforcement people. Did you find that to be true?

"Oh, yeah. Every time the law come around it was because some other feller who made liquor turned me in. Mine was better than theirs and everybody knowed it. I's getting all the business and they would turn me in hoping to get shed of me."

Alex, where did you get your stills?

"Oh, I made them, and I made a heap of them for other people. I'd go over here at Rogersville and buy the copper and make them."

In the early days when copper was not available, how was whiskey made? I heard an old man say once that they used an iron kettle and a blanket.

"Oh, yes. That's what they used before they had any material to make a regular still. Put your mash in an iron kettle and then take you a yarn blanket, double it, and put it over your kettle. Then you boiled it real slow—sorta let it steam a little, and that blanket caught the steam. When the blanket got so wet it couldn't hold no more, you'd wring it out in something and you'd have your liquor."

I understand the price of whiskey went up during prohibition?

"Oh, yeah. Why, I remember when you could buy all the liquor you wanted for $1.00 a gallon. Then after this prohibition came about, it got as high as $30.00 a gallon. That's when a lot of people got into making liquor just for the money and they'd do anything to get a run off. A heap of times it was poison."

I've heard of people dying of poisoned whiskey. What causes it to become poison?

"Some people would put lye in their whiskey to make it bead. That's the way you tell the strength of liquor, you know, by the size of the bead that comes on it when you shake it. You could put a little lye in it and you'd have great big beads and that made it

look like good strong liquor. It'd taste strong, too. They'd get old car batteries and take the water out of them and put it in their liquor. That would make it bead.

"I don't know at the people that died of drinking bad liquor. They's a feller lived right up here named Lee Miller. I don't guess they was a better man in this country. He started down here to Sneedville to court one day, and he stopped to talk to another feller and he gave Lee a drink of liquor. Now that one drink of liquor killed him. They thought it had lye in it. Some people will do anything for a nickel."

When the price got so high I suppose most people used sugar?

"Yeah, you could make it so much faster by using sugar. Straight corn liquor is a lot better but it takes a heap longer to make. Straight corn liquor's got a better taste. You can get so drunk you won't know you're in the world, and quick as you sober up, you feel just as good as you did before you drunk it—maybe better. They ain't nothing no better for medicine than straight corn liquor."

Did you char your whiskey?

"I've done that several times. You want to get white oak and take the sap off it, then split the timber in small blocks and take and char it; just burn it like you was making charcoal. Put that in a barrel of liquor and let it set four or five days, and boy, your liquor will look like coffee. That gives it a good taste and a good flavor too."

Were there quite a few people in your neighborhood who made whiskey?

"Oh, they's might near half the people up there on the ridge that made liquor, at one time or another, men and women."

Did the women actually make it?

"Yeah. I recollect two old women that lived up the hollow here and made liquor all the time. Grandpap had made them a big hogshead (barrel) that held about a hundred gallon. They never did pay him for it, and one day he sent Pap and Dan Creech down there to see if they could get them women to pay him a little bit. They got to the house and they wasn't no one there. Pap and Dan stood around a while and then they heard somebody talking down around the creek. They walked down there and learned that the voices were coming from that big hogshead. Both of them women were in that big barrel stomping down the mash, stark naked. They didn't have a stitch of clothes on.

"Pap told them what they was after. They said the only way they had to pay for that hogshead was with honey. They kept a few bees. Pap and Dan come on up to the house and them women got out of that mash, washed off in the creek, and put on their

clothes. They come up to the house and give Pap a gallon of honey for payment. Now Pap said that was the truth."

Were either of them married?

"They didn't have no men folks, but they had several children. Making liquor was the only way they had of making a living. Law, they had it hard."

The people who made whiskey were called moonshiners, and the ones who sold it for the moonshiners were called bootleggers. Where did these terms come from?

"A lot of people made their whiskey of a night, by moonlight. I reckon that's why they got to calling it moonshine.

"Back then most all the men wore boots. They'd tie their britches around their leg and their boot with a string, and that way they could put a bottle in the top of their boot, and nobody would notice it. They'd go around where they was holding court or where an election was being held and sell it. When they wanted to get their bottle, they'd slip around behind a building and untie that string and get it out."

All of Alex's neighbors spoke highly of him, but a few alluded to his fondness for old John Barleycorn. During my first years of visiting him, Alex kept a little liquor hidden near his workshop. He had dug a small hole underneath the floor of a log crib where he kept a jar or a bottle. He kept it covered with a plank, and would kick a few corncobs over it so there was no trace of the hidden spirits.

Once, when Alex and I were out buying items for the Museum, we visited an old moonshiner who lived on the banks of the Clinch River. He didn't know me very well, and wouldn't admit to having any moonshine, but he offered us beer instead. Alex accepted one, turned the bottle up and drained it completely, removing it from his lips only once. When I commented on how fast he drank it, he seemed surprised. "Why, pshaw son, that's the way I drunk beer, back when I followed drinking. I can't stand this sup, sup, sup. I just always take two drinks to a bottle. I could drink it all in one drink if I could hold my breath long enough."

He had "quit" drinking years before this, and the scanty supply under his corn crib was for medicinal purposes only, or so he said. His son, Mutt, disapproved vehemently, so Alex hid it away from the house. Though I never saw him the least bit intoxicated, Alex made no secret about his drinking in earlier days.

Alex, you mentioned a time or two that you not only made moonshine, but that you also drank a good deal.

"I drunk a pint or more of liquor every day for, I guess, 40 years. I lived on it. Got to where I'd have to set it by my bed. Along in the

night I'd wake up and have to take me two or three swallows before I could go back to sleep."

How old were you when you started drinking?

"I was just a boy when I first started taking a drink—eight or nine years old. I recollect the first time ever I took a drink of liquor.

"The Bell family lived right up above us, and they made and sold liquor. Pap never drunk, but he never bothered them—never give them no trouble nor nothing. One day two fellers come by our place and wanted to know where they could find some liquor.

"I said, 'We don't fool with it, but if you need some you take that road and go about three quarters of a mile, and you can find some I guess.'

"One of them asked would I show them the way, so I went along.

"They bought them a half gallon of liquor, and they give me a drink of it. I took it and law, I thought that was awful. That was the first liquor I'd ever drunk.

"They was another feller who lived right close, by the name of Joe Ogle. Joe was about the worst crippled feller ever I seed, and he couldn't work much—only made a little liquor.

"I used to help him do things and he thought a lot of me. One day Mother sent me out there to borrow some coffee. Joe was setting on a big rock with a jar of liquor beside him and he said, 'Here, I'm gonna give you a drink of whiskey. Do you want it?' I said, 'Yeah, I'll take it.' I drunk some of it and it made me pert near drunk before I got home. From then on I went out there and got whiskey from him any time I wanted it. That got me used to it, and I drunk whiskey for, I guess 50 years. After I learned how to make it I never did buy much liquor, and I never did get dog drunk but one time in my life."

Was that when you were young?

"Yeah. I was out in the woods and I catched a big mud turtle and took it to Joe's and he said he'd give me a quarter for it if I'd clean it and fix it for him to eat. Well, I took that quarter and bought me a pint of liquor from him. I drunk most of that, and before I got home I's so drunk I didn't know where I was at."

Did your Daddy find out that you were drinking?

"He found out about it some way, and oh, he give me a jacking up. He said, 'Now that's the worst habit you ever got into in your life. You better quit that.'

"But, I didn't listen to him. I got to where I could turn up a half pint of liquor and drink every drop of it, and you wouldn't have knowed it if you hadn't smelled it on me."

You never missed any work on account of your drinking?

"Oh, no. It just helped me to work and to eat. That was the first

thing I'd drink in the morning. I'd go feed my team before breakfast so they'd eat by the time I got ready to go, and I'd keep me some at the barn. I'd drink me a drink or two and come back and eat breakfast. I'd get ready to go to work and I'd take me another drink and go.

"I'd hide me out two big kegs in the field, and cover it over right good. When I's plowing I'd stop the team every once in a while and get me a drink. I'll swear, by the time I'd lay the crop by (in late summer) I'd have both them kegs of liquor drunk up. I can take you up there today and show you that hole where I kept it buried."

What made you decide to quit, and how were you able to give it up?

"It was getting a hold on me, and I *had* to quit. Got to where I couldn't eat nor nothing. I said I'd quit if it killed me and I done just what I said. For two weeks I couldn't be still, couldn't hold nothing without just jerking and trembling all over. I thought it *was* going to kill me. Margie said, 'Ain't you got something that you can drink that will stop that?'

"I said, 'Yeah, but I'm not a drinking it. I've quit.' I stayed right with it, and it finally left me and didn't bother me no more. I never have craved liquor no more like I did."

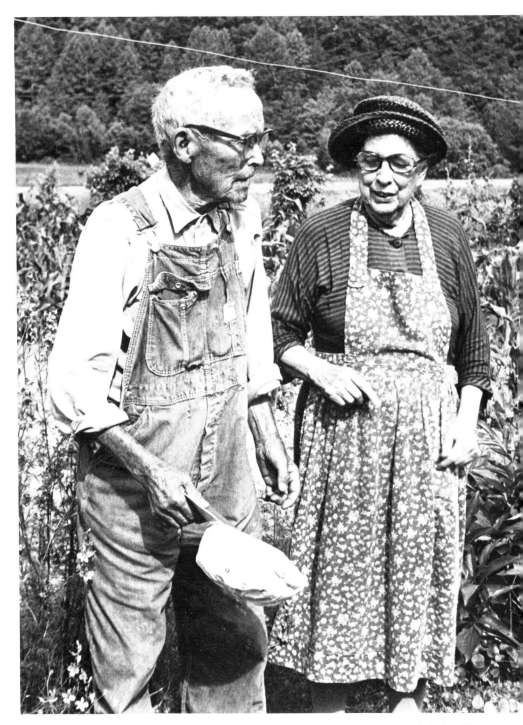

Alex makes a social call on Ila Mae Martin, his neighbor and "girlfriend".
(Photo by the author)

The Pioneer Community

"Oh, What A Time We'd Have At A House-Raising."

When a family, or a community of families, must struggle daily for enough food and clothing merely to survive, it is unlikely they'd be given to attending gatherings and meetings merely for the purpose of socializing. But by the same token there exists, it seems, an innate yearning in people to meet and interact with others.

The frontier society met this need in its usual innovative fashion. People had their gatherings, their visitations, but when they did so it served a utilitarian purpose. They seeded cotton while visiting with neighbors for the coming of the New Year. They peeled apples, broke and strung beans, shucked corn and make quilts as they visited. The people also met and visited at church, baptisings and funerals. There were few if any instances where they gathered solely for recreational and/or social purposes. This frontier attitude was very much alive when Alex came upon the scene. He vividly remembers such events, and actively participated in many of them.

Alex, all the history books, it seems, speak of log rollings, quilting parties and so forth—about how the neighbors would get together and have workings. Do you remember any of these?

"Lord yeah, we've had a many of them. Corn shuckings, bean shellings, candy pulling, and apple peelings. It wasn't no trouble to get people to come to a working. They wasn't many people here then, but everybody that you'd ask to a bean stringing or corn shucking or something would come if they's able to get there. You couldn't have that no more. I'd hate to think about trying to have a corn shucking now. Wouldn't be two people show up.

"Back not long after I's married and living on the ridge up there, I was cleaning up a piece of ground, about five acres, to put out my corn crop. It was getting late and I knowed I wouldn't get a crop if I didn't get it cleaned and planted right away. I decided to have a ground clearing and log rolling, and I had 21 hands come to a working and I cleaned it up in one day."

Did you just put out the word that you were going to have a ground clearing?

"Yeah. Why, it would tickle them to death to get to go to a working for they knowed they was gonna get something good to eat."

Who cooked for all those people? Did Margie do all that?

"Cooking? Margie and Mama. Mama was living then and she helped get dinner. They killed two big fat hens that day and made dumplins, and they had all kinds of vegetables. Plenty of beans, pickled corn, kraut, and big old cobbler pies. Just had a real dinner.

"I don't know at the house raisings I've went to. I bet you I've been to 25 or 30 of them. Wht a time we'd have at a house raising!

"Calloway Livesey, over on Blackwater, had a good farm that run across that creek plumb back to the top of the mountain. About two-thirds of the way up they was a big basin with seven or eight acres that was fairly level. You could have plowed it with a tractor, only they wasn't no tractors back then.

"Well, he decided to build him a house up there, and he come one day to get me to help him decide where to put it. We climbed up there and picked out a place and I told him what kind of timber to cut, and how big to get it, and he put right in and cut it and snaked it down close to the house seat.

"One evening he come down to my place and said, 'Now I've got the logs snaked in and I'm ready for you to go to work on that house.'

"I says, 'I'll tell you what to do Calloway. Me and you can't put them logs up by ourselves. You have a working and get some good men and we'll put that house up and maybe cover it in one day.'

"'Oh,' he said, 'we can't do that in a day!'

"I said, 'You get me a few good hands and I'll show you.'

"Well, I never seed such a crowd of men that turned out for that house-raising. We put that foundation down, notched them logs and put them up, and got half the rafters on in one day. We had a man stationed at each corner to notch the logs, and I was one of them. When we got done, Al Moore, he was Calloway's father-in-law, he went around and looked at it and said: 'Well, I've just been inspecting and Alex Stewart has put up the nicest corners of airy one here.' I made every one of my joints fit just like they had growed there."

Were the logs hewed?

"No, they was just round, long logs. They was 20 feet long. I believe the house was about 16 or 18 feet wide.

"Calloway's wife had cooked a hog's head for dinner, and she didn't take its eyes out; just cooked it whole. When we went to eat, that hog's head was setting on the table a looking at us. (He laughed.) But, they eat it just the same.

"Miss Moore and her girls come and helped get dinner that day and oh what a dinner they had! They was about 20 hands there, and everyone worked."

And none of them charged anything?

"No! They never did think about charging a penny. You can't get people to do that now."

Other than workings, I suppose church meetings were one of the few times people in the community got together.

"Oh, yes. If they had a revival, people would wrap up in bed quilts or shawls and wade the snow five or six inches deep to go to meeting. Old grey-headed fellers with beards way down to here would be a setting there, and more of a crowd than you could get today. I've set there and listened to the preacher preach many a day. Old Vige Collins couldn't read nor write, but he'd come down there and preach and boy, what a crowd he'd have. That man could preach!"

Did you ever hear of what they called protracted meetings?

"Oh, law yeah. They used to have them protracted meetings in Jonesville, and places like that. People would go there and camp out on the ground or stay with people, or sleep in their wagons if they had them. They'd attend all the preachings, and they'd visit with one another. Sometimes they'd last two or three weeks. I've heard Grandpap Stewart talk about it. They'd have a time."

Another form of church service involved the handling of poisonous snakes, talking in unknown tongues, and sometimes drinking strychnine as a testament to one's faith. Although these services have received widespread attention and much media coverage, only a very few mountain people participated in these rituals. The basis for this sometimes deadly practice is ostensibly the scriptural reference, Mark 16: 17-18 which states: "and these signs shall follow them that believe: In my name shall they cast out devils; they shall speak with new tongues; they shall take up serpents, and if they drink any deadly thing, it shall not hurt them; they shall lay hands on the sick, and they shall recover." I asked Alex if he was familiar with snake handling meetings.

"Oh, I've seed them handle snakes many a time. Henry Sweeney, he lives right down the road here in that log house, used to do that all the time. I've knowed him ever since he was born. He's up around 70 or 75 years old by now, I guess.

"I've seed him handle them copperheads and put them around his neck. That man could preach! Jesus Christ! It was awful to hear him preach. But now he's quit the snake handling. He's just gifted someway. He can't read nor write, but that man could preach some of the best sermons ever you heard. He'd get somebody up beside him to read for him." (In the early summer of

1985 I received word that Henry was back handling snakes and that he had been bitten on the neck by one. The report indicated that because he had been bitten "several" times before his immunity was such that the last bite had little effect on him.)

Where did the snake handlers have their meetings?

"Different places. They used to have them down there in Sneedville regular. Maude Bell and her man, they took up with the Holiness and she could handle them snakes anyway she wanted to, but one finally bit her."

What happened?

"One bit her on the arm and she like to have died in spite of all they could do."

(Mutt interrupts his father on one of his rare occasions. "She got bit with one later and it killed her." Alex ignored Mutt's interjection completely.)

Did they have them in the church house?

"Yeah, they'd have them in a big box. They'd have music and hollering and finally get around to picking them up. But they never picked one of them up until they had that music playing. It drawed them snake's attention.

"They'd reach in that box and bring one out. I've seed Henry lay a copperhead around his neck and stand there with it till it'd start crawling off and he'd reach up and get it. It was as big around as my arm. It'd hang down both sides of him. It must have been four or five feet long."

When they started the meeting, did they have a regular sermon first, and a singing, or what?

'They'd sing and play the music a while, then they'd get whoever they wanted to read the Bible for them. It was a sight to watch and hear them. They'd get in the biggest way. Law! They'd shout and shake their head and make noises to where you couldn't understand a thing they said, talk in unknown tongues, and run up to that box and grab them a snake. The music never stopped. They'd have a guitar, a fiddle, banjo and they'd sing. Oh, it twas awful."

And they talked in unknown tongues?

"Oh, yes, you couldn't understand a thing they said. When they jerked their heads, it looked like they'd fly off of their shoulders, and them a handling them copperheads and rattlesnakes all the time."

Alex, I know that most of the people in your area hunted and trapped for the meat and for the hides and furs. But in many areas people would get together and hunt foxes purely for the fun of getting together and for the sport of hearing the hounds run. And of course, they never tried to actually catch or kill the fox. Was there any of that type of fox hunting around here?

The 18th verse of St. Mark, chapter 16, reads in part: "...they shall take up serpents..." Alex, in describing the snake handling meeting he had attended said, "Oh, twas awful to watch them." (These photographs were taken in nearby Cocke County, Tennessee by Ken Murray)

"Old man Lou Trent down here, that's Margie's granddaddy, kept fox hounds all the time and he was a terrible feller to fox hunt. He and some other men would go fox hunting at least one night every week. He'd carry a little board to set on when the ground was cold or wet.

"They'd find a high point on one of these ridges and build them up a fire and set there, sometimes all night, and listen to them hounds run. They knowed whose dog was hottest on the trail by the way he barked, and they could tell how close the pack was to the fox. Everybody wanted his dog to be at the head of the pack, and they'd argue, sometimes, about whose dog *was* leading the others.

"One time Lou run a fox all night, and it got about daylight and we was eating breakfast and we heard them coming 'round the side of the ridge. Pap run and got his pistol and when the fox come out by the house he shot and killed it.

"In a little while here come the dogs and of course they stopped when the scent of the fox stopped, and they's a running around everywhere all confused. In a little while, here come Lou and some more fellers inquiring about where the fox went to. By that time Pap had him about skinned and Lou, he got so mad! He said, 'God-damned if I'd had that fox killed for $10.00'

"Oh, he was a terrible man to foxhunt. One time he took his two hounds out hunting. Lou and Loud was their names. The hounds catched a fox, and he stopped by an old lady's hut up there to warm up—least he used that as an excuse. She had two or three children lying on the ground—didn't have no floor in the house. He went in with that fox, and she asked what he'd take for it.

"He said, 'Well, I'll give you the fox if you'll let me sleep with you, and she said, 'All right, I'll shore make a trade with you.' They was just starved to death, and they skinned that fox and cooked it."

What other types of sports were there?

"Well they'd fight dogs, sometimes, and chickens. Right up here in the gap of the ridge there was a level place, and people would gather there and bring their fighting roosters. They'd bring banjos and fiddles and they'd have a hoedown along with it. A lot of mean women would come there and they'd have a time."

I asked Alex if he could think of any other activity which was engaged in mainly for the fun of it. His reply was most interesting. He said that sometimes they would serenade neighbors by plucking a tightly stretched and rosined string tied to the victim's house. They called it tattooing. I was sure I misunder-

172

stood and I had him repeat it, and again he said: "Tattooing. Didn't you ever hear of tattooing?" Well I couldn't imagine anything in the mountains of Hancock County resembling the maritime practice of coloring the skin.

I decided that Alex was mispronouncing some other word, or that he was confused, but when I consulted "Mr. Webster" I was surprised to find that tattoo once meant "A call on a drum, fife or bugle." Alex had added yet another word to my vocabulary. I asked him to explain tattooing.

"You take and drive a nail over the door or around the window frame of a house and tie a string to that nail, and then go off in the woods and pull that string tight. Take you some English rossom (rosin) and rub backwards and forwards on that tight string and it makes the awfullest racket ever you heard. Sounds like somebody's tearing the whole house down, but nobody can tell where the noise is coming from. They would serenade people after they got married, or to scare people and such as that. They'd have a lot of fun out of it.

"They was an old feller who lived over here by the name of Uncle Boone Gibson. He lived to be a 118 years old, they said. I don't know, for sure, but I know he was awful old.

"They's a feller that come by Uncle Boone's place one day, him and his wife, and they had no place to stay. Well, they got to talking to Uncle Boone and he felt sorry for them and he took pity sakes on them and let them move into an old waste house he had. This feller was to cut firewood to pay for his rent.

"Well, after he got moved in he'd come down to Uncle Boone's and just stay around and talk and eat, but wouldn't cut no wood much.

"Uncle Boone seed they wasn't nothing to him. He wouldn't work—wasn't no account. He said he'd give anything in the world to get shed of him but he was afraid to run him off, afraid he'd come back and burn him out or something.

"One of his neighbors, Jerry Mullins, said, 'I'll tell you how to get shed of him. Tattoo him. You won't have to tell him to go. He'll go hisself.'

"Well they fixed up that string while that feller was away, and that night Jerry Mullins and some other men slipped up above the house to where that string was tied. They took that English rossum and commenced tattooing that feller, rubbing it back and forth. They said that made the awfullest racket ever you heard.

"Well, that old man run out of the house trying to find the cause of such a racket, and they slowed down, but when he went back in the house, they started up again. It liked to have scared

him to death. He thought shore that the haints was after him, and the very next day, he moved out." (Alex laughed.)

How about footraces, wrestling and things like that?

"Oh, it was awful at the footraces, jumping, and wrestling we used to do. Men and boys would gather somewhere on Sunday afternoon. We'd have a feller lay down and stretch out on the ground, and then we'd scratch a mark at his feet and one at his head. He'd get up and try to jump the length of his body flat-footed. Now that's harder to do than you might think."

In races, I understand people would scratch a line in the dirt and start from there. In other words they would "start from scratch."

"Yeah, just take a stick and scratch a line in the dirt and that would be your starting line. Sometimes we'd have races on one foot. Just hop along. We'd run races like that till we'd get so sore we couldn't walk. Boy it was a sight to see people wrestle. We'd wrestle till we'd wear one another out, trying to see who could throw the other down and keep him there.

"Now we shore had some good times back then. People didn't get together too often but when they did they was a lot more friendly than they are now. They'd get together to help one another out, but you don't hear tell of that no more. Not like you used to."

On Death, Buryings, Funerals And Coffin Making

"I Never Charged A Penny For Making A Coffin."

In January 1982, when Alex had just turned 91, I spent several hours with him in his tiny back room where he'd begun to spend virtually all his time during the winter months. It was a bleak, windy day. He sat, as always, with his chair tilted against his bed, facing the one window which graced the room.

Gary Hamilton, a Knoxville photographer had accompanied me, and he took dozens of photographs which bothered Alex not at all. He was one of the few people I ever knew who did not, in one way or another, pose for the camera; and he was just as oblivious to the recorder.

The dreary, melancholy day was, I thought, quite appropriate for the subject I wanted to discuss with him—funerals and burying customs.

I was surprised the first time Alex touched on this topic. He talked of burials with no coffins, and of funerals conducted months after the burial. He remembered when funeral services were not held in churches, and when there were no flowers or grave decorations connected with funerals. No lettered markers were erected to denote the resting place, and the headstones were but rough uncut rock chosen randomly, on the basis of their proximity to the grave. In an endeavor to learn more about these customs, I asked several questions.

Alex, I think I mentioned to you a letter I found in an old trunk in the Smoky Mountains. It was from a man whose wife had recently died, and it was addressed to a Baptist preacher, asking him to come by and preach his wife's funeral some time in the spring of the next year. I thought it was a very strange request, but you told me this was not at all uncommon.

"Oh, no. When I was growing up and somebody died they wouldn't have no funeral when they buried them. They'd take them to the graveyard, and if they's anybody around handy, why they'd sing a song or something, pray maybe, and put them down in the grave. Now, if they was a purty good (important) person they'd generally have the funeral preached later on.

"When old George Bell's wife died, he didn't have her funeral till she'd been dead nearly a year. The people took rails and rocks to set on when they finally preached her funeral."

Would the service, the funeral, be held in a church, or at the cemetery?

"It was generally held at the person's home, or out in the yard. This practice of preaching the funeral in the church, that's not been in style too long. Oh, I say they've been doing that for 25 or 30 years. (I'm sure time has passed faster than Alex realized and that he was a little off the mark here.) I remember the first time ever I heard of a funeral being preached in a church. I thought that was the oddest thing ever was. He was a Trent and they had the funeral right down here on Panther Creek.

"When Mama died I was about grown, and by that time people had begun to have funerals sorta like they do now, only not hardly as good. I was a staying with a preacher over on Blackwater by the name of Munsey when Mama died. I's a working for him the day she died. They come and told me she was dead, and I come on home, but I went back there the next day and asked him would he come up and tend to it for me. He had a funeral sort of like they have today, and people talked about it."

I understand the practice of having flowers at the funeral and for decorating the graves wasn't carried on either?

"No. This flower business, you never heard that named. The first ever I knowed of having flowers about the grave was after Uncle Witt died. He was buried next to his mother right down from where Ellis lives. Then later his wife died and they was three graves there. Well, Old Spade Gibson, he was a preacher that lived right out the ridge. He come down to them graves and had a service. He got out there and started gathering every wild flower he could find, and he had all the crowd gathering flowers, and them that was too small he would give a flower so they could put it on them graves. Now, that's where the flower business around here all started from. I don't know where it started anywhere else, but that's where it started in this country.

"That's the way things was done back then. Now, if somebody dies and they don't have $500 worth of flowers and a big expensive funeral, it's a sight to hear people talk. The Savior—you can't find where they was flowers put around him. He was just wrapped in a linen cloth and a rock rolled over him."

I suppose the neighbors would dig the graves?

"Yeah, they didn't have no trouble getting a grave dug. Everybody, pert near it, would come if they knowed about it, and help dig a person's grave when they died."

I imagine it was hard to get enough coffins during epidemics.

"They died, sometimes, might near faster than they could put them away. I've seed people put away without any coffins. They'd just wrap them up in cloth, quilts, or whatever they could get, and put boards over them and cover them with dirt. They's a graveyard right up the ridge here, not half a mile, and I don't know how many folks is buried there, but I bet they ain't five people that's buried in coffins.

"Old Hannah Goodman died up here on the ridge and they buried her without a sign of a coffin. Just left her everyday clothes on her, cut out a place for her to lay and buried her. Didn't have no funeral service nor nothing. I was there."

Was it customary for people to have certain personal items buried with them?

"Sometimes an old person would want to be buried with his walking cane, his pocket knife, or something like that. They said the Indians would be buried with their dog, gun and bow; but I never saw nothing like that buried with the whites.

"When I lived over on Blackwater they was a feller named Lee Horton who lived right close to me. Me and him was good friends. Him and his wife took the flu, let's see, in 1918 I believe.

"I was up early one morning getting breakfast. Margie had just had a baby and wasn't able to do much, and I was making up dough to make biscuits when here come Bert Livesey. He said, 'I's wondering if I could get you to go up and help lay out Lee Horton.'

"'Lay out Lee,' I said.

"'Yeah,' he said, 'Lee's dead and I've been all up and down this creek and can't get nobody to help lay him out. They're all afraid of catching the flu and dying themselves.'

"I said, 'wait a minute and I'll shore go.'

"I just dropped what I was a doing, didn't even eat no breakfast, and struck out with him. When we got there his wife was bad off, right at the point of death. We laid him out, me and Bert, and got him ready to be buried. He'd began to get cold, and we had to straighten him out. He'd died all humped up—drawed up. Finally we got him straight. Took two chairs and put a plank from one to another, put a quilt under it and got him on that and laid him out. By the time we got him laid out, I guess we's two hours getting him fixed, his father-in-law, he come up and another feller or two with him, but they wouldn't come in the house. They's afraid to. Me and Bert had to fix him to put him away and they was just three of us at his burial.

"They said, 'Lord, I wouldn't have done that for nothing. If you take that you'll die shore!'

"I said, 'You don't die but once, I don't reckon.' I didn't have the flu for over a year after that. Finally I took it, but I'm still here yet."

What, exactly, do you mean when you say you "lay a person out"?

"We'd dress them and get them ready for burying. We'd put a nickel on each eye to keep them closed. Most everybody I saw die, died with their eyes open and if you let them get cold that way, then you could never get them closed. If you kept them coins on their eyes till they got cold, you could take them off and the eyes would stay closed. If you didn't have any coins you could use little flat stones. I've seen that done. Now, the funeral homes slip a little piece of paper under the eyelids and that keeps them closed."

You mentioned the flu outbreak of 1917. I imagine it killed a lot of people here, just as it did across the country?

"Oh, it was a sight. Sometime the whole family would be down and nobody to wait on them. There was a feller that lived across the creek from me named Charlie Mullins. They thought shore he would die and they was setting up with him. He had an awful high fever and they didn't expect him to live through the night.

"Along about twelve or one o'clock they went to nodding and Charlie slipped out of the house in nothing but his underwear. He was out of his head. He come over to my house and started beating on the door and waked me. There he stood in the snow, soaking wet from wading the creek. Didn't have on no shoes, nor coat, nor nothing.

"'Jump up right quick,' he said, 'They're after me and they're going to kill me.' His feet was cut and bleeding and I could see he didn't know a thing in the world. I built up a fire and got him warm. When I looked out and seen a light moving around across the creek, I knowed they's out looking for him. I hollered at them and they brought some dry clothes and come and got him.

"Well, that broke his fever and he got well. Doc Trent said later that that was all that saved his life."

We hear a lot about the smallpox epidemics of pioneer times. Were there such outbreaks in your area?

"Oh, I'll say. Pap and Mama both had it and nearly died. One of my sisters was married and lived up in Virginia and she and her man both took the smallpox. He was a coal miner. They didn't have nobody to take care of them and Mother she went up there to help them out. Well, in a few days she come down with the smallpox too, and Pap went up there and helped out for two or three weeks. He hadn't been back home more than two or three days when he come down with it and he got to where he couldn't go at all. He took to his bed and like to have died despite everything. He thought he was dying one night, but he managed

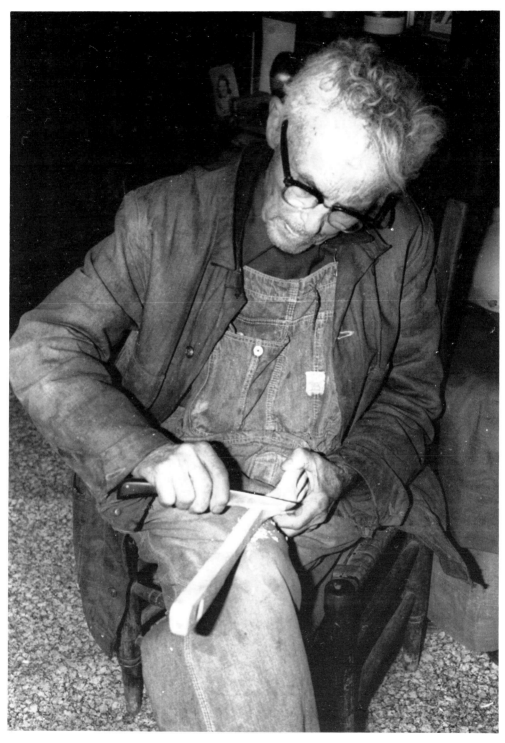

Alex was almost always making something—even when he was engrossed in talking about the days of long ago. Here he is shown, at age 90, making a wooden fork. (Photo by the author)

to pull through. He had blisters all over his face the size of quarters, and when he finally got well, them scars stayed with him for years.

"The doctor wouldn't come in on him when he was down. He'd come to within a hundred yards or so of the house and he'd holler. I'd go down and get the medicine and take care of Pap, and the doctor never set foot in the house. There was families that had two or three to die, and they was a lot of children that died. It was awful."

What type headstones were used to mark the gravesite?

"Oh, somebody would just pick up a rock and set it up. They never thought of having any lettering cut on it. Old Lou Trent was the first man I knowed of who had what you'd call a regular tombstone. They put up a rock at his grave and it had his name, his date of birth and all. Why, a lot of people would come down there just to look at that tombstone. They'd never seen one before."

How long, after a person died, was it before the burial?

"It depended on the weather. Generally it was two days, but if it was warm weather they'd bury them the day after they died. People would gather at the home when somebody died, and they'd take food if they could spare it, and they'd set up all night with the family. Old man Mahoney—he lived up there adjoining us—he got his neck broke and died and they set up with him for three nights. I don't know why his wife kept him so long. I helped dig the grave and made the coffin for him."

I assume that the coffin was generally not made until after a person died. In other words, no one had a supply of coffins where you could go and choose one as we do now.

"Oh, no, no. Never thought of looking about a coffin until a person died. Then you'd make the coffin to fit them. Clay Bell's daddy died and he had a nice coffin made and they undertook to put him in it and they couldn't get him in. It was too little.

"They'd had him up two days and they's kindly in a rush about putting him away. Well, Clay come to me and asked, 'What are we gonna do? We can't get Dad in that coffin.'

"'Well,' I said, 'You'll just have to make another one.' He asked me could I make one, and I said, 'Yeah, if I've got the right kind of lumber.'

"'How long will it take you?' he said.

"They was a law that you couldn't bury nobody after four o'clock and it was up in the morning then.

"'Well,' I says, 'if you get the lumber I can build it in a few hours.' He went down to the barn and got out the lumber and I started planing it down, and I never stopped till I got it done. By

the time I finished and we got him in it, it was past three o'clock. But we got him put away before four o'clock.

"After that, people started coming to me all the time to get me to make coffins. I made coffins for years. They was a Maxey boy come up to my place one time to get me to make a coffin for his twin babies. He asked me if I'd ever made a twin-baby coffin. I said, 'No, but I can.' We went and got the lumber and I made an awful nice coffin. I made it wide at the shoulder and barely sloped it toward the feet. Made it look good. I lined the outside with black cloth, and the inside with white cloth, and I got two little cotton pillows for it. I've thought about that a lot—how them two little babies looked laying there in that coffin side by side.

"Marie Johnson had a set of twins who died when they was a few weeks old. One died one day and one died the next, and I made a twin coffin for them. I've made many a coffin."

How much would you charge for making one?

"I never charged a penny in my life for making a coffin, because I knowed that one day I was going to have to have one for myself."

It is possible that no one tramped the hills and mountains of Southern Appalachia more than did Alex Stewart and it is likely that no one loved them more nor understood them better. (Photo taken about 1974 by Ken Murray)

Living Off The Land

"We Didn't Have S'Much To Eat But It Was Pure."

If the reader can imagine living in an area four or five hundred miles from a town in which only a few staples were available, and if he can imagine having little or no money with which to purchase these staples, then he will begin to understand how it was on Newman's Ridge when Alex was a child. It was only 20 miles to the stores in Jonesville, Virginia, but it took most of a day to walk there, about the same amount of time it would take today's family to drive from Bristol, Tennessee to New York City. The distance from a trading center and the almost total lack of cash resulted in the people of that area developing a self sufficiency which was perhaps unsurpassed anywhere in America. Not only were these people able to find or raise all their food, they learned how to make sugar, salt, vinegar, all sorts of teas, and other pseudo-luxury items such as soda, yeast, soda-pop, chewing gum, and even a sort of "coffee."

The forest may appear unproductive and unyielding to those not familiar with its many secrets, but to a knowledgeable and perceptive native, it yields a rich and varied bounty. One of the more important foods produced in the wild was honey. The honeybee is thought to have been brought to America in the early 1600's by the English. The settlers took colonies of bees with them as they moved west, and swarms escaped, returning to the wilderness habitat from whence they were first captured, thousands of years before.

I knew that Alex had, for many years, kept a number of beehives. I asked him about his experience with wild bees.

Alex, when I was a boy there was an old man in our community who spent most of his time roaming the mountains hunting, fishing, and looking for bee trees. Did you ever hunt bee trees?

"I don't guess there's a feller in the country that's found more bee trees than I have. I got out one fall and searched up and down this ridge for miles around and I found 21 bee trees. I marked them and went back in the spring to get them, and when I went back, they was only one stand of bees left."

What happened, did someone beat you to them?

"Some *thing*, not some one. When they got cold and froze up during the winter, the squirrels got in there and tore up their nests and eat that honey. Killed them out. They would have got the other swarm except it was in a hole so small that they couldn't get their heads in."

I take it that most of those bee trees were on other people's land?

"Oh yeah, but once I found a bee tree and marked it, no matter whose land it was on, the bees belonged to me. If the owner of the land where the tree stood got the bees, then you could law (sue) him. You shore could. I've knowed of that happening. Now, you couldn't cut the other man's tree unless he agreed to it. If he didn't give you permission to cut the tree, then you'd have to climb up and get the bees out, or leave them alone.

"I found a big white oak back here on the ridge that was just a swarming with bees. It was on Elvin Fleenor's place and I asked him could I cut the tree and get that honey. Told him I'd divide with him. But he wouldn't agree to let me cut it. He thought he'd wait a while and get the honey hisself.

"I just come off and said no more to him. The next day I got a feller to go up there to where the tree stood. I took me a rope, a bucket, and a hatchet. I stood there and studied the situation a few minutes, and I finally said to myself, 'you're mine.' About 30 feet up that white oak, right close to where the bees were going in and out of the hole, there was a big limb. This limb come right over and nearly touched a big beech tree.

"I climbed up that beech and took me two long poles, made me a sort of a bridge from the beech over to that white oak limb. I tied them poles to where they wouldn't roll or scoot. I took the hatchet and cut into that hollow white oak, and raked all the trash out and got about two and a half gallons of the prettiest honey you ever saw. I let it down a little at a time in a bucket to the ground, and that feller on the ground poured it in a lard can.

"I told Elvin about that and it liked to have killed him. He said I shore had the nerve to climb up there in the top of that tree and risk falling out. Said he wouldn't have done that for the best farm on the ridge. He asked me how many stings I got and I said I didn't get one. I smoked them out of that tree before ever I started chopping."

How do you go about finding a bee tree?

"If you go to where there's water in the woods you'll nearly always find bees there. When they're raising their young, they're all the time packing water to them young'uns. When they get all the water they can carry, they'll go up high and then head for the tree."

Is it true that the bee will make a straight "bee line" for its home?

"I've heard people say that they'd always go as straight toward the bee tree as you could shoot a bullet, but that's a mistake. I've followed them where they would go up a hollow, and cut around on the other side of a hill."

I'm sure you couldn't keep your eye on a bee for a mile or two, while running through the woods following him. What would you do when you lost sight of him?

"Just stand there and watch, and directly you'd see another one headed in the same direction. You'd follow him as long as you could see him, and then wait for another one. Just keep doing that till you found the tree."

I've heard of people putting out various types of concoctions to attract wild bees so they can follow them to their trees. They call that baiting, I think. Did you ever do that?

"Yeah, I've used bait to attract bees. I'd get me some tansy leaves and crumble them up in a little honey and set it out in a pan or bucket. If it was a warm day, the bees would smell that tansy and be there in no time. I don't care where you set that, they'd shore smell it. They'd fill up on that honey and head toward their tree, and all you had to do was follow them."

You've kept bees about all your life, haven't you?

"Oh, yeah. I had over 30 stands when I lived up there on the ridge. I've still got 16 or 17 stands out there in the yard now. I let Ricky have them to tend on the halves. He got a good lot of honey this year."

Did you ever buy a stand of bees?

"I never bought a stand, and I never sold a stand. I captured them from the woods. Started doing that a long time before I got married. After I found a bee tree and cut it, I'd take a crosscut and saw into where I could get at them. You'd have to use a smoker when you started tearing into their nest. You've got to get that queen. She's a big long thing, and looks just like a big yellow wasp. Just exactly. You get her and put her in a box and the rest of them will follow her just like a gang of pigs will follow an old sow."

I suppose you captured a lot of bees when they swarmed?

"Oh, yeah. Nearly every spring, if you'd be on the watch, you'd find a swarm or two of bees. I'd find a swarm and get me a gum (a hive made from a hollow black gum tree) to put them in and rake them up by the handful. They'd swarm around my face till I couldn't see for them. Never would sting me. They're not bad to sting when they're swarming."

What time of the year do bees swarm?

"Oh, they start about the first of April and on up till June, sometimes later. But the earlier you get them, the better off you are. A bee swarm in May is worth a stack of hay; one in June is worth a silver spoon; and one in July is worth a bluetail fly.

"That's just about right, too. If you get them in April and May when the apple trees are blooming, you won't have no trouble. If you get a swarm after June, they don't have time to make enough comb to keep them through the winter. They's not too much blooming after that. Oh, of course you could feed them along and that would help."

Every hive had to have a queen?

"Oh, yes. If you don't have a queen you don't have nothing. They'll just fly off in all directions. There was a preacher who lived down here on the lower end of Panther Creek, by the name of Jim Books. He had a big gum of bees and it come a rain and just about flooded them out. The gum was so full of mud that the bees could barely get in and out. He come up here to get me to help him move them.

"I made him a new gum and went down there. I pried one side off the old gum and was just scraping them bees up with my hands, putting them in the new gum. He had a boy helping me and he seen the queen. He said, 'look at that damned old wasp,' and before I could stop him he grabbed her and killed her. I said, 'wasp the devil, you've killed the queen.' (Alex laughed heartily.) I thought his daddy was going to kill that boy. Just grabbed her and mashed her to death. Called her a damned old wasp. I said, 'you just as well take the bees and throw them in the creek. They're not worth a nickel without the queen.'"

I suppose honey was a very important food when you were growing up, and while you were raising your family.

"It would have been hard to have got along without honey. Most of the time it was the only sweetening we had. You could make your breakfast on a piece or two of bread and a little honey.

"Five or six gums is all the bees you need to make enough honey for a family. I used to keep a lot more than that when I sold honey. Got to where you could get $2.00 a gallon for it. Then they started requiring you to have them inspected and pay a tax if you sold honey; so I just quit. I just keep enough for my own use. You've got to tend to bees or they'll soon die out.

"I've fooled with bees since I was 12 or 13 years old. I wouldn't give a man a dime to set down and write me a book about bees. I could write one myself. I've set and watched them and studied them for hours at a time."

Alex launched into a long discourse on the characteristics of the workers, the drones, and the queen and their relationship to one another. He told about the drones, which he called old roosters, and how they did no work whatever, staying in the hive, fertilizing the queen and "eating up" what the little workers brought in. He pointed out that these drones often become too numerous, especially in the fall of the year, and that the workers would get rid of most of them. They would carry them outside the hive, he said, and either sting them to death, or cut their wings off so they could not return to the hive.

A few hours later as Mutt and I walked down toward the sawmill we noticed an unusual amount of activity on the little platform in front of one of Alex's bee hives. On closer observation we found the worker bees carrying the drones out into the cold November air. The drones seemed addled and dazed, and weren't even resisting the ostracism imposed upon them. The energetic little workers took them to the edge of the platform and rolled them off where they were left to die. We watched for a moment and then Mutt said, "Pap shore knowed what he's talking about."

On another occasion Alex was talking about how important the honeybee was to the mountain folk. He had finished his discourse, and I couldn't think of anything else to ask him for a moment. Solely for the purpose of breaking the unaccustomed silence, I asked what I thought to be a rather foolish question. But the question was better than I thought it to be, because it prompted a most interesting and informative answer.

Alex, was honey from yellow jackets and bumblebees any good?

"The yellow jacket's honey ain't no account. But they ain't no better honey than bumblebee honey. They store it in little cups, about the size of a big thimble. Sometimes you can get 15 or 20 of them cups from one nest. Along about the last of May is the best time to get bumblebee honey. You've got to get it before the young ones get up any size, for they'll eat it up faster than the old ones can pack it in. You've got to be awful careful when you're robbing a bumblebee's nest. If you ever get them stirred up then you're in trouble sure enough.

Did you ever get honey from the locust tree?

"The locust tree produced a pod about a foot long. Now, when that pod got right plump and quit growing, you knowed it was full of honey. You could gather them in the late summer, on up into the fall, and they'd keep pretty good. You could take one of them pods and take two boards and squeeze it and the honey would run out. It's not as good as bee honey, but you can eat it or use it to sweeten with, either one. The blight come and killed about all the locust trees out, and now you hardly ever see one."

You've often told me that some of the families on Newman's Ridge practically lived out of the woods. What were some of the other things the forest produced?

"Back then there was a little tree, a bush, they called a sarvas (service or Juneberry tree) tree. They had berries that was good to eat if you got them when they was green. They're about the size of a huckleberry. I've gone to a sarvis tree many a time and picked a half gallon. They're no good to make a pie with—too bitter. But if you get them at the right time you never eat a better berry than a sarvis. They're just about all gone now. You never see a sarvis tree no more.

"Did you ever eat any black haws? They used to be a sight of them and if you got them right after the first frost they's good. You could eat all them you wanted and they wouldn't hurt you. A hackberry is pretty good too, but they's not much flesh on him. Just mostly a big seed and a skin."

I used to go out with my grandfather to hunt wild hazelnuts. Did you have them here?

"Hazelnuts? Yeah, we'd gather them. We'd get walnuts, hickory nuts, chinquapins and chinquapin acorns. A chinquapin tree don't get very big. I never did see one grow higher than that door. They have a burr like a chestnut. The chinquapin oak had an acorn that looked a heap like a chinquapin. That's why they called it a chinquapin oak. That's about the only kind of an acorn you can eat. The rest of them are too bitter.

"Before the blight killed the chestnut trees, why the woods was just full of chestnuts. A lot of families lived on chestnuts in the fall of the year and half the winter."

I understand people used to let their hogs run wild and fatten on acorns in the fall?

"A hog will do pretty well on black oak and chestnut oak acorns when they first fall off. But they won't eat most acorns until after a good freeze. They don't taste so bitter after they freeze.

"They used to be just acres of mayapples that growed in the woods. You know what a mayapple is don't you? It grows up about a foot or so high and has fruit on it that gets about the size of a peach. They smell good, and taste good too, when they're ripe."

There were several kinds of edible berries, I suppose?

"There was all kinds of huckleberries in the mountains, wild raspberries and blackberries, and dewberries. Dewberries grow flat on the ground on a vine. I've picked many a gallon of dewberries. They've got the best flavor of any berry you ever eat when they're good and ripe. They make the best jelly. I could eat a glass full of them any time."

What about pawpaws?

"People used to might near live off pawpaws. I saw Jim Maxie

set down once with his hat full of pawpaws and eat the last one of them. Pawpaw's that grow on a tree out in the field, out in the open, won't last long after they fall off. The insects and things will soon eat them up. But you find a pawpaw patch in the woods, where the leaves cover them, and they'll keep a long time. I was out hunting one day and I hadn't had anything to eat. It was in the winter time. I smelled pawpaws and I got to scratching under the leaves and the ground was just covered with them. I set down and eat the biggest bait ever you saw."

There were several kinds of wild grapes?

"There was a lot of different kinds of grapes that was good to eat. Fox grapes, 'possum grapes, pink grapes, summer grapes and muscadines. The muscadines were the biggest grape there was. You could smell a big vine of muscadines a half mile, might near it, and that's the best way to find them. Oh, they're good. The 'possum grape was small, about the size of a number three shot, and they wasn't much to them. The pink grape was sour, but it made awful good brandy. Law at the brandy I've made from them pink grapes."

In his discussion of wild food, Alex mentioned artichokes. The plant he described was the Jerusalem artichoke, which produces a rough tuber somewhat like the potato. I have raised them in gardens, but never knew they grew wild. A little research revealed that they are one of the very few plants which will grow either in the wild, or as a cultivated plant.

Another interestig aspect of Alex's comments on artichokes was his mention that they could be "smelled out" by pigs. This is reminiscent of the great European delicacy, the truffle, which grows mainly in France and which is dug with the assistance of pigs. The claim is made that the pig can smell a truffle from a distance of 20 feet, even when it is buried deep in the ground. The pig is allowed to root it out, but the valuable fungus is quickly taken from him for use in the finest restaurants. (A recent article on the subject indicated that the current price for truffles is $500.00 per pound.) Naturally I was surprised when Alex described how a Tennessee hog could smell an artichoke in much the same manner as a French pig could sniff out a truffle.

"Up here where Pap lived, on the back side of the place, there was two or three acres that was pretty flat and artichokes would grow there as thick as if they had been planted. They produce a sort of 'tater that grows sometimes two feet deep. People would come there and bring sacks and baskets and dig them artichokes. They eat pretty good.

"Now a hog could find them when a man couldn't. I've seen a hog root so deep that they might near had to stand on their head.

189

Oh, they knowed exactly where to root, and you could tell by the way he was rooting when he was going after one. I reckon mother nature must have give him a powerful sense of smell."

The last time I was up here you were telling me about a kind of mushroom Kyle and Dora Bowlin brought you which you liked so much. It's called wildfish I think.

"Law, at the wildfish in the woods this spring. They grow to about the size of your arm, and the end is right blunt, just like you'd broke it off. They come out early in the spring, just about the time trees start putting out their leaves. When they get to turning a sort of grey color, you need to get them. They don't last long. They have a little bitty bug on them, and them bugs will destroy them. After you gather them in, you can take and put them in water and them bugs will everyone float off."

How do you cook them?

"You just split them open and fry them like you was frying a potato. It'll just take a few minutes. They taste just like fish, only better. I'd like to have a mess of wildfish today."

Because of Alex's truly astounding knowledge of "old-timey things" I often forgot that he had kept up with modern-day contrivances and methods as well. His comments on the mushroom he called wildfish, and whether or not they could be frozen, is illustrative.

Dorie and Kyle gathered a great lot of wildfish this spring and put in the deepfreeze. I told Dorie that they wouldn't keep too long that way. If you eat them right away, they do pretty well, but it don't take long before they're ruint. They won't keep in the freezer like a lot of other food. I'm afraid she'll lose them." (Dora Bowlin proof-read this manuscript, and after this paragraph about freezing wildfish, she penciled in the following: "How right he was! I had to throw away several bags.)

Did garlic grow wild, too?

"People would go far and near looking for garlic and ramps (rampson.) They'd put a little salt on them, and a piece of bread, if they had it, and eat them raw. They'd eat the blade and the heads too. If you eat ramps and garlic you'll never be bothered with worms. But they'll smell you all day."

On my way to see Alex one morning in early spring I saw an old, bonneted woman out in the middle of what appeared to be a barren field. She carried a basket in the crook of her arm and her eyes searched the ground, from one side to the other as she trudged along. Occasionally she stooped to pick the tips of some tiny plant which had barely made its way from the yet cold soil.

Anyone who knew anything about rural Southern Appalachia would have known that this old matriarch was looking for salad. And likewise, a person with even a cursory familiarity with the folkways of our region would have known that salad is always cooked instead of eaten raw.

The little cress that peeps, unnoticed, from beneath a blade of dry corn fodder, the dock that grew on the south side of the haystack, and the hardy dandelion were all candidates for the salad pot. But one had to know which plants were edible, at what stage in their growth to gather them, and what other plants to mix with them.

The stooped old lady reminded me of the hundreds of kindly old souls whom I'd known who looked forward to picking the first salad in the spring. It was, for many, the first time they had walked the fields and forests since the gloomy and dismal days of winter had begun, and the greens tasted good after so long without fresh vegetables. The daughters-in-law would inquire as to "what all" was included in the brew, the men would ask for more, and the old women who picked and cooked the salad would be happy.

I knew that Alex would be able to tell me all about salad greens which grew wild in the meadows and mountains of Hancock County.

What were some of the greens people would pick for salads in the early spring?

"We'd go to the woods and fields and hunt different things. We'd get lamb's quarters. Oh, what a sight to see people picking lamb's quarters. That's the best stuff you ever had. Woolen britches is pretty good, too. We'd get what they called shouny. It grows in big round bunches the size of a plate and looks like mustard, only the leaves ain't as big. You'd cut it off and the milk would just run out of it. It takes north land to grow shouny.

"Dock is all right if you get it while its young, but if you let it get to be a right smart size, its no good. There's three different kinds of dock: yellow dock, narrow dock, and burdock. Burdock isn't good for a salad but the others is about as good as mustard. You take plantain and mix it with narrow dock, about half and half, and that's the best salad I ever eat, might near it. I don't like too much dandelion in a salad. It makes it bitter.

"Hydrangea, when it first comes out, before the leaves grow on it, is good. We'd pick kitty too. Oh, that kitty is a good salad.

"Did you ever hear of cropped cabbage salad? It's better than regular cabbage. Before your cabbage headed out, you could cut off them bottom leaves and cook them by theirselves for a salad, or you could mix them with other greens. Put you a big piece of meat in, if you had it, and cook that down good. It wouldn't hurt

your cabbage at all about heading out, to pull off them bottom leaves. They'd finally go to waste anyhow.

"Poke come on later in the spring. It would be out big enough to pick between the first and the tenth of April and you'd hardly ever see a poke stalk but what somebody had broke out the top for a salad. You've got to get it when its young and tender. You use the leaves for a salad, but you can take and fry the stalks. Slice them up like you would okra, roll it in meal, and you've got something that's worth eating. Margie used to can polk stalks, and poke salad too. Poke salad, if it's got at the right time, is the best salad ever I eat."

Do you like dry land cresses?

"No, they're too bitter. I used to eat water cresses, but I never cared too much for them either. Now, they was what they called a branch lettuce that growed in the branches in early spring that was pretty good. You could cook it in a salad, or you could kill it with hot grease like you do tame lettuce."

Did you ever eat any sheep sorrel?

"Sheep sorrel is awful sour and it's good to put in your sweet apples when you're cooking them. A sweet apple has got a sickening taste when it's cooked and they're no account for a pie. But you take and put some of that sheep sorrel in, and it shore brings out the taste. You can make a pie out of nothing but sheep sorrel if you sweeten it pretty good. It tastes just like an early apple pie."

Before we leave the foods you got from the fields and forests, tell me about making sugar.

"There was a big stand of sugar (maple) trees that stood up on Grandpap's place and we'd tap them every year. Pap and Grandpap would generally tap them in February and March and let them run in big wooden troughs. It was my job to pack the sap from these troughs to where we had two big iron kettles to boil it in.

"Lord, I'd go in a trot all day long, carrying that sap water over them hills and rocks, trying to keep them troughs from running over. I've got so tired that I wished I'd never see another sugar tree. I would have druther seen my coffin a coming, might near it, than to have seen another bucket of that sap.

"I'd help boil it off too. I was fixing up the fire around the kettles one day, and I was wearing an old cotton shirt that Mama had made for me, and it catched fire. It burned way up past by elbow, and liked to have killed me. They was great blisters that come up, and after the sun went down Mama took a needle and opened them blisters up and they's a half pint of water that come out of there. She put a poultice on it and it soon got well, but the scars stayed with me for 40 years."

How many gallons of sap does it take to make a pound of sugar?

"A bushel of sap will make a pound of sugar, or it'll make a quart of molasses, or three pints of syrup."

What's the difference between maple molasses and maple syrup?

"Tree molasses, or maple molasses, is just a little thicker than tree syrup. That's all. You just let them boil a little longer."

A large kettle that held two bushel would only make two pounds of sugar, you say. How long would it take to boil down a kettle full?

"Oh, it would take about all day long."

I know that this was your main source of sweetening, but did you have extra sugar to sell?

"Oh, yeah. That was about the only money we had coming in all winter. I remember one time they's an old feller by the name of Clum Testerman who come to our house to buy some sugar. Mama had a two-gallon brass kettle plumb full of that sugar and she turned it upside down and it dropped out in a big solid cake. Old man Testerman said, 'I'll swear, ain't that pretty.' He gave her 10¢ a pound for it.

"Some people would put a little cane molasses in the sugar to make it pay off better, but it wasn't as good. Pap never would allow us to do that. Said it wasn't right."

Ten cents a pound amounts to only 20¢ for the day's labor in boiling it down, not to mention carrying the sap to the kettle and the other work involved.

"Well, you wouldn't get rich at it, but every little bit helped out."

Most people, even in our own region, assume that cane molasses was made here since the earliest pioneer times. But you tell me that this practice came on later.

"People didn't make cane molasses because they didn't have mills to grind it on. The first cane mill ever I saw was the one Grandpap Stewart made. He made it every bit out of wood, rollers, cogs and all. The rollers had some play in them, and the first time you run your cane stalk through, it would just bust it, and you wouldn't get much juice. He'd have a man setting on the other side to hand them stalks back to be run through the mill again. We'd take two or three of them and twist them together and run them through the second time, and that way we'd get most of the juice. We pulled the mill with an old bull, and people would come from miles around to watch us make molasses.

"A few years later, Jessie Maxie bought a mill with steel rollers, and it wasn't long before a lot of people started raising cane patches and making molasses. They'd eat it with bread, and

they'd use it to bake pies and cakes. It got to where people would might near live off molasses."

You've told me about all the wild meat people ate. I've always heard that 'possum and sweet potatoes were considered to be a great meal.

"Oh, boy. Nothing's no better than 'possum and sweet potatoes. You just skin him and parboil him with a little salt and some garlic, then take him out and stick him in the oven. Put some sweet taters in with him if you want to. Buddy, you've got something that's good to eat.

"Some people won't eat 'possum because they're so nasty. They was a woman who lived over across the creek and she'd come over on Sundays every once in a while with her children for dinner. She was here once and Margie was baking a big 'possum I'd caught. That woman wanted to know what smelled so good, and Margie told her what it was. She said, 'Law, don't tell me you eat them nasty things.' Said, 'they'll eat any old dead thing they is.'

"Margie said, 'they ain't a bit nastier than a chicken or a pig.' Well, we set down to eat and that 'possum smelled so good that she reached over and got her a little bite. Then she got her a whole leg, and I never saw anybody eat as much 'possum in my life. She said, 'the next time you catch one, be sure and let me know.'"

Did you ever fatten 'possums?

"Yeah, they'd fatten just like a hog. If he's young and skinny you can feed him a few weeks and it's a sight how he'll gain. They'll eat anything—every kind of a scrap you can think of. They love pawpaws and persimmons. Get him up to where he weighs about seven or eight pounds and you've got some good eating.

"When Pap killed a rabbit in the winter time he'd skin him and hang him up in a tree near the house. When we wanted one we'd cut him down and roast him over the fire. We'd use a green hickory stick to roast him on. If they was the least bit of grease from him, we'd pull him from the fire and let that grease drip on a piece of bread till it quit dripping. We'd save every drop."

The spring of 1982 brought the World's Fair to Knoxville, and with it a flood of visitors from throughout the world to the Museum of Appalachia, which was located only 18 miles north of the Fair site. Every time I planned the 80 mile trip to see Alex, it got postponed for one urgent reason or another, but one bright, sunny day in late spring I decided to escape from all the din and visit Alex in the peace and quiet of his Panther Creek home. As it turned out, I got one of my memorable lessons concerning wild food.

I found the cheerful old fellow sitting on the front porch with Mutt. A one-eyed cat rested on his lap. The location afforded them a grandstand view of the meadows, the Panther Creek bottoms, and the precipitous mountains beyond. Alex's eyes lit up when he saw me. "Well, I'll be switched," he laughed. "I's a setting here a studying about you just a while ago." (He always said that.) "I told Mutt I sorta expected John Rice to come up today, but when it started getting late, I sorta give you out."

It was quiet on Panther Creek—not even a breeze to stir the leaves of the maple trees in the yard. The late afternoon sun shown horizontally on the meadows, making them especially beautiful.

Let's see, Alex, I want to record a little, if you don't mind. What is the day of the month?

"Today is the 4th," he responded promptly and confidently. He had no appointments, nor commitments, but it was characteristic of him to keep up with everything.

What were you looking at when I came up, down there in the meadow?

"We thought we saw a mud turkle (turtle) but it wasn't. Just a big rock. We saw one crawling across down there the first of the week and I sent Mutt down to get it. I've seed a lot of turkles but I never saw one any bigger than that one. I showed Mutt how to clean it, and it made a dish-pan full of meat. We cooked him and that was the best piece of meat ever you put in your mouth. We've got some of it left in there yet. Did you ever eat any mud turkle?"

I hadn't eaten mud "turkle" before but I began to suspect I was going to do so before long. I've eaten many kinds of wild meat, including 'possum, but the thought of eating a mud turtle was less than appealing. We caught them when I was a child, and I remembered their wrinkled, leech-covered legs and their awful, putrid smell. I hoped they would have some beans and potatoes, and wouldn't push the turtle.

I used to know people who hunted the soft-shell variety to eat, but I never heard of anyone eating these old hard-shell turtles.

"That's right, a lot of people don't think a hard-shell turkle is any good to eat. They're a little harder to clean, but they've got just as good a meat as the soft-shell. I used to catch them all the time and I eat every one I caught."

How did you catch them?

"I'd catch them on trot lines and in fish baskets. You can go along the creeks and feel along in holes back under the bank and catch them with your hands. He can't bite you under water, but when he leaves the water, buddy you better watch out. He'll snap your finger off."

What was this one doing out in the middle of the field?

"They spend all their life in streams or in ponds, around water. But they's times when they'll migrate from one body of water to another. They'll cross from here and go all the way over to Blackwater."

Cross over the top of Newman's Ridge?

"Yes sir! I was up on top of the ridge one day squirrel hunting. The dog had treed two or three squirrels and I shot them out. Then I heard him start barking again up on the ridge. I could tell by the way he barked that it wasn't a squirrel he's barking at. When I went to him he had a great big old mud turkle. He was heading from this side of the ridge over toward Blackwater. I got him and come by Joe Bell's house and he wanted to buy it off me. I offered to give it to him but nothing would do him but to pay me for it. He said, 'if you'll dress him for me I'll give you 50¢.'

"If I've got good hot water to scald him in, I'd druther clean a turkle than a fish. You can take the heart out of a turkle and lay it out by its self and hit'll beat for an hour, and it not attached to anything.

"A turkle will dig down in the mud in the fall of the year a foot or more deep and stay there all winter. They'll come out around the first of April. I had a marshy bottom down here that stayed covered with water. One winter I went in there and started digging drainage ditches and I don't know how many turkles that I plowed out—way down in the mud hibernating for the winter."

Did they ever catch your chickens or your ducks?

"I can tell you a tale you won't believe. I had a pond out here and it was full of turkles. They got so bad about catching my young ducks that I had to keep them killed out. They was a lot of crows that raised their younger over here in the ridge and they'd come over to this pond to water. One day I heard the awfullest racket that ever was down at the pond. I run down there and they was a bunch of crows flying around everywhere, hollering, and carrying on, and they was diving down to the pond. When I got there I seed what had happened. A turkle had one of them crows pulled plum under the water with just his head sticking out. The crow had walked in the pond to wash hisself, I guess. They're bad to wash all the time. And that turkle had catched him by the leg. I grabbed that crow by the head and pulled him out of the water and that old turkle was still hanging to his leg. They won't let go."

I've always heard that when a turtle got hold of something, he wouldn't let go until it thundered.

"I've heard that all my life. I guess that's about right. Oh, they'll eat all the ducks up. If you don't watch them, they'll get one or two every day until they're all gone. Get off me! (Alex

fussed at his one-eyed cat that jumped onto his lap.) I wish you'd go to your young'uns. That was the prettiest kitten you ever saw. It come here when it was just a little thing and a old hen pecked one of its eyes out."

How do you cook turtle?

"They say a turkle has seven different kinds of meat, but I just put it all together. Put it in a big kettle with plenty of water. Put some garlic in, a little salt and some 'taters. Take about a pint of tomato juice and pour in, pepper it good and let it cook down. You don't need to add any seasoning. They've got enough fat about them. Oh, boy. You talk about eating."

The sun had disappeared and we could barely see the meadows down on Panther Creek. It was almost dark and very pleasant on the front porch, but a cool breeze had begun to float up the valley. Mutt decided Alex should go inside.

"Get up Pap, you don't need to be out here in this night air." Mutt cautiously took hold of one of his father's arms and Alex bristled.

"I'll thank you to tend to your own business," Alex said as he pulled away. "I've done pretty well taking care of myself." Mutt just grinned and let him be. He knew better than to insist. In a very few minutes Alex decided that we'd best go into the house, a decision he pretended was completely his own. Although his legs were, as he said, "wobbly as dish rags" he refused all offers of help. He staggered, half bent over, barely making it from one chair to another until we reached his room.

Mutt built a small fire, and then disappeared. It wasn't long before I heard movements coming from the kitchen, the sound of pots and pans being shuffled around on the stove. In a few minutes I smelled something strange, and I knew I was about to have my first meal of hard shelled mud "turkle."

Alex continued to talk and I continued to listen, but I kept thinking about the smelly and thoroughly detestable creature and I'd decided to flatly refuse to partake. Then I thought of how this would hurt their feelings. I knew I couldn't refuse to sample it, no matter what the consequences.

It wasn't long before Mutt appeared with a half grin on his face and a demeanor of self-satisfaction. His only comment was, "Come on John Rice, let's eat." As I was led away, Alex was telling me to be shore and eat plenty of that mud "turkle."

Mutt had taken the cooked turtle, rolled it in flour and fried it to what the commercials would have described as being a crisp, golden brown. Although he had corn bread, gravy, beans, and cabbage, Mutt had placed a big piece of turtle on my plate, just to make sure I didn't miss it. It looked and smelled good, and when I

took the first bite, I knew all my anxiety had been for naught. It was truly tasty and I soon asked Mutt to pass the turtle again. He was delighted.

Alex was not feeling well, and had not come to the table, but he anxiously awaited my verdict. After all, he had spent a good part of the afternoon extolling the tastiness of "turkle." His reputation was on the line.

"Well John Rice, did it make you sick?"

"Alex, in all the years that I've known you, you've never misrepresented anything. But when you told me how great that turtle was, I confess, I thought you were getting a little carried away."

Alex sat and puffed his pipe as he waited anxiously for me to finish.

"I have to admit that the turtle is every bit as good as you said—even better."

Alex laughed and laughed. I don't think I ever saw him so pleased. Finally, he said, "I won't steer you wrong, son. If you wait for me to steer you wrong, you'll be waiting a long time."

Later that same year, on a hot summer afternoon, we sat again on his front porch and talked. It was one of those days where the intense heat and the humidity causes wavey, vapor streaks to rise from the ground. There didn't seem to be much to talk about, and the only sound was the occasional call of a bobwhite. I remembered how my grandfather, in his old days, would call them to within a few feet of where he sat, by imitating the female partridge. I asked Alex if he ever did that.

"Yeah, I've been calling one up here every day or so. I guess that's him you hear. Every time I call he'll fly a little closer and finally he'll come here in the yard. Law, back when people was raising wheat and oats this valley used to be full of bobwhite."

They were considered to be very good to eat, weren't they?

"Oh, yeah. It used to be that you'd take your gun everywhere you went, in case you saw a quail, rabbit or something. I was going across Newman's Ridge once with Pap to the mill. I killed four squirrels by the time we got to the top of the ridge. Pap said, 'what are you going to do with them squirrels? You're not going to carry them all the way to Blackwater and back are you?'

"I took them out beside a big log and scratched a hole in the ground and buried them so they'd stay cool, and so the flies wouldn't blow them. In a few hours we was coming back with our sack of flour we'd had ground. I was ahead of Pap and I's fixing to go dig my squirrels out when here come a gang of partridges walking down the side of the road. I just eased my sack of flour off my shoulder and dropped down and them partridges went right

over to where there was a big huckleberry bush. Just beyond them I saw a rabbit's ears sticking up. I drawed right down on that rabbit and killed him and four partridges in one shot. (He was using a shotgun.) I give the rabbit and squirrels to Pap and eat the partridges. Oh, how good they was."

Alex, every time I think of something I thought couldn't be produced by your people, I find that they either *did* produce it or they produced a substitute for it. But what about tea and coffee. Coffee and tea plants are grown in foreign countries.

"When people couldn't get regular coffee, they'd make it out of wheat. Take and parch it and then grind it up and it makes purty good coffee. I've drunk it many a time. You can take and parch corn, get it as brown as you can without burning it, and that makes coffee too. Same with chestnuts. You could put you in a little tree syrup or molasses to sweeten it up."

What about chicory?

"You could use it for coffee, but I never cared nothing about it. It used to grow around here, but I ain't seen no chicory in a long time. People would mix a little with their coffee along.

"For tea we used sassafras mostly. It made a good tonic, too. That's the best smelling stuff you ever smelled. You'd use the roots. Spicewood made good tea, but you'd use the twigs instead of the roots. Once in a while we'd make mountain tea, but it wasn't too good. It'll thin your blood, but if you drink too much of it, your blood will get too thin. You can make a pretty good tea out of birch, but nothing beats red sassafras and spicewood."

I remember a big vinegar barrel in the cellar at my grandparent's homeplace. They made their own, and I'm sure you did also. How did you go about making vinegar?

"You take your apples and beat them up good and put them in a wooden barrel. If you have two bushel of apples, you need to add about a gallon of water. They'll lay there and rot, and then they'll work off. The more they sour and rot the better your vinegar is. It's just nature for it to be that way.

"There's a time in the making of the vinegar that a mass will come up in there and make seed, and that starts the mother. The mother is a spongy looking thing about the size of your hand. That makes the vinegar. If the weather is warm you can make vinegar in five or six weeks, but it takes twice as long or longer in cold weather.

"When your vinegar got worked off and made, you would take it out, strain it and put it in another barrel for storage. Grandpap had a big 60 gallon barrel that he kept full of vinegar all the time. Had a wooden faucet in it. When Grandma needed some vinegar to pickle something with, I'd go there and draw her out some. It would keep right on. Hit never got too old."

What kind of apples are best for making vinegar?

"You need sweet apples to make good, sour vinegar."

Sweet apples! I would have thought sour apples would have been best. But when you think about it, it makes sense. Sweet apples have more sugar and that causes better fermentation. Could you make vinegar from anything other than apples?

"Oh, yes, if you have a mother. Now I've seed my grandma take that mother out of the barrel and dry it. It looked just like a cake of soap. If you kept it from molding it would last from one year to another. Sometimes people would come along and borrow a little piece of that mother to make them some vinegar. You could take a piece of that and put it in a vessel with some molasses, or some sweetened water, and you could make vinegar that way.

"You can take pure apple cider and make vinegar, but it's not good like when you grind the whole apple up and let it rot. That's the reason this store-bought vinegar is no good. They put a whole lot of acid and stuff in there to make it taste like vinegar, but its never seen a apple. They have a pretty picture of a apple on the bottle. 'Pure apple vinegar,' it says. It ain't no such thing."

Since childhood I'd heard the expression, "as thick as hops" but I had never seen a hop growing in Southern Appalachia. I inquired among numerous old folks but found no one who had seen, even heard of, hops in this region. The enigma of the popularity of the expression about hops in an area that grew no hops lingered in my mind. I put this question on my list of items to discuss with Alex.

Alex, did you ever hear of hops?

"Lord, yeah. We used to have two hop vines, and they'd come up every spring. It's a tame vine like a grape vine, only thicker. They growed pods that looked like a little, long apple. They're about the size of a banty (bantum) egg, and they're the best smelling stuff you ever smelled. Yes sir, I've used many a pod of hops."

What were they used for?

"Hops had lots of uses. You could make your yeast out of them to make your bread light. You take the milk that you're going to use to make your bread and mash up two or three pods of them hops and put in it. Let it set about 24 hours, and when you make your dough from that milk it will might near jump out of the pan. Just a handful of dough will fill a big vessel. It makes your bread light and puffy, and makes it taste a heap better too. My mother always kept big pokes full of dried hops.

"If you wanted to make your milk clabber quicker, just drop a pod or two in, and in a few hours it would commence to clabber. We used hops for medicine. It's good to put on a boil or rising—

makes them come to a head. Of course they were used to make beer. We never used them for that, but that's the most important thing in making beer."

What was the origin of the expression, "as thick as hops?"

"Them vines would grow almost all the way 'round the house, and they would just be covered with them pods. One vine would make, I guess, four or five bushel of hops and they'd be so thick you couldn't touch the vine without touching one of them hop pods. I reckon that's how come they started saying 'as thick as hops.'"

You told me once about making your own baking soda?

"We'd burn these limestone rock and make lime. We talked about that the other day. If you didn't have soda or baking powder to put in your bread, you could use a little of that burnt lime, but you don't want to use too much, or it'll hurt you."

In reading an account about rural English life in the last century, much was made of the extreme hardships of the country folk. The statement was made, for example, that even the farmers seldom ate butter. It was considered to be too valuable for their own consumption and was sold to the more prosperous city folk. They would use, as a substitute, hog lard. I could hardly wait to ask Alex if he had ever heard of this practice.

Alex, you have said that few families had butter to eat. What did they use in place of butter? Did they have a substitute for it?

"They'd use just regular old hog lard sometimes. I've seen Pap, many a time, take lard, salt it a little, and put on his bread. He could make a meal out of that. I've eat it. It eat pretty good. Pap liked it better than butter."

I've always heard that salt was considered one of the most important items in pioneer times, and that it was one of the most scarce. Were you able to produce your own salt?

"If you could find a little stream or a spring that had a good deal of salt in it, you could take and boil the water down and get a little salt. The cattle would lick around in the mud sometimes, and you could tell by that where they was salt.

"They used to be a salt well down here on the east end of Blackwater. They had big iron kettles down there that they used to boil the water in. They called them salt pans. They held eight or ten bushel and they were lined up in rows. Had a regular salt works going there.

"After they closed it down, some of them big kettles was used for scalding hogs in. I remember, when I was a small child, that old Dr. Mitchell down here had one that he used about butchering hogs. You finally bought it, didn't you? It's down there at your Museum."

We've talked a good deal about all the food which the forests produced. But what about gardening? Was that an important source of food?

"Oh, I'll say. My Grandma Stewart was the best hand to garden, I guess, that they ever was in this country. If I was to tell you how she growed cabbage back then, it'd look unreasonable. I'll swear she'd grow a cabbage head that big (he used his arms to encircle an area as big as a basketball) and she'd raise a hundred.

"An old lady lived right out from us by the name of Patsy Maxie, and she come out there one day and asked Grandma what she would charge her for 20 cabbage heads. Grandma said, 'For good cabbage heads, I get a nickel apiece.'

"Well,' she said, 'I want 25 heads.' We went down to the garden and pulled them out, and Grandma, she just charged her $1.00 for all them.

"The name of them cabbages was late flat Dutch. She'd always sow her seed the first Monday in August, for the fall cabbage crop. It wouldn't be but just a few days till they'd come up. She'd hoe them two or three times, and she'd take them fine shavings from Grandpap's woodworking, and put them along the side of the cabbage plants. She said it held moisture and made them grow.

"She had to go past her garden to go to the spring to get water, and she never failed to take something to put on it to enrich the soil. She said that anything that would rot was good for the land. Well, she was right about that. She'd save her ashes, what she didn't use for other purposes, and pack them down and put on the garden. She'd go to the woods and get black dirt to put around her vegetables. Oh, what a gardener she was."

What did she use to keep the bugs and insects off of the vegetables?

"We didn't have none to amount to anything. No sir. I can remember the first bean beetles that ever come in this country. I was up there tending my corn and bean patch and they was on the beans, and I got to looking at them. I hated to kill them they looked so purty to me. I went and left them, and directly they was eating my beans up."

What about potato beetles?

"Well now, the tater bug's been here ever since I've knowed of. Ashes is good to get shed of tater bugs. And if you want to catch them old cabbage worms, reach down and trim off that bottom leaf and lay it right across that head, sprinkle just a little bit of table salt on that, and you're through with them worms. That's the way they done back then. Ashes work too. I don't know if it kills them or not, but it stops them from eating."

"Grandma raised 40 to 50 bushels of sweet potatoes every year. She'd make hills just like a haystack and put two slips (plants) in

Alex and son Mutt on their way to plant winter onions—in October 1980.
(Photo by the author)

every hill. They don't do that no more. When they got big enough to dig, why all you had to do was just take a hoe and rake the dirt away from them, reach down and pull your taters out. That's the only way she knowed how to raise taters.

"She had what she called a winter onion, and it would stay green all winter long. In the early spring they would just jump up. People would come there and buy a whole row of green onions. She'd get a quarter a row for them. That's all a lot of folks had to eat.

"She'd keep parsnips in the garden the year 'round. When fall come the stalks would die down, and she'd never dig them. Any time during the winter that she wanted some parsnips to cook, she'd go pull her up two or three big ones. They stayed good all winter."

What else did she raise in her garden?

"Oh, she would raise pumpkins, all kinds of beans, corn, beets, turnips, squash, rhubarb, horseradish, peppers, asparagus, and just about every kind of vegetable that you could think of. She never raised any tomatoes. Nobody ever heard of tomatoes back then.

"She had some gooseberry bushes. Oh, I've gone to the gooseberry patch with Grandma and Grandpa and set down, when they'd get ripe, and eat a pint of them. Now I can't find one nowhere. I had some here but they died out and left. They was them big long, green gooseberries and when they got ripe they was clear. You could see through them. Just looked like they was full of water. Talk about a good pie."

And asparagus was grown back then?

"My daddy had beds of it. He'd dig down about six inches and fill it with rich dirt and manure, and it would grow stems as big as your finger. It was still there the last time I was up there. But you've got to keep the soil loose and take care of it for it to pay off. It gets to where the sprouts are little and spindly and no account."

Apparently the women tended to the garden more than the men?

"Un uh, that was mostly woman's work. The men did most of the farming, working horses or cattle and things like that. But when it come to taking care of the gardens and orchards and things around the house it was usually left for the woman."

Alex, we know that you had to raise or hunt all your food, we know that people knew nothing of canning in the days of your youth, and we know there was no means of refrigeration. If you didn't eat a squirrel or fish in a few hours, it would spoil. You've told us that most of the people didn't even have a spring at their disposal. So I want to ask you some questions about the various methods you used to preserve, to keep, food for long periods of time.

"There's different ways to keep different things. Some things we'd dry, others we'd pickle, or sulphur, or bury, or salt down. It depends on the kind of food as to how you would fix it."

My grandparents, and even my mother, dried green beans in the sun. We'd have to put them out every morning, and take them in at night. Is that the way you dried your vegetables and fruit?

"Lots of people would just dry their stuff in the sun. But that takes so long, and worms and bugs are bad to get in them like that. Pap made two dry kilns for Mama to use. Things would dry so much quicker in a kiln, and they weren't as tough. The sun makes them tough."

What do you mean by a dry kiln?

"He'd build a furnace out of clay and rock about eight feet long and four feet wide. He'd put a big flat rock on top and cover it good with clay mud. He put a chimney at one end, just like you was going to make molasses. Build you a big fire under that and before long that rock would get hot and that clay mud on top of that rock would dry out and be just as hard as concrete. That would hold the heat for hours."

Why did he have two drying kilns?

"We had a lot of apples to dry. We'd peel them, core them and cut them up and put all we could on one kiln. We'd put a cloth on the clay to keep them clean. While they was drying on the first kiln, we were getting a batch ready for the second one. You had to turn them every once in a while to keep them from scorching. When they got good and dry, we'd sack them up and hang them overhead in the house and they'd keep all winter."

Did you and Margie have a kiln?

"Yeah, I built one. I don't know at the kilns I've built for other people. I built the chimneys up about four feet high so they would draw the smoke out good. You want to use hickory and blackjack oak for your fire. That'll hold about the same temperature and it'll hold the heat longer. You don't want to get it too hot or you'll burn whatever you're drying.

"Law, I've dried hundreds of pounds of fruit that way. I'd get 2½ to 3¢ a pound for dried apples and dried peaches at the store. It had to be nice, good fruit or they'd turn it down. They always bought mine, but they turned a lot of folks down on what they brought in."

"Old Bill Green run a government still right up yonder, and he'd buy all the dried fruit you'd take him, to make brandy. You could take him a wagon load and he'd buy it every bit. He'd pay you off in brandy or whiskey."

And you could dry berries this way?

"Why, law yeah. My Mother dried many a blackberry. I'd pick them for her. Didn't you ever eat dried blackberries? They eat good. You can put them in water and cook them and you can't tell them from a fresh one.

"We'd dry grapes, too. Make them into raisins. We had a tree we called a damsel (damson). It was a kind of plum and we'd dry them and make prunes. It was a regular prune tree.

"Beans, law we'd dry beans on them kilns for weeks at a time. Just take green beans and break them like you were going to cook them, and put them on the kiln instead. They'd get so dry they'd rattle like shucks. That's what we called them, 'shuck beans.' some people called them leather britches."

I've heard of drying pumpkins.

"The way we always dried punkins was to cut them up in

round rings about an inch wide and hang them up on the porch or somewhere to dry.

"When you go to cook dried punkins, you need to put plenty of hog meat in it. It ought to be cooked a half day to make it good. I wouldn't care (mind) to have a mess of dried, cooked punkin right now."

You mentioned pickling food. How did you go about pickling beans, for example?

"You put them in a big kettle and cook them, not too done. Take them out, spread them on a table and pour cold water on them beans till they got perfectly cool. I've done that many a time for Mama.

"When they cool down good, put them beans in a big wooden barrel and fill that barrel up with water. Then put enough salt brine in to where it will hold up an egg. When the egg floats up to the top, with half of it sticking out, you know you have enough salt.

"Then get some little thin, flat rocks and put them on top of them beans, to hold them down. If you don't, they work up and come out all over the place. You let them work several days and you have some beans fit to eat.

"That's the same way with kraut. If you want good kraut, always make your brine salty enough that hit'll float a egg. You can put too much and it won't do, and you can put too little and your kraut's not good. Same way with beets, cucumbers or anything like that. Mama would always know just how much salt it took to fix it."

Well, brine isn't anything but salt is it?

"Salty water is all it is. Hit will purify (the food) and it'll keep all winter. You take them beans out and rinse them off good, put them in a skillet with a little grease and fry them up. They's already cooked so you don't have to fry them much. That's the best beans you ever eat. They wasn't so good if you cooked them like fresh green beans. They's mostly just to fry. Lord, I've stole my hands full of them pickled beans many a time. Sometimes Mama would pickle corn and beans together. She'd put her a layer of beans and a layer of corn. She'd cut it off the cob. I tell you that's good."

You mentioned sulphuring fruit?

"My mother sulphured fruit all the time. She'd take one of these big wooden barrels and set a pie pan in the botton with two big spoons full of sulphur in it. Set that sulphur afire and it would smoke for hours. She'd put a big flat rock underneath the pan to keep from burning the bottom of the barrel. She'd take a big basket of apples and hang it from the top. She had a little stick that laid across the top of the barrel, and she'd put that through

the basket bail. That would let her basket hang free so the fumes could get all around it. See, a basket will let that smoke get through to the fruit where a solid vessel wouldn't.

"She would take an old quilt and put over the top of the barrel and that would keep the smoke and fumes from escaping. She'd leave that basket of apples in there about all day and the fruit would shrink to about one-third of what it was. We would take them apples, after they was sulphured, and put them in another barrel to store them in. We would just sulphur one run a day and it took nearly all summer, it seemed like, to get one big barrel of sulphured apples.

"When you wanted to make you some fried apple pies during the winter, or if you wanted a baked pie, you would just get a handful of them apples and they'd be as pretty and white as ever. But you had to wash that sulphur off. You couldn't eat it if you didn't."

The sulphur would kill all the bacteria and that's what kept it from spoiling?

"Yeah, that sulphur was high-powered stuff. When you took that quilt off the barrel, you better not have your head over it. Them fumes coming out of there would shore stifle you and burn your lungs. I like to have got strangled to death like that once. I took the cover off and the fumes (sulphur dioxide) blew out in my face and it seemed like it was 20 minutes before I could get my breath.

"That's why it's so good about preserving things. It kills all the germs and bacteria. They used it to fumigate houses to get rid of chinches, and they used it after someone died of smallpox or some other bad disease. It would kill every flea and bed bug in the house."

I suppose it would get rid of the rats, mice, snakes and everything?

"Oh, yeah. It would get rid of the devil if he's in there."

You mentioned earlier the sweet potatoes your grandmother raised. I know they were an important food for the people back then, but it seems to me it's hard to keep them for any length of time.

"A sweet potato will go through a heat and rot on you if you ain't careful. You have to get them dried out, and then keep them in a warm, dry place. They ain't no sweet potato that's good to eat like it ought to be till it's dried out. Grandma had her a little celler dug under the floor, right next to the fireplace, where she kept her sweet 'taters. She had a trap door to it. It held 25 bushels and she'd fill it full and cover them with leaves and they'd last all winter. She'd have potatoes left over for seed every spring. People would come there to get their seed 'taters to plant."

I understand that one of the most popular old-time methods of keeping certain vegetable and fruits involved burying them in the ground, what they called "holding up".

"Oh, everybody would hold up a lot of their stuff, if they had anything. I've helped my Grandma, and my mother too, bury cabbage. We'd pull them up by the roots and bury them upside down, with just a little bit of the root sticking out. That way you could find them and pull one up any time you wanted to cook a mess. They'd keep all winter and be just as pretty and white and crisp as they could be. The freezing made them tenderer."

What other kinds of food would you bury?

"You could keep turnips, beets, apples—find a sort of high place, where the water wouldn't stand and dig out a big hole and line it with straw or leaves. You could use moss if you had it. Put your vegetables in, cover them over with straw and then pile you a mound of dirt on top of that. That would turn the water off and your stuff would stay dry and crisp all winter."

Didn't you mention once that your Grandfather and Grandmother Stewart had an apple house?

"They had a dug-out, back in the back with a roof over it. Called it their apple house. In the fall of the year we'd gather bushels and bushels of apples and put in there. They had the biggest apple tree I ever saw that growed in their front yard. It had an apple on it called a 'sheepnose' that was awful good. That tree was loaded down with apples might near every year.

"When the leaves fell along in October and November we'd go to the woods and get sacks full to put on them apples. Grandma said it took leaves to keep apples. I've gone down there many a time in the dead of winter and got a bucket full of apples. They'd stay good till long about April."

Pork was the favorite meat in Southern Appalachia. From it a family could obtain its year's supply of ham, streaked meat and sausage. The rendered fat, or lard would be used daily for cooking and frying.

Every old-time homeplace that I recall had a special building for storing pork. It was sometimes called the meat house, but almost always it was referred to as the smoke-house, though most people never smoked their meat. The one, sometimes the only item, found in these old pioneer smoke-houses was a trough carved from a single poplar log. In the small smoke-houses of the poor mountain settlers, this trough tended to be smaller, just as the smoke-house itself was smaller. In the wide and fertile valleys, and along the rivers, both the smoke-houses and the meat troughs were often two or three times as large as those found in the

mountains. A thousand times I've been told the troughs were used to "salt down" the winter's supply of pork.

There is no question but that these troughs *were* used for this purpose, after salt became available. Indeed the practice of curing and preserving pork in salt continues to the present day. But this requires an enormous amount of salt, and it was a scarce and highly costly commodity in frontier times.

It didn't seem possible that a family could afford, or even acquire, this much salt in pioneer times. In an endeavor to learn if there had been another method, an earlier one, of curing and preserving pork, I inquired among the old mountain folk whom I encountered. Always the answer was the same. "They just packed it in them big troughs and covered it with salt." I had pretty much given up on finding the answer to this perplexing question when Alex touched on the subject one night.

"Grandpap Stewart had a big log smoke-house and he had two big poplar meat troughs—one on each side. They was about four feet square and they was as long as the house. Every fall he'd kill a drove of hogs and he'd pack the meat down in the troughs and cover it with salt. No, he didn't salt them, he covered them with wood ashes."

With this one short sentence, we had found the answer to the baffling question of how the pioneers kept their meat.

Alex, did I hear you right? Did you say your Grandfather packed his meat in ashes? I never heard of that.

"He cured his meat that way all the time. When he broke up housekeeping Pap got one of them hams that he had cured in ashes that was seven years old, or so they said. When he brought it in, Mama said, 'Joe, I don't believe a dog would eat that meat.' It looked awful. Pap says, 'I'm afraid you're mistaken.' He washed the ashes off and it was just as pretty as could be. It was just as yellow as a pumpkin. And when he cut down in-under that rind, just a little thin rind, you could eat that meat without frying it or anything."

I remember my Grandfather Irwin talking about eating raw pork and I've always wondered how this could be. I now assumed that it was cured in ashes like you are talking about.

"Oh, I've eat a lot of it without it being cooked. It was as good as any meat you ever eat. He never hung his meat. He didn't use no salt. Them ashes preserved it and made it just as solid. It wasn't soft.

"Now you need hickory or black jack to make good ashes. Them's the strongest ashes they is. The ashes you get from soft wood ain't much account. No strength about them."

Would he use the ashes from the fireplace?

"No, they wouldn't be enough. He'd gather in a great lot of hickory and black oak, blackjack we called it, and he'd pile it up crossways and burn it for the ashes."

In discussing hog butchering, it occurred to me that Boyd Stewart probably didn't have a metal vat nor an iron kettle big enough to heat the water required to scale the large number hogs he killed.

Alex, how did your Grandfather heat his water for hog killing?

"Well, he'd heat it with rocks. He'd take and make him a rick of good hard wood and he'd cover that with good sized rocks. He'd burn the logs and purty soon them rocks was hot. He'd take them and put them in a log trough made out of poplar, and that'd heat the water right away. Then he'd roll them big hogs in there and scald them and scrape them."

What did he use to lift the rocks over into the trough?

'He had a big paddle-board that he'd run up in-under them and pitch them into the vat of water. And he wouldn't care if part of the ashes went over in there too. It made the hair come off better. That lye from the ashes helped to bring off the hair."

Did he smoke the meat before packing it down?

"After he cut it up, he'd let it drain out for a day or two. He'd dig two big trenches and build big fires in them and hang the meat over them to smoke. If we didn't have any bad luck we could smoke two batches a day. We'd smoke the side meat and the shoulders, but Grandpap said he'd rather have his hams unsmoked.

"He'd put a layer of ashes in the bottom of his wood troughs before he'd put his meat down. Then he'd put another layer of ashes, a layer of meat and so on till he got them full. He wouldn't put a speck of salt about his meat. Them ashes would take up the moisture and dry it out. He'd leave it there till he got ready to eat it. You didn't have to worry about it spoiling."

What method did you use for preserving sausage?

"We'd keep in in shucks. Take a big pretty ear of corn and shuck it right careful, and it would surprise you how much sausage that shuck would hold."

You had to fry it first?

"Yeah, fry it and pack it in there and then tie the end right good so it couldn't get any air. You could just hang them shucks full of sausage up on the wall or from the ceiling anywhere in the house, and it would keep right on. Mother would fix souse meat the same way."

I want to talk to you a little about cooking. I've eaten some of your cooking over the years, and I know that Bill Henry has eaten

a good deal more than I have, and we both agree that you are truly a great cook. Before we talk about your own cooking, I wanted to ask you about some of the conditions you saw as a boy regarding cooking. Some of the homes, you have said, didn't have any metal utensils at all. How, for example did they bake their bread.

"I've eat many a mess of ash cake. Clean you off a place on the hearth right close to the fire and sprinkle a few ashes there—just enough to cover the rock. Put your dough there and cover it up with ashes and then put you some hot coals on it. You could take a poker or a stick and peck on it to tell when it was done."

You would think that the dough would get full of ashes.

"It won't. When it gets done, just turn it upside down and peck it a little, and blow them ashes off and you never eat no better bread. If I's burning wood here instead of coal I'd have me some ash cake ever once in a while."

It's hard to believe that people were so poor that they couldn't afford even one iron baker. But I suppose that there were a lot of them like that?

"Oh, law yes. They's been hundreds and hundreds of families that lived off ash cake in this country. They didn't have a cooking pot in the house. They cooked their bread, 'taters and meat right there on the fire. If they went out in the spring and got a mess of salad greens, they'd have to go somewhere and borrow a pot to cook them in. My mother loaned her kettle out many a time."

How do you make corn bread?

"I take my meal and put in a dab of sugar, a little soda, some salt, and just a little lard. You don't want so much lard in your corn bread that you can taste it. I mix that up with buttermilk. You can use sweet milk but buttermilk is better. If you don't have either one you can use water, but that makes your bread hard."

Bill Henry tells me that you're the best biscuit maker he ever knew. What's your secret for making such good biscuits?

"It's all in knowing how. After I sift my flour I put in a little soda, so much grease, mix it with buttermilk and work it. Now you don't *pretend* to work it, you've got to roll up your sleeves and get in there and just keep working it. That causes it to rise and be lighter. I don't know at the preachers who have eat here and said them was the best biscuits they ever eat in their life. I haven't seen nobody that could beat me when it comes to making bread."

Alex, we're always asking questions about what the average meal was like, the type food served for breakfast, or supper and so forth. But from what you've said, the people ate whatever was available.

"That's exactly right. I've made a meal many a time on nothing but a bowl of cornmeal mush. Sometimes we'd just have a glass of clabbered milk for supper. It's thick, you know, just like jelly and

you eat it with a spoon. We didn't go to the store and buy nothing. If we had any candy, gum, soda pop, cakes, or anything like that, we made them ourselves."

I never heard of people making their own soda pop.

"You put two or three spoons full of molasses out in a bowl, sprinkle you a little soda on that, and just a little vinegar, not too much, and watch it boil. It just boils and pops like you've got a fire in-under it.

"It'll get thin, just like the soda pop you get in the stores now. I've drunk it till my belly would bust, nearly. George Bell's folks would come down about every week and we'd make two or three gallons of that soda pop and drink it every bit. We'd use a quart of molasses before we'd quit."

And you made your own candy?

"Oh, law yes. We'd have candy pullings. Take two chairs and set them back to back. You'd have a boy in one and a girl in the other and they'd start pulling and stretching that candy and handing it backwards and forwards as fast as they could while it was still hot. When it got hard it would be just like a piece of glass.

"I'd like for you to see a candy pulling. It's funny to watch them go at it, pulling that candy back and forth across them chairs with both hands. It wasn't no trouble to get a crowd of boys and girls to come to a candy pulling. Just put out the word and they'd come from far and near."

What kind of flavoring did you use?

"We'd gather our own flavoring. We'd get peppermint from along the banks of the creeks. We'd gather horehound and flavor with that sometimes. Take that and put in your kettle where you were cooking the candy and add a little soda and it was soon ready to be pulled."

And chewing gum?

"You take the turpentine from a pine tree and the rossum (rosin) from a sweet gum tree and mix it, and that makes the best chewing gum you ever put in your mouth.

"Mother made a sweet bread she called gingerbread. We'd go out and gather wild ginger, dry it good and grind it up. It's good flavoring for bread. It's a good tonic and blood medicine too. I've dug a sight of wild ginger."

I'm sure it was pretty rough when you were growing up, and the food was very scarce at times, but you enjoyed it, didn't you?

"Oh, yeah. We got along better and enjoyed ourselves more than people do today. And people lived longer."

You've mentioned, at one time or another, several people who were a hundred years old, or older.

"I've knowed I don't know how many who claimed they was over 100. Howard Mullins over here on Blackwater, you knowed him, was said to be 109 years old when he died. I remember when he first got married. There was another feller by the name of Howard Collins. He had two brothers, Bailey and Noey. They all three lived to be over 100, according to their records.

"Old Boone Gibson, from what Pap and Grandpap said, lived to be about a 118 to a 120 years old. He had the biggest hands and arms on him of any man ever I seen in my life. He was awful big. He wasn't fleshy, just big boned.

"Ikie Johnson up here lived to be way over a 100 years old. I knowed him all my life. He would make baskets and scrub brooms and things like that. He would load his little mule down with them things and be gone two or three days peddling them out. He'd trade baskets for little scraps of meat. He carried an old greasy sack with him to carry the meat he traded for. I've seen him coming many a time with that old sack full of stuff.

"People was so much healthier and stronger than they are today. We didn't have s'much to eat, but what we did have was pure and it agreed with us. Now then when you buy your food from the stores, you don't know what you *are* eating."

I've fooled with bees since I's a boy. I've still got 16 or 17 stands out there in the yard now. (Photo by Gary Hamilton)

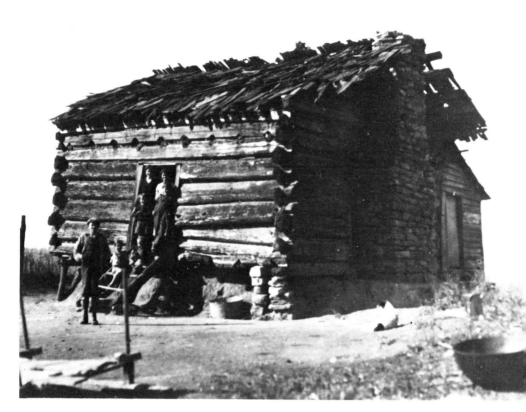

When Alex said: "They's a heap of folks that don't know what hard times is," he must have had families like this in mind. (This photograph was taken in a nearby community in the 1930's by Lewis Hine)

Hard Times That Lasted Too Long

"They's A Heap Of Folks That Don't Know What Hard Times Is."

As he discussed various topics, Alex often alluded to the hard times and bad conditions he had observed on Newman's Ridge. He talked of his neighbors who had to resort to eating terrapins, house cats, skunks, and even rats. He remembered bark-covered houses, dirt-floored cabins and at least one family that lived in a hollow tree. He spoke of women who went barefoot the year 'round and of proud, hard working men who could never supply enough food for their families. I asked Alex about the stark and desperate conditions which descended upon so many of the people who lived on Newman's Ridge—about the hard times.

"I know a little something about hard times, son. I come up with a whole lot of it. But of course they was a lot of folks that had it a whole lot harder than we did. Grandpap was counted as one of the best livers there was around anywhere. Grandpap and Lou Trent was the only two fellers around that had horses back when I can first remember, and Grandpap kept two cows, some hogs, sheep, and chickens. He had it good beside a lot of the folks.

"It's miserable to think about how some folks lived. They lived in little one-room pole cabins and you could throw a dog through the cracks. They'd have dirt floors and I've seen them when they wasn't a stick of furniture in the house—not a bed to sleep in, a chair to set in, nor a table to eat off of. In the summertime most of them would sleep around in the woods, on the ground. Now people think I'm lying when I tell them this, but I swear it's the truth.

"Grown women would go from house to house begging to wash for you for a piece of meat or a little corn to feed their younguns. There was an old feller named Bill Gibson and he'd come to work all day long for a hen. I don't know at the hens Mama let him have.

"It was hard for you to set down at the table for a meal without somebody coming to help you eat. If we ever had anything left over, a piece of bread or a 'tater, Mama would save it in case somebody hungry came by. I've knowed people to come by

begging for these old, thick pieces of meat skins. Don't know how in the world they managed to eat them.

"I recollect once that Pap hired a neighbor woman, Lou Ann was her name, to come and help us chop corn. He couldn't hardly afford to pay her, but he mostly hired her because he took pity sakes on her. It turned off cold and started to snow and she didn't have no shoes and just a very few clothes and she was about to freeze. Pap unhitched the old mare and we went in for dinner, and Mama had an old ragged pair of shoes and she told Lou Ann, 'If you can get them shoes on you can have them.' She said, 'Lord, yes I can wear them.' That was the proudest woman ever you saw.

"Poor old thing, she got in a family way and was out working in the field for Frank Collins when she fell off a rocky ledge and hurt herself. She had a misarriage and died."

So the women worked in the fields the same as the men?

"Oh, yeah. They's tickled to get a chance to work back then. Times was so hard they had to work or starve. There was another woman that helped us work the corn patch. Her name was Betsy Miter. She was a tall portly-looking woman. Her man wasn't worth shooting.

"One day we was clearing a new ground, digging out roots and stumps and burning them in a big pile. Well, she run upon one of them old terrapins and she killed it and put it in the fire and cooked it. When it got done she busted it open with her hoe and set down to eat it. Now a person's got to be awful hungry to eat a terrapin."

I suppose they just had to eat anything they could get?

"That's exactly right. It'd tickle them to death to catch a 'possum or a rabbit to eat. They'd never think about skinnning a varmit like that before they eat it. They'd just take his insides out and put him over the fire and cook him, head, ears, feet, tail and all. I can remember when they was half the people who lived right out of the woods, eating varmits, nuts, pawpaws, haws, sarvis, mayapples, and such as that.

"They'd make it purty good in the summer and fall, but along up towards Christmas they was up against it. I'll tell you they shore did see trouble. One feller, he lived right over yonder on that ridge, come over and begged Margie's Daddy out of a cat. He took that cat home, killed it and fed it to his family. Now, he shore done that. He was a Collins. Well, when you get to thinking about it, a cat is a lot cleaner than a 'possum, or even a chicken. They ain't no kind of old carrion that a chicken won't eat."

You told me once, Alex, that some of the people you knew ate skunks or polecats.

"Oh, yes, Jim Johnson would eat ever polecat he'd catch. Course he wouldn't catch them in the summertime. He'd wait

until the fall of the year when the fur was good, and he would skin them and get the hide and then he'd eat the polecat. That's as good a meat as ever I eat."

You've eaten it, too?

"I eat two bites. I used to catch them in the fall, for their fur, and they'd be just as fat as mud. I'd take and render them out to get the oil. Now you'd be surprised how much oil you'll get from a good fat polecat. You'll get over a pint. I's rendering some on the stove one time and it just smelled so good and looked so good, and I said, 'I'm a gonna taste of that.'

"I got a leg out and I declare that was the best piece of meat ever I laid in my mouth. If you know how to skin one, you don't get a bit of that scent on the meat."

What did you use the polecat oil for?

"That's the best thing ever you put on leather. If you put it on a burn before it has time to blister, it'll never biister. It'll draw the fire right out. And it's good for croup. The kids used to be awful bad back then to take the croup, and they would be stopped up till they couldn't get their breath. You could take a teaspoon of that skunk grease and let them swaller it and in a few minutes it was all over with."

Will it keep in a bottle or jar, just like hog lard?

"Yeah, and it don't cake. I don't care how cold it gets, hit won't cake. It's sort of yeller. It looks like castor oil. Why, they was people who'd come to our place from all around to get that polecat grease.

"People just did whatever they had to do to live. Now there was an old fellow named Jim Mason who lived up on the ridge here, and he was in his corn crib one day shucking corn. They was a lot of rats in there and he killed two or three, skinned them and took them home and cooked them. He tried eating them but he couldn't do much good at it. Said they was too strong."

I suppose most people ate corn bread?

"Yeah, they was lucky if they had corn bread. They was very few folks that ever had any flour to make biscuits. A lot of folks had no bread at all. A lot of times they'd just parch corn and maybe roast some 'taters, even for breakfast. I don't know at the times people would come and want to borrow a few ears of corn to feed their family. Pap would always give them some, and I never did know of him charging anything for it. He always tried to manage so he'd have plenty of corn.

"Now, there was an old feller that used to live right here where I live now, and he made a crop one summer on nothing in the world but mustard and bread. That's what he eats three meals a day: breakfast, dinner, and supper. He'd mix up his meal and just bury it in the ashes and cook it that way. Ash cake, they called it. He had three or four children, and they'd go out and pick green

mustard and that was their meal. They'd each have them a little gourd full of water to drink.

"I was passing by there one day and stopped to talk to him a minute. He was eating dinner. He said, 'You're welcome to come eat with me, but all I've got is green mustard and ash cake.' He said, 'I wish I had more to offer you, but that's all we've had all spring.'

"Back then people would go out and dig up wild onions to eat. They was a family that lived up here on top of the ridge over a bluff. They was a lot of wild onions that growed at the foot of that bluff, and every day they would go down there and eat them wild onions. They're awful good for your heart, and they claim they're a good blood medicine too."

I guess a man would do almost anything to get food for his children if they were starving?

"Johnny Wilson lived way on the back of Lou Trent's place and he got up against it. He had nine or ten children and they run out of corn one winter, and had nothing for his family to eat. He got to slipping down to Lou's place at night and climbing up over the logs in his crib and stealing corn. Lou got to noticing one day and he saw where the top of that corn was going down and he set a big steel trap where they had been reaching through the cracks.

"That night about ten o'clock Johnny went down to get some more corn and he climbed up to the top of them logs and retched his hand in there and got caught in that trap. He was hanging up there by one hand and the other one in that trap and couldn't get down. He commenced hollering: 'Oh, Lou Trent, Oh, Lou Trent. Come and get me out.'

"Lou heard him and come out and hollered back. He says, 'I'll come and get you out at daylight.' Made that poor man hang there by one hand all night. When day come he went and got him out and made him come up to the house and eat breakfast with him. Yes sir, made him come and eat breakfast. Johnny said, 'I didn't do it because I was too sorry to work, but my children was hungry and I had to do something.'

"Lou said, 'Now you could have told me and I'd let you borrow some corn, or give you some, but don't you never steal from me again. The next time by God I'll catch you with some buck shot.' He let him go.

"Johnny liked to have lost that hand in spite of everything. He kept it tied up for I don't know how long, and when it did get well his fingers were all crooked and twisted and they stayed like that till the day he died.

"Lou give him a job cutting wood for him. Oh, at the wood that man could cut. He never stopped, and he was the choppin'est man in this whole country. He cut, I guess, a thousand cords of

wood for Lou. Lou got to liking him and trusted him with anything he had. He was honest, in a way. He wasn't what you'd call a rogue.

"Johnny had seven boys, but they never worked like he did. They was a rail fence close to where they lived, on Lou's place, and sometimes when it got right cold they'd go out and cut up them rails for firewood rather than to go to the woods and chop down a tree. Old Lou would hear them and he could tell by the sound when they was chopping rails. Yes sir, it sounded a little different. He'd go up there and make it hard on them. He'd make them go to the ridge and split out rails and fix the fence back. Johnny claimed he couldn't do nothing with his boys. Lou said, 'I've raised a few boys myself and I'll be Goddamn if they don't do what I tell them to do.'"

I suppose there weren't many cooking vessels, and not a lot of what we call silverware?

"No, the women and children just ate with their fingers. The men would use their pocket knives, if they had one. They was a family that lived out the ridge from us that didn't have a cooking pot in the house. They'd cook their 'taters and corn in the fireplace in the ashes. And if they ever had a piece of meat, they'd just roast it over the fire.

"Pap bought the first tin vessel ever I seen. It was a little tin bucket that held a gallon. My grandmother Stewart didn't have a tin vessel in her house. The cups, knives, forks, spoons, pitchers, bowls and everything else was made out of wood or gourds. Granny had a big gourd that she used to milk in. It had a hemp and flax rope for a handle. There wasn't a glass dish about the place, and no glass in the windows.

"I tell people that now and they think I'm lying. I try not to misrepresent it, and if I do it's because I don't know any better."

My old friend, Oscar Ely from Harlan County, Kentucky, has often told me about his great-grandfather raising his family in a big hollow tree. Did you ever hear of that?

"Yes sir. There was an old woman named Liza Lamb. She had three or four young children and didn't have no place for shelter and they lived in a big hollow poplar tree for a while. I've seed that tree many a time. It stood on the north side of the ridge back here.

"Poor old thing, she had a hard time feeding them kids. She'd come up to Grandpap's and Grandma's and want to wash for something to eat. She wasn't a good hand at washing and Grandma would just give her some 'taters, or corn, whatever was ripe, and let her go on. She could just barely get enough to keep her nakedness hid. Her children was just stringy headed little old things, never no shoes and half the time no clothes. It was just pitiful to look at them.

"They finally moved in a cave right up the ridge from where I lived. They called it the Brock Cave. The Brocks had lived in there at one time. Yeah, I've been back in that cave many a time. After you got back in there a ways, they was a pretty good-sized room, and that's where they stayed.

"After they moved out of that cave, people would go there to make music. They'd take their banjos and fiddles and have a big time. They'd go there about every Sunday. Music sounds good in a cave."

I know that every family wasn't lucky enough to be located near a spring, especially those who lived on the ridge. Where did they get their water for cleaning, bathing, cooking and so forth?

"About the only thing they used water for was cooking and drinking. In the summertime they might go down to the creek and take a bath. In the winter time some of them would heat a little pan of water on the hearth, and take a rag and wipe off a little bit.

"Oh, plenty of them never took a bath. I'll swear to God, I've seed children with their hands and feet so rusty, black and cracked up where they'd get welts and crust on them that you couldn't tell if it was flesh or what. They would be just as black as that chimney jamb right there. And their face and hands just about as bad. Oh, I've got so sorry for them I could die, might near it.

"In the spring of the year the young girls would build a dam across this creek down here on my place so the water would be deep enough for them to take a bath. I was down there one day in the spring and they was half dozen girls there taking a bath and them stark naked. Didn't pay no more attention to their hind-ends showing than if they didn't have one."

So, when you were growing up you didn't even have the old galvanized tubs?

"Oh, no they didn't come in for a long, long time. I can remember the first cake of store-bought soap that I ever saw. 'Lennox' was the name of it. It was just as yellow as a pumpkin. You could use lye soap to wash in, but you had to wash it off right away. You couldn't put it on and stand around. It would sure eat your skin."

Alex, considering the fact that many people had very little clothing, that the houses were so open, it seems that some of them would have frozen.

"Oh, yeah. It was pretty regular back then. There was two or three women that froze to death right up here on top of this ridge. I remember, like it was yesterday, when a woman and her two children froze to death. She lived in a little log house, and had no bedcovers, and no way to get wood for a fire. It come a real cold spell and they just froze to death."

"Poor, but proud, resolute and independent," seems to describe this mountain man whose cabin and land is remarkably similar to those early homes on Newman's Ridge. It was from homes such as this that many successful business and professional people sprang. (Photo by Lewis Hine)

I realize that conditions were hard for everybody back then; but it seems that the women and children suffered most. Do you remember telling me, years ago, about the woman who cooked dinner for the fieldhands the day after giving birth to a child?

"Yeah, I recollect that. Mama had a sister that lived across on the other side of the mountain and she wanted to go see her. She got me to go with her to carry the baby. It was about six or seven miles over there, and just before we got to where Mama's sister lived we stopped at Dick Johnson's place to rest. Mommy knew Miz Johnson. Well, Miz Johnson was stirring around there getting dinner for a bunch of thrashing hands. Mama asked how she was feeling.

"She said, 'I feel purty good considering I had a baby last night.' Mama said, 'You did?' Miz Johnson said, 'Yeah, and I've

221

got the afterbirth tied around my leg.' Now, that's the truth if ever I told it."

You've often talked about the scarcity of food and how many people didn't even have enough corn to eat. I presume that these extremely poor folks never had any livestock.

"A heap of folks, most of them that lived on top of the ridge, never had a hog, cow, mule, nor no kind of stock."

When I was a child, in the depression, I remember some poor mountain people who fattened hogs on certain kind of weeds. They called them hog weeds. Did you ever hear of that?

"Oh, yeah. They's plenty of weeds that will keep a hog. There's what's called a river weed that a hog will do well on. Pursley is awful good hog feed. Now you can shore fatten a hog on pursley.

"It has a little round leaf and grows pretty flat and low on the ground. You can get you a armload of it in a few minutes. It has a stem on it about as big around as your little finger. I've gathered it myself to feed hogs."

I had never heard of "pursley" and I thought Alex was referring to parsley, or perhaps parsnips, which sometimes grow wild in this area. But neither parsley nor parsnips fitted the description Alex gave of the plant he called pursley.

I must say that I'd begun to wonder if Alex had just thought up the name, but *Webster's International Dictionary* came to the rescue. Pursley is therein described as, "an annual herb with a fleshy, succulent stem and obovate leaves." The more preferred spelling is "purslant." We'll take off a half point from Alex's score for not using the preferred pronunciation.

Alex continued his discourse on how hogs could be fattened without the use of domesticated crops. He pointed out that the plant which is commonly called "poke" is a good hog feed. Poke, as mentioned earlier, has always been a popular plant for human consumption in the early spring, especially in certain areas of the South. It is cooked, often with other greens. These cooked greens were, and are, called poke salad. But I had never heard of it being used as hog feed.

"Oh, poke's good for hogs if you cook it. You take the stalks and put you a little salt in and cook it, and buddy them hogs will light in on it like it was corn. And hit cleans the worms out of them, too.

"When I lived on the Widow Mullins's place on Blackwater she kept hogs. That mountain was just full of poke, and she'd go every day and get her a load of that and cook it for her hogs.

"Boy, I've seen her pack the heaviest load of poke stalks out of that mountain many a time, on her hip. She had a big kettle she always kept to cook it in. She gave them about three messes every

day. She had seven or eight pretty good hogs there at one time, and she mostly fattened them on poke."

Well, when the weather became cool enough to preserve the meat in November, the hogs were butchered, I suppose, so you didn't have the problem of wintering them. But what about feeding the cows, and the horsestock through the winter when the corn was gone?

"Why, the few people that had cattle or horses used to winter their cattle, might near it, on wintergreen. Right across Indian Ridge over there, the ground was covered with it. Hit growed a long, flat leaf. People would take sheets and sacks and go there and gather it to feed their cows. Law I've seed them do that many a time. Poor old Singletary Johnson's daddy and mother would come out of that ridge carrying great bundles of that wintergreen. And old man Mahoney he'd go to the woods hunting it.

"Now there's four or five different kinds. One kind we called winterfurin. Then there's another kind that's called maidenhair. That's the prettiest thing ever you looked at. I just wish you had the time to go with me back up here on the ridge and I'd show you some maidenhair."

Alex's unusual comment about the beauty of this plant is interesting. An encyclopedia on herbs and gardens describes the maidenhair fern, or adiantum, as being among the most beautiful of greenhouse ferns. Alex's comments indicating that there were various types of wintergreen was also verified. The encyclopedia describes the types of wintergreen as shallon, checkerberry, teaberry, or gaultheria, and also states that it belongs to the heather family.

Alex continued discussing the problem people faced in providing food for their livestock, under conditions where they could scarcely feed themselves.

"Back then people didn't have no meadows, generally, and they didn't have any hay. They'd feed their stock a little corn fodder, and shucks. You couldn't get a cow now to look at a shuck, let alone eat one. They would even feed them corn cobs. Yes sir. Beat them up right good, boil them down in a kettle and put a little salt on them. I've seed them do that many a time."

Livestock were allowed to run loose at that time, weren't they?

"Oh, yes, they didn't have fence laws then. The folks that had livestock would put a brand on them and let them go. Grandpap had a big branding iron he used for his cows. He would notch or slit the ears of his hogs and sheep. He had to have his brand registered at the courthouse in Sneedville, and nobody else could use that brand. We fed our stock once in a while so they'd stay around, and we'd salt the cattle every few days and that helped to

This "pole", or unhewn log cabin, is of the type Alex often alluded to as being typical of those found on Newman's Ridge in the early days. This one has an addition built on the front. Note the stick-and-mud chimney which Alex talked about. These chimneys were ostensibly built to lean away from the house so that the prop could be removed, thus allowing the chimney to fall away from the structure in case it caught fire. (From an old photograph in the Museum of Appalachia Collection labeled "Tennessee Mountain Home"—Photographer unknown)

keep them coming back. In the fall of the year when the acorns began to fall, the hogs would get as fat as mud balls."

The people today, don't really know what a hard time their ancestors had, do they?

"The people that think they've got it hard today are on a gravy train compared to what folks used to have to go through. Why, back then if they ever went anywhere they had to walk, and if it was real cold they would might near freeze. I've seen them going to a meeting humped-back and crippled and everything else. The women would have old rags wrapped around their heads, and they'd wrap up in quilts. They didn't have a sign of a coat. If it wasn't too cold they would carry their shoes on their arm till they got pretty close to the meeting house. Then they'd set down and put their shoes on, and when the meeting was over they'd take them off and carry them to save wearing them out. Now, I'll swear that's the truth. I've seen that not just once or twice, but time and time again.

"Hard times! I *say* hard times. They's a heap of folks today that don't know what hard times is."

Witches And Other Strange Happenings

"Grandpap Stewart Said It Was The Truth."

I don't know whether or not witches ever existed, but after hearing Alex tell about them, I'm certain of one thing. If they ever did exist, they did so on Newman's Ridge in and around Grandpap Stewart's place.

You told me a story once about an old man who ran a corn mill whose wife turned out to be a witch. How did that go?

"That was old Spot Collins. He lived about four or five miles from here over on Blackwater and he put up the first gristmill that was ever in this community. Back then they didn't understand gearing them up to where the stones would turn fast. They went awful slow and it would take two or three hours to grind a turn of corn. They had to run night and day to do any good.

"Old man Spot Collins had four girls: Doshia, Laurie, Keary, and Cary. They run the mill during the day and he had a feller to come in about bedtime to run the mill all night.

"Spot went down there one morning early to take the miller his breakfast and he was dead. There wasn't much said about it except that he died there, suddenly. After a while Spot hired another feller to run the mill of a night, and it wasn't long before they found him dead too. After that Spot suspicioned something.

"About that time there was an old circuit riding Methodist preacher that come by and held a meeting at Spot's house. They wasn't no churches back then and they would just meet in people's houses. Well that old preacher, he wore a long scissor-tail coat. He stayed there several days and preached of a night.

"Spot got to telling him about what had happened and that he couldn't get anybody to run the mill at night. Everybody was afraid. People was needing their corn ground to make bread, and so that old preacher agreed to run the mill a few nights till Spot could find somebody.

"He went down there the first night and started the mill up. It was powered by one of them old wooden waterwheels. He poured the hopper full of corn and set down on an old wooden bench to read his Bible while the corn ground. I've set on that bench a thousand times, I guess, waiting for my turn of corn to be ground.

He set there a few minutes reading his Bible and here come a cat. He had the mill locked so tight that a rat couldn't get in and he didn't know how it got in. The cat come up and rubbed around his leg and meowed, and he spoke to it, and asked it to have a seat. It jumped up on the bench and laid down with the old preacher. He went on reading his Bible and in a little while, here come another cat and done the same way. Laid down beside him.

"The preacher carried a great big hunting knife all the time, and he had it laying beside him. He'd heard the tales about the other two men dying and he didn't know what might happen. All of a sudden them two cats made a lunge at his throat and he grabbed that knife and struck at one and cut its foot off and it fell to the floor. He looked down at it and it was a woman's hand with a gold ring on one of the fingers.

"The next morning Spot got up early and told his wife to get up and get them some breakfast while he went down to get the preacher. She said she'd get up in a minute and he went on down to the mill. He asked the preacher how he got along and he said: 'All right. I just had one little racket. Two cats jumped on me and I struck and cut off a foot from one of them. That's it laying over there.'

"Spot went over and looked and he said, 'That's my wife's hand. That's the ring I bought for her when we got married.

"They shut the mill down and went on up to the house to get breakfast. Spot's wife was still in bed. He told her again to get up and she said, 'I feel bad. I'll get up directly.' He said, 'Yah, you low-down bitch you.' Said, 'I've been thinking you was a witch for a long time, and now I know it.' He said, 'Here's your hand. You get out of here and never come back.' Made her leave before breakfast.

"A lot of people say that it don't look like it could be true. But Grandpap Stewart said it was the truth."

You told me once about another witch that caused a lot of trouble—killed your Grandfather's hogs, made the cows give bloody milk and so forth?

"That was an old woman named Adaline Jensey. She went around the neighborhood a begging and bumming. She'd come in at Grandpap's every two or three days at meal time and set down and eat a big bait. When she got through she'd bum them out of some milk or butter or some meat and then she would leave.

"One evening she come by and eat supper and then she asked Grandma could she have a quart of buttermilk to take with her. Grandma told her that her cow was just about dry and that they didn't have enough milk for her own family, and that she just

couldn't give her any. Well, that made old Adaline mad and she went off all puffed up.

"Grandpap had five big, pretty hogs that run loose up in the woods above the house, and two or three days after that old woman was there, one of the hogs died mysteriously. It come running off the hill just as hard as it could run squealing like it was stuck. It run down in front of the house, and run 'round and 'round three or four times and fell over dead.

"Grandpap said he took that hog out and buried it and the next day, at about the same time, here come another one that did the same thing. Fell over dead just like the first one.

"The third day the exact same happened, and they was a woman there by the name of Janie Mullins. Grandpap was wondering what in the world had gone wrong with his hogs and she told him they was witched. Grandpap said, 'Witched! I don't believe in no such stuff.' She said, 'Go in the house and get me a butcher knife and I'll show you that they're witched.'

"Grandpap brought her a butcher knife and she took it and cut that hog open and let its entrails fall out. Grandpap said them entrails started crawling around over one another on the ground just like a bunch of snakes. Said he never saw anything like it before or since. He said that put him to thinking.

"Old lady Mullins said, 'Now they's a witch somewhere close by, and she's got it in for you.' She said, 'You've done something to make her mad, and if you don't put a stop to her, she'll keep on and aggravate you to death. She'll kill every last one of your hogs, then she'll cause your cow to give bloody milk, your horse to go blind and all kinds of mischief. She'll get you out and ride you all night long all over the country, and just before the chickens start crowing for daylight, she'll ride you back home. You'll be more tired when you get up then you was when you went to bed.' Grandpap knowed in reason that it was old Adaline Jensey doing the witching. Miss Mullins told Grandpap how to stop her.

"She says, 'You go down to the spring where she gets her water and find a good-sized tree that faces toward her house. Take your knife and cut out her picture on that tree as best you can and then drive a nail in the part where you want her hurt. If you want her head hurt, drive the nail in the head, if you want her to break her neck, then you drive the nail in the neck, and so forth.'

"Well, Grandpap didn't much believe in it but he thought he'd try it anyhow. He slipped down to old Adaline's spring about dark that night and carved her picture on a buckeye tree and drove a nail in her knee. The very next day she come out of her house right early and slipped and broke her leg. Grandpap never did have no more trouble with his hogs dying, nor with any kind of witching."

Many people would never start digging a well without using a water witch to find the best place to dig. How did that work?

"Find you a witch hazel bush and get you a good sized fork off it. Go out to where you're thinking of digging a well and walk around with that forked stick. You hold one of the forks in each hand, and let the main prong point out in front of you and you put a dime on that end of that prong. Whenever you find an underground stream, that prong will point right straight down towards the ground. I don't care how tight you hold it, it will twist right out of your hand when you come across water. And the closer the water is to the top of the ground, and the more there is, the stronger the pull on that fork.

"They used to be an old man named Tom Pratt that followed that. He had him a water witch and he found water for people. He'd dig you a well, too, if you wanted him to. He'd walk around for half a day, sometimes, before he found the best place to dig one. Law, I've seen him do that many a time."

Did you ever hear of children being marked?

"Oh, yeah. That can happen any time during the first three months a woman's with child. If she gets scared or real mad at somebody, wherever she puts her hand, that's where the child will be marked. There was a woman over here on Blackwater and she got awful scared one time, and she slapped her hand to her face, and when that child was born nearly half its face was gone. It was the awfullest looking thing you ever saw. I've seen her a many a time."

The reader will recall the many references which Alex has made to the phases of the moon. He cut timber, peeled bark, castrated animals, dehorned cattle, made shingles, planted his crops and a hundred other things, all in accordance with the moon's phases.

It shoud not be inferred here tht a dependence upon the moon's signs was peculiar to Alex and the people of his area. Indeed these beliefs were held throughout early and rural America to a great extent. The almanacs were a major source of information relative to the signs of the moon and the zodiac. They were printed as early as the 1600's, and became increasingly popular and remained so for two hundred years. "Poor Richard's Almanac," which Benjamin Franklin started in the 1730's, was perhaps the best known of these publications. Few homes in the country were without some type of almanac during the last century, and while these annual booklets have largely disappeared from the American household, they are still available for the stalwart few who refer to them almost daily.

It should be pointed out that those who planned their work around the phases of the moon do not consider these beliefs to be mere superstition. Many people who scoff at the black cat type of superstition are the staunchest believers in the effects of the moon. Alex is an example.

You go by the signs of the moon for just about everything you do, don't you?

"Yeah, I've always been a fool about that. If you don't believe in it, just try it for yourself a few times. They's shore something to it. The Bible says they's a time to do all things and if you don't believe it, they ain't no use for you to try and believe nothing. It says there's a time to build, a time to cut down, time to dance, a time to die and a time to do everything we do. It's right there for you to read."

When's the best time to split roofing shingles and to cover a building with them?

"Make them on the old of the moon and put them on the roof on the old of the moon. That way they'll stay flat down and they'll last longer. If you put them on at the wrong time they'll cup up, and curl up and bust and everything else."

Do the signs have anything to do with fence building?

"You want to build your rail fence on the old of the moon and I'll guarantee it'll stand right on and on. If you put it up on the new of the moon the rails will warp and crook and it'll finally fall down. The same thing is true about putting in fence posts. If you dig your holes and put the post in on the old of the moon you can get nearly all the dirt back in the hole. Tamp it good and it will never move. But you try doing the same thing on the new of the moon. You won't be able to get half the dirt back in the hole; and no matter how tight you tamp that post, it'll be loose in a few days. Now, I've seed that tried time and again.

"They's a time to plant everything, and they's a time not to plant. Plant your corn on the new of the moon and it'll come up quicker and make a great big stalk, but the ears will be little and no account. Everything you plant, you want to check the signs first."

Speaking of the moon, do you think that man has really gone to the moon?

"Well, John Rice I've thought about that a lot. It's like the little boy said: 'Could be so—I don't know.' I was down here at the Children's Museum and they showed me a rock that they said absolutely come from the moon. It was a funny looking rock all right, but I wasn't up there to see them get it. It's just too much for me to know.

"People have ventured too far. If they're going up there and picking up things and bringing them back, it could effect the seasons. The moon is like a watch, it needs all its parts. You take a fifth wheel out of a watch and it ain't going to run. If they keep taking things off the moon, there won't be anything left up there to shine."

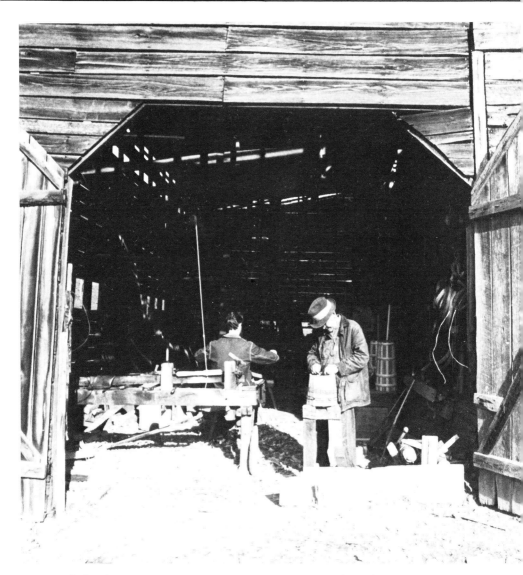

While Alex worked, he talked—usually about philosophy and nature and such as that. He is shown here working in his barn-shop with Bill Henry, who learned the coopers trade from Alex. (Photo by Robert E. Kollar)

Alex on Philosophy, Religion, Nature, and Sundry Things

"A Good Neighbor Is Worth More Than Money."

One never had to guess where Alex stood on a given issue. If you weren't sure, all you had to do was ask him. He never hedged, or tried to discover where the questioner stood before answering. Although Alex was very much a product of his environment, he sometimes held beliefs quite different from those of his peers. Whatever his views, one could be assured that they were *his*, formulated in his own fertile and always active mind. He not only would tell you what he thought, he would tell you why he so thought. Unlike some people who work with their hands, Alex was just as opinionated about social, political, and religious matters as he was concerning the best way to design a plow, make a crossbow or build a house. To make sure one understood his point, he would often bolster his answer with an anecdote.

Alex, do you think people today are as neighborly and helpful as they used to be?

"Oh, Lord no. Back then if you was airy bit sick, why they'd light a pine torch and come to see about you. They'd bring in food and they'd stay right there and help you as long as they's needed. They'd set up all night with you. Law I've done that a many a night with sick folks.

"If you got to where you couldn't tend your farm the neighbors would get together and come in and take care of your crops, cut your wood and feed your stock till you got well. They'd divide whatever they had with you. Everybody, just about, was that way.

"People just don't have the feeling for one another that they used to have. It's awful, no older than I am, at how they've changed. Back then a good neighbor was worth more than money."

What do you suppose the next 75 or 80 years will bring?

"I'd hate to be here. If things keep on the way they're going, people, in 75 years, won't care no more about one another than one hog cares for another. It's just about that way now."

I suppose people trusted one another back then?

"Oh yeah, people trusted one another. This fellow from over on Blackwater come by one day and wanted to buy a hog from me. I come up to the house and got my gun and shot one for him and

helped load it on his wagon. I sold it to him for 8¢ a pound and he was going to take it up the road here to where they had a set of scales. He said, 'Lets go and have him weighed.'

"I said, 'No, you can weigh that hog without me. I've got work to do, and it's not going to help his weight for me to be there. You can weigh him and pay me if you want to, and if you don't then you'll be the loser.'

"I told him the hog would weigh from 325 to 330 pounds but he didn't think so. In a few days he come back and paid me and it had weighed within three pounds of what I'd said. He said, 'They ain't no use to weigh a hog when you guess him.'"

And people were more honest then?

"Oh, hello yes. Their ordinary conversation then was worth more than a man's oath is today. I mean, taking it on the average."

I guess you've been fooled a few times?

"I shore have. I've took their word to be the truth and come to find out it was nothing but a lie. I ain't got no use for a feller that lies."

Do you think people are working as hard today as they used to?

"No, no, no. One man back then could do the work of two men today. He was stouter and didn't care what kind of work you had for him. Now, if you get a feller to work, he wants to pick and choose what he does."

What do you think of the young people of today?

"Seems like young people ain't got no interest in learning things like they used to have. That is, they're not interested in the things that would be of benefit to them. They're learning the fast way to get by, but a heap of it, in my way of looking at it, ain't worth too much."

What do you think of education?

"You can take two boys and let one go through the eighth grade like they used to, and you take and put the other one in college and let him finish, and if you ain't awful careful, the one that's gone through the eighth grade will naturally have a better education than the one that went to college. Now I've noticed that."

It's interesting that Alex did not confuse schooling with so-called education as so many people are wont to do. His answer does not imply that he disfavors education, simply that the person with less schooling may be better educated. And of course he is the classic example of that tenet.

I asked him what he thought of welfare, and he said, "It ain't more than right." But I soon learned that he was referring to Social Security income, and not actually to welfare. He proceeded to tell me a story that explained his answer.

The left shed of this large barn served as Alex's workshop for nearly 40 years. The center structure is his corn crib, and the one at right is the blacksmith shop. The foothills of Newman's Ridge can be seen in the background. (Photo by the author)

"I had a neighbor who lived down the road, Ben Wilson was his name, and he asked me one day if I's drawing Social Security. I said, 'Yeah. I've been paying in all along and I figure I ought to get something out of it. It's not like I'm getting it for nothing.'"

"'Oh,' he said, 'That's sorry,' and he shook his head. 'I wouldn't do no such thing. That's too dirty.'"

"A few years later I heard that Ben had started drawing Social Security hisself. I run into him down here in Sneedville one day and I asked him how he was doing. 'Well,' he said, 'I feel purty good.'

"I said, 'You're looking awful good—better and calmer than you was. Maybe them Social Security checks are helping you.' I said, 'Now you're worth $2.00 to every nickle I'm worth and here you are a drawing. I don't believe in no such stuff.' (Alex laughed heartily.) Buddy, he didn't know what to say. I shore gave him a raking. He sorta hung his head down and didn't say nothing."

It is understandable that Alex observed and analyzed those things related to farming, medicine making, and craft work; but he was also fascinated by things which had no bearing whatever on his work or avocations. One could not know Alex Stewart for long without realizing he is innately curious and inquisitive about everything. A conversation I had with him about insects is illustrative of his unbounded curiousity.

On my way to see him on a summer day in 1982, it occurred to me that I had not yet heard the vociferous hollering of what we call the jar fly (cicada). I recalled that they usually started in early summer, and that their coming was a cue that the plowing and hoeing of corn could be dispensed with or laid by, as we called it. Naturally we looked forward with the greatest anticipation to the annual coming of the jar fly. When I got to his house, I asked Alex when one could expect to hear them.

"They's supposed to be hollering now, but law, I don't care how much they hollered, I couldn't hear them. Well, let's see— Mary (his daughter) said they was hollering up where she lives.

"They generally come in about the last of June. See, summer sets in the 22nd of June, and the jar flies generally come in about that time. They ain't half the jar flies nor katydids nor nothing like they used to be. The jar flies used to make so much racket people couldn't hear the bells they had on their cows. They'd have to hunt half a day before they could find their cows at milking time. I've heard Pap quarrel about that many a time. You'd have to get right up on them before you could hear the bell ring.

"Now the locust, he just comes every 17 years. (The 17 year locust is actually a type of cicada.) One year when I lived up here on the ridge they just covered up the country. They loaded down all the timber and the garden stuff, and in places you could rake them up by the gallons. They'd split every tree limb in sight and lay them full of eggs. They worked on persimmons, sassafras, and apple trees worse than anything. All them trees have thin, smooth bark. They'll work on a young oak sprout, but after it gets so big the bark gets rough and thick and they'll leave it alone. Every limb they split would die and fall off, and when the eggs hatched them little worms would bore in the ground a foot or two deep. They don't come out for 17 years.

"Back then people didn't have their yards in grass like they do now. It would pack down like concrete, might near it, and they would keep it swept off. That year when the locusts come, them yards was as full of holes as a sifter bottom, where them locusts had come out. I've thought about that a sight. If you'll examine a locust you'll find that he's got a 'w' on each wing."

It's almost time for katydids to come too, isn't it?

"Yeah, it's about time for katydids. They commence hollering about the time the sun goes down and they holler all night."

What's a katydid good for?

"I don't know. I never learnt what he stood for. He's a animal that nothing won't eat. You'll never see a bird nor nothing eating one of them. A hog will eat might nigh anything but he won't eat a katydid. He just hollers till he passes away. I reckon he hollers hisself to death." (Alex chuckled.)

Did you ever pay any attention to ants?

"Ants? Oh, ants are worth a whole lot to us if we had sense enough to know it. They keep the ground worked up and opened up and that lets the water soak in.

"I've set and watched them and studied them for hours at a time. If a man could work his legs as fast as an ant could, he could go faster than a airplane. They're the fastest things, I reckon, they is on legs.

"I used to have a seven acre field up there on top of that ridge that was full of big red ants. They was over an inch long, and that's the only place I ever saw them. You could disturb them and they'd make a noise. They'd go woosh, woosh. They was red with a little black speck right in top of their head. I reckon they're ants. They was made just like ants."

I had come to realize that I didn't need to worry about asking Alex embarrassing questions. He always had an answer, one which came quickly, freely, and without pretentiousness. But I had one about his whiskey making and drinking, and his strong religious beliefs, which I thought might cause him trouble. He had done so well on everything else that I decided to try him.

Alex we've talked a good deal about your strong religious beliefs, and at the same time you've told me about your years of whiskey making. Do you think whiskey is made by the Lord or by the devil?

"The Lord created it. He gave man two choices on how to use it. One is the Devil's way and one is the Lord's way. It's no sin or harm for you to take a little sip of liquor because you think you need it. But if you're drinking it just to make you feel good and rich then you're doing wrong.

"I never was drunk—what you would say real drunk—but twice in my life."

Mutt, who appeared to have been sleeping throughout our conversation, suddenly came to life. He growled, and then gave a lazy, ho, ho, ho. "I think you're stretching it just a little bit Pap." Alex, visibly upset with Mutt's contribution, said "That Mutt. He's all right. He don't understand like he ought to, but he's all right."

What do you think of today's preachers?

"A lot of them will go to school and get a good education, then go to Bible School, learn this and that, and they don't know the Lord a bit more than a dog does. They'll get up and preach the biggest sermon that ever was, and when it's preached it ain't no account. They've not been called to preach and they're just preaching for the money, and their preaching is just a big puff of wind. That's all it is.

"Now, hit's no more trouble to tell if a man's preaching the truth than it is for me to set here and spit in the fire. I've got no more use for a man who don't tell the truth than a duck has for a flying machine.

"That's one reason I quit going to church. The preachers are interested in putting out new things in place of teaching the Bible. They're adding to it. They're trying to get ahead of the Lord, but I don't believe they'll ever make it. It's all right to belong to a church, to sorta keep you lined up—to keep you thinking about things—but as far as your name being on a church roll, it ain't worth nothing. The Lord says that your name has to be written up *there*. It don't mean any more to have your name written on a church roll then it does for me to write it down on that board laying over there. You get as good a blessing praying out in the field as you do anywhere else. Yes sir, you will. You don't have to go to a meeting house to find the Lord. He's everywhere."

Mutt very seldom interrupted his father, but he is an avid church goer and a preacher and, according to the neighbors, had once discussed the possibility of having Alex "churched" (expelled from the church) because of his drinking. He could hardly restrain himself when the subject of religion was being discussed. But every time he started to interject a thought, or take issue with Alex's authoritative pronouncements, Alex would talk louder and faster and with more fervor. At one point Alex said that the Lord wanted us to get together and visit and have a good time and that he paid no attention to our foolish talk. Mutt disagreed, and he slipped in his version before Alex could cut him off. "The Lord takes it all down—good and bad."

Alex was getting tired of being corrected. He responded: "I don't know whether He takes it all down or not. I've not been up there—but I'm expecting to go.

"If you're living for the Lord you won't commit no sin. But if you should backslide and commit a sin, then you'll feel condemned. If you go around puffed up and don't ask for forgiveness you'll have inner guilt, right here. (Alex pointed to his heart.) But He'll forgive you seven times 70—if you're not *too* bad."

In 1980 and 1981 Alex experienced a series of ailments and a general decline in health. He was in and out of the hospital several times, and many of us feared that his health would never improve. He was, after all, nearing his 90th year. I visited him during this period, and though alert, he was in great pain from arthritis and other ailments and was somewhat despondent. He had just come home from the hospital, and it looked as if he might have to return again soon.

When I asked him how he was feeling, I didn't expect a full analysis of the "why" of his illness. But he had deduced the reason for his suffering, and he proceeded to inform me.

"The reason I'm a setting here suffering today and a punishing is because I haven't done what the Lord wanted me to do. I can preach you one of the biggest sermons you ever listened at, and every word would be out of the Bible and it would be true; but I've fought it (preaching) ever since I was about 15 years old. I've drunk liquor and rambled and played cards, but not to gamble—just a little rook and things like that.

"But the devil kept me out of preaching just like he's kept a sight of people from doing the things they're supposed to do. If it weren't for the devil it wouldn't be no trouble for us all to be good. He's got as much power, in a way, as the Lord has. He puts things in front of us that looks good and you've got to be careful not to fall for them.

"My suffering and paining here is because of disobedience and I'm thankful for it because I'd druther suffer here than hereafter. The righteous has to suffer because we don't do just what He wants us to. We ain't got nobody living today that's living perfect to His plan. I don't think we do, I could be wrong but I don't think I am. But He forgives us of things we do. He knows we're not too sharp. Style and pride is what's gonna take most people to Hell."

Alex I think you've done pretty well. You've got more friends than just about anyone I know, and I don't know a single person who doesn't like you. I don't see how you could have improved very much.

"Well, I always paid my debts, I never stole anything, or went to jail or nothing like that. I never lawed anybody, or got lawed and I wouldn't charge you a price for anything if I thought it would strain you. I'd give it to you before I'd do that. But still, I didn't become a public man like He wanted me to do. He just took pity sakes on me and let me stay here and do what I've done. I think about that every day, not just once in a while."

What do you mean by a public man?

"That means praying in public, singing and working for the Lord openly. Not just setting on a stump somewhere and doing nothing. It bothered me for 40 years and that's what got me started drinking liquor, trying to keep it off my mind. But it don't bother me any more.

"Now there's a difference between religion and salvation. Anybody can do religion, go to church, help one another, and do the right thing, but that's not salvation. You have to be converted. And if you don't get converted you're headed toward Hell just as shore as a fat hog is headed for the meat house.

"When you're raising your garden you're always bothered with weeds, grass and insects. That's the devil, and you have to keep all them things away or you won't produce anything. The same way with people—you've got to keep the devil away if you're going to amount to anything.

"I've read the Bible from lid to lid several times, and they can't no preacher get up and take his text without me keeping up with him. Half the time I can keep ahead of him. I shore can, and I can tell when he leaves the Bible just as well as I can tell when he's getting up to leave to go somewhere."

I asked Alex what he thought of blacks and the way they were treated and he told the following story. In so doing he dramatically depicted the prejudical attitude held by some of the ignorant whites; and at the same time he conveyed his own feeling on the subject.

"I was working at the Extract in Big Stone Gap, Virginia, and the boss was a preacher. There was an old Negro man rolling coal and firing the boiler. That was the awfulest job that ever was. It would get so hot that a white man couldn't hardly stand it. One Friday this old Negro come up to the boss and asked to be off the next day—Saturday."

"'What do you want off for?' the preacher asked.

"'I wants to go to church,' he said.

"'They ain't no use for you to go to church,' the preacher told him. 'You ain't got no soul. Niggers don't have souls.'

"'Oh, Boss, I's afraid you're mistaken. When this old black Bill get up there to heaven, he'll be just as white as you are. I've got a home in heaven if you or anybody else has got one there.'

"That old black man was past 80 years old I guess, and he was awful hurt by the preacher telling him that. He cried. The preacher finally agreed to let him off.

"I've thought about that a lot. I thought pretty well of that preacher up till then. After that I didn't have any more use for him. They's a lot of people that will tell you that a Negro don't have no soul. But I know better. If a Negro hasn't got a soul, then

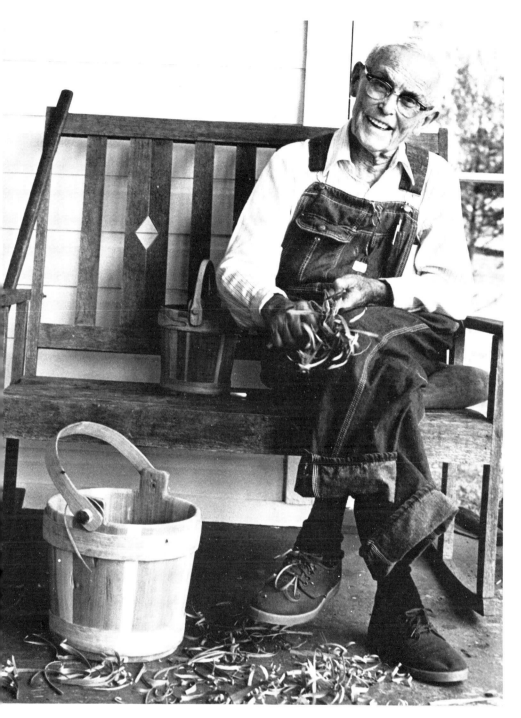

In the late summer of 1984 several dozen friends and relatives brought covered dishes of food and spent the day with Alex. He had hugged dozens of women, kissed scores of babies, and talked incessantly for several hours when this photo was taken; but company revived him and he appears fresh, alert and rested—at least for a 93 year old. (Photo by Robin Hood)

we ain't got one, according to the Bible. I've read enough of it till I know."

Another example of Alex's compassion and independent thinking is reflected in his statement concerning butchering sheep. In a society where almost no one questioned the slaughter of animals for food, Alex voiced his concern.

"I swear, I just don't think it's right to kill sheep. They'd hang them up by their hind feet and cut their throats, and they'd holler and cry so pitiful as they bled to death. Every time I set down to eat lamb I think about that. I just never did think that was right. They never was anything more harmless than a sheep. I used to kill a few, but I don't no more."

Soon after the 1984 presidential election I asked Alex if he was satisfied with the results. He gave me an ambiguous answer, and after I thought about it, I decided that ambiguity, in relation to politics, was pretty appropriate.

"I voted the straight Republican ticket, and never lost a vote. I knowed Reagan would win. They nearly always give the President a second chance. I never was no hand to mess in politics. Do you remember when McKinley was President? No, I guess not. That was long before your time. He got the name of being an awful good President. I can remember him getting killed just as well as if it was yesterday.

"Now I'm afraid we're going to have another war. It's about time. We've had one about every 20 or 25 years, ever since I can remember. The Democrats are going to keep on till they cause it.

"Did you hear Mondale criticizing the president on the radio? I never heard the beat, or anything like it in my life. But I guess he told the truth or they would have lawed him. I'd just as soon be under a good Democratic administration as under the Republicans, as far as that's concerned."

I guess there were people trying to buy their way into office even back then?

"Oh, yes, I guess its always been that way. I sold a feller $200.00 worth of liquor once over here in Jonesville just before election time. He was going to get elected on liquor. I said, 'oh, oh, that won't do.' But I had the liquor to sell and it was up to him what he did with it. He bought him five dozen pint bottles and give it out, and he got beat by 180 votes and oh, gee, he was mad. Folks took his liquor and voted against him. (Alex laughed.) He had no business trying to buy his way into office in the first place.

"One of the candidates for sheriff give old Johnny Colts $5.00 to vote for him. Well, the supporters of the other candidate for

sheriff found out about it. They went up there and got to talking to Johnny and before he knowed it the polls had closed and he didn't get to vote. He had to give the $5.00 back and they said he cried, he hated losing that $5.00 so bad."

Do you think it's wrong to sell your vote?

"I've studied about that. Is it right or is it wrong. If you take time off from your work, it seems like you ought to have something for it. But I believe it's wrong. It might not be, but I feel it is. Selling your birthright. I never took a penny in my life for voting."

Alex, you've always been extremely independent. You never had to depend on anyone for anything it seems. Did you ever borrow any money from the banks?

"Twice in my life I've borrowed a little money out of the bank. The first time was when I got mad dog bit. I was wanting to take the dog's head to Knoxville to have it analyzed and I didn't have any money to get me down there and back and pay the doctors. I went to the bank and borrowed $25.00."

Did you have any problem getting it?

"Not a bit. They knowed why I needed it and they just let me have it."

You said you borrowed from the bank twice?

"Sam was working in Maryland and he had a chance to buy a right new Pontiac for $375.00 and he wrote me for the money. I went to the bank and borrowed it and sent it to him. In about three or four months he brought it down and give it to me. That was the first Pontiac that ever was in Sneedville. I drove it down there once and it was a sight to see the people running and looking at it.

"I didn't have no more use for a car than a hog had for a sidesaddle. I swapped it for a T-model and got $550 to boot, and then I sold the T-model. That was the last car I ever owned. You couldn't drive a car up to where I lived, and I knowed that somebody would steal it if I left it off down here. I made pretty good, paid off my debt and I got out of the car business while I was ahead."

I was in New York last week with Alex Haley and we talked about you at some length with Walter Anderson, the editor of *Parade* magazine. He wants to come down and talk with you.

"If I could remember like I used to, I'd enjoy talking to him. The Bible says you're twice a child and once a man, and that's true. The doctor give me five more years, if something unusual don't happen. I said, 'Things can happen mighty fast.' Now, he's a good doctor, but he don't know any more about that than a cat knows when Sunday comes. I'll just be here as long as the Lord wants me to be."

One seldom see's smoke from the forge, or hears the ring of the anvil in Alex's tiny blacksmith shop now—and rust is gathering on the face of the hammer and on the handles of the tongs. Alex doesn't work much here anymore. (Photo by Gary Hamilton)

A Head Full Of Memories

"They Was A War Over Here At Mulberry Gap."

It is extemely difficult for one generation of people to understand the history, culture, and true feelings of a group of people who have preceded them. The manner in which history is traditionally taught in our schools does little toward addressing this problem. How, for example, can we truly understand the beliefs, fears, loves, and aspirations of our pioneer ancestors by studying the Monroe Doctrine, the fiscal problems of 1837, the French-British rivalry, or the merits of the gold standard? While these subjects are important, they reflect, at best, the thoughts and philosophies of a handful of political activists, scholars, and entrepreneurs. There is little in most history books which can help us understand the hard-working, God fearing, common people who comprised maybe 90% of the population at any given time.

In order for us to know these people, one needs to understand their daily lives by looking beyond election results, economic policies and the speeches made by the statesman of the day. Alex Stewart provides a glimpse into the past through his memories of his neighbors and their day-to-day routine. Few historians could have observed more closely, been more perceptive, and recorded in more detail than he. It is true that he made no photographs, rendered no drawings, and didn't know the meaning of fiscal independence, demography, population mobility, or economic deprivation. He wrote nothing down, yet he indelibly inscribed in his mind the deeds, plights, and feelings of his people.

This chapter is devoted to these reminiscences of long ago events which happened on and near Newman's Ridge. He talks on such varied topics as the mysterious Melungeons, the time he was bit by a mad dog, the George Ball murder, and smaller things such as the first time he saw a watch, and how his grandfather could make wooden ropes. These are topics of little importance, except that the knowledge of them helps us to understand the private lives and thinking of those people on Newman's Ridge, and in a broader sense, frontier people in general.

Alex often mentioned the Jesse Maxie family, who lived near his childhood home on Newman's Ridge. The story of this family is a classic example of the American rags-to-riches epic. It embodies a lesson for those who believe that all dire poverty is the result of shiftlessness on the part of the poor themselves.

"I was just a setting here yesterday studying about the Maxie family. I'd give anything—of course they ain't many of them left now—but I'd give anything to see them. Law at the hard times they did have. They'd take them an old basket in the fall of the year and go out in the woods and gather wild grapes, and persimmons, black haws, and pawpaws to live on. I've knowed them to have pawpaws for breakfast, and just a little parched corn for dinner and supper.

"Jesse finally got ahold of a few dollars and he bought an old worn-out sawmill and set it up at the foot of the ridge. The outfit was so no-account that it would take him a half day to saw two or three logs. But he was a worker and he just kept working at it till he saved up a little money, and he pulled out and went to Oklahoma.

"Well, when he got out there and bought him a little place, every bit of money he had left was 50¢. Now, you talk about hard, he lived hard for eight or ten years. He sold an option on his place for them to dig for oil, and they come in there and struck oil right away. They struck a gusher, and it just gushed out of the ground for seven years and they didn't even have to pump it. He got 700 barrels a day for his part. He built a town out there and he owned the whole thing.

"One of the girls, Mary was her name, was the first teacher that I ever had. Pap was a member of the School Board and he give her a school way out on the ridge. After they got rich she would come in here often and we'd set and talk about what a hard time they had before they left here."

Once when Alex was talking about the hogs running wild in the mountains, he was reminded of a man in Kentucky who decided to build a rail fence around a large section of mountain land he owned, and this reminded him of a rather risqué story.

"There was three fellers that lived right up the creek that got a job over in Kentucky—Old Fleenor Gibson, Jim Gibson and Crocket Miser, was their names. They undertook to cut and split rails and fence in 100 acres on the mountain over here on the edge of Kentucky for a man named Jenkins. Old man Jenkins soon died. He was a rich man, and he left his wife all kinds of money. She asked them to go on and finish the fence for her so the hogs could run in there.

"Every week these three men would come back home for the weekend. One Sunday afternoon as they was walking back to Kentucky, a feller stopped them and begged to go along. His name was Pete and he was about to starve. He wanted to go with them and work. They got a penny a rail, and he wanted to make a little money to buy something to eat.

"Fleenor said Pete was a great big old strapping feller, stout as a mule but not worth a dime to work. Said he was absolutely no account. But he kept begging and finally they agreed to let him go.

"They went back up there and cut rails all Monday morning and at noontime they come down to a big spring to eat. This spring was across the road from where the widow Jenkins lived, and she come out to bring them some buttermilk to go with their dinner. They said she was the best looking woman in that whole country.

"Well, she brought that buttermilk out and she seed Pete setting up on the bank, and his clothes was just wore off him, he was so poor. His behind was naked as a bird's ass, and his britches was tore out here in front so that he couldn't keep hisself hid at all. Everything he had was just as plain as your hand. Great old big, long thing that come almost down to his knees.

"She stood there and talked to Fleenor and ever once in a while she'd glance over at Pete. Finally, she got her milk jug and started back toward the house, and she asked Pete if he'd like to come with her. He was so bashful he wouldn't go. Finally she said: 'I've got a lot of good clothes that my husband left, and I'd like to give you some.' Well, that pleased him and here he went.

"Well, them fellers kept setting there waiting for Pete to come out of the house and he never did. They started hollering for him to come on, and still he didn't come. In a little while she stuck her head out the window and said: 'You all go on about your fence building. Pete's not going.'

"Well them men went on back to the mountain and worked for the rest of the day. They come down a little before dark and there set Pete all reared back in a big rocking chair on the front porch of the house. He had on a white shirt, and a necktie, and a black suit. They didn't hardly recognize him, he was so dressed up.

"She kept Pete on there for years and wouldn't let him get out and work. Of course he wouldn't have worked nohow. He stayed there as long as she lived, and when she died she willed him the farm and all her money. Now, Fleenor told me that more than once and he was an awful good man and never accused of lying. He swore that was the truth."

Perhaps the most mystery-shrouded group of people in America

are the Melungeons, who lived on Newman's Ridge near Alex's boyhood home. As was pointed out earlier, it was my fascination with these people which first led me to the area.

Although the researchers, writers and historians who have studied them differ on several aspects of the Melungeons, there are a few areas of agreement. First, all historical evidence seems to bear out the commonly held local belief that they were living there when the first white pioneers arrived. It is further agreed that the Melungeons had characteristics distinctly different from the surrounding Anglo-Saxon population. Henry R. Price, an attorney from nearby Rogersville, has done extensive studies and writings on the subject. He describes them as having an olive-like dark skin, and straight black hair. Their eyes range in color, he observes, from coal black, to dark brown, to deep purple, to gray. He points out that they have high cheekbones like the Cherokee, but thin lips and narrow faces.

Jean Patterson Bible has also done extensive studies on the Melungeons and has published a book, *The Melungeon Yesterday and Today*, on her findings. She, like others, concludes that the origin of these people remains a mystery. There are, however, several theories.

Perhaps the most popular hypothesis is that they are of Portuguese descent. According to this theory, Portuguese sailors shipwrecked off the coast of North Carolina, intermarried with the Indians, and eventually made their way inland. There are several sub-theories. One is that these Portuguese were Christianized Moors who fled to the New World in order to escape the Inquisition. Price points out that it is a matter of historical record that in 1665 Portugal dispatched a fleet of ships to Cuba and that they were never heard from again. The most common Melungeon names are: Goins, Collins, Brogans, and Mullins. Price points out that these names might be Portuguese derivations of Mageoens, Colinso, Braganza, and Mollens. It is easy to imagine how these names could have been Anglicized to their present spelling and pronunciation.

But there are numerous other theories. Some believe the Melungeons are descendents of the Lost Colony of Roanoke Island, who intermarried with the Indians. Those who support this theory offer as evidence the fact the Melungeon people, from the earliest time, have had English names.

A third theory is that the Melungeons are descendents of the Carthaginians who first came to Portugal, and from there to the New World. According to this premise, they landed near the North Carolina—South Carolina border, and then later came into upper East Tennessee. Judge Lewis Shepherd of Chatta-

nooga, while arguing a lawsuit involving the Melungeons in 1872 stated that they were, "pureblooded Carthaginians."

There are those who feel that the Melungeons sprang from some of DeSoto's troops who either deserted or were lost from the main party. There is strong evidence that DeSoto passed through what is now Tennessee in 1540, and a number of his men were never accounted for.

There are other theories, some of which seem as plausible as those discussed above. But the fact that there continues to be numerous such theories is evidence within itself that the origin of the Melungeons remains shrouded in mystery.

As Jean Bible points out, the origin of the word "melungeon," as it is applied to this group of people, is also mysterious. Here again there are several theories. Perhaps the most accepted one is that the word is derived from the French word, Melangeon, meaning "mixed breed." French traders and trappers were in this area long before the English and could very easily have first applied the term, Melungeon.

My first personal encounter with the Melungeons occurred when, at the age of 18, I borrowed my father's old Plymouth and, along with a college friend, drove to the heart of Melungeon Country on Newman's Ridge. The trail which served as the only road to the area got rougher and more rocky as we neared the top of the ridge and it wasn't long before we were hopelessly stuck. When we opened the car door to survey our plight, we were literally struck with the strong odor of moonshine whiskey. I had heard that the favorite occupational pursuit of these people was the making of illicit whiskey. I had heard also that they frowned upon strangers coming unannounced into their midst, and I'd even read stories about strangers who never returned from the Melungeon settlement. But here we were, completely immobile, doubtlessly within a few yards of an operating still. My friend knew some of the families, having become acquainted with them when they had worked occasionally as farm hands for his father. We agreed that he should go for help.

He approached a tiny log cabin, the only sign of civilization we could see. In a few minutes two middle-aged men came out, accompanied by a half dozen boys, ranging in ages from their early to late teens. On their way to our car they were joined by three other men.

When this strange looking band reached the car, they surveyed the situation. They muttered gutturally among themselves and I understood not a word. They were gaunt and ragged, and their hair was long, unkept, and dark. None were clean shaven, but as I recall, none had long beards.

I doubted if there had ever been an automobile on this rocky wagon road before, but they seemed to know what to do. Some of the men went into the woods and broke off bundles of twigs and small limbs. They motioned for me to start the motor and attempt to go forward. As I did so, some of the men fed the twigs under the spinning wheels, while the others pushed. The smell of burning rubber on the boulders soon dominated the whiskey scent, but the car didn't move. I started to get out, but one of the older men motioned for me to try again. Everyone seemed to push harder, and the car inched forward over the slick rock, until the tires caught on the branches and we were free. I thanked them, even offered to pay them, and again they responded in a barely audible and totally incoherent manner. There was no laughter among them. Not even a smile. After we were a few hundred yards down the tree-shrouded lane, I looked back and saw our benefactors, motionless silhouettes, watching our departure.

Alex brought up the subject of Melungeons when I was talking with him on a very cold night in December 1981, when he was in his 91st year. He was an authority on so many subjects, I was anxious to hear his comments on this fascinating topic.

Where do you think the Melungeons came from?

"I don't know. We ain't got no history of where they come from. I've heard my granddaddy talk about them a sight. When I's about eight or nine years old I went with my dad back up there and we seen plenty of them. There was an old man who lived about middle-ways up the ridge by the name of Williams. He was an old pensioner and he got Pap to make him six chairs and he couldn't come and get them, so I went with Pap to deliver them. Poor old feller (Williams) he just couldn't hardly get out of his chair and he said: 'Now Mr. Stewart, you watch them folks going back out of here. Don't have nothing to do with them. They're liable to stick a knife in you.'"

What kind of houses did they have?

"All they had was just huts. Didn't have no floors in them. They'd have poles laid down (to make a rectangular pen) and they'd fill that with straw, shucks, and stuff to sleep in. The men wore deer hides for shoes. They called them moccasins. You couldn't understand hardly anything they'd say. Their hair would come down along here (Alex pointed below his shoulders) and it was just as black as a crow."

How did they make a living?

"Oh, they just lived out of the woods like animals—wild animals."

And they didn't have any furniture in the huts?

"Oh, no. Just had poles and rails to set on. Wasn't a chair in the house, nor a bedstead. The chimney wasn't no higher than that

mantel there. Hit was on the outside and just high enough to keep from burning down the logs. You really couldn't call it a chimney, just a rock pile. And they didn't have no stoves, nor nothing like that. They'd broil their meat in the fire.

"Around the house they'd clean up and make a little patch of corn. Time it got to be roasting ears, they'd start eating it and keep right on till it got so hard they couldn't eat it. After it got hard, they'd put it in the ashes, shuck and all, and parch it till it got brown.

"Their cheekbones just stuck way out, and their noses was long. I've studied about them, and I've dreamed about them many a time. They's a whole lot told on them that wasn't right—according to what my granddaddy told me. Some of the older ones would try to be friendly with you. You could tell by their actions that they wanted to be good to you."

And you say that you couldn't understand them?

"No. Shoot, I could understand a goose just as good as I could understand them."

Did they speak some foreign language?

"I couldn't tell what kind of language they did have, it was so funny. Jabber, jabber, jabber—it was so fast you couldn't understand anything they said a'tall. They'd point and show us what they wanted. They knowed we couldn't understand them. Called a watch a 'satz.' Pap had a watch and when he pulled it out and looked at it, they pointed and said 'satz, satz.'"

I never heard that word before, have you?

"Never heard it before nor since. Now when them Presbyterians started coming up there they helped them a sight and got them to where they could talk to you. Oh, they (the Presbyterians) worked at it the hardest—getting them straightened out. Before that, they didn't know a letter in the book."

Do you think the Melungeons were part Indian?

"No sir, I don't believe they was. They was blacker than the Indians and they was rougher in a way than the Indians—the older ones was."

Did they call themselves Melungeons? Did they object to being called Melungeons?

"No, they wanted you to call them Melungeons. That's what they was."

I've heard that they came originally from Portugal or Spain. Did you ever hear that?

"Well, I heard lots of places where they come from, but they don't know a bit more than I do, when you get right down to it. They're just a putting on a lot of stuff. Just a guessing at it. A heap of people think they got shipwrecked way back yonder.

"They shore seen a hard time. Why, I bet they's lots of days they didn't have a bite to eat. They'd raise a few 'taters and eat them as long as they lasted. Then through the winter they just hunted for their living. Most of them didn't have a pot in the house to cook in. They'd do their cooking in the fire.

"They was 15 miles down through there that they wasn't hardly a cleared field to grow a crop. Nobody lived in there but them and that old man Williams. They lived on that ridge from one end to 'tuther."

I'm not certain whether or not Mahaley Mullins was a Melungeon, but she lived amongst them, and was likely blood related. I *am* quite certain, that she was the best known person ever to live on Newman's Ridge, except, of course Alex Stewart.

I had heard stories about this fabulous woman long before I visited the area, and long before I knew Alex. In the early part of this century her fame spread beyond Hancock County, and she became the subject of numerous newspaper and magazine articles. Both the oral and written stories about Mahaley varied greatly, but there was general agreement on certain aspects of her life; notably that she was a lifelong bootlegger, and that she was a woman of enormous size. According to some accounts she was so large that it was necessary to take down one end of the log house in order to remove her when she died.

I knew that Alex had known this matriarch of Newman's Ridge and I was anxious to hear his version of her. He smiled broadly when I asked him if he remembered Mahaley Mullins.

"Lord, I can see her just as plain as I can see you. You don't remember her? No, you couldn't, she's been dead 60 or 70 years.

"Well, I was just a small boy and Uncle George Livesey had a girl that took the measles. They wouldn't break out on her and she was about to die. They told Uncle George to get some liquor and give her and that would shore break them out if anything would. He come by to get me to go up and show him where Aunt Haley lived. I's just a boy but I knowed where she lived.

"We went up there, to the old log house where she lived and went in, and she was a laying there on an old rope bed. She had a keg of liquor under her bed and she had a siphoning hose she used to draw it out. She had a little tin cup to measure it in, and that was the first tin cup that ever I seed. I thought it was the funniest looking thing.

"She was so big she couldn't walk. They said she weighed 700 pounds, but they was just guessing. They had no way to weigh her. Uncle George told her what he wanted, and she siphoned him out about a pint—measured it out in that little cup. Oh, she

was something to see."

And the sheriff never bothered her?

"Oh, people would turn her in ever once in a while and the law would have to go up and arrest her. When they arrested her, she'd just lay there, and they was nothing they could do. They couldn't get her out of the house, let alone carry her off that ridge. (Alex laughed.) Never did get her down to the jail house that I knowed of, and she laid there and bootlegged as long as she lived. Her boys made the liquor for her and she sold it."

I've heard that they had to tear down part of the house when she died in order to get her out?

"They couldn't get her out. They just left her in her bed, and made the coffin around the bed. Then, of course, they couldn't get the coffin out of the house. They was a great, wide chimney in the house, and they tore that chimney down so they could get her out. They just drug her a little ways out from the house and buried her."

They had to take the entire chimney down to get her out?

"Yeah, it wasn't a very high chimney, though. Back then the chimneys, a lot of them, just went up six or eight feet high."

Did you ever hear of a stick-and-mud chimney?

"That's the kind we had at home. Mama had a great gang of turkeys and they was a big old black gobbler in the bunch. All the hen turkeys roosted down below the house, but that old gobbler got to roosting on top of that stick and mud chimney. That warm air drawing through it felt good to him on a cold night, I guess, and there's where he roosted.

"Well, one night Mama was cooking a big pot of mush. She had it hanging back in the fireplace and that turkey shit down the chimney in that pot of mush. Oh, that made her mad, and the next day she had me kill that gobbler, and that's the only one she had.

"The next spring one of the turkey hens disappeared and stayed gone all summer. I's setting on the porch one day and here she come flying in. We drove her in the barn and caught her, and she was so poor she couldn't hardly walk. Come to find out, she'd been setting on a nest of eggs all summer and they wouldn't hatch because she hadn't been with a gobbler. She had set on them eggs for four months and had just about starved."

I think you mentioned once driving turkeys to market.

"Oh, you can drive them just like cattle. But when the sun starts to go down they'll find them a tree and go to roost. Once they take a notion to go to roost you had just as well hang it up. It's all over for the day. I used to drive turkeys from over here on Blackwater all the time. Me and Margie raised more turkeys than anybody around here.

The main street in Sneedville is the starting point for this old time turkey drive, which is doubtless similar to those in which Alex participated. They were being driven to Morristown, a distance of some 30 miles, where they would be loaded on railroad cars and bound for the eastern markets. (Taken about 1932— photographer unknown)

"They'd buy up turkeys down here at Sneedville till they had several hundred. Then they'd drive them clear over to Rogersville or Morristown to be shipped out. Took two or three days sometimes."

Did you ever go on a cattle drive?

"I've helped drive two herds. We drove them to Ben Hur, Virginia, and loaded them in railroad cars to be shipped to Lexington, Kentucky. The cattle belonged to old man Drinnen. He would go all over this county buying up cattle. He would wear old ragged clothes, and his shoes half gone, in the mud and snow. That was the tackiest looking man that you ever saw, but he was worth more than airy man in this county. He had a big farm, and he owned seven stores.

"He had the successfulest dog I ever seed in my life. He'd tell that dog which direction to drive them cattle, and he'd keep them in the road. If they was a fork in the road, he'd tell that dog which road to take."

What did you do with the herd at night?

"We'd stop at somebody's house and spend the night. There

was an old man by the name of Hines that lived right on the road over on Walden's Creek. We'd feed the cattle there and stay the night."

I don't think you ever told me the full story about the time you got mad dog bit.

"Well, my oldest girl, Mary, started walking to school one morning. Just a little while after she left I heard her screaming and I run down there to see what was the matter. When I got there a big dog had a hold on her and it was just about to eat her up. I had bought her a fine yarn sweater for her to wear to school, paid $5.00 for it, and that dog had just tore that sweater plum off her.

"I grabbed me the biggest rock I could find and hit that dog in the head and knocked him down, but before I could get hold of another rock, he jumped up and grabbed me by the leg and wouldn't let go. I finally twisted around and got on top of him and got both hands around his neck, but he just held onto my leg. He sunk his teeth almost to the bone. I tried to get my knife out to stob (stab) him through his heart, but I couldn't do it.

"There was a boy down below me on the side of the ridge

plowing, and I hollered for him to come up there. He come running and pulled out a .38 pistol and shot that dog right through the head and me a holding him.

"That feller went on back to plowing and I took Mary back to the house. She was scared to death. I got her some clothes on and after we got her sorta pacified, I went back to bury the dog. When I got back I found he was gone. He'd gone up to Brake Queener's place and killed a great big pup, and he was standing over that pup with slobber running out of his mouth.

"We got a shotgun and killed him and I got to studying about it. I said, 'They's something wrong with that dog.' I didn't know he's mad at the time. I didn't want to think he's mad. But rather than take a chance, I went and got an ax and cut his head off and put it in a bucket and got some ice and put in it, and took it to Knoxville. It took all day to go to Knoxville (about 70 miles). My uncle had a T-model car and that was the only car in this country. When we got there it was dark, and all the doctors had quit and gone home.

"We went to a feller by the name of Albert Burkett. I's raised up here with him and played with him when we was little boys, and he married my second cousin. He was a big business man and got to be president of a big company in Nashville.

"Well, he finally managed to get a doctor to meet us at the hospital. He laid that dog's head on a table and split it wide open with a hatchet. He took a little piece of glass and a little paddle and put some of them brains on that glass and put it under one of them microscopes. He looked over at me and said, 'Now don't let this scare you.'

"I said, 'Why, go ahead, it won't scare me none.'

"He said, 'The dog's mad. He's got the very worst case of it.'

"He said they was three kinds and this was the worst kind. He wanted to know when he bit me, and I told him. 'Now,' he said, 'it's already been two days and you and the girl have to take the shots and you have to start right now.'

"He let me look through the microscope and I swear you could see them little bitty things a twisting and crawling over one another. They wasn't no longer than a gnat and they was finer than a thread. They looked like maggots crawling in something dead. That man who studied and made that microscope, he shore knowed what he was a doing."

(Alex had just been told that he and his daughter had been bitten by a rabid dog, and yet he was still observant enough to remember the microscope and describe it in detail after half a century, a clear indication of his fabulous curiosity and his interest in everything he encountered.)

"He sent the medicine to Dr. Trent there in Sneedville and I had to take 21 shots and Mary had to take 18. We'd walk from home every day down there and get our shots.

"On our way down there one day, we passed an old man's house and he said, 'Are you the man who got mad dog bit?' And I told him I was.

"He said, 'Well, I don't want a thing to do with you,' and he was walking off right fast while he was talking. He said, 'I got attacked by a mad man once and it took seven men to pull him off me. They had to tie that man up to a tree just like a dog, and nobody could get near him. They had to throw food to him.'

"Now I thought to myself that that was a lot of encouragement—him thinking I was a going mad.

"Well, I did come in nine-tenths of going mad. On the third trip down there to get my shot, I didn't know nothing. I don't even remember going down there, but when I finally come to myself, I's standing in the jail house door talking to the jailor's wife, and she was a backing up, just scared to death. I went up to the Doc's and got my shot, and I was telling him about it, and he said, 'Son, if you'd been just one day later starting the shots, you would never have made it.'

"It didn't bother Mary as much as it did me cause she had on that sweater and them heavy clothes, but he bit me right through the leg. You can see the scar there yet. (Alex rolled his overalls up to show the 70 year old scar.)

"Now I wouldn't go through that again for all the land from here down to Sneedville. A man don't know how painful them shots is till he goes through them. They tell me they've got a lot better way of taking care of that now, and it ain't near so hurtful."

As far as the writer knows there is no known treatment for a victim of rabies, once the symptoms appear; and before the modern vaccine there was no effective medical treatment for those bitten by a rabid animal. Certain agents such as opium, belladona, bromid of potash, and ether had been tried, but without avail. I'd heard vague references to a pioneer remedy which involved the use of what was called a madstone. These madstones were very rare, and I'd never found a single person who had even seen one. Since we were on the subject of mad dogs, I decided to ask Alex about them.

Alex, did you ever hear of a madstone?

"Madstone? Oh, yeah, I've seed two in my life. Old Dr. Livingston had one—the first I'd seed. It was about the size of the palm of your hand. It wasn't exactly round, sort of squarish, and it had little tiny holes all in it. They come out of the stomachs of

deer. That's the only place you'll ever find one, and they's not one deer out of 50 that'll have one. The other one I saw belonged to an old man over here. Ah, shucks I can't think of nothing no more. McGhee! Old man McGhee, had one.

"When you got bit by a mad dog, they claimed you could put a madstone right over the bite and it'd stick there until it absorbed all the poison. Then it would just drop off. A madstone was worth all kinds of money."

We've talked a lot about your herb doctoring, but you didn't do any surgery, did you? How was it possible to perform operations with no hospitals?

"I didn't have the right kind of tools to operate, but I've seed it done. I was up here on the ridge working with a feller, Sexton was his name, and he got his arm broke so bad they had to take it off. He was a big square-shouldered feller and I guess he weighed over 200 pounds. Old Dr. Mitchell come up there and took that arm off. Just give him a little morphine tablet. It was pitiful to see him lying there with one hand, and the other laying over there beside him on the table."

What happened if someone broke a limb and Dr. Mitchell was at the far end of the county?

"There was an old feller up here by the name of Lee Burchett and he followed that. If you got your leg broke, why he'd come down and make some splinters (splints) to put around it and tie it up. He'd go to the woods and dig some roots that he'd boil down and make a poultice to bathe your leg, or whatever you broke, to take the swelling out.

"Lou Trent was a good hand at setting bones. He'd go far and near to anybody that got their arm or leg broke. He'd bind them up and put splinters on and wrap it tight, but not so tight that it would cut off the circulation. He was a good stock doctor too. He was gifted at it."

I suppose the fights and the shootings that you've told me about created the need for a good deal of doctoring and medical attention.

"Oh, Lord, it was awful. Every week, not just once in a while, somebody would get shot or cut all to pieces. They was a Collins feller that lived on the ridge and they laid him open with a butcher knife and his guts just dropped out. They was two boys come along, a Williams boy and a boy named Ardale Collins, and they took and washed the dirt off his insides and stuffed them back. Then they took his shirt and bound him up and took him to old lady Livesey, who was sort of a doctor. She dabbed him up and put some stitches in him and he got well.

"Now, Pap's uncle, Bert Goins, he got shot right square through the bowel. It missed his backbone by half an inch, and it

just happened not to have hit any of his entrails."

How did this come about?

"They's having a big party right out here on the ridge—fighting chickens, making music, and drinking liquor. Uncle Bert was laying there by the fire and Ed Anderson come up and shot a hole through him with a .45 caliber cap-and-ball pistol.

"They went and got Dr. Curry. He lived up toward Kyles Ford. Well, somebody there had one of them silk handkerchiefs and old Dr. Curry, he twisted it up, tied a little switch on the end of it, put some medicine on the handkerchief, and pulled it clear through Uncle Bert. Pulled it out the other side, and the old scutter got well."

What happened to Ed Anderson, the man who shot your Uncle Bert?

"Hit took Uncle Bert four or five months before he could get up and go. He said he'd kill that son-of-a-bitch if ever he laid eyes on him. He got him a big pistol and carried it looking for Anderson. He (Anderson) lived right over here on Blackwater, and when he heard that Uncle Bert was up and about, looking to kill him, he left the country and went to Indiana. I never did hear from him no more."

When Alex finished the story about his great uncle's intent to kill the man who had shot him, he sat silently for several moments. He picked up the half-used twist of the bullface tobacco and with his pocket knife started shaving off thin layers to fill his pipe. He tamped it gently into the bowl with his gnarled index finger and as he did so he gazed out the window, never looking at his pipe. He didn't need to. He had done it ten thousand times before, and I was convinced he could have done just as well in total darkness. Finally, he had just the right amount of tobacco and he reached into his overalls for his matches. It was at this point that I asked Alex if he ever carried a pistol. It was an idle question, and I was not prepared for Alex's rather dramatic answer.

"Yeah. I carried one a little over three years, to kill a feller with. I carried it under my shirt, right here, and just as shore as my britches went on of a morning that gun went on. It was a .38 special, six inches in the barrel."

Who was the fellow, and what had he done?

"His name was Load Williams. He was a hateful, overbearing feller, not fit for nothing. He catched me gone and come up to my house one day, drinking and raising cain, and slapped Margie and the kids around. She finally grabbed the shotgun and shot at him. He jumped behind a tree just as she shot and she knocked the bark off right where his head had been.

"When I come home they told me about it, and I said, 'I'll kill that son-of-a-bitch if it's the last thing I do.' Well, his grandpap was a pretty good old man and he went and told Load that I was out to kill him, and Load stayed away from me. Ever time I saw him he was in a crowd and I couldn't get to chance at him. We sold a feller 12 or 15 turkeys up here at Kyles Ford for a shooting match one time and we drove them up there. I guess they was 75 people there when we got there, and Load was amongst them. He seed me and the first thing I knowed, he was gone.

"He knowed I meant business and he shunned me every chance he got. I would have killed him just as shore as I'm a setting here, if I had ever found the chance.

"But I got to studying about it and I thought that nobody got hurt, nobody damaged, and to kill him would be on my mind on and on. I said, 'I'll just let it go,' and I took my gun off and hung it on the wall. They was a print of that gun in my side where I'd carried it so long. He's the only feller that I ever got in my mind to hurt. And now I'm proud that I didn't get a chance to do it."

It may be difficult for some to understand how a man as kind, compassionate, and gentle as Alex could want to kill another human. To understand the answer to this question one has to understand the historic background of Alex and his kin. Horace Kephart, in his book *Our Southern Highlanders*, addresses the question of violence in mountain communities.

He points out, for example, that the homicide rate in an area of Western North Carolina where he was living at the time, was about one in 1,000. The national rate at that time was one in 16,000, the rate in Italy was one in 66,000, and the rate in Germany was only one in 200,000. Why was the murder rate 200 times greater among my Appalachian friends than among the German's?

Without pretending to have a complete and definitive answer to these perplexing statistics, the following suggestions are offered. First, the pioneers of this rugged and inhospitable land tended to be self-reliant, stout-hearted and individualistic in nature. Perhaps more importantly, they had to refine these qualities once they took their place in the wilderness, in order to survive. As Kephart pointed out, their independence grew more haughty and their individualism more intense. In their isolation there was little specialization of labor as compared to the old countries, and even compared to the more populated eastern section of this country. There were no carpenters, blacksmiths, tanners, etc., in most early and sparsely settled areas. A man, then, had to build his own furniture, do his own stone work, his own doctoring, blacksmithing and otherwise provide for the needs of

his family. He also, to a great extent, had to be responsible for his own law enforcement.

Many of the counties in Southern Appalachia were quite large, the roads poor, and bridges often lacking altogether. Law enforcement under such conditions was difficult. It sometimes took days just to summon the sheriff, and even if he determined the identity of the culprit, the chances of catching him were slim to none. So, if justice was to be done, then the victim, or most often the head of the household, had to assume responsibility for it.

In a land where there existed few social organizations and where there was little community interaction, family ties and family loyalty became stronger. Kephart states that the weak social structure contributed to an "undying devotion to family and kindred. Mountaineers everywhere," he stated, "are passionately attached to their homes." He goes on to offer that their ties to kinship were greater than those of any other Americans he knew.

Given these circumstances, it was Alex's duty to assume the responsibility for punishing someone who had encroached on his home and abused his family. He would have been a coward, less of a man, if he had not done so. At least I think that's the way Alex looked at it.

You were talking earlier about all the knifings and shootings. Did you know any of the murder victims?

"Oh, I knowed about all of them. The one closest home, I guess, was Little George Ball. His uncle killed him."

How did this come about?

"It was in the fall and I was fixing to make molasses. I looked up and seed Melvin Collins running down the road toward me, all excited and out of breath.

"I said, 'What on earth's the matter?'

"He said, 'I seed the awfullest sight. Little George is laying down there below his house—dead! His Uncle George has killed him.'

"Well, they wasn't allowed to move him till they had an inquest. They sent for old Doc Mitchell, and by the time he got there, I guess they's 30 or 40 people down there. Little George's face was covered up with fly blow (fly eggs). That beat anything ever I seed. He'd been shot in the face and you couldn't tell that he'd ever had one. Doc tried to get somebody to clean them fly blows out of his face so he could investigate, and he couldn't get anybody to do it. He said to me 'Take you a little stick and see if you can rake them off.' I got down there with a stick trying to rake them, but it was just like raking mud. I said, 'I can't do no good. I don't want to tear the hide off him.' Doc said 'They ain't but one

way I know that you can get them off. If we had some whiskey to pour on them, that would get shed of them.'

"I said, 'We can get the whiskey, Doc.' I sent Tim Gibson up to the house to get a quart of liquor. I was just about to vomit all over the place when Tim got back with the whiskey, and I turned that up and took me a sup of it. We used that quart of liquor on them fly blows, and that got them loose. Old Doc counted 12 shot around George's face and 20 some around his chest.

"He musta put every shot that shell had in him. Well, they made a coffin just as quick as they could and put him in it. His sister, one of them, lived out here about a mile the other side of me. She married Ross Sweeney. He had a team of mules and a sled. We put him on that sled to take and bury him back here on top of this pint (point). He stunk so bad that Ross couldn't drive. I got ahold of the reins and drove them out there and helped put him away. Doc said, 'I'll tell you, you got more nerve than airy man down there.' I'll swear, it seemed like I could smell that man for a month."

What did Old George have against his nephew, Little George?

"Well, now, Little George lived right there at the Virginia and Tennessee line and he was bootlegging. He'd sell liquor in Virginia, so they couldn't get him here in Tennessee. Old George was selling liquor too, and he took some up to Virginia to sell. Little George didn't like his uncle coming over into his territory selling liquor, and they got into it. Little George got his uncle down and just beat him all to pieces.

"The old man got up, come home, got his shotgun and went right back and killed Little George. He went to the penintentiary ten years for it—he served eight years and come back. See, Old George was afraid of Little George, so he hid out and bushwacked him. That's what made it look bad and that's why he got so much time."

I've heard you talk of Old George Ball before. He was a pretty good fellow, wasn't he?

"Oh, yeah! He was as nice a talking feller as you ever met. Yes sir. He had nine children at the time and his wife was dead. He spent all his money on lawyers and going to court, and when they took him off they had to sell his farm to pay his debts. His children moved off and built them a little house down here on the creek. I wish it was light enough and I'd show you where they lived. They's just one of them children still living.

"Now Little George was as mean as a blacksnake. He kept slipping around and stealing his daddy's liquor. Burley Ball was his daddy's name and he lived right next to us. Well, Burley catched him at it and they got into it and Little George started to run and his daddy put six holes in his hat.

"They said he was running after two or three women over on Blackwater, and his wife couldn't get him to stop. Stayed gone half the time. She was at the house when she heard the shot that killed him. They said, Little George hollered, 'Oh, Sally.' That was his wife's name. She just turned and walked back in the house and said, 'I guess you'll quit going to Blackwater now.' She just let him lay there for two days, until some of the neighbors found him. She never went to the burying. They had two pretty little girls—as pretty as you ever looked at. One went down to Knoxville and worked in a restaurant for years. She was a fine woman for the chance she had."

Alex, you indicated that if George Ball had killed Little George in a fight, if he hadn't bushwacked him, he might not have gone to prison. I suppose many of the murderers didn't have to serve time.

"No, a lot of them just went on about their business. That happened right down here at Sneedville. Jim Thompson and me worked on the railroad together for a long time, and he was a good feller until he started drinking. He got into it with his brother-in-law Hobart Scandlyn. Well, Jim got to drinking one day and he went down to where Hobart run a store to kill him. He hollered out to Hobart, 'Come out here, this is where you're going to die.' Hobart just reached down under the counter and pulled out a pistol and shot Jim and he fell out the door backward— dead. There was never a thing done about it, and them Thompsons quietened down after that."

Did you ever hear of the infamous Green-Jones feud that took place over here on War Creek?

"I've heard a lot of talk but I never learned too much about it. They was a war over here at Mulberry Gap that went on for years between the Collins and Brewers. Somebody would get bushwacked over there every little bit.

"Old Caney Collins had two boys, Ardell and Pettibone. One of the Brewer boys was out to get them and Caney knowed it, and he waylaid and killed the Brewer boy first. I knowed Caney well.

"Well, them two boys, Ardell and Pettibone, went and confessed to the murder to protect their daddy, and they got sent to the penitentiary for life. Pettibone died there. Caney lived to be awful old and just before he died, he owned up to the killing, and they give Ardell a pardon. I've studied a heap about that."

Alex, once, when you and I were going down the road over here on Fox Branch, you showed me where you saw a man killed. Do you remember that?

"That was Nat Fletcher—the one who got killed. Him and two brothers got into it over a cow that had got out. Nat shot one of the brothers in the hip, and he shot Nat, and Nat was begging for

There was nothing that Alex enjoyed more than a Sunday gathering at his place where he entertained both young and old with his humorous quips, mountain sayings and tales of long ago. (Photo taken in Alex's front yard in the summer of 1984 by Robert E. Kollar)

mercy. Oh, I never heard no such begging in my life. I was up the road a ways and no way to help. They all had guns. About that time the other brother walked up and shot Nat again in the chest and that killed him. He walked over to a paling fence, and jerked a paling off and struck Nat in the head with it two or three times after he had shot him down. Oh, it was awful how that poor man begged; but they sure put him out of business.

"They sent them two brothers to the penitentiary, but they got a pardon in a few years. I've forgot who the governor was who give them that pardon."

On one of my more recent visits I found Alex sitting on his front porch, swatting flies, whittling occasionally, but mostly just looking out on the crops down on Panther Creek. I told him that I had a lot of questions and that I would pay him 10¢ for every

correct answer. He laughed heartily and said, "Well, I'll make me some money today." Then I said: "But I'll decide whether or not the answers are right." "Oh," he said in a response as quick and jovial as his first, "In that case I'll just keep my mouth shut."

The questions I had in mind were those which had occurred to me at various times as I traveled through the mountains, or as I pondered the mystery of some aspect of early Appalachian life. They followed no central theme, except that they related, in one way or another, to the pioneer lifestyle with which Alex was so familiar.

Alex, I know the early pioneers had to have saltpeter to make gunpowder, and for other purposes. John Sallings, who lived up the river a few miles told me that he dug saltpeter in a cave during the Civil War. (According to the *Guinness Book of World Records*, Sallings was the last survivor of the Civil War and the oldest person in the world when he died at the age of 113.) **Did you ever hear of any saltpeter being found around here?**

"Yeah, we had a place right near home where we'd get it. Right back from where we lived, I'd say 500 yards, there was a big cliff on the north side of the ridge. It was just straight up and down like a wall, and it was from 50 to 75 feet high. In a right cold winter everything would freeze up, and when it thawed out that saltpeter would ooze out from the cracks in them rock. It would be right white—looked like regular salt. After a while the water would dry up, evaporate, and what you had left was saltpeter. You could go there and scrape it up."

What were some of the uses of saltpeter?

"They used to use it a sight in the army. They'd put it in everything they eat. Kept the men from being so mean and running around (after women).

Is that right?

"That's right. Yes sir! Swaller it a few times a day and you'll stay at home. You won't have no more use for a woman than a cut boy. You won't be wanting to run about. If you don't believe me, you try it."

I'll take your word for it.

"It tastes sour. Just as sour as vinegar. It's pretty good to clear up your throat and your lungs. Limestone rock, now, is the only thing that will produce saltpeter."

It's interesting that Alex would point out that limestone is necessary for the formation of saltpeter. He was, not surprisingly, right. The chemists call saltpeter, potassium nitrate, and they confirm that it is formed in limestone caves during the decaying process of plants and animals.

When Alex finished his comments on saltpeter, he complained about the faulty matches he was using in an attempt to light his pipe. (Interestingly, one of the primary uses of saltpeter today is the production of matches.) The first two he tried wouldn't strike at all. The third one flashed up vigorously, but died completely before he could light his pipe. He became perturbed and started searching his pockets for another. As he did so he said, "I wish the man that made these matches had them stuffed up his tail, and them every one on fire."

He finally got his pipe lit and he puffed contentedly. It was a hot, lazy summer afternoon and we both were happy just to sit and watch his one-eyed cat groom her kitten. Moments before she had been curled in Alex's lap, but the stifling pipe smoke was too much for her. Alex studied the cat and I knew he was pondering something interesting about her.

"I feed that old cat all the time, and the more I feed her the poorer she gets. I reckon she gets out here and catches lizards. Eating lizards is what makes them poor, you know."

Yeah, I always heard that.

Alex sat there looking at the cat and chuckled to himself. I didn't ask him what was so amusing—I knew he was about to tell me.

"Lizards. Law at the times I went lizard hunting when I was a boy. I'd take some long grass and make me a lasso and I'd go out to an old rail fence and I'd slip up on them and lasso them. Sometimes I'd catch a string of them as long as my arm. I didn't have sense enough to know what I's doing, killing them lizards like that. They're the best insect catchers they are. But of course I wasn't thinking about anything like that then.

"I was up there on the south side of the mountain one day squirrel hunting. I set down and leaned back against a big hollow tree to wait for a squirrel. All of a sudden I heard dirt and rotten wood falling down inside that tree and I looked around and here come a lizard out of there, and I bet he was two feet long. His head was plumb red and he was as big around as my arm. He come right toward me licking his tongue out and I shot and killed it. I've never seed nary a one like it before nor since.

"I was telling people about it and there was an old man by the name of Frost, and he said it was a santypede. Said he'd seen two or three, and that they was as poison as a rattlesnake."

You mentioned rattlesnakes, Alex. Were there many rattle-snakes and copperheads on the ridge when you were growing up?

"Oh, yeah, they was plenty of them. Now they was a lot more copperheads than rattlesnakes. This is the first year that I haven't killed at least one copperhead.

"I's working up here on the ridge one day in the cornfield, and I kept hearing my dog barking down on the lower side. They was several rock piles there, and I figured he had a young rabbit in one of them, so I didn't bother to go to him. Well, he barked and barked, and when I started home for dinner I come down by there and I could hear that rattlesnake a singing. I prized a big rock off of him, and when I did he rared back like he's going to strike. When he done that, I got him in the head with a stick.

"Margie never had seen a rattlesnake, and I said, 'I'll take him to the house and let her see it.' Well, I went out there and skinned me some bark and made me a little loop, and put it around his neck and carried it to the house. I laid it down in the yard, and while we's standing there looking at it, hit come to and struck me right there on the britches' leg. As luck would have it, he didn't bite through my overalls, but I'll tell you, I come might near getting rattlesnake bit.

"A rattlesnake ain't so ill as a copperhead. If you don't disturb a rattlesnake too much he ain't nigh as apt to bite you as a copperhead. Now that dog I's telling you about, he got so he could kill every copperhead he found, and he never got bit. He'd grab them right in the middle and shake them so fast they didn't know what was a going on. He never give them a chance to bite."

Did the snakes ever get in your house?

"A great big old rat had got down in my basement and was eating up my 'taters. I set me a steel trap in his road, where he went in and out, and I sorta covered it over with leaves, trash and stuff. I went down there one morning to get some 'taters and there was one of the biggest copperheads that ever I seen. I had catched him right in his middle as he crawled over the pan of the trap. He was as long as this here walking stick, and as big as my arm. He was just a wiggling and a fighting like everything, trying to get away. If it had bit a feller, he wouldn't have knowed what ailed him."

It is a well known fact in the mountains that blacksnakes and chicken snakes would swallow bird eggs, and later burst them by wrapping themselves tightly around a tree or post. These snakes often raid hens' nests. I vividly remember finding a hen's nest so high up on the side of our straw stack that I could barely reach it. I climbed as high as was possible for an eight year old boy, then thrust my hand into the nest which was a couple of feet above my head. Instead of feeling a nest of eggs as I had expected, I grabbed a handful of chicken snake. Until this day I never reach into a hen's nest without first making sure of its contents.

It was customary to gather eggs every day, in the late afternoon. In rural Appalachia the hens made their nests in the fence

corners, under floors, and in whatever concealed area they could find. Finding the nest was most often the task assigned to the youngsters. Once a nest was found, it was hoped the hen, or hens, would continue to use it for a long period of time. But if all the eggs were removed, then the hens may become intuitively disillusioned and seek another hiding place in which to lay their daily eggs.

In order to prevent this from happening people would leave one or two eggs in the nest. Eggs were very valuable, and leaving them overnight subjected them to the danger of dogs, snakes, and other marauders. Hence, the idea of the nest egg was introduced. The egg was marked so that it could be readily identified and left in the nest permanently. Frequently, an artificial egg was made and used as the nest egg. In later years, glass eggs were used, and were almost certain to fool the old hen. Before the advent of the glass egg, wooden eggs, painted white, were used. Perhaps the most popular nest egg in early Appalachia was the egg gourd which grew to a size and shape remarkably similiar to that of an egg. If this little gourd, which most people grew, would fool a hen, it is only reasonable to assume that it would likewise fool a chicken snake, and herein lies the tale. Alex recalled vividly the snake that swallowed a gourd nest egg.

"I's setting on the porch of my house up here on the ridge with George Ball, the feller I told you about a while ago, that killed his nephew. We looked and saw a big blacksnake crawling from in-under the floor into the yard. George said: 'It's swallered something ain't it.' I said, 'Yeah, he must have swallered a goose egg.' Hit looked bigger than a hen egg. I just walked out there and picked that blacksnake up by the tail, held it up, and I swear it had a place in its belly wore out. He'd swallered one of them gourd nest eggs, and he just couldn't bust hit. He'd wore a hole plumb out in his belly where that gourd had him swelled up and you could see that gourd sticking out.

"I let him go, but I don't know if he ever got over swallering that gourd. I never killed a blacksnake. They kill the rats and mice around your barn and corn crib, and they'll keep the copperheads killed out."

Is it really true that blacksnakes kill poisonous snakes?

"Yes sir. I set right on top of the ridge one day and watched it happen. I was planting corn and it was awful hot and I set down at the end of the field to rest. I heard something right down below me, and I looked and seed it was a blacksnake wrapped around a copperhead. He was trying to choke him to death, and he tried to stay up as close to the copperhead's head as he could so he wouldn't get bit. But he slackened up a little and that copperhead

bit him. Well, that blacksnake cut loose from the copperhead and run off down in the hollow to eat some kind of grass that took care of that poison. They's a certain kind of grass that kills that poison and that blacksnake knowed what kind it was. Then he come right back and lit on that copperhead and killed him.''

One of your boys got copperhead bit, didn't he?

"Lloyd got bit. I was working down here for John Miser topping corn and Lloyd was following along behind me pulling the fodder. He was barefooted and a copperhead bit him on the foot. He said: 'Dad I'm snakebit,' and I turned around and seed a big copperhead and killed it. And oh boy, his foot was hurting him. His foot and leg got to swelling and it was as big as two legs.

"I grabbed him and run over to John's house and he was gone. His wife was there and I said: 'Have you got any turpentine? My boy's been copperhead bit.' She got me a 10¢ bottle of turpentine and I turned it upside down on that snake bite, and you could see the poison coming out. I guess if I hadn't used that turpentine, he might have died.''

Did the snakes bother your livestock very much?

"I've had some to get bit, but generally then can smell a snake, especially a horse. You can smell a snake when he gets mad. Smells just like a plum granny (pomegranate). But I did have a big, purty mule that got copperhead bit. It bit him under the throat. I went to get him one Monday morning to go to work and he was swelled down under here just bigger than a gallon bucket. His nose was a dripping water, and he wouldn't eat nothing. I stood there, felt of him and said, 'You're a dead mule.' I started to walk off and leave him, but I walked back and eyed him and picked up my knife and slit a little place where he was swelled out so bad. When I did, I bet you they's over a gallon of stuff come outta that place. I wouldn't have give nothing for him, but I swear that mule got well about the quickest of anything ever I seed.''

I was just thinking about how difficult life must have been for the women. Just the job of washing clothes for a dozen or so people would have been difficult without any running water. How did they manage this in the winter months?

"Poor old Nal Gibson, I've seed her many a time down here on Blackwater Creek washing her clothes. She had her a big block of wood where she'd lay her clothes after she got them out of the creek. She'd take a great long stick and beat them. They called that a battling stick. I used to make battling sticks for Mama.''

She didn't have a kettle for heating the water?

"No, she just washed them in the creek. She'd use a little home-made lye soap, and then she'd beat them and every time she hit them, why, the water would fly in all directions. My mother

always heated her water outside in them big iron kettles. Then she would lay them out and beat them with battling sticks."

What did they do about washing if the creek was frozen and they didn't have a kettle to wash their clothes in?

"During the cold, snowy months they just didn't do any washing. What few clothes they had they just wore right on most all winter, and them so greasy and dirty that they would stand up by theirselves, might near it."

When they beat the clothes with those sticks, how did they keep from breaking the buttons?

"Ha. They didn't have no buttons. Back then we had little wooden pegs made out of pine to hold the clothes on. If you forgot to take them out when you washed, you'd break every one of them."

"I never seed any buttons till Grandpap Stewart made them. He made them out of cow horns. He'd go far and near to get him some cow horns to make buttons. He had him a little compass that he used to mark them out with, then he'd take his knife and whittle them out. He used a little drill to make the eyes. Why, he used buttons in place of money. If somebody worked for him or if they helped Grandma in the garden, he'd pay them in buttons sometimes."

I understand that cow horns were used to make combs?

"I've seen Grandpap and Pap both make combs out of cow's horns. They'd split the horn and boil it and get it right soft. It was just like rubber and they would mash it plumb flat. They'd split one end of a log and pry it open till they could get that flattened horn in it. Then they'd take the wedge out and that log would come back together and hold that horn flat till it dried out. Then it would stay that way."

That's interesting. I never heard of that before. The log served as a vise.

"That's what it was, a vise to hold that horn flat. After they took it out they'd take a saw and cut it in small pieces. Then they'd cut the teeth with the saw, and finish it up with a file. Pap made what they called a tucking comb. Women drew their hair up on top of their head in a ball, and they'd use this comb to hold it. Called it a tucking comb. Oh law, they thought they's flying when they got theirselves one of them tucking combs."

Once while sorting through a load of relics I had bought in Claiborne County, Tennessee, I found a short section of what I first thought was an ordinary rope, but it had an unusual look and didn't appear to be made from either cotton, hemp or other familiar material. Its basic components did not appear to be threads, but rather appeared to be pliable splinters of wood. I had

never heard of a wooden rope, nor had any of the authorities with whom I conferred. None of my reference books or research materials mentioned it, but when I found another piece of wooden rope in Western North Carolina, it occurred to me that I hadn't consulted with the ultimate authority: Alex. I asked him if he had ever heard of wooden rope.

"Grandpap Stewart used to make wooden ropes. He'd cut a hackberry tree or an elm tree and put it in a small creek or spring branch to let it soak. He wouldn't put it in a big creek for fear it would get washed away.

"He'd leave it there several weeks and let it get water-seasoned. When it got good and soaked he would just take his fingers and get a little string of that wood grain, right at the end of the log. He would start pulling and that string of wood would follow the grain for the full length of the log. He'd keep doing that until he had enough of them strings to plait together and make him a rope. He could make it as big as he wanted to. He'd make some awful big ropes that they used to tie them double log rafts up of a night down here on the river. Hit shore took a powerful rope to hold them rafts when the tide was up."

How about wooden water pipes—do you remember them?

"My great uncle, old Will Turner, put in a water line from the ridge all the way down to where he lived on Caney Sinks. It was a half mile or more and he made wooden pipes to carry it. He took pine poles about eight or ten feet long and bored holes with a long auger. He made them so one end would fit in the other and they wouldn't leak a drop after they got wet and swelled up. He had that water run right into his house. It was gravity fed and it run all the time, day and night."

Alex, I've got a few unrelated questions dealing with the very early, oldtime ways. First I wanted to ask you if any people had access to newspapers?

"The first newspaper I ever heard of was called the *Hancock Times*. It was a small paper; just two sheets to it and it cost 15¢ a year. I started taking it when I was about nine years old and took it for years. It finally got to where it would cost 75¢ a year and I dropped it.

"People on the ridge found out that I took that paper and they's all the time coming there to beg me out of them newspapers."

Most of the people couldn't read, could they?

"No. They wasn't wanting them to read. They used them to paste up on the inside of their houses to keep the cold air out. They wasn't anything any better than newspapers to shut out the air from them old log houses. It helped the looks of them too."

So they used it for wallpaper. What did they use for glue?

"We'd take flour and mix it with water and make a paste. The

mice would get in there between the paper and the logs and eat that paste if you didn't keep after them. You could see them working in behind that paper. We'd take sharp sticks and jab them. I've killed many a one that way."

There's a very old fiddle tune called Leather Britches, and it seems that I've heard that some of the pioneers wore these. Did you ever hear of that?

"I recollect that my great-grandfather Livesey wore a pair of leather britches. It seems like they was horse leather, but I can't be for sure."

When I was a child my Grandfather Rice had what we called a foxhorn. He would never allow us to blow it because it was used as a means of communicating with the neighbors and any blast on it had a certain meaning. Did your people use that method of communicating?

"We had great long horns made from cows horn. We used them if somebody got hurt bad or was real bad sick, or if we had a fire. We had a certain toot to alarm the neighbors and they'd come running to help out. We used them to call the hands in to dinner from the fields. You had a certain kind of toot, toot for that. Mama wouldn't allow me to get out and just blow for the fun of it. She lectured us good on that—not to give out any false alarms."

We talked earlier about branding cattle before there were any fence laws—back when there was open range. Do you remember when barbed wire first came in?

"Yes, sir. I remember when the first barbed wire came into this country. Old Lou Trent had gone down to Knoxville and bought some, and was putting it up on his place. They was a feller that lived on Lou's place named Lou Castle and he was putting that wire up. I thought them jaggers looked dangerous. People come from all over this country to look at that barb wire. It looked funny to me."

Most of the household items that we have today, according to what you've told me, were non-existent when you were growing up. Simple things that we take for granted—like clocks and watches.

"I remember the first watch ever I seed. George Ball made liquor and somebody come by and traded him a watch for that liquor. I thought that was the greatest thing that ever was. He's the only man in the county that had a watch. He'd go to town and he'd pull that watch out every little bit to wind it up, and it was a sight to hear people talk about that."

When you were a boy did you ever have wild animals for pets?

"I've raised squirrels and groundhogs, but coons make the best pets. I've had two or three, but one pet coon I kept for a long time. I raised it from a baby and it slept in a box in the corner of the

house. If I come in with a pocket full of chestnuts, it would smell them and it'd take them out of my pockets. He would set on my shoulder all the time if I'd let him. He could take his paws and part my hair the same as you could. He was a lot of trouble to tend to and I finally turned him loose one spring. I marked his ear, and that fall I was hunting up there in the ridge and my dog killed a big coon and when I examined it I saw that it was my pet. I always hated that."

At a little past midnight on the morning of January 20, 1985 the temperature stood at 21° below zero at the Museum. There was a spirited wind which, according to the U.S. Weather Bureau, created a chill factor of more than 50° below zero. I was checking on some of the livestock when I heard what sounded like the sharp report of a rifle in the nearby woods, followed by a similiar sound in a different section of the woods.

Almost immediately it occurred to me that what I'd heard was a tree freezing and literally exploding. I vaguely remembered hearing my grandfather talk about timber freezing, but this was the first time I'd heard it myself. It is caused, I understand, by a combination of very cold weather and by a relatively high concentration of sap in the tree. A few days before, the weather had been unseasonably warm, and I thought the warm spell might have caused the sap to rise a little. While pondering this unusual phenomenon, it occurred to me that Alex could shed some light on the subject. The next time I saw him I raised the question.

Did you ever hear trees freezing and bursting?

"I've heard that many a time way back yonder. I've been out in the woods on right cold times and heard the timber a popping and cracking, but it was winter back then. We don't have the winters nothing like we used to have."

Does that damage the trees?

"Yeah, it hurts them a sight. It causes them to be what they call windshaken."

Alex, I know that windshaken timber is no good for lumber. It just falls apart and separates when you cut it; but I confess I thought it was was caused by high winds.

"No, wind won't hurt timber much. It will just spring thisaway and thataway, you see. But that freezing just pulls it apart. Any tree from a foot on up will freeze if it gets cold enough, and if there's enough sap in it. There's more sap in late winter. It starts rising a little, and every time the moon news, the sap comes up and when the moon gets old, the sap goes down.

"Some trees are worse than others to freeze. Hickory is about the worst to get froze and windshaken of any tree there is. We bought a boundary of timber off of Dave Johnson up here and

there was 30 or 40 hickories on it that was two and three feet thick. We'd cut them and they'd just fall apart. They was windshook and they weren't fit for anything. Once a tree gets windshook it stays that way. It won't grow back. Hit's no account.''

When I visited Alex one spring morning in the early 1960's, he was sitting in front of his barn workshed in the warm sun working on some small item I could hardly see. He seemed elated to have company, as he always did. I asked him what was he making.

"Now you tell me," he said with a grin on his face. "Do you know what it is?" he asked holding up a curved bone-like item about three inches long.

Well, I think that's one of those famous 'coon toothpicks. They call them Arkansas toothpicks don't they?

He laughed heartily. "That's right. Now how did you know that? They're made from a coon's dick.''

And you actually use them as toothpicks?

"Oh yeah, that's what they're used for. I used them for 12 months out of the year to pick my teeth. All I've got now is second hand (false) teeth, so I don't need toothpicks any more.

"I had one here one time and I'd taken babbitt and melted down and put on the big end. I made a knob of it, and it looked purty. They's a woman come here one day and seed that, and she said, 'What'll you take for that?' Said, 'I've always wanted one of them.'

"'Well,' I said, 'you can have it if you want it.' And she just seemed tickled to death. It sorta plagued me when I found out what she wanted. (The word plagued as used here means to embarrass. This was the first, and I believe the only time, I heard Alex use it; but I heard it used occasionally in Southern Appalachia before by, among others, my father and his brothers.) If I'd a'knowed she's coming I'd a hid it. But it didn't bother her at all.''

Alex Becomes A Celebrity

"I Never Did Believe In Getting All Diked Up Just Because Company Was Coming."

Alex was 53 years old when he moved on his new farm on Panther Creek. He soon built himself a house, and for the next twenty years cultivated his bottom-land farm, operated his sawmill and spent a little more time fishing and hunting. Then, when he was in his seventies, he went back to the mountain crafts and pioneer activities which was to bring him fame and notoriety.

Tell me about getting started on your new farm on Panther Creek.

"After I got the farm paid for it took about all the money I had. I noticed that these bottoms down here was tee-totally covered with this old yellow dock. I had to plow the bottom anyhow, to plant corn, so as I plowed it I had the boys to dig and pick out the roots of that yellow dock. People up and down the creek made fun of us. Well, we shipped it to North Carolina and got ten cents a pound for it. We sold over $200.00 worth that summer."

Did you build the house?

"The boys helped and we built it ourselves. I made me a wagon and hooked my mules to it and went up here on the mountain and got the logs. We hauled them to the sawmill and had them sawed. Then I hauled the lumber down to Sneedville and had it planed and sized."

Supplies were scarce about that time weren't they, because of the war?

"That was towards the end of the War and you couldn't hardly buy anything. The nails and tin was the biggest things I needed to buy anyhow, and I had to go way up in Kentucky to find them."

Where do you get your water?

"It comes from back over on the second ridge from here. I was up there squirrel hunting one day and I come to this big spring. It belonged to Singletary Johnson, one of Margie's uncles. I got down on my knees and got me a good drink, and I thought that was the best drinking water I ever tasted. It was cold and clear and had them little pennywinkles in it. You know what they are don't you?

"I stood there and looked at that spring and I said to myself, 'that water can be put down to my house.' I said, 'I'll put it down there', and I did. I run me a pipe from up there and we have all that good spring water run right here in the house and it don't cost me a penny. I let seven other families around here have water, and it don't cost them anything either. It's all gravity fed."

The happenchance manner in which I met Alex has already been discussed. From the time of that first meeting, Alex started making various old-time items which I bought for the Museum. He started out with staved pieces such as churns, tubs, buckets, and piggins. When one of us thought of some other long-forgotten item, he would have it made by the time I next visited him. He made dough trays, scrub brooms, bowls of various types, rolling-pins, mouth bows, billies, chairs, baby cradles, fish traps, whiskey stills and crossbows, to mention a few. A very few older folk in the community remembered Alex Stewart, the old-time craftsman, but most of his neighbors were seeing a new and exciting side of the old farmer on Panther Creek.

People began to notice some of Alex's handiwork which was on display in the Museum. Among those who observed and admired these artistic creations was Bill Henry, the noted whittler and craftsman of Oak Ridge. Bill, who is my longtime friend, was employed by Union Carbide Corporation, but he had a most profound interest and appreciation for the Appalachian region and its people. He grew up in the stark coal mining camps of East Tennessee and Kentucky and is no stranger to mountain people and their ways.

From the time Bill first saw Alex's work, he wanted to meet him. He got that chance in October 1966 at the Southern Highland Craftsman Fair in Gatlinburg, where Alex had gone for a visit with two VISTA workers, Mike and Ann Hughes. Although Alex was old enough to have been Bill's grandfather, the two craftsman became fast friends and Bill became a frequent visitor to the Stewart homeplace. In the fall of 1975 the East Tennessee Craft Council arranged for Bill to serve a four week apprenticeship with Alex. He received a leave of absence from Union Carbide, and the Tennessee Valley Authority financed the program. Bill described these events as a "dream come true." Commenting on his memorable stay, Bill said:

"I moved in with Alex and Mutt on January 19, 1976 for a four week adventure that I shall never forget. Alex's shop was a half enclosed shed on the old barn that stood some 200 yards behind the house. It was a delight to the senses. The dirt floor was always ankle deep in cedar shavings, chickens cackled and crowed in the hay loft, and cows mooed in the adjoining stables. From the open

end of the shed one had a full view of the log corn crib, the blacksmith shop and the sawmill. Beyond that lay the fertile meadows of Panther Creek, and beyond that Indian Ridge."

It was in this primitive and picturesque setting that the two worked and talked, day after day. On very cold days, when the temperature hovered near zero, they would work by the fire in Alex's little room inside the house. Bill asked questions, listened and learned, and he came to admire his mentor more each day. The following are excerpts from the daily journal which Bill kept during the month he spent there.

"Alex is a good cook and does all his cooking on a big wood-burning stove. He bakes biscuits every morning and if they're not all eaten he dips them in water at noon and heats them in the oven. They taste as good as freshly baked. He is a wonderful teacher and he takes his job seriously. But he is always jovial—always displaying a sense of humor. One morning I was washing the dishes while he swept the kitchen. I started to move out of his way, and he said: 'That's all right Billy, you don't have to move. I'm just sweeping out the big things so we won't stump our toes on them.'"

At the end of his stay, Bill made a long entry in his journal. He described Alex as being "as good a man as ever came down the pike. He is curious as a cat, tough as a pine-knot, independent as a hog on ice, industrious as a honeybee, and as handy as the pocket on your shirt. He is also a bit of a paradox; frugal as a Scotchman, yet he would give you the shirt off his back. If you gave him just cause, he'd knock you down, then help you up and dust you off. He has a heart as big as all outdoors and a mind like a sponge, absorbing everything with which it comes into contact. My very dear friend, Alex Stewart."

And then he said: "If we had men with his qualities of integrity, frugality and good sense in positions of authority, our nation wouldn't be in the shape it's in."

Alex enjoyed the relationship quite as much as Bill. After all, his greatest delight in life was helping others. He talked of their association with fondness.

"Bill stayed here a month and one day. Oh, we had a time together. I made him a shaving horse, turning lathe, and the whole outfit. That liked to have tickled him to death. We named the shaving horse old Silver. I believe he said he'd been offered $75.00 for it. Said he wouldn't take a hundred for it. I told him that was a mighty high horse. He learned the trade pretty good and he got to where he could make about anything, but he had to go back to work down there at Oak Ridge, and he slowed down on making buckets, piggins, and churns. He's retired, I believe, from his job and I expect that he'll go back to making things again."

Alex turned 85 that January (1976) and he was already gaining widespread fame. In commeration of his birthday he received letters or telegrams from Governor Blanton, Senator Howard Baker, Senator Bill Brock, Congresswoman Marilyn Lloyd and Congressman Jimmy Quillen. He had scores of visitors, who, in addition to members of his family, included several friends and admirers from Knoxville, Oak Ridge and other East Tennessee communities.

He was delighted at the "turn-out." He willingly posed for pictures, held the babies, kissed the women, donned a big black wig and a Mexican sombero, and played several tunes on the mouthbow. Then he blew out all 85 candles on the cake his daughter Edith had baked for him.

In 1976 Alex and Bill Henry were invited to participate in the Festival of American Folklore in Washington, D.C. Some felt that the ordeal might be too much for Alex, but he was determined to go. He later said: "I meant to go if I had to come back in a box." He said he'd always wanted to go to Washington and see "all them foreigners."

Tell me about the first time you went to Washington.

"They come and got me and took me up there and I stayed with them seven days."

Did you enjoy it?

"Yeah, I liked it all right. They's so good to me I couldn't help but like it. I's never treated better in my life. I wasn't used to it. Made me ashamed, they treated me so good. Never thought about getting a penny out of it or nothing. I took a tray I'd made, a bucket, and a piggin with me. I was to work three hours of every day while I's there and they's a giving me $25.00 a day. They come to me and said, 'work if you want to and if you don't, you don't have to.' Said, 'you've done enough work already for people to see how its done. Take your time, and if you want to run about, go on.' They took me about all over Washington. Took me out to where Kennedy was buried, and took me to where all the money was being made. Showed me the first money that was ever discovered in the United States, and a rock off the moon—boy I don't know what all. They kept me on the road all the time. When I first went to the Smithsonian, they come running out to meet me. I wondered how come they all knowed who I was, and then I looked around and there was a life-sized picture of me." (The life-sized color photograph of Alex was actually at the National Geographic Society's Headquarters.)

Did you see the President while you were there?

"When I got back home a heap of folks asked me that. I told them that I could have, but that I got to studying, and said to

myself, 'If I go in there to see the President, he'll ask me ever question in the world. He'll want to know where I'm from and what's my occupation. He'd see that big badge I had on that said I was a cooper, and he'd come down home aggravating me to death, wanting to learn that trade and I just decided I didn't want to be bothered.' If I had seen him, I would have just seen another man and I've seen thousands of them. I'd druther see you anytime than the President."

Who was the President then?
"Johnson. I didn't see him but I saw the White House all right. I had seen it on money so much, I wanted to see it to see if they had it right. They was exactly alike. (The picture on the money and the White House.)

"Not long after I got home the President sent me a birthday card. Yeah, he shore did. They brought me in the mail one day and I come to this big square envelope that didn't have no return address on it. I thought it was an old company letter or some kind of insurance, and I just throwed it back on the table. A little later

on I said, 'I'll just open you up to see what you are, and it was from the President.''

Where did you stay when you were in Washington?

"I boarded at the Alexander Hotel. Was you ever out to his hotel? It's built out of rock, I believe, and its got 600 rooms in it. I slept in the sixth story.''

I believe that was your first plane ride. Tell me about it.

"When we first got ready to get on the plane they had people there to investigate us to see what we was carrying on us. The bells went off when I went passed them, and they found out I was carrying a knife. They asked me if I had anything else in my pocket. I said, 'Yeah,' and I pulled out a big twist of homemade chewing tobacco and offered that feller a chew. He told me to go on through. That liked to have tickled Bill to death.

"After I got on the plane, I looked up in front where they had all the machinery and everything that run the plane. The whole thing was just filled up with buttons where they operated everything. I was peeping in and one of the men in there grabbed me, and said, 'I'll bet you're wanting to see in here.' I says, 'Yeah, that's what I was wanting.' He took me in and showed me all the buttons and gadgets and what they was used for.

"We got up there five thousand and some feet and we run into a big storm and we had to cut around it—go through a big hole, they called it. They told us to put our belts on, that it might shake us up a little. Well, we got through that hole, and I never noticed when we went through. That made us five minutes late getting into Washington.''

And the trip didn't cost you very much?

"From the time I left home till the time I got back, it cost me 15¢. I got thirsty one day and I went over and bought me a coke-cola. It cost me 15¢ and that was every penny that trip cost me.''

Several would-be craftsmen heard of Alex and wanted to apprentice with him. He welcomed them all and he tried with care and patience to teach them what he knew. Some of them stayed with him for weeks at a time, and of course he charged nothing for his teaching, nor for their room and board. I asked him about one of his former "students.''

What ever happened to the boy who stayed here for so long, and worked with you?

"That boy from Nebraska? I got a letter from him tuther day. What happened to it Mutt? Alex started pawing through stacks of papers and letters which lay on the little table. He ignored the fact that a dozen or so trinkets and papers fell to the floor. Mutt started to tell him where to find the letter, but Alex pretty much ignored

In his later years it seemed that Alex was the recipient of some sort of honor every few weeks. Here artist Bruce Corban is presenting him with a copy of a detailed penciled sketch he did of Alex. (Photo by Robin Hood)

him, or pretended to. Finally he found the letter, and he left the table, and the surrounding floor, littered with papers and other items.

"Here it is. Oh, he thanked me something terrible for learning him to make all those things. He sent me a picture here of a rocking chair he made. Looks purty nice too, but I think its bottomed with twine. I bet I showed him 50 times how to make a chair. He finally caught on. Here's a picture of two straight chairs. They don't look too bad neither.

"He undertook to make a bucket for his mother. Well, he worked, and he worked, and he worked on that bucket and I got sorry for him. I said, 'now Frank you've just got to remember one thing.' He said, 'What's that?' I said, 'You've got to make it in your head before you make it with your hands.'

"He said, 'I'm doing the best I can.' I saw he wan't getting nowhere, and I set in and helped him, and oh, he was pleased to death when we got it finished. He said his mother would shore be pleased with that.

"Now I believe that he was as nice a learnt boy as ever I've knowed. The first time you heard him talk you wouldn't think they's anything to him. But he's got a head full of sense."

Even before he went to Washington, Alex was beginning to gain recognition outside his home county. Dr. Thomas Burton of East Tennessee State University was instrumental in producing a documentary film, "Alex Stewart: Cooper." In 1974 I introduced film producer Joe Adair to Alex. The result was that Alex became the "star" in a documentary film on Kentucky and Tennessee produced by the Westinghouse Corporation and shown to millions of people throughout the country.

In 1975 the phenomenally successful *Foxfire* series included Alex in the *Foxfire 3* volume. The 58 pages, 60 photographs and numerous illustrations devoted to his cooperage presented Alex to millions of readers throughout the nation. In 1975 Alex was featured in full color on the cover of the National Geographic book *The Craftsmen of America* and while in Washington in 1976 he was given a personal tour of the National Geographic offices by the Society president, Robert Doyle.

His popularity continued to grow. He appeared on the covers of the Tennessee Valley Authority's *Perspective* and the Tennessee Folklore Society publication *Bulletin*. Magazine and newspaper articles about the little mountain craftsman became common. He was even sought out and interviewed for the Japanese version of *Playboy* magazine.

The City of Oak Ridge, describing him as a superb craftsman and a wise and greatly loved philosopher, designated April 29, 1978 as Alex Stewart Day. Several years later, the Hancock County Commission officially set aside the first Friday in each October as Alex Stewart Day in that, his native county.

In addition to the Museum of Appalachia, his crafts have been displayed in the Children's Museum at Oak Ridge, the Tennessee State Museum in Nashville, the Smithsonian, the Folk Arts Center in Asheville, North Carolina, and Silver Dollar City, near Gatlinburg, Tennessee. This popular theme park celebrated Alex Stewart Day in October, 1984.

Tennessee's Governor, Lamar Alexander, described him as "an amazing craftsman," and U.S. Senator Howard Baker said that Alex had "brought dignity and significant historic value to our folk culture." *Foxfire* editor Eliot Wigginton said, "I'd put Alex at the very top of the list—hands down" (of old-time craftspeople).

He was shown in television commercials, on note cards, and was the subject of a most detailed pencil drawing by Artist Bruce Corban. He was in constant demand to participate in major craft shows and mountain festivals in the region. A slide presentation of Alex and his crafts was shown throughout the duration of the 1982 World's Fair in Knoxville. But the crowning accolade came when he was chosen to receive the National Heritage Fellowship from the National Endownment For the Arts, Division of Folk

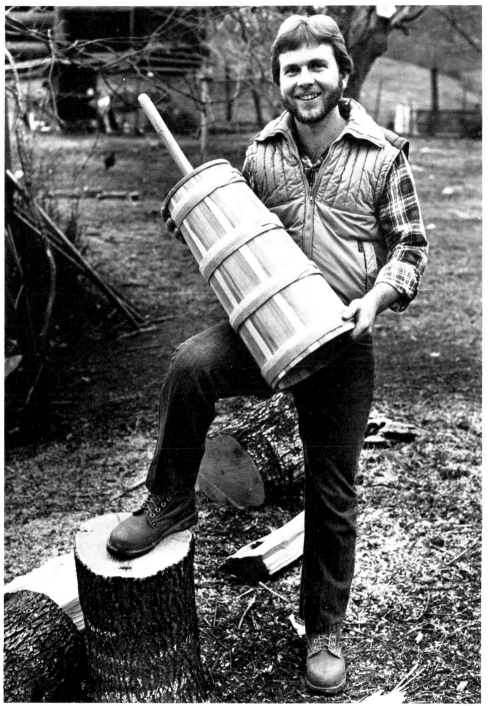

Of the more than 80 descendents which Alex has, only his grandson Rick learned the art of coopering, and Alex was more than delighted that this old Stewart tradition would live on after he was gone. Rick is shown here with one of his recently completed churns, an example of one of the many crafts he learned from his venerable grandfather. (Photo by Robin Hood)

Crafts. He was one of only 16 people in the country to receive such an award that year, and the first Tennessean ever to receive this honor. Many people wrote letters and made contacts in Alex's behalf, but it was largely through Bill Henry's untiring efforts that Alex was chosen for the award. Although he was now 92 and unable to walk more than a few faltering steps, he was as determined to make the trip to Washington as he had been six years earlier—even more so. (I think the $5,000.00 that went with the award had something to do with it.)

His granddaughter Sherry, a nurse from Rogersville, Tennessee, accompanied Alex on the trip and provided him with constant and attentive care. Rick and Bill also accompanied him, and I joined them for the award ceremony described in Chapter I. Finally in that same year, Alex received the Governor's Outstanding Tennessean Award.

The notoriety Alex received affected him not one iota. To my knowledge he never saw any of the films in which he was involved, nor any of the television programs or commercials. I asked him once about the National Geographic book on whose cover he appeared, and an unsuccessful search was made for it in the environs of his piled-up table. Mutt finally remembered that Alex had given his only copy to someone who admired it.

Alex valued his friends, his neighbors, and his relatives most. He cared little about publicity and therefore paid little or no attention to television or movie cameras. It never occurred to him to try and present himself in any kind of special way—to be anything other than himself. He summed it up pretty well when he said: "I never did believe in getting all diked up just because company was coming. A terrapin wears the same hull all his life."

The Last Days

"I Never Thought I'd Come To This."

The spring of 1982 was a bad one for Alex. His health had deteriorated to the point where he couldn't retain even the few bites of food he ate, and his strength was waning daily. He was beyond any type of work, even whittling, and he spent the long days either lying in bed, or sitting in the chair beside it. Loneliness and his inability to engage in any of his crafts contributed to his despondency, and this, I think, retarded his recovery.

I visited him on the first day of May of that year and found him in bed recuperating from pneumonia. He was weak and so short of breath that he couldn't talk above a whisper. He said he hadn't been able to eat anything, and was just living off the medicine the doctor prescribed for him. He had just returned from the hospital where, he said, they had given him "seven quarts of bluto" (glucose).

I told him I'd brought some grits and he agreed to try them. By this time Rick had arrived and as we went to the kitchen to fix the grits we talked about Alex's alarming condition, and we both feared the end was near. When we returned to his room, we found he had crawled out of bed and was sitting in his chair. The grits seemed to agree with him, and he ate almost half a bowl. "Now that's the most food I've eat in a month."

Within an hour the old Alex Stewart had returned. He was weak and frail, but he was back. He was talking about the weight he had lost, and I asked him how much he weighed. "I've got a pair of scales in there but I weigh such a little that I hate to get on them. I know I don't weigh over a hundred pounds, if I weigh that."

He decided to light his pipe, and he chuckled when he noticed the amount of smoke he had produced. This reminded him of a story.

"I was down here at the store one day trading and they was a lady that come in that weighed, I guess, over 200 pounds. Her legs was as big around as a churn, and she was the nearest naked of any

"The old grey mare ain't what she used to be. Can't walk, or whittle, and can't half see. I never thought I'd come to this." (Photo taken in 1984 by Gary Hamilton)

woman I ever saw in my life. Just a little narrow piece of cloth up here, and shorts on that didn't half cover up her behind. Nobody knowed where she come from.

"She was a grabbing things right out from inunder me, groceries and things, and she might nigh run over me two or three times. Sorta shoved me out of the way. I's smoking my pipe and she looked at me and said, 'shu-u-u, what's that I smell?' She says, 'how in the world do you stand that awful smell? Why do you smoke that stuff?'

"I says, 'lady, that's the only protection I've got. If I get around somebody I don't like, I just light up my pipe and I'm shed of them.'

"Buddy, she took right out that door and that like to have tickled that storekeeper to death. Said that was worth $5.00, just to see."

I was afraid that Alex's animated storytelling would weaken him even more, but it seemed to have the opposite effect. The members of his family always said that the company of people he liked was his best medicine. Indeed, it did seem so. After a few minutes I asked him if he was getting tired. "No, I never get tired of talking. If I's like I used to be I could wear out a dozen fellers and still want to talk on."

Well, since you're not too tired, I'll ask you one last question. How did Panther Creek get its name?

"This valley used to be filled up with panthers, way back yonder."

What exactly is a panther?

"Oh, they was great big animals, bigger than a big dog. They was brownish looking and their noses had a little whitish circle around it. They had great long claws and they'd kill your pigs, calves and they'd jump on you, too. The devilish mean things, they'd eat you up. Didn't you ever see one? I've seen them that would weigh, I guess, a 150 pounds.

"The last one I saw was one the Burchet boys down here killed. Ever time the dogs would tree it, it would jump out when he heard them coming. They run it all night and finally got him treed about daylight. They shot it out of the tree and it whupped seven dogs but they finally killed it. It was seven feet long from the end of his nose to the end of its tail.

"My great, great, uncle, Gransard Holland, lived right down the valley here and he followed hunting all the time. He had the best old hound dog in the whole community. He was awful big. Old Jake was his name and he was a regular tree dog.

"One night he treed up here on the ridge and when Uncle Gransard went to him, he saw it was a panther. He shot two or

three times with his old muzzle loading rifle. The last shot wounded him but it didn't kill him. Here it come down out of that tree and right on top of that dog. Well, that was Uncle Gransard's last bullet. He had a pewter spoon tht he carried to eat with, and he grabbed that spoon and bit the end off and chewed it up and made a rifle ball out of it. He put that bullet in his gun and killed that panther, but by that time he had split the dogs entrails out.

"'Poor old Jake,' uncle said, 'you're a gone dog.' He stuffed his guts back in his belly and carried him home and sewed him up. He went back and carried that panther home, skinned him and rendered him out. He took the grease he rendered from that panther and greased old Jake with it ever once in a while, and that cured him. He got well.''

I kept a pretty close check on Alex for the next few weeks, and miraculously his health improved markedly. He ate the grits once or twice a day, claiming it was the only food that he could eat, and he wondered why he hadn't thought of them himself.

Perhaps the most important factor contributing to Alex's remarkable recuperation that summer were the frequent visits to his home by several young nurses. The program was sponsored by a group called "Your Home Visiting Nurse Service," a non-profit organization funded by Medicare. The nurses kept a watch on his general health and made sure he took the medicines the doctor prescribed, but the best medication of all were the visits themselves. The nurses fell in love with Alex, and he with them. Mutt allowed that nobody but the nurses could get him to visit the doctor, or to go to the hospital when his blood pressure became dangerously high. Every time I visited him he had some story about Ella Freeman, whom he called Sis, or Clara Holt, or Linda Collins. He began to start whittling again and I was told that he even made a walking cane or two.

"There's a nurse here yesterday to see me, and she asked if I had a big Thanksgiving. I said, 'I bet they ain't a person in the country that had as big a Thanksgiving as I had.' She said, 'what did you have?' I told her I had a turkey and eight big hens. 'Eight hens,' she said. 'Are you telling me the truth?' 'Yeah,' I said. 'I had the turkey on the table for dinner while the eight hens was standing out there in the yard.'" (Alex laughed heartily at his joke.)

One day, Ella, Rick and his granddaughter Renée, brought Alex down to the Museum, mainly to see his old log cabin which by now was fully restored. He was delighted. He was the official tour guide, pointing out various features about the fireplace, the pole rafters, and the notching used on the poplar logs.

At noon he had a hearty meal with the entourage at our table. Then he was ready to tour the remainder of the Museum Village. He was largely confined to his wheelchair but he thoroughly enjoyed explaining to his "girlfriends" the uses for many of the pioneer relics as well as the herbs that grew in the gardens. Tourists gathered around to hear first-hand about the crossbow, the hand-made bear trap, and numerous other items. At the end of the day he was still going strong. His enthusiasm never waned and his gaiety never faltered.

Alex's friendship with the visiting nurses was not without its problems. One of his old "girlfriends," Mattie Jane, apparently got wind of his young visitors and she made some disparaging remarks about them. This, of course, infuriated Alex.

Did she really get mad about the nurses coming here to visit you?

"Yeah, she didn't like it, and throwed off on them. She's the longest tongued woman ever you saw. I like her and all like that, but she has to keep that tongue a-wagging. She'd talk about the Savior."

Was she serious about wanting to marry you?

"Yeah, she'd a married me in a minute. Shucks yeah. She called up here so much I could might near tell her ring and I wouldn't answer the phone. (He laughed.) I wouldn't marry her if she was strung with pure gold. What do I want with a woman to set here and look at—no benefit to me."

Alex Haley accompanied me to visit Alex once, about the time he (Alex Stewart) was having trouble with his erstwhile lady friend. She phoned Alex and launched a verbal attack that got louder and more spirited as she continued. Alex Haley, Mutt and I could hear her as well, perhaps better, than Alex was able to hear her. He tried unsuccessfully to interject a few bits of humor, but she never gave him a chance. Alex laid the receiver in his lap for a while, but Mattie Jane never paused in her barrage. Alex was much amused, and finally said, "I think I'll just let her go," whereupon he took the receiver and hung it up.

By 1984 it became apparent that the Alex Stewart story was a never-ending one, and that I would never fully complete it, at least not in time for Alex to see it. So I decided to wrap it up, as best I could, with one last visit in the fall of the year.

It was Thanksgiving weekend, 1984. The night had been cold but by mid-morning a blanket of warmth had spread over the countryside, the result of the bright sun, and the total absence of any wind. Everywhere there was stillness, quiet, sunshine, and cedar trees. Majestic green cedars grew in such profusion and abundance here as to cause them to be seldom appreciated, but

their beauty is not diminished by this lack of appreciation. Their deep, rich, green seemed even more dramatic against the backdrop of stark, dormant hardwood trees.

By the time I reached Sneedville, I had started to think of Alex and the world he saw and knew as a child. There were many authentic reminders of the past, but there were also evidences of a modern lifestyle encroaching upon the pastoral countryside.

The approach to Sneedville from the south followed the Clinch River. No change here from pioneer times, and no change either on the steep ridges and bluffs which lay across from this most beautiful and historic stream. A few miles further and I was in the real world of Alex Stewart. Panther Creek was on my right and Indian Mountain rose sharply beyond. Fenced fields contained small herds of cattle and a surprisingly large number of horses. They grazed on the lush fescue as if it were mid-summer. There had been no miracle grass like Kentucky fescue in Alex's time.

There were fields of corn, mature and brown, and smaller patches where the tobacco crops had been raised. Some barns were still laden with the golden leaves of curing burley, but more often there were piles of tobacco stalks beside the barns, indicating that it had been "handed off." It seemed that half the vehicles on the Panther Creek Road were old model trucks loaded with baskets of tobacco, bound for market in Tazewell or Rogersville or maybe even Knoxville.

Blue smoke rose from the chimney of nearly every house, and ricks of oak and hickory were stacked on the porches, and in the yards. I don't remember a single homestead without a turnip patch, and I saw two women pulling turnips and picking greens for dinner. There were small hillside houses with big cars from Maryland, Michigan and Indiana, owned by the children, grandchildren and great-grandchildren of those who lived there. The families almost always came home on Thanksgiving, Christmas, the 4th of July, and especially Memorial Day. That's when they visited and decorated the graves of their relatives. They called it Decoration Day.

Newman's Ridge was in full view, now, and it remained the same gentle, tree-covered mountain I imagined it to have been when pioneer Boyd Stewart first came there. But down on Panther Creek the mix of the old and new was everywhere. Abandoned privies sat beside shiny house trailers, log bee hives rested underneath television discs, and an old Melungeon woman helped her granddaughter from a green Pontiac that bore a Baltimore sticker.

The countryside was largely devoid of people. No children out swinging in the apple trees, playing bullpen, or exploring the mysteries of Panther Creek. I saw no boys rabbit hunting,

running their trap lines, or hunting arrowheads in the meadows. No men were out salting their cattle, butchering hogs, or just fooling with their hounds. I wondered why. The day was so beautiful and the countryside so picturesque. Why weren't people out enjoying it.

The answer came to me suddenly when I realized it was Saturday morning and that there was a television antenna on nearly every home. I could image a group of pajama-clad children in front of every set, and how later in the afternoon the men would gather to watch the football games. It was the day that Tennessee played Kentucky.

I passed the local beer joint, recently built, and thought of how Mutt always complained about its appearance in the neighborhood, saying it was "a dirty shame" that the good people didn't get together and have it closed. Another minute and I could see Alex's little white house on the hill above the road with Newman's Ridge looming in the background. Then I was there.

The sawmill was a hive of activity. Sam and three more sons of Alex were there: Frank, Lloyd, and Vol. There were several other helpers. Some rolled the big logs to the ravenous saw, Sam operated the carriage, while the younger men carried both the plank and the slabs away. There was no use trying to talk over the noise of this contraption. I'd see them later. It was just as well, for I was anxious to see the patriarch of the hills anyway.

Alex was almost blind now, reading only with the aid of a magnifying glass. He could walk just a few agonizing steps, and his severely arthritic hands no longer permitted him to engage in whittling, the last of hundreds of activities he had mastered throughout his life. When I opened the door I could barely see him for the smoke. He had just lit his pipe and was puffing vigorously, sitting in his chair facing the window, as he always did. He laughed when he saw me. "Well, you did make it. I'm shore proud to see you. Get you a chair."

I asked about his health, and for a fleeting minute he indulged in a trace of self pity.

"Ah, I ain't much John Rice. The old grey mare ain't what she used to be. Can't walk, or whittle, and can't half see. I'm just here. I never thought I'd come to this."

I turned the recorder on for the last time and soon Alex had gone back to those early days on Newman's Ridge—to the happy, carefree times of his youth and childhood. We had returned to another time, and there were no shiny house trailers, television antennas, or big cars from Baltimore and Detroit.

The last time I visited Panther Creek was April 17, 1985, and there were more people around the Stewart homeplace than I had ever seen. They stood in clusters or moved slowly and quietly from one group to another. The apple trees were blooming, the lilacs spread their fragrance across the meadows and the grass was lush and dark; but it was nevertheless the most sad and somber day that had ever come to Panther Creek. Alex Stewart was dead.

I had received word on Saturday that Alex's condition had worsened and that he'd been taken to the Rogersville Hospital. I arrived a few hours later to find his room and the adjoining hall crowded with kin. They said he had been asking for me, and they escorted me to his bedside.

Though he gasped for every breath and his voice was just a muffled whisper, he wanted to talk. He asked about my "folks," the weather and how the crops were doing.

His granddaughters Carol Sue, Wanda, Kathy, Sherry, and Renée had been caring for him night and day. They wiped the perspiration from his brow, gave him sips of water, and adjusted his pillow every few minutes. When they were not otherwise occupied, they held his hand. "He loves for us to hold his hands. That soothes him better than anything." And so it seemed.

Talking was a strain for him and I soon told him I'd come back to see him in a day or two. I didn't understand his reply, but his granddaughter, Kathy, later told me he'd said, "Come back before 12:00 tomorrow." He died the following day at 11:35.

Writer Elizabeth Gaynor and Photograper Kari Haavisto were visiting with us for a few days while working on an article for *Parade Magazine*, and they accompanied my wife Elizabeth and me to the funeral. We parked at the sawmill, and the first one to greet us was Rick, the only one of Alex's many descendants to take up the cooper trade. He asked us to sit with the family at the funeral. "We always think of you as part of the family," he said. I could think of no higher compliment from a close-knit, clannish mountain family.

We went first to McNeil's Funeral Home in Sneedville where the body lay. The Chapel was full, mostly with relatives, and they sat, talking in whispers, or weeping softly. At the front of the room was the open coffin—handmade of red cedar. Cedar had always been Alex's favorite wood, and I thought of his remark about the many coffins he'd made. "I never charged a dime for making a coffin, for I knowed I'd need one for myself someday."

He was dresed in his overalls, with his pipe in the bib pocket, and he wore a white shirt. He always wore a white shirt for very special occasions.

In a few minutes the procession formed behind the hearse and we made our way to the Panther Creek Missionary Baptist

Church, just two miles from Alex's home. As the caravan slowly wended its way out of the village and up Panther Creek, every car and every truck that we met was stopped and the occupants sat in solemn respect. Old men working in their gardens, and woman tending their flowers stood motionless and silent as we passed. It was Alex's final trip up Panther Creek. Everyone knew.

The dirt and gravel road to the little church on the hill was steep and rough and a pick-up truck stalled and rolled backward nearly hitting a black Lincoln Continental that bore a Texas license plate. Someone said the Lincoln belonged to one of his granddaughters.

There was no one telling us where to park, or where not to park. Everyone found a place in the church-lot, or in an adjoining field and when all available space was taken, the road itself was used for parking. The pallbearers carried the coffin to the front of the church, and placed it amid a profusion of flowers. Family members, friends, neighbors and admirers soon filled the little church to capacity, and others stood outside the open doors, and along the sides of the building. It was the warmest day of the year and the cross-breeze was most welcome.

The Reverand Lester Greene opened the ceremony. He read the scriptures and talked about his visits with Alex and the faith he professed. He talked about how Alex was now in a home of no more sin, sorrow, or suffering. Then he was joined by a woman and two other men who formed a quartet. One of the men hummed a long, drone-like tone to set the pitch, and their clear, resonant voices rose, without accompaniment, as natural and as beautiful as the spring countryside that we could see through the open doorways. One of the old hymns was "In A Land Where We'll Never Grow Old," and I thought how Alex would have liked that.

As the chords of that mournful old hymn wafted over the meadows of Panther Creek, the coffin was opened for the last time. One by one all those present filed by for the final farewell. We were sitting within a few feet of the coffin and it was heartrending to observe the sorrow on the faces of those who had loved the old man so much. There was his protégé Bill Henry, his dear friends Kyle and Dora Bowlin, the nurses who had cared for him so faithfully, and the granddaughters whom I'd last seen the night before Alex died, sitting by his bedside holding his gnarled hands.

There was Rick and Reneé who grew up with him and who had the kind of relationship children are supposed to have with their grandfathers. Everyone tried to retain his composure, but when they saw Alex for what they knew would be the last time, they wept openly. His nine chidren were all there. They each held his

hand for a moment and the girls each kissed his brow, and whispered a barely audible goodbye. One of the sons collapsed in front of the coffin and had to be carried out by three nearby men. But the saddest sight of all was when Mutt came forward to view his venerated father for the last time. No one would miss Alex more than he.

The coffin was closed, the pallbearers carried the pretty cedar casket to the waiting hearse and those in attendance left the church and found their vehicles. We were on our way to Trent's Cemetery, which is located on a hill at the back of the old Tivis Johnson place. We passed plowed fields waiting for the burley tobacco plants, and we passed the old log barn which Alex had once suggested that I should buy. We reached the cemetery at the crown of a hill with a commanding view of Panther Creek Valley and Newman's Ridge. A few words from the preachers, a prayer, and the crowd was dismissed. Then Alex was lowered into the grave beside his beloved Margie and the two children they lost so long ago.

People milled around and talked about what a fine funeral it had been and how good the singing was. One old man looked about him and suddenly realized that he was out of step even with the rural folk of Panther Creek. He remarked to a friend that he was the only man there wearing overalls. "No," his friend replied, "You're not the only one. Alex is wearing his overalls, too." The old man nodded, and seemed relieved.

A wrinkled old lady said, "I've knowed him all my life" and a younger man said, "I couldn't have had a better neighbor." Someone else observed that all his children, grandchildren, and great-grandchildren had either attended the funeral or paid their respects at the funeral home. The crowd dispersed slowly and the people went their separate ways.

A few minutes later we joined relatives and close friends at Alex's house. Both the kitchen table and the dining rooms were laden with food which had been brought in by the neighbors. It reminded me of the many birthday parties we'd attended in honor of Alex, but there was no laughter nor merriment today—no birthday to be celebrated.

Every room in the house was filled, as was the front porch and much of the front yard. People talked of their memories of Alex, about what a long and productive life he had lived, and how he was better off now.

I walked up the little dirt road behind the house toward the barn. I didn't feel like talking. The anvil in the blacksmith shop was beginning to rust and the forge clearly had not been fired in years. I passed the log crib where Alex stored his corn and the barn shed where he had worked so long and faithfully. No one was in

sight and I felt completely alone with the memories of my old friend. His old cooper tools still hung on the wall, and the ancient Stewart toolchest where Alex kept his smaller and more valuable handtools set nearby, but the shavings were no longer rich in color and clean with fragrance. They were dusty and without lustre or aroma.

As I started back toward the house, I saw Sam coming up the road from the sawmill. He and Alex were as close as a father and son could be. We met at the blacksmith shop. I never knew whether he was going to the barn to be alone, or whether he came because he knew I was there. I never asked.

When we met he said: "Pap wanted you to have his old toolchest." I said, "No, that ought to stay in the family. Rick is the only one left to carry on the Stewart trade and it ought to go to him."

"No," Sam said, in a warm but resolute manner. "Pap told me just a few days ago that he wanted you to have it. Rick does too. You've done so much for Pap. You can put it in the Museum along with the stuff you've got that he made. If you don't come and get it, we'll bring it to you."

The hardest part of the day was leaving. Poor Mutt came to see me off, but he couldn't say anything. I think he knew we'd no longer see much of one another. He put his arm around me, and finally he said in a halting, barely audible voice: "We love you." That's all he could get out. I said: "I love you too, Mutt." That was the first time, I think, that I'd ever said that to a man. We had lost our greatest friend, and that mutual loss had somehow brought us closer together.

"I may never return to Panther Creek," I thought as we drove away. Without Alex Stewart it would never be the same, and I wanted to remember it as it was.

We had to pass the little graveyard as we drove out of the valley and we were all silent as we did so. The cemetary was several hundred yards off the main road, but we could see the grave tent, and the multi-colored flowers surrounding it. I remembered what Alex had said about death. "Everybody that's borned has their days numbered and when it comes your time to go, all the herbs, medicine, doctors, hospitals and everything else can't change it. You can shorten your days by what you do, but you can't prolong them."

Index